3.00

PRODUCTION FOR THE GRAPHIC DESIGNER

2
REVISED EDITION

PRODUCTION FOR THE GRAPHIC DESIGNER

BY JAMES CRAIG

WATSON-GUPTILL PUBLICATIONS, NEW YORK

First published 1990 by Watson-Guptill Publications,
a division of BPI Communications, Inc.,
1515 Broadway, New York, N.Y. 10036

Distributed in the United Kingdom by
Phaidon Press Ltd., Musterlin House,
Jordan Hill Road, Oxford OX2 8DP

Library of Congress Cataloging-in-Publication Data
Craig, James.
 Production for the graphic designer / by James Craig ;
edited by Margit Malmstrom.—2nd rev. ed. p. cm.
 Includes bibliographical references and index.
 ISBN 0-8230-4416-5
 1. Printing, Practical—Layout. 2. Book design.
I. Malmstrom, Margit. II. Title.
Z244.C78 1990
686.2′252—dc20 90-43574
 CIP

Manufactured in U.S.A.

Second Edition, First Printing, 1990

1 2 3 4 5 6 7 8 9 / 95 94 93 92 91 90

Dedicated to every graphic designer whose printed piece did not quite measure up to expectations.

Contents

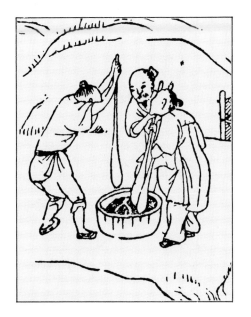

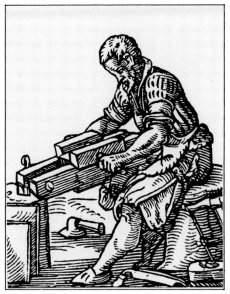

Acknowledgments

Every section of this book has drawn upon the skills and combined knowledge of a different group of professionals in the field; I'd like to thank all those individuals who gave information, advice, and enthusiastic support to help make this the best book possible:

Typesetting. Morton Friedman and Linda Lenihan of Alphatype Corp., Norman Hanson and Nancy Carr of Linotype Co., R. W. Hummerston and Dale Lehn of Varityper, Inc., A. D. B. Jones and Rene Kerfante of Monotype Corp., Richard Jones and Jerry Levitz of Harris Corp., Lynn Déspres of Berthold Inc., Paul Thiel and Boyd Hill of Agfa Compugraphic, Jackie Johansen of Itek Graphix, and Dick Weltz of Weltz Ad Service.

Printing. Bill Anderson of World Color Press, Inc., Joe Cavallo of Howson-Algraphy Ltd., Paul Kwiencinski of Halliday Lithograph Corp., Lou LaSorca of Algen Press Corp., Pete Peterson and Linda Readerman of Arcata/Halliday, Ray Prince of Azoplate, Irwin Roth of Pioneer Moss Inc., Charles Shapiro of Graphic Arts Technical Foundation, Jack Siderman of Pantone, Inc., Dan Soskin of Printing Industries of Metropolitan New York, Inc. Ed Sturmer of Colorline, Mike Kullman of DuPont Corp., and Jack Mackowski of Hoechst Celanese.

A special thanks to Norman Sanders of Laurel Printing and Michael Josefowicz of Red Ink Productions for reviewing the entire printing section and helping determine the best mix of old and new technologies.

Paper. Ralph Heilman of RIS Paper Co., Dave Knauer of S.D. Warren Co., Tom Kramer of the American Paper Institute, Jon Moberg of Mead Paper Co., Jack Robinson of Andrews, Nelson, Whitehead, and Steve True of Lindenmeyr Paper Corp.

Imposition, Folding, and Binding. W.P. Bourquin of Harris Corp., George Clark, Jr. of Holliston Mills, Inc., Paul M. Grieder of Industrial Coating Group, Ted Tuck of Charles Bohn & Co., and Milton A. Walberg of Scott Graphics, Inc.

Mechanicals. Leonard Hyams of Parsons School of Design.

Desktop Publishing. Janet Susich of Apple Computers, Inc., Eddy Lee of NeXT, Inc., and Ed Howe at IBM Corp.

And most important my personal friends with hands on experience who could help translate the often confusing technical jargon into a language designers can understand. My thanks to William Bevington, Jane Eldershaw, John and Pat Noneman, Jennifer Place, and Rob Winter.

In every undertaking there are a few who contribute much more than is expected. There are four people whose extra effort on this book is appreciated: Carl Palmer of DuPont Company, who cheerfully took on the awesome job of reading and re-reading the sections on typesetting and production under pressure of time; Bob Loekle of Amalgamated Lithographers of America, Local 1, for his expertise in color printing; my first editor, Margit Malmstrom; and Harry Siddeley of URW, North America, who gave generously of his time and wide knowledge of typesetting and desktop publishing and never seemed to tire of reading the same pages over and over.

To Carl Rosen, Stan Redfern, and Marybeth Tregarthen—my editor, production director, and production coordinator—a special thanks for all their extra efforts to insure that this edition will remain as popular as the first.

And last, to my accountant, Kip Samuels, who had absolutely nothing to do with this book, but always wanted to see his name in print.

Introduction

Although specifically written for the graphic designer and the design student, this book is equally intended for anyone connected with the production of printed matter,whether in editorial, promotion, or even production. It is also intended for those in specific areas of production—typographers, printers, etc.—who would like to learn more about how the other areas operate.

My purpose in writing *Production for the Graphic Designer* was to enable a person wishing to understand any area of production to locate the desired information, fast, within the covers of a single book. It was also my purpose to present the information in as simple and straightforward a manner as possible. To this end, the concepts have been kept basic enough to serve one purpose: to give the designer the necessary information so as to be able to make the most informed decisions all along the way, from rough comp to finished printed piece.

The designer should know enough about production to understand: (1) what the possibilities are in terms of typesetting, printing, paper, etc. (2) what factors to consider when choosing between systems, methods, processes, etc., and (3) how to *communicate* specifications to the people responsible for translating the designer's ideas into a printed piece.

Throughout, I have tried to keep the book simple and free from unnecessary or overly technical information. And I have tried to maintain the concept of the book as a working tool; that is, a book that contains *useful* information rather than information for information's sake.

Finally, the glossary, which contains over 1,100 entries, brings together definitions and explanations from every area of production to offer an up-to-date, comprehensive, single reference source for students, teachers, and professionals.

It is my hope that this book will help fill the gap between design and production, expanding the potential of the graphic designer, easing the transition from older methods to newer ones, and helping the designer plan ahead and work with production to get the desired results.

Comments on the Second Edition
In the 1967 film *The Graduate*, Dustin Hoffman is taken aside by a well-meaning friend of the family and given a single word of advice "Plastics." Today, the word would no doubt be "Electronics."

Since *Production for the Graphic Designer* was first published in 1974, electronics has completely revolutionized the communications industry and significantly changed the way in which graphic designers work. Copy can now be prepared on disks, designs created on video screens, images screened and separated by lasers, and entire jobs sent in digital form anywhere in the world at lightning speeds.

While computer technology has increased speed and cut down on drudgery, it has not altered what is expected of the product. We still look for excellence in design, quality printing, and paper suited to the job. The computer has merely provided new tools with which to achieve the same quality production that has always been the designer's primary goal. This marriage of new technology to traditional values means that much of *Production for the Graphic Designer* has not been altered. On the other hand, entire sections have been added to encompass desktop publishing, laser imagers, digital type, etc.

This revised edition of *Production for the Graphic Designer* reflects, we hope, the same mix of traditional and new that the designer will encounter in the workplace and will help provide a balance between the time-honored information inherent in fine design and the ever expanding possibilities offered by computer technology.

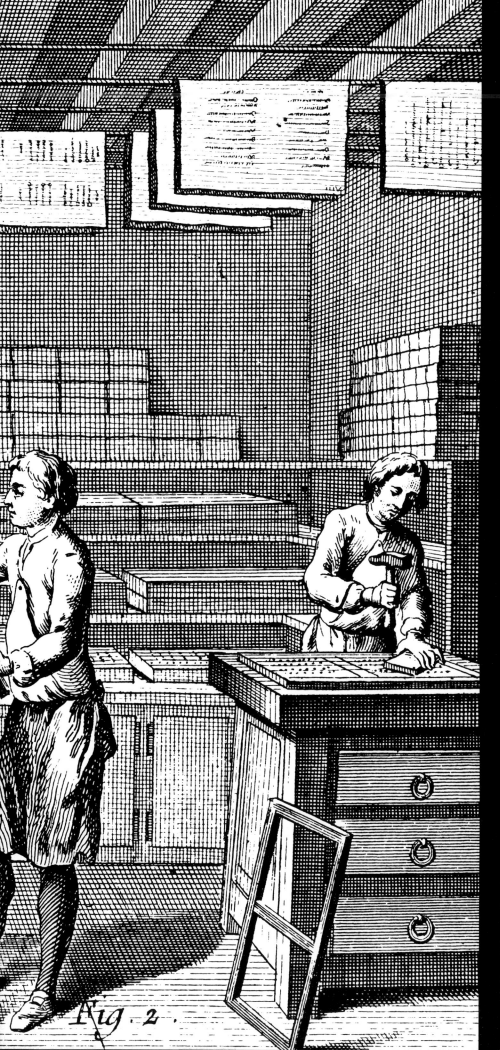

Typesetting

Typesetting, also called *composition*, was traditionally done by the printer. Until this century most printing shops had their own composing room and compositor, or typesetter. Today, most printers have given over the function of typesetting to typographers and service bureaus.

In this section we shall discuss the five ways type is set: by *hand*, *machine (casting)*, *typewriter*, *phototypesetting*, and *digital composition*. We shall begin with a brief review of the basics of typography in order to define the terminology that is used throughout this book.

An 18th century composing room. The two compositors at left and center are setting type in composing sticks and assembling lines of type into wooden trays, called galleys. The "stone-man" at right is using a planer to level a form made up of pages of type locked up in a metal chase, like the one in the foreground.

Typography

The basic terminology used in all typesetting methods is derived from metal type. As we shall see later, some of the terms have been modified to accommodate the newer typesetting methods, such as photo and digital composition, but most are still in use today, regardless of the typesetting method.

ABCD
EFGHIJK
LMNOPQRST
UVWXYZ
abcdefghijklmno
pqrstuvwxyz
1234567890
& .,:;""?!()
• /#$%¢*

FONT OF TYPE

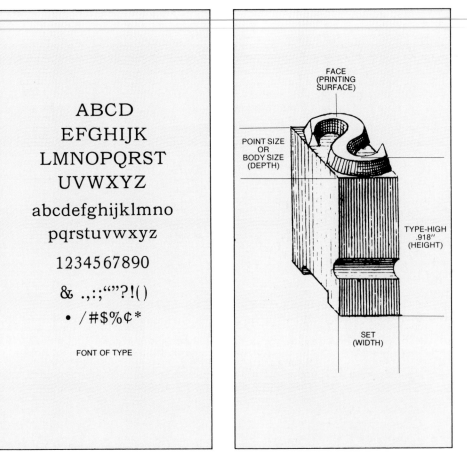

Type. The individual letter, figure, or punctuation mark is called a *character*. The large letters are called caps or *uppercase* characters; the small letters are called *lowercase* characters. Traditionally, a complete alphabet of one style of uppercase and lowercase characters, with figures and punctuation marks, is called a *font*. Today, the term is used more freely and may represent all the sizes of a particular typeface.

If we group together all the type sizes and type styles of a particular typeface (roman, italic, bold, extended, condensed, etc.), we get a *family* of type.

Measuring Type. There are two basic units of measurement in typography: *points* and *picas*. There are 12 points in a pica and 6 picas in an inch. Type is measured in points; the line length, or *measure*, is measured in picas.

To understand how we arrive at the point size of type, let's examine a piece of type: it is a rectangular block of metal with a printing surface on top. The block is called the *body*, and the printing surface is called the *face*.

The height of the body is .918″ and is known as *type-high*. Although this dimension is not important to the designer, it is very important to the printer that all type be exactly the same height in order to print evenly.

The width, called the *set width*, is dictated by the width of the individual letter, the letters *M* and *W* being the widest and *I* being the narrowest.

The depth, known as the *point* or *body size*, is the dimension by which we measure and specify type.

Type comes in many sizes, the most popular typefaces ranging from 5 point to 72 point. Type sizes 12 point and smaller are referred to as *text types*, those larger are called *display types*.

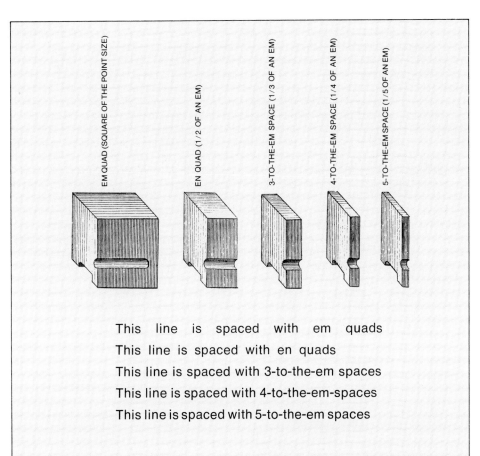

This line is spaced with em quads
This line is spaced with en quads
This line is spaced with 3-to-the-em spaces
This line is spaced with 4-to-the-em-spaces
This line is spaced with 5-to-the-em spaces

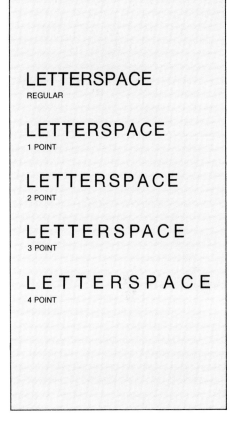

Wordspacing. Spacing between words, with metal type, is accomplished mechanically by inserting pieces of metal between words. Being lower than the printing face of the type itself, they do not come in contact with the paper and therefore do not print.

These pieces of metal, called *spaces* and *quads*, are related in size to the *em quad*, which is the square of the type size. For example, if the type is 60 point, the em quad is a square 60 points x 60 points; if the type is 10 point, the em quad is 10 points square.

Since an em quad would produce too much space between words, smaller pieces of metal, which are subdivisions of the em quad, are used. *Normal* word-spacing assumes the use of ⅓ of an em space between words, or 3-to-the-em spaces; *tight* wordspacing, 4-to-the-em spaces; and *very tight*, 5-to-the-em.

Letterspacing. The materials used for spacing between letters are very thin. Most fonts have spaces of 1 point (made of brass) that can be used singly or in groups. Others are even thinner: ½ point (copper) and ¼ point (stainless steel). There is even a letterspace made of paper. Consider how thin a piece of paper is—this will give you an indication of just how finely letterspacing can be adjusted.

Note: With some technologies letter-spacing is also referred to as tracking.

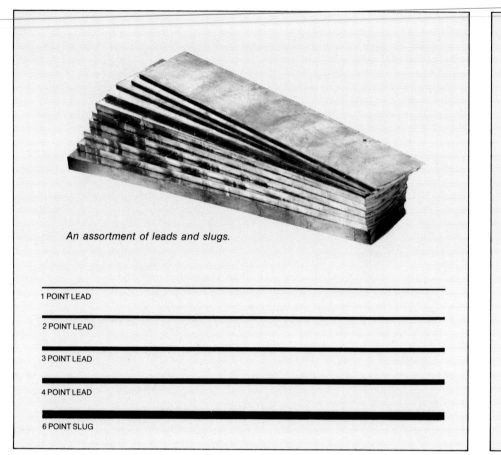

An assortment of leads and slugs.

1 POINT LEAD

2 POINT LEAD

3 POINT LEAD

4 POINT LEAD

6 POINT SLUG

There are five basic ways to arrange lines of type on a page; the style you choose is dictated by esthetics, legibility, and the amount of copy to be set.

There are five basic ways to arrange lines of type on a page; the style you choose is dictated by esthetics, legibility, and the amount of copy to be set.

There are five basic ways to arrange lines of type on a page; the style you choose is dictated by esthetics, legibility, and the amount of copy to be set.

There are five basic ways to arrange lines of type on a page; the style you choose is dictated by esthetics, legibility, and the amount of copy to be set.

There are five basic ways to arrange lines of type on a page; the style you choose is dictated by esthetics, legibility, and the amount of copy to be set.

Leading. In addition to the space between words and letters, it is also possible to vary the space between the lines of type. To accomplish this, metal strips of various thicknesses are placed between the lines. This is called *leading* (pronounced *ledding*) or *linespacing*.

The metal strips themselves, called *leads (leds)*, are measured in points. The most common sizes are 1, 2, 3, and 4 point. Leads 6 points or more in thickness are called *slugs* and are cast in 6, 12, 24, and 36 point. Both leads and slugs are less than type-high and therefore do not print.

Type that is set without leading is said to be set *solid*. If 10-point type is set with 1-point leading, it is set "10 on 11," which is indicated 10/11: the first figure indicates the type size; the second figure, the type size *plus* the leading. The type you are now reading is 9/11 Helvetica; that is, 9-point Helvetica type with 2 points of leading.

Arranging Lines of Type. There are five basic ways to arrange lines of type on a page. (1) *Justified:* all the lines are the same length and align both on the left and on the right. (2) *Unjustified:* the lines are of different lengths and align on the left and are ragged on the right. (3) A similar arrangement, except now the lines align on the right and are ragged on the left. (4) *Centered:* the lines are of unequal lengths with both sides ragged. (5) An *asymmetrical*, or random, arrangement which has no predictable pattern in the placement of the lines.

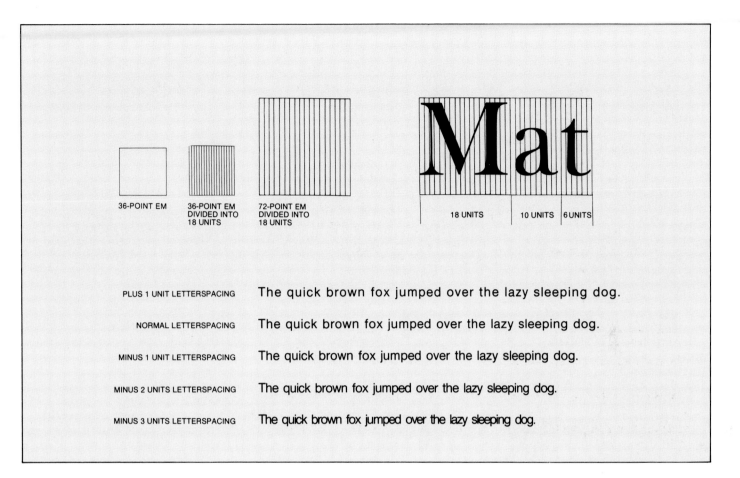

36-POINT EM

36-POINT EM
DIVIDED INTO
18 UNITS

72-POINT EM
DIVIDED INTO
18 UNITS

18 UNITS 10 UNITS 6 UNITS

PLUS 1 UNIT LETTERSPACING The quick brown fox jumped over the lazy sleeping dog.

NORMAL LETTERSPACING The quick brown fox jumped over the lazy sleeping dog.

MINUS 1 UNIT LETTERSPACING The quick brown fox jumped over the lazy sleeping dog.

MINUS 2 UNITS LETTERSPACING The quick brown fox jumped over the lazy sleeping dog.

MINUS 3 UNITS LETTERSPACING The quick brown fox jumped over the lazy sleeping dog.

Unit System. The unit system is a measuring and counting system used by photo- and digital typesetting systems to determine when a line of type is ready to be justified. It is based on the division of the em (the square of the type size) into equal, machine-recognizable increments called *units*.

If you examine the illustration above you will see that the em has been divided into 18 equal segments, thus forming the basis of an 18-unit system. You will also notice that the size of the unit, like the size of the em, varies from one type size to another. For example, a unit of 72-point type will be larger than a unit of 36-point type.

Measuring Type in Units. The set width of individual characters and spaces is designed with a fixed unit width or *unit value*. This unit value also includes a small amount of space on either side of the characters to prevent them from touching when set.

To get an idea how this system works let's set the word *Mat* on an 18-unit system. The cap *M* is 18 units wide, the lowercase *a* 10 units wide, and the lowercase *t* 6 units wide. So the entire word is 34 units wide, regardless of the type size.

By thus totaling the unit values of the characters and the spaces between the words, a counting mechanism is able to measure a line of type in units and determine when it is ready to be justified.

Advantages of the Unit System. One advantage of using the unit system is that the "color" of the setting can be controlled by adjusting the units of space between the letters. This means that the type can be set with regular, loose, tight, or very tight letterspacing.

Letterspacing can also be adjusted on a selective basis, reducing space between certain letters while the rest of the setting remains the same. This is called *kerning* and is usually used in letter combinations that are improved by the deletion of one or two units of space, such as *Te, Ta, Ve, AW, YA,* etc.

The number of units to the em varies with the manufacturer and may be 4, 9, 12, 18, 32, 36, 48, or more. The greater the number of units to the em, the closer together the letters can fit (letterfit) and the more flexibility there is in word-spacing and letterspacing. Although a greater number of units to the em results in a greater possibility of typographic refinement, for the average job there is a point beyond which further refinement is either unnecessary or unnoticeable.

Handset

The process of setting type by hand has changed little since Johann Gutenberg's time in the 15th century. The compositor, or typesetter, works with the same tools now as then: a composing stick, a type case (a shallow tray, divided into compartments, that holds the type), and the metal type itself (letters, punctuation marks, figures, and spaces). The type is known collectively as the *font* and individually as *characters*. Characters that are not part of a regular font are called *sorts*.

Setting. First, the compositor adjusts the composing stick to the desired pica measure, or line length. To set type, the composing stick is held in one hand and with the other hand type is selected from the type case. To justify the lines of type additional wordspaces or letterspaces are added.

To create the proper amount of leading, the compositor inserts metal strips called *leads* between the lines. When the composing stick is full, the lines of type are transferred to a long shallow tray called a *galley*. The compositor continues to set type until the galley is full or the job is completed.

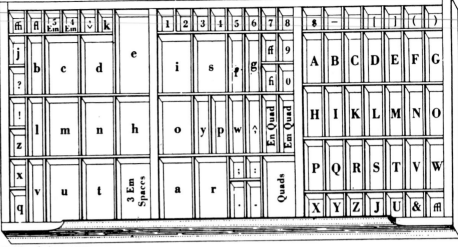

California type case.

The next step is to "make up" the job; that is, to assemble the various elements (text type, display type, rules, cuts, etc.) according to the designer's layout. If the job is small, it may be made up directly on the galley; if larger or more complex, it may be made up on an imposing table, traditionally known as the "stone."

Because the type consists of hundreds of individual pieces, it is important that they be held together securely, or "locked up." This is done by tying up the type with string, or by surrounding it with "furniture": strips of wood, metal, or plastic. These in turn are held firmly in place with metal clips or magnets. Type can be locked up in three ways: on the galley, in a metal frame called a *chase*, or directly on the bed of the press.

Collectively, type and other printed matter locked up and ready to be proofed or printed are called a *form*.

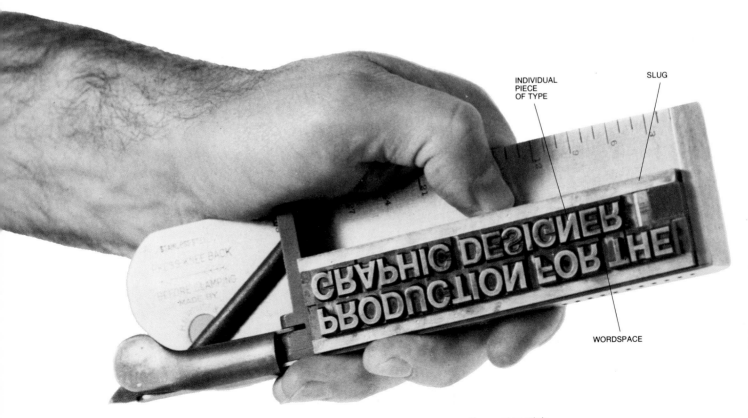

INDIVIDUAL PIECE OF TYPE

SLUG

WORDSPACE

Composing stick.

Type in a galley, held in position with galley clips.

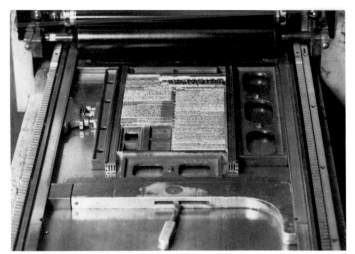

Type form, locked up on the bed of a proofing press.

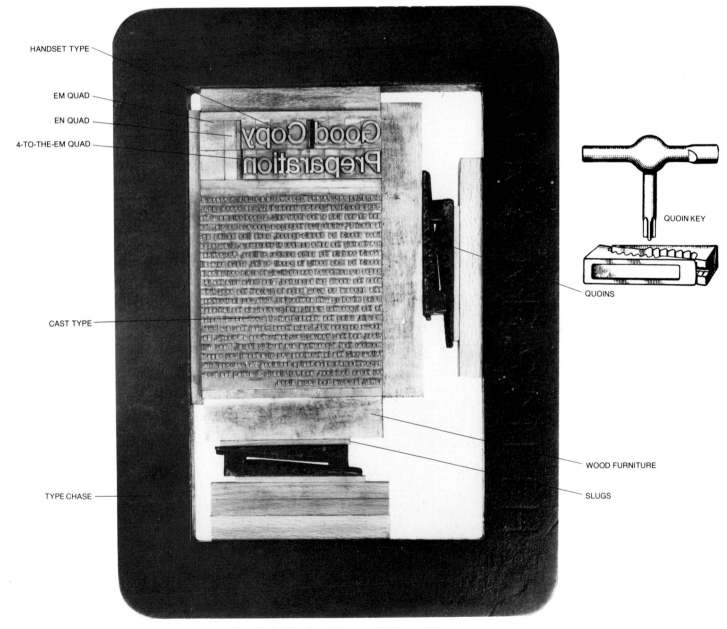

HANDSET TYPE

EM QUAD

EN QUAD

4-TO-THE-EM QUAD

CAST TYPE

TYPE CHASE

QUOIN KEY

QUOINS

WOOD FURNITURE

SLUGS

Type locked up in a chase ready for proofing.

Proofing. It should be noted that there is a difference between proofing type and actually printing it. A proofing press is a relatively small, slow-speed, hand-operated or power-operated press designed primarily for pulling a dozen or so proofs of each job. A printing press, on the other hand, is designed to operate automatically at high speeds and print large quantities of a given job.

The proofs pulled at the proofing press are called *galley proofs* or *rough proofs*. The reason for making these proofs is to allow both the typographer and the client to see that the job has been correctly set. Before the proof is sent to the client a *reader's proof* is first proofread in the shop. Either corrections are made or it is indicated on the reader's proof that errors have been noted and will be corrected.

Several proofs, including the reader's proof, are then sent to the client for proofreading. These may be read by a proofreader, author, editor, or copywriter, depending on the job. The designer also gets a proof to make sure that the job has been set as specified.

The corrections made on the various proofs are then transferred to a *master proof*. All corrections are marked either *PE* or *AA*. PEs are printer's errors and will be corrected free of charge by the typographer; AAs are the author's alterations and will be charged to the client. AAs also include editor's or designer's changes. The master proof is returned to the typographer, who makes all the corrections indicated.

The type is then locked up on the bed of the proofing press and a new proof called a *reproduction proof*, or *repro*, is pulled on a special coated paper. The quality of this proof is of the utmost importance, as it is used by the designer in the preparation of the mechanicals: it will be photographed and made into a printing plate for eventual reproduction.

After the job is completed, the type is cleaned and distributed; that is, put back into the type case. Great care is taken in distributing type, as letters carelessly thrown into the wrong compartments may not show up until a new job is set and proofed. Compositors are warned to "watch their p's and q's," as it is very easy to confuse certain letters, especially these. The leads, slugs, and furniture, arranged by thickness and length, are also put away for future jobs.

Setting type by hand is a slow, time-consuming process that not only requires the services of many skilled compositors, but also huge amounts of space to store the many fonts required by a printer or typographer. It is no wonder that one of the major priorities of the late 19th century was the design of a mechanical typesetting machine that would render handset type obsolete.

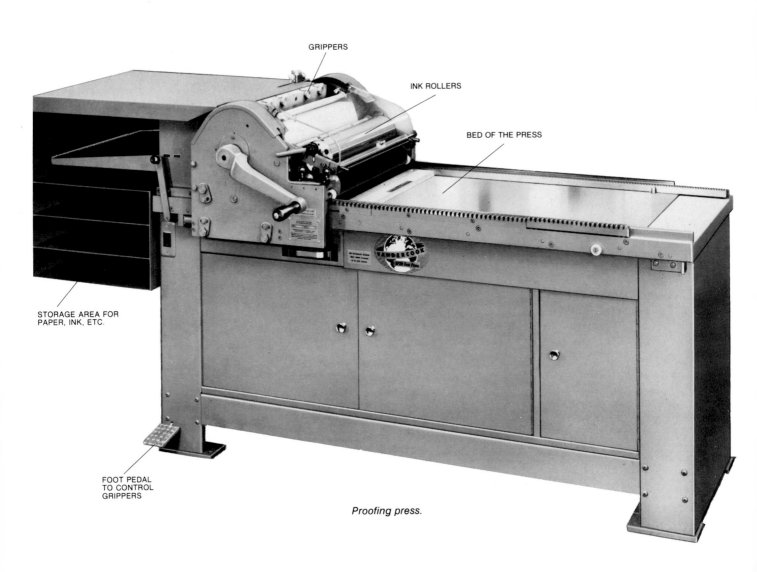

GRIPPERS

INK ROLLERS

BED OF THE PRESS

STORAGE AREA FOR PAPER, INK, ETC.

FOOT PEDAL TO CONTROL GRIPPERS

Proofing press.

Good Copy Preparation

Preparing copy for the typesetter is a crucial procedure. Copy should be typed on standard 8½ x 11 bond paper, and on one side of the sheet only. A good column width is about 6", which gives the page a generous margin. The lines should be double-spaced, each line having approximately the same number of characters. Every page should contain the same number of lines. Corrections should be made neatly in pencil or ink. Make sure all pages are numbered consecutively to avoid confusion in case the sheets get separated. Also make sure the job title appears on every page to prevent the copy from being mixed up with another job. Write your instructions to the typesetter clearly and precisely in the left-hand margin, using the standard set of proofreaders' marks shown on page 154. Learn these marks; they are brief, clear, and they convey your instructions efficiently. Remember that typesetters are terribly literal. They will follow only the instructions you give them; you cannot expect them to make design decisions. The responsibility for these decisions, and for clearly directing the typesetter, is yours and yours alone.

Rough proof with corrections indicated.

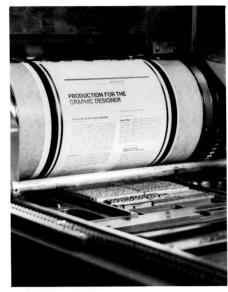

Pulling a repro proof.

Good Copy Preparation

Preparing copy for the typesetter is a crucial procedure. Copy should be typed on standard 8½ x 11 bond paper, and on one side of the sheet only. A good column width is about 6", which gives the page a generous margin. The lines should be double-spaced, each line having approximately the same number of characters. Every page should contain the same number of lines. Corrections should be made neatly in pencil or ink. Make sure all pages are numbered consecutively to avoid confusion in case the sheets get separated. Also, make sure the job title appears on every page to prevent the copy from being mixed up with another job. Write your instructions to the typesetter clearly and precisely in the left-hand margin, using the standard set of proofreaders' marks shown on page 154. Learn these marks; they are brief, clear, and they convey your instructions efficiently. Remember that typesetters are terribly literal. They will follow only the instructions you give them; you cannot expect them to make design decisions. The responsibility for making these decisions, and for clearly directing the typesetter, *is yours and yours alone.*

Repro proof.

EXPLANATION	MARGINAL MARK	ERRORS MARKED
Take out letter, letters, or words indicated.		He opened the windoⱷw.
Insert space.	#	He opened thewindow.
Turn inverted line.	@	He opened the window.
Insert letter.	e	He opned the window.
Set in lowercase.	lc	He Øpened the window.
Wrong font.	wf	He opeɾed the window.
Broken letter. Must replace.	×	He ⱷpened the window.
Reset in italic.	ital	He opened the window.
Reset in roman.	rom	He opened the window.
Reset in bold face.	bf	He opened the window.
Insert period.	⊙	He opened the window.
Transpose letters or words as indicated.	tr	He the window opened.
Let it stand as is. Disregard all marks	stet	He opened the window.
Insert hyphen.	=/	He made the proofmark.
Equalize spacing.	eq #	He opened the window.
Move over to point indicated. [if to the left; if to the right]		[He opened the window.
Lower to point indicated.	⊔	He opened the window.
Raise to point indicated.	⊓	He opened the window.
Insert comma.		Yes he opened the window.
Insert apostrophe.		He opened the boys window.
Enclose in quotation marks.		He opened the window.
Enclose in parenthesis.	()	He John opened it.
Enclose in brackets.	[]	He John opened it.
Replace with capital letter.	cap	he opened the window.
Use small capitals instead of type now used	sc	He opened the window.
Push down space.	⊥	Heopened the window.
Draw the word together.	⌒	He op ened the window.
Insert inferior figure.		Sulphuric Acid is H₂SO₄.
Insert superior figure.		2a + b² = c.
Used when words left out are to be set	out, see copy	He window.
The diphthong is to be used.	æ	Caesar opened the window.
The ligature of these two letters is to be used.	fi	He filed the proof.
Spell out words marked with circle.	spell out	He opened the 2d window.
Start a new paragraph.	⁋	door. He opened the
Should not be a paragraph. Run in.	no ⁋	door. He opened the window.
Query to author. Encircled.	was?	The proof read by.
This is the symbol used when a question mark is to be set. NOTE: *A query is encircled.*	?	Who opened the window
Out of alignment. Straighten.		He opened the window.
1-em dash.	1/M/	He opened the window.
2-em dash.	2/M/	He opened the window.
En dash.	1/N/	He opened the window.
Indent 1 em.	☐] He opened the window.
Indent 2 ems.	☐☐] He opened the window.
Indent 3 ems.	☐☐☐] He opened the window.

Proofreader's marks.

Machine Set

The solution to the problems surrounding handset type was a mechanical typesetting method that involved the casting of type from molten metal. For this reason, machine-set type is also referred to as *hot type*.

Typecasting was by far the most popular method of setting text type (display type continued to be set mainly by hand) until the arrival of phototypesetting in the 1960s. There are four major typecasting machines: Linotype, Intertype, Monotype, and Ludlow.

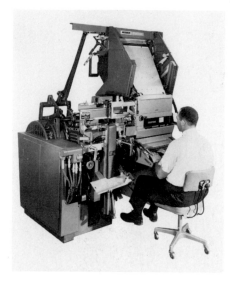

LINOTYPE AND INTERTYPE

Linotype was invented in 1886 by Ottmar Mergenthaler, a German immigrant living in Baltimore. Intertype, which is based on the Linotype principle, was developed in 1911. Because the Linotype and Intertype machines cast lines of type rather than individual characters, they are called *linecasting machines*. (The name Linotype is derived from the casting of a "line-of-type.")

In both systems, the operator sits at a keyboard. The machine is adjusted to set type to a desired pica measure and leading. The upper front of the machine carries a magazine, a slotted, metal container that holds the *matrices* (more commonly called *mats*), or lettermolds, of the type to be set. When the operator strikes the keys, the matrices fall into position to form a line of type. The operator sets as many characters and wedge-shaped "spacebands" for word-spacing as possible.

When the operator is ready to cast the line, a lever is pulled setting off a series of events: the line, made up of mats and spacebands, is transferred to the casting mechanism; the wedge-shaped space-bands are driven up between the words to justify the line; molten metal is forced into the mats; and a line of type, or "slug," is ejected onto a pan. As soon as the type is cast, the mats are returned to the magazine and the spacebands to the spaceband box, ready for the next line. The operation takes about 15 seconds.

After the job is set, the type is locked up on a galley and a proof is pulled. When the type is no longer required it is melted down for reuse.

The standard linecasting machine is designed to set type from one magazine at a time. This magazine contains 90 duplex (two-character) mats, capable of setting either two styles of the same typeface (for example, Garamond roman and italic) or two different typefaces (Garamond and News Gothic). There are also machines that set type from two magazines at one time. This permits the mixing of four type styles, such as roman, italic, roman bold, and italic bold. It also permits the mixing of four different typefaces; however, not all typefaces align on the same baseline.

Linecasting machines are designed to set type from 5 to 18 point, in measures up to 30 picas. It is possible to set to wider measures by "butting slugs." In this case, the operator sets the line in two parts and then butts the slugs together to make one line. Some special machines do set type up to 42 picas.

Linecasting machines can set type and leading as one piece. For this reason, it is impossible to reduce the amount of leading once the type has been cast. Leading can be increased, however, by inserting leads between lines by hand.

Corrections may present a problem as any change within a line means the entire line, and possibly all the succeeding lines in the paragraph, will have to be reset.

Casting is less time-consuming than handsetting, therefore less expensive. The average operator should be able to set type at the rate of 3 to 4 lines per minute. (A line in this case is the industry standard: a newspaper line consisting of straight matter set in 8-point type on an 11-pica measure.) Some casting machines are designed to be driven by teletype tape, which increases the output to about 10 lines per minute.

Today, most modern industrial nations have replaced typecasting machines with photo or digital systems. Many Third World nations, however, still use typecasting machines.

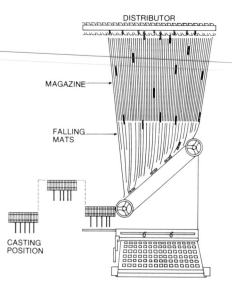

Slugs ready for printing.

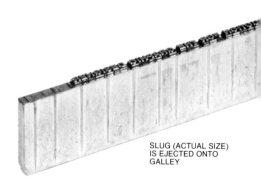

SLUG (ACTUAL SIZE) IS EJECTED ONTO GALLEY

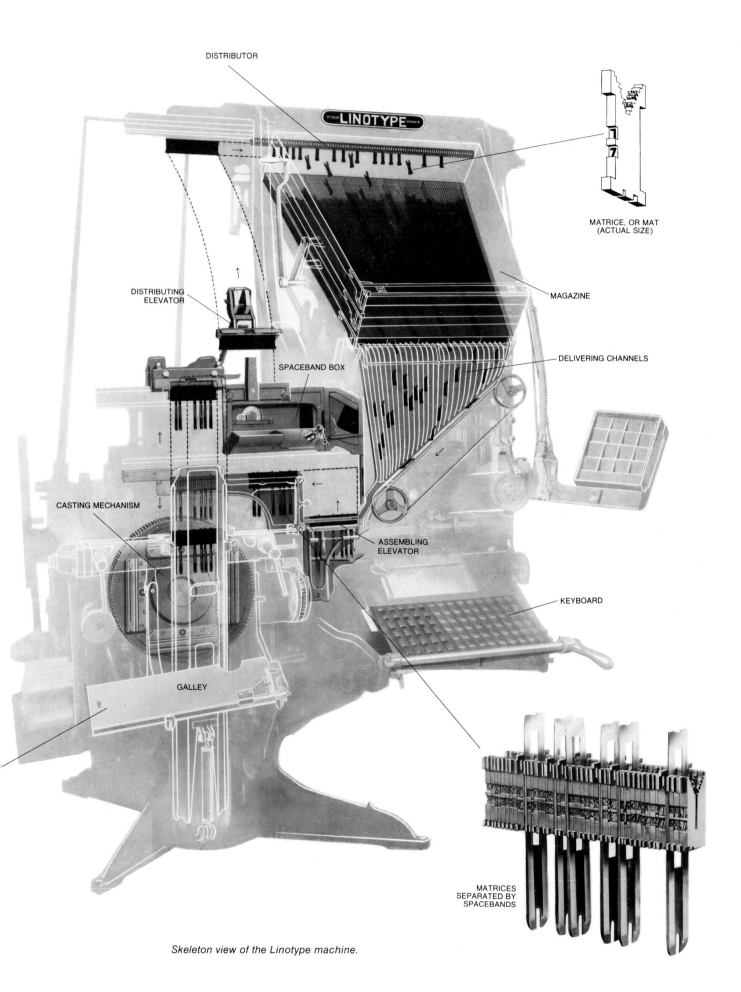

DISTRIBUTOR

MATRICE, OR MAT
(ACTUAL SIZE)

DISTRIBUTING
ELEVATOR

MAGAZINE

SPACEBAND BOX

DELIVERING CHANNELS

CASTING MECHANISM

ASSEMBLING
ELEVATOR

KEYBOARD

GALLEY

MATRICES
SEPARATED BY
SPACEBANDS

Skeleton view of the Linotype machine.

MONOTYPE

The Monotype system was invented in 1887 by Tolbert Lanston of Washington, D.C. As the name suggests, Monotype casts the characters one by one rather than as a complete line. It is a combination of two machines: a keyboard (perforator), and a typecaster.

To set type, the operator first adjusts the machine to the required pica measure and leading. As the copy is typed, a perforated paper roll is produced, which is used to drive the typecaster. It is the combination of the holes that dictates the letters, spaces, and punctuation marks, etc., to be set.

To justify the lines of type, a counting mechanism automatically registers the set widths of characters as they are typed. When the maximum number of characters per line has been reached, a bell rings to alert the operator, who then determines how much additional space must be added to justify the line. Space can be added between words, letters, or both. Up to this point, no type has actually been set, there is just a perforated, or encoded, paper roll.

To set the type, the roll is placed on the typecaster, where it directs the casting mechanism by means of compressed air. The air passing through the perforations brings the matrix-holder and the specific matrix, ready to be filled with molten metal, into the proper position. Once the type has been cast, it is ejected onto a galley a character at a time. When the galley is full or the job completed, a proof is pulled. After use, the type can be melted down.

Monotype can set type from 4½ to 14 point in any measure up to 36 picas. Each matrix case holds 272 individual matrices, which makes it possible to mix roman, italic, and boldface types all in the same line. It is also easy to take out individual matrices and replace them with special characters not in the regular font called "pi characters." This makes Monotype ideal for such complex settings as tables, charts, and scientific and mathematical material. It is also widely used for textbooks. Furthermore, because each character is set separately, individual elements in a line may be corrected by using pre-cast sorts out of the typecase without having to reset the entire line.

As with Linotype, Monotype can cast type and leading as one piece. So again, it is possible to increase the leading, but not to reduce it.

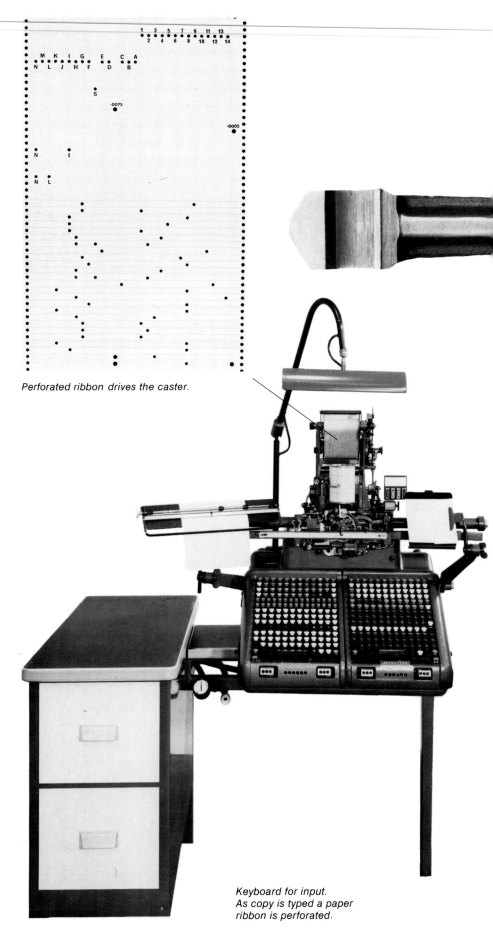

Perforated ribbon drives the caster.

Keyboard for input.
As copy is typed a paper
ribbon is perforated.

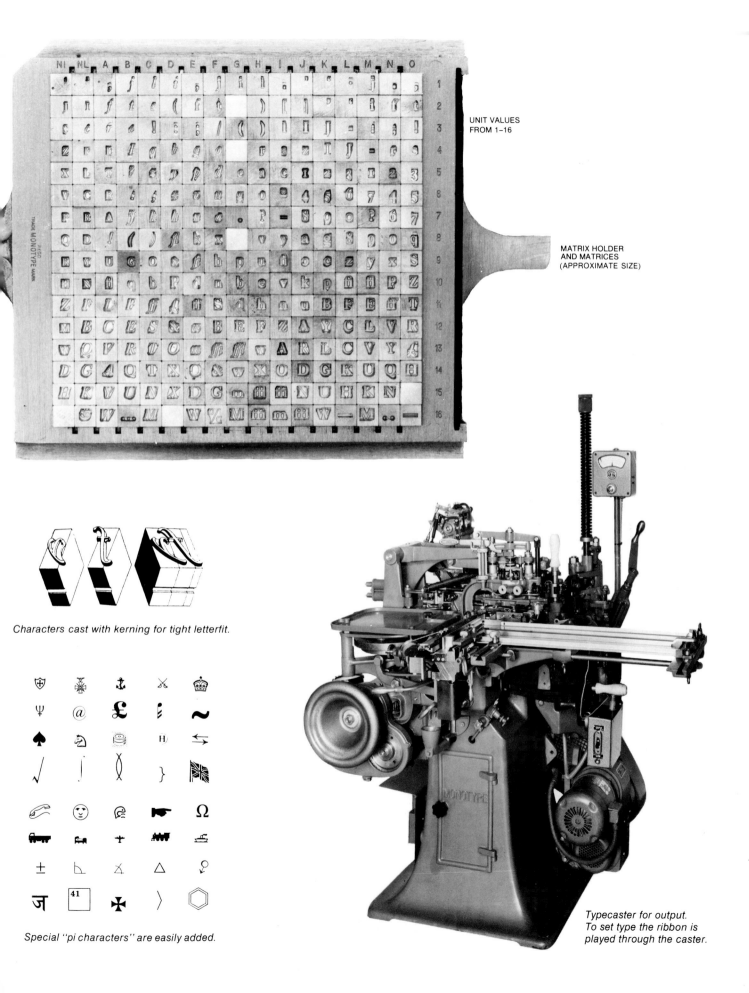

UNIT VALUES
FROM 1–16

MATRIX HOLDER
AND MATRICES
(APPROXIMATE SIZE)

Characters cast with kerning for tight letterfit.

Special "pi characters" are easily added.

*Typecaster for output.
To set type the ribbon is
played through the caster.*

LUDLOW

The Ludlow system was suggested by Washington I. Ludlow and perfected by A. Reade in 1906. It is a combination of handsetting and casting. Like Linotype, it produces a slug, but in a different way. The operator handsets the type matrices and leading in a composing stick. They are then locked into a casting machine where they are covered with molten lead to produce the slug. The faces of the slugs are polished and they are placed on a galley. Then a proof is pulled, after which the slug is melted down for reuse.

Ludlow was designed primarily for casting display type from 12 to 72 point. This was ideal for newspaper headlines.

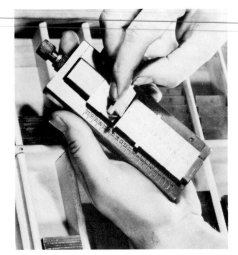

Handsetting type matrices with Ludlow composing stick.

Ludlow slug.

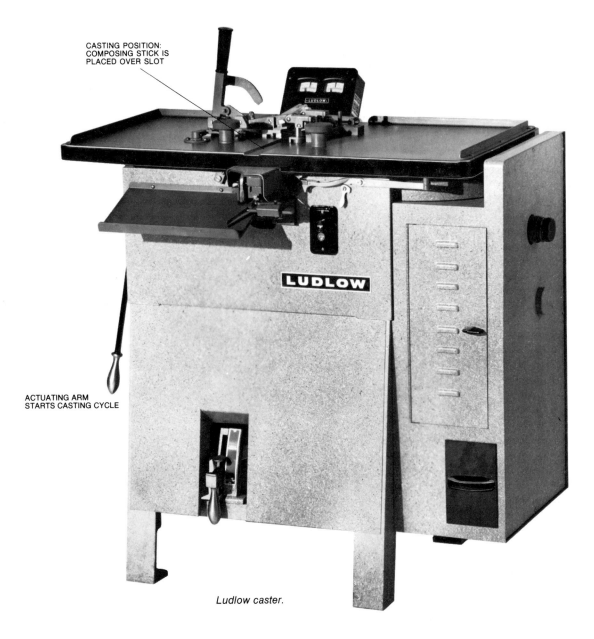

CASTING POSITION: COMPOSING STICK IS PLACED OVER SLOT

LUDLOW

ACTUATING ARM STARTS CASTING CYCLE

Ludlow caster.

Typewriters and Word Processors

Although typewriters and word processors cannot be considered typesetters in the true sense, they do provide inexpensive composition for low-budget jobs consisting of text type. Display type has to be set by other means.

TYPEWRITERS

Most people think of typewriters as being for personal or secretarial use. There are, however, typewriters capable of producing justified type in a number of popular typefaces.

Typewriter composition, also known as *strike-on* or *direct impression*, is probably the simplest of all typesetting methods and does not require the services of a skilled typographer. The two most popular systems are VariTyper and IBM Selectric Composer. While many are still in operation, their manufacture has been discontinued.

Both systems have a good selection of typefaces in a range of text sizes. Because the width of each character varies, they can be set closer together, improving the letterfit. This offers an advantage over the 1-unit system of regular typewriters where all characters occupy the same amount of space.

Typewriters produce only a single copy; if more than one is required, the job is either retyped or photocopies are made. If camera-ready art is required the copy is simply typed directly onto reproduction-quality paper.

VariTyper. VariTyper is the oldest of the desktop, strike-on systems. It is a 4-unit system that holds two fonts of type in sizes ranging from 3½ to 13 points. The VariTyper is manually operated, and the copy has to be typed twice in order to produce justified copy.

IBM Selectric Composer. This is virtually a one-person composing room. There are two models: the manual, consisting only of the Selectric Composer (SC), and the tape-driven system, consisting of a Magnetic Tape Selectric Typewriter (MT/ST) for input and a Magnetic Tape Selectric Composer (MT/ST) for output.

The Selectric Composer offers about a dozen workhorse typefaces carried on the IBM ball font. It is a 9-unit system that permits seven different character widths. Type sizes range from 6 to 12 point. All font changes must be made manually and justified setting requires a second typing. A second typing, however, can be avoided by using the tape-driven system.

WORD PROCESSORS

Word processors are basically sophisticated electronic typewriters. They offer the ease and familiarity of the typewriter, but with such expanded features as a memory capable of holding around 50,000 characters (about 25 pages), unlimited external storage on a 3-inch (100 kilobyte) removable disk, a multiline character display, a dictionary/thesaurus, and a spelling/grammar/punctuation checker.

Word processors print letter-quality documents from daisy wheels in approximately a dozen type styles in either 10-pitch (pica), 12-pitch (elite), or 15-pitch (micro). Most type styles are based on a 1-unit system and not proportional spacing.

Word processors are ideal for such tasks as writing reports, book manuscripts, and letters and creating spreadsheets. They are more popular in industry than in the design field, where the versatility of desktop publishing systems are preferred (see page 25).

Note: Copy stored on word processing diskettes cannot be used for setting type: all copy must be rekeyboarded or transferred to a floppy disk compatible with typesetting equipment.

IBM Selectric MT/ST.

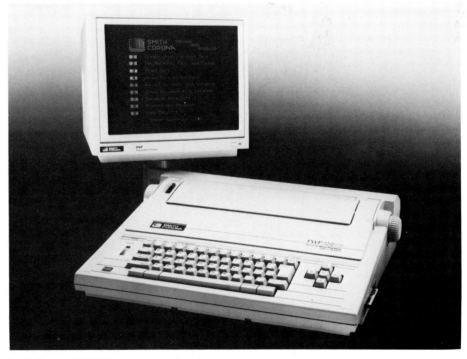

Smith Corona PWP100 personal word processor.

Phototypesetting

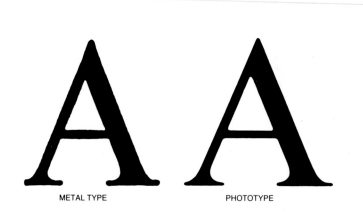

METAL TYPE PHOTOTYPE

Typography
Typography

ADJUSTABLE LETTERFIT

TYPE ON FILM

Phototypesetting, or *photocomposition*, created a revolution in the typesetting industry in the sixties by providing a fast, flexible, efficient, and relatively inexpensive means of setting type. It was also the ideal typesetting method for offset lithography, which was rapidly replacing letterpress printing, a process more suited to metal type. Here are some other attributes of phototype:

Phototype is sharper. Metal type has to be inked in order to print. Unfortunately, the pressure of metal type against paper causes "ink squeeze," which tends to make the edges of the letterforms irregular. In phototypesetting the individual characters are projected onto paper or film, resulting in the sharpest possible letterforms.

Letterfit is better. As long as type is on a piece of metal, there is a limit to just how close the letters can be set. With photo-typesetting the individual characters can be set tight, touching, or overlapping. And with the aid of prisms the letters can be slanted, extended, or condensed.

Phototype sets on film. One of the unique advantages of phototypesetting is the capacity to set type and make up jobs directly on film, thus eliminating the need for a mechanical. Not only does this save time for the designer, but also for the printer, because there are no "out of process" steps such as shooting a mechanical and developing film before making the printing plate. The advantage of staying "in process" is that it allows the printer to make plates from original art, thus assuring a better-quality plate.

The first generation of phototypesetting machines were photo-mechanical and first came upon the market in 1946 with the Intertype Fotosetter, developed by Herman Freud. The Fotosetter, a modified version of the linecasting machine, had a camera in place of the metal pot, and the matrices were designed to carry film negatives of the individual characters. The camera photographed each character individually and was capable of setting type from 5 point to 36 point from a single matrix.

One of the advantages of the Fotosetter was familiarity; a linecasting operator could run the machine with very little retraining. The operator keyboarded the copy, as usual, while making all the end-of-the-line decisions such as how many words can fit on a line, should a word be hyphenated, and if so, where. In

this manner, the keyboard operator continued to have great control over the quality of the setting. Unfortunately, the first-generation Fotosetter saw only limited success and never posed a serious threat to metal type.

While first-generation phototypesetting systems were a step in the right direction, it was the speed and reliability of the second-generation systems perfected in the fifties and sixties and spelled the death of the linecasting machines and metal type in general. The first commercially successful machine was the Photon, developed by Rene Higonnet and Louis Mogroud in 1949.

Second-generation systems were not adaptations of old technology, but true phototypesetting machines involving sophisticated, electronically controlled, spinning disks containing negatives of the characters to be set. On command, the rotating disk would stop and a beam of high-intensity light would flash through the negative, exposing the character onto either paper or film. Besides rotating disks, other systems employed film strips and grids as font carriers.

Although second generation phototypesetting systems vary greatly, they all share three basic components: a *keyboard* for input; a *computer* for making end-of-line decisions, storing information, and controlling the output; and a *photounit* for output or typesetting. Add to these three units a device for editing and correcting, such as a *visual display unit* (VDT), and you have a typical phototypesetting system.

Phototypesetting components vary depending on the system: they may be simple or complex; separate or combined into a single unit. Let's examine each.

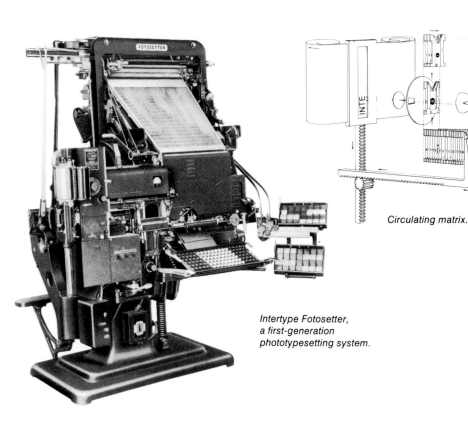

Circulating matrix.

Intertype Fotosetter, a first-generation phototypesetting system.

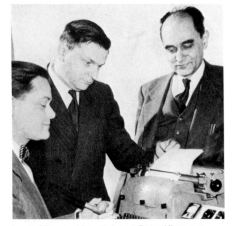

Louis Moyroud (center) and Rene Higonnet (right) with early Photon phototypesetting machine. Bill Garth (left) was founder of Compugraphic.

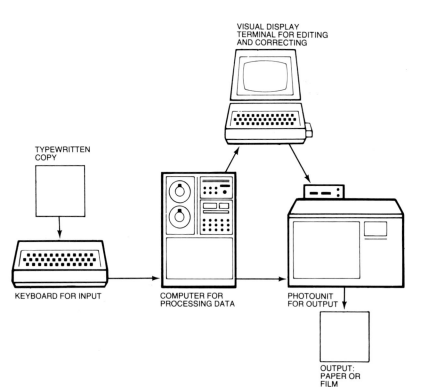

VISUAL DISPLAY
TERMINAL FOR EDITING
AND CORRECTING

TYPEWRITTEN
COPY

KEYBOARD FOR INPUT

COMPUTER FOR
PROCESSING DATA

PHOTOUNIT
FOR OUTPUT

OUTPUT:
PAPER OR
FILM

A typical second-generation phototypesetting system.

INPUT

Before copy can be set it must first be typed on a special keyboard. This keyboard is like an ordinary typewriter except that it has extra keys for such special formatting functions as font changes (typeface or type size), letterspacing, tabbing, leading, etc.

Most keyboards are equipped with some type of visual display that permits the operator to see the words as they are being typed. In this way, if a mistake is made it can be corrected before the data is recorded or transmitted to the typesetter. The visual display may be small and capable of accommodating only a few words, or it may be a large VDT designed to show many lines.

There are two basic keyboard systems: *counting* and *noncounting*, also known as justifying and nonjustifying respectively.

Counting Keyboard. This is the more complex and expensive of the two keyboard systems, and it demands more skill, as the operator must have a knowledge of typography.

Before typing the copy the operator must know the specifications: typeface, point size, line length, justification mode (justified or unjustified), letterspacing, wordspacing, etc. As the operator types the copy, the unit widths of the individual characters are totaled and shown on a scale. When the operator nears the end of a line, a light or audio signal indicates that the line is ready to be justified. At this point the operator (or computer) makes an end-of-line decision (hyphenation and justification), the tape is punched, and the operator proceeds to the next line.

Noncounting Keyboard. This is less expensive and simpler than the counting keyboard, requiring an operator with the ability to type at high speeds rather than someone with typographic skills. All the operator need be concerned with is inputting the copy and paying attention to such items as which words are to be set in italic or bold and paragraph indents.

One of the advantages of noncounting

keyboards is that copy can be key-boarded in advance of type instructions. If the type specifications are already included, they can be changed before the type is set. Furthermore, the same input can be used to set the same job in a variety of typefaces and measures.

Perhaps the major advantage of noncounting keyboards is speed. It is estimated that one-third of the counting-keyboard operator's time is spent making end-of-line decisions. The noncounting-keyboard operator, however, is free to type continuous copy at maximum speed, leaving it up to the computer to determine the hyphenation and justification. Unfortunately, the quality of the end-of-line decisions cannot be determined until the type is set; if it is poor, corrections can be costly.

OCR Systems. The input systems described so far are basically the same: the operator types the copy on a keyboard, which produces a tape or disk. With the OCR (optical character recognition) system, the keyboard operator is eliminated, as the copy is put through a scanner that is able to "read" the individual characters and produce the necessary tape or disk.

Warning lights indicate when line is ready to be justified or is overset.

No flash creates space the width of given character(s) without exposing them onto film.

Remaining line length.

Point size.

Typeface.

Leading.

Supershift for keyboarding fractions or other special characters.

Shift for keyboarding caps.

Unshift for returning to normal lowercase.

Visual display allows operator to see and edit the last few characters typed. Also tells him where he is in case of interruptions.

DISPLAY PANEL

Code delete allows operator to make corrections by deleting a character.

MAIN KEYBOARD

Word delete allows operator to make corrections by deleting a word.

AUXILIARY KEYBOARD

Special instruction keys for coding out the proper magazine (font), changing from roman to italic, to caps, or to boldface, etc.

Regular typewriter keys.

Special instruction keys for wordspacing, letterspacing, flush left, flush right, etc.

Program formatting keys for setting pre-specified instructions stored in computer memory. For example: "Set text in font #1, 28 picas wide, indent paragraphs 1 em, and hang all end-of-line punctuation."

Counting keyboard

STORAGE

Regardless of whether the keyboard is counting or noncounting, the keystrokes and formatting instructions need to be recorded in order to drive the typesetter. The most common methods for recording are perforated paper tape, magnetic tape, floppy disks, or hard-wiring.

Paper Tape. The perforated tape, approximately 1″ wide, is very much like an old player-piano roll, on which the position of the holes dictated the keys to be played. For each character typed, a unique configuration of holes is punched. If corrections are necessary, a new tape must be punched. Because holes are permanent, paper tapes cannot be reused. They are also difficult to store.

Magnetic Tape. Magnetic tape, more commonly referred to as "mag tape" can be either open-end (on reels) or in cassettes. Magnetic tape permits a more concentrated recording of information than paper, so although the initial cost is higher, it is less expensive in terms of the amount of information that can be stored. Furthermore, magnetic tape can be erased and reused. Magnetic tape systems are also faster, quieter, and more reliable than paper systems.

Disks. Among the disks presently used in phototypesetting the floppy disk is the most widely used. The floppy disk is not unlike a flexible 45 RPM record, except that the information is recorded electronically, in segments rather than grooves. Floppy disks are inexpensive, reliable, and can store more information in a given space than either paper or magnetic tape. Some can even be used on both sides. They are also easy to store and are reusable.

One of the major advantages of the disk is the ease with which corrections can be made. Paper and magnetic tapes are "serial," which means that in order to get to a certain point on the reel you must start at the beginning and play it through. Disks, however, have "random access," which means that it is possible to go directly to a given area.

Hard-wiring. Some keyboards employ neither tapes nor disks to drive the output unit, but are hard-wired to store the typesetting information on magnetic disks or drums. This method has been used primarily on *direct-entry*, or *direct-input*, systems where a single operator controls all functions: input, editing, correcting, and output.

Paper tape.

Magnetic tape.

Disk.

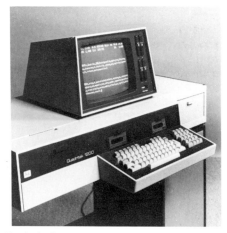

Hard-wired.

Perforated paper tape, actual size.

COMPUTER

The computer is basically an adding machine with an expanded memory. Its job is to process the unjustified tapes and, among other things, to make end-of-line decisions. How well it does this is determined by the computer's programming (referred to as *software*, to differentiate it from the equipment itself, which is referred to as *hardware*). The more thoroughly the computer is programmed, the better the chances of correct hyphenation, even wordspacing, and generally good typography.

In some phototypesetting systems the computer unit is an integral part of the photounit. In this case, the unjustified tape is fed directly into the photounit and a minicomputer resolves the linebreaks as the type is being set.

When the computer unit is separate from the photounit, the unjustified tape must first be converted into a justified tape. In this case, the computer reads the unjustified tape and produces a new, justified tape capable of driving the photounit.

There are four systems by which computers can be programmed to resolve linebreaks: hyphenless, discretionary, logic, and exception dictionary. However, not all computers are designed to use all four systems.

When setting type hyphenless, the lines are justified by increasing or decreasing the wordspace. On some machines, letterspacing can be adjusted to help justify the line. This can be distracting and the designer should have a sample set before deciding whether he wants to use letterspacing as well as wordspacing. The disadvantage of hyphenless setting is that wordspacing can be disastrous, especially if setting type to a short measure.

If composition must be set hyphenless, it is a good idea to consider having it set flush left, ragged right. This way the wordspacing will be even and any excess space will be at the end of the lines where it is not noticeable.

Hyphenless. In this system, no words are hyphenated. The lines are justified by increasing or decreasing the wordspacing, and on some machines, the letterspacing. This can create some very poor wordspacing and letterspacing, which may require the resetting of lines to create more pleasing results.

```
The com-puter is basic-ally
an adding machine with an
ex-pand-ed memory. Its job
is to process the unjust-ified
tapes and, among other things,
to make end--of--line
decis-ions. How well it does
this is deter-mined by the
com-puter's pro-gramm-ing
(re-ferred to as "soft-ware,"
to differ-entiate it from the
equip-ment itself, which is
re-ferred to as "hard-ware").
The more thor-oughly the
com-puter is pro-grammed, the
better the chances of correct
hyphen-ation, even word-spacing,
and gener-ally good typog-raphy.
```

Discretionary. Here, the computer needs a little help from the keyboard operator. As the operator types the copy, every word of three syllables and over is hyphenated. The computer, when justifying a line, uses its "discretion" to choose only the hyphenation it needs, disregarding that not needed.

Computer independent of the photounit.

STORAGE

Regardless of whether the keyboard is counting or noncounting, the keystrokes and formatting instructions need to be recorded in order to drive the typesetter. The most common methods for recording are perforated paper tape, magnetic tape, floppy disks, or hard-wiring.

Paper Tape. The perforated tape, approximately 1″ wide, is very much like an old player-piano roll, on which the position of the holes dictated the keys to be played. For each character typed, a unique configuration of holes is punched. If corrections are necessary, a new tape must be punched. Because holes are permanent, paper tapes cannot be reused. They are also difficult to store.

Magnetic Tape. Magnetic tape, more commonly referred to as "mag tape" can be either open-end (on reels) or in cassettes. Magnetic tape permits a more concentrated recording of information than paper, so although the initial cost is higher, it is less expensive in terms of the amount of information that can be stored. Furthermore, magnetic tape can be erased and reused. Magnetic tape systems are also faster, quieter, and more reliable than paper systems.

Disks. Among the disks presently used in phototypesetting the floppy disk is the most widely used. The floppy disk is not unlike a flexible 45 RPM record, except that the information is recorded electronically, in segments rather than grooves. Floppy disks are inexpensive, reliable, and can store more information in a given space than either paper or magnetic tape. Some can even be used on both sides. They are also easy to store and are reusable.

One of the major advantages of the disk is the ease with which corrections can be made. Paper and magnetic tapes are "serial," which means that in order to get to a certain point on the reel you must start at the beginning and play it through. Disks, however, have "random access," which means that it is possible to go directly to a given area.

Hard-wiring. Some keyboards employ neither tapes nor disks to drive the output unit, but are hard-wired to store the typesetting information on magnetic disks or drums. This method has been used primarily on *direct-entry*, or *direct-input*, systems where a single operator controls all functions: input, editing, correcting, and output.

Paper tape.

Magnetic tape.

Disk.

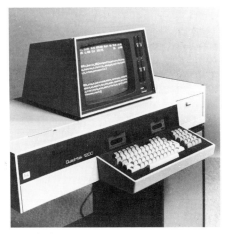
Hard-wired.

Perforated paper tape, actual size.

COMPUTER

The computer is basically an adding machine with an expanded memory. Its job is to process the unjustified tapes and, among other things, to make end-of-line decisions. How well it does this is determined by the computer's programming (referred to as *software*, to differentiate it from the equipment itself, which is referred to as *hardware*). The more thoroughly the computer is programmed, the better the chances of correct hyphenation, even wordspacing, and generally good typography.

In some phototypesetting systems the computer unit is an integral part of the photounit. In this case, the unjustified tape is fed directly into the photounit and a minicomputer resolves the linebreaks as the type is being set.

When the computer unit is separate from the photounit, the unjustified tape must first be converted into a justified tape. In this case, the computer reads the unjustified tape and produces a new, justified tape capable of driving the photounit.

There are four systems by which computers can be programmed to resolve linebreaks: hyphenless, discretionary, logic, and exception dictionary. However, not all computers are designed to use all four systems.

When setting type hyphenless, the lines are justified by increasing or decreasing the wordspace. On some machines, letterspacing can be adjusted to help justify the line. This can be distracting and the designer should have a sample set before deciding whether he wants to use letterspacing as well as wordspacing. The disadvantage of hyphenless setting is that wordspacing can be disastrous, especially if setting type to a short measure.

If composition must be set hyphenless, it is a good idea to consider having it set flush left, ragged right. This way the wordspacing will be even and any excess space will be at the end of the lines where it is not noticeable.

The com-puter is basic-ally an adding machine with an ex-pand-ed memory. Its job is to process the unjust-ified tapes and, among other things, to make end--of--line decis-ions. How well it does this is deter-mined by the com-puter's pro-gramm-ing (re-ferred to as "soft-ware," to differ-entiate it from the equip-ment itself, which is re-ferred to as "hard-ware"). The more thor-oughly the com-puter is pro-grammed, the better the chances of correct hyphen-ation, even word-spacing, and gener-ally good typog-raphy.

Hyphenless. In this system, no words are hyphenated. The lines are justified by increasing or decreasing the wordspacing, and on some machines, the letterspacing. This can create some very poor wordspacing and letterspacing, which may require the resetting of lines to create more pleasing results.

Discretionary. Here, the computer needs a little help from the keyboard operator. As the operator types the copy, every word of three syllables and over is hyphenated. The computer, when justifying a line, uses its "discretion" to choose only the hyphenation it needs, disregarding that not needed.

Computer independent of the photounit.

TYPICAL RULES OF LOGIC

- Insert a hyphen before the suffixes *ing, ed, ly, ty, day.*

- Insert a hyphen after the prefixes *non, pop, air, mul, gas, gar, cor, con, com, dis, ger, out, pan, psy, syn, sur, sul, suf, sub, mis, ul, un, im, il, ig, eu, es, os,* and *up.*

- Insert a hyphen in a sequence of numbers broken up by commas after a comma.

- Do not hyphenate if less than five letters in a word, or if less than two characters before or after a hyphen. For example: *ring* not *r-ing.*

- Do not insert a hyphen before the suffix *ing* if preceded by one of the letters *d, t,* or *h.*

- Do not insert a hyphen before the suffix *ed* if preceded by one of the letters *v, r, t, p,* or where *v* is a vowel.

- Do not insert a hyphen before the suffix *ly* if the word ends in *bly.*

- Do not insert a hyphen before the suffix *ty* if the word ends in *hty.*

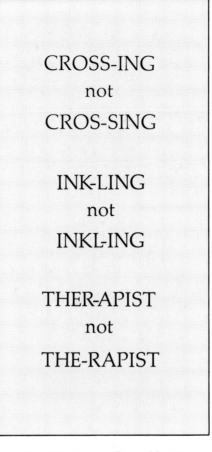

CROSS-ING

not

CROS-SING

INK-LING

not

INKL-ING

THER-APIST

not

THE-RAPIST

Phototypesetter with computer and photounit combined.

Logic. The computer is programmed with a specific set of rules of hyphenation (hyphenate between double consonants, before *ing,* etc.). All words covered by these rules will be hyphenated accordingly. If the rules cannot be applied, the word will not be hyphenated; instead, the line will be justified by adding wordspace and/or letterspace. As with the hyphenless system, this can result in cases of poor wordspacing, again making it necessary to reset lines.

Also, there are words that can be hyphenated according to logic, but should not be; for example, *ring* should not be hyphenated *r-ing.* There are many words like this that are exceptions to the rules of hyphenation. For this reason some computers have an exception dictionary.

Exception Dictionary. To avoid poor hyphenation, some of the more sophisticated computers are equipped with an *exception dictionary.* This dictionary covers words and proper nouns that are exceptions to the computer's rules of logic. The computer first searches the exception dictionary. If the word is listed (for example, *ink-ling*), the computer hyphenates accordingly. If the word is not listed, the computer tries to hyphenate it according to the rules of its logic system. If no rule is applicable, the word will not be hyphenated and wordspace will be used to justify the line. Not all exception dictionaries are the same; some contain only a small number of words while others, with expanded memory capacity, are very extensive. Some computers, with sufficient memory capacity, carry a complete dictionary plus most common proper names in memory.

Note: The computer may also have difficulty determining exactly what the author meant and this could affect the hyphenation. For example: *de-sert* and *des-ert* or *mi-nute* and *min-ute.*

Interior of a small computer containing four microprocessor chips.

OUTPUT

It is the photounit, or phototypesetter, that actually sets the type. This output is so fast that it would take dozens of highly proficient keyboard operators to produce enough input to efficiently utilize its capacity.

The photounit is a combination of photographic, electronic, and mechanical components. The type font is carried as a negative image on an *image master*. Depending on the system, the image master may be either a disk, grid, film strip, or drum.

To set type a high-intensity light (xenon) is flashed through the characters, projecting them onto photosensitive paper or film. In some systems the image master remains stationary while the light source moves, in others the image master spins or rotates while the light remains stationary.

Photounits vary greatly in method of handling the image master; number of image masters, and fonts per master, handled at one time; range of type sizes (controlled by lenses available); maximum line length; method of projecting the image onto photosensitive paper or film; speed of output; and control electronics.

Also, some photounits use a different image master for each type size, while others use a single image master that can be reduced or enlarged by a lens system to produce a number of different type sizes.

These are just a few of the mechanical differences in photounits, which may or may not affect the quality of the setting. From the designer's point of view, how the type gets onto the paper or film is less important than how the type looks. To avoid any disappointment, the designer should always have a type sample set showing the specified typeface on the correct measure with the proper amount of leading.

Mergenthaler VIP.

Harris-Intertype Fototronic TXT.

Monophoto 600.

Disc font used by Photon.

Grid font used by Alphatype.

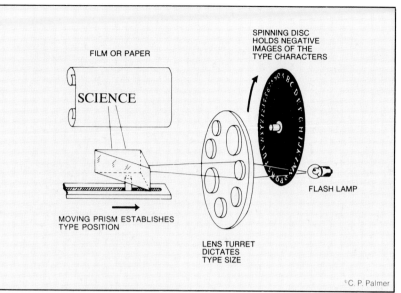

SPINNING DISC HOLDS NEGATIVE IMAGES OF THE TYPE CHARACTERS

FILM OR PAPER

SCIENCE

FLASH LAMP

MOVING PRISM ESTABLISHES TYPE POSITION

LENS TURRET DICTATES TYPE SIZE

°C. P. Palmer

The basic principle of phototypesetting.

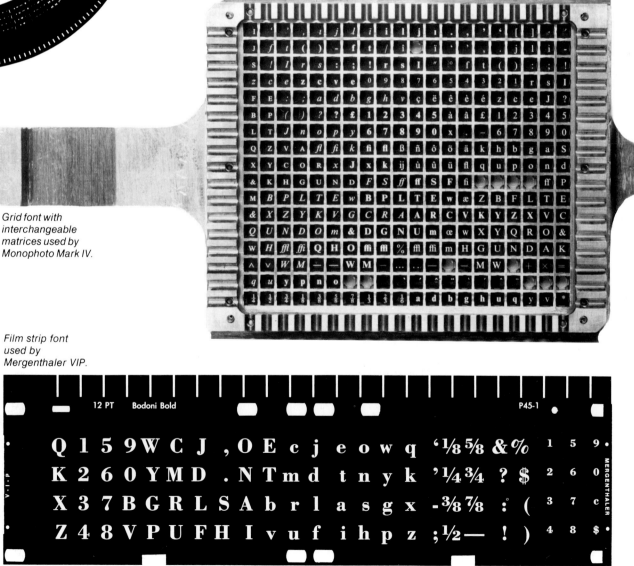

Grid font with interchangeable matrices used by Monophoto Mark IV.

Film strip font used by Mergenthaler VIP.

12 PT Bodoni Bold P45-1

Q 1 5 9 W C J , O E c j e o w q '⅛⅝ & % 1 5 9
K 2 6 0 Y M D . N T m d t n y k '¼¾ ? $ 2 6 0
X 3 7 B G R L S A b r l a s g x -⅜⅞ : (3 7 c
Z 4 8 V P U F H I v u f i h p z ;½— !) 4 8 $

Removing cartridge from photounit.

Kodak processor for stabilization paper.

VGC's Total Camera III *for processing RC paper.*

IBM duplicator for making copies of proofs.

Diazo for making reader's proofs from film.

PROCESSORS AND PROOFS

After the type has been set, the paper (or film), contained in a lightproof cartridge, is removed from the photounit and is ready to be developed.

The most common developing method is to place the cartridge into a *processor* that automatically develops and dries the paper. The particular type of processor is dictated by the paper: a stabilization processor for stabilization paper and an RC (resin-coated) processor for RC paper.

Processors can be either daylight-loading or darkroom-loading. Daylight-loading processors, as the name suggests, can be used under normal lighting conditions, while the darkroom-loading processor can only be used under safelight conditions.

After the type is developed, a proof is made. There are a number of ways to produce proofs. If the job is set on paper, the most common method of producing a reader's proof is to make a photocopy. For a reproduction-quality proof, Kodak has a PMT® (photomechanical transfer) method and Agfa has a Copyproof® method.

For jobs set on film, the typographer is more likely to use Diazo, which is a photographic contacting process that produces high-quality reading or reproduction proofs on paper or film. (See *Photographic Paper and Film* on page 41 for additional information.)

EDITING AND CORRECTING

There are four stages of the phototype-setting process in which corrections can be made: before keyboarding, during keyboarding, after keyboarding, and after typesetting. Editing and correcting becomes more costly with each stage, so all changes should be made as early as possible.

Before Keyboarding. It has been estimated that it takes thirty times longer to correct a typing error than it takes to type something correctly. Therefore, the best and least expensive time to make corrections is before keyboarding. The copy should be properly typed, with adequate margins for type specifications and coding. Well-organized and clearly marked copy reduces the possibilities for error. And make sure that the copy has been carefully edited and approved by all parties.

During Keyboarding. The next best time to make corrections is during keyboarding. Most keyboards are equipped with a visual display that enables the operator to see and correct errors as the copy is being typed.

After Keyboarding. The most common method of editing a disk (or tape) after keyboarding is with a VDT. By playing the disk through the VDT, the operator can get a visual readout of the copy. If an error is found (or new copy is to be added) the correction is typed on the keyboard, which simultaneously produces a corrected disk.

After Typesetting. If the corrections are not extensive, the typesetter will simply set a patch, which are spot corrections on repros, that the designer will strip into the original repro.

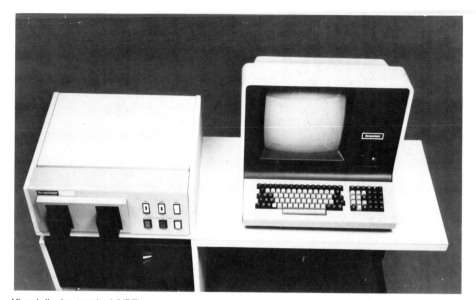

Visual display terminal (VDT).

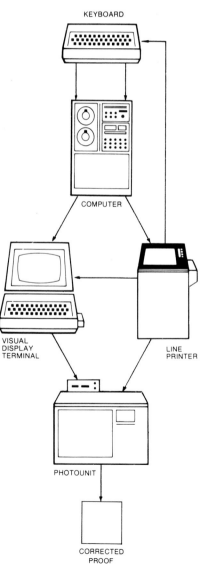

KEYBOARD

COMPUTER

VISUAL
DISPLAY
TERMINAL

LINE
PRINTER

PHOTOUNIT

CORRECTED
PROOF

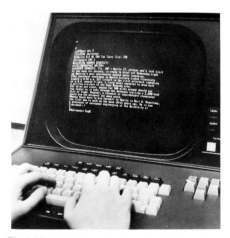

The VDT produces a visual readout of the copy.

Editing and correcting sequences using either a VDT or a line printer.

PHOTODISPLAY UNITS

Phototypesetting machines are great for setting text type, but many leave much to be desired when setting the larger display sizes. Often the type is fuzzy and the letterspacing poor. To obtain acceptable display type, designers often turn to photodisplay systems (or laser typesetting systems, where size is not a problem).

Photodisplay machines offer an inexpensive method of setting display type and are easy to operate. Most work on the same principle as phototypesetting machines: the type font, carried on a disk, grid, or film strip, is placed in the machine and adjusted manually to set the character in position. A key is pressed and a light beam exposes the letter onto photosensitive paper or film. After the setting, the paper or film is developed, fixed, and washed. This operation takes place either in the machine or a separate unit.

There are two basic photodisplay systems: *manual letterspacing* and *automatic letterspacing*. With the manual letterspacing system, the operator can see the results and is able to visually control the letterspacing. The opposite is generally true for automatic letterspacing, where the operator must work "blind" and has only limited control over the letterspacing.

The majority of photodisplay systems set type on a continuous strip of paper or film about 2″ wide, which is adequate for setting single lines of type but can present a problem if the type is to be set on more than one line.

VGC's Photo Typositor

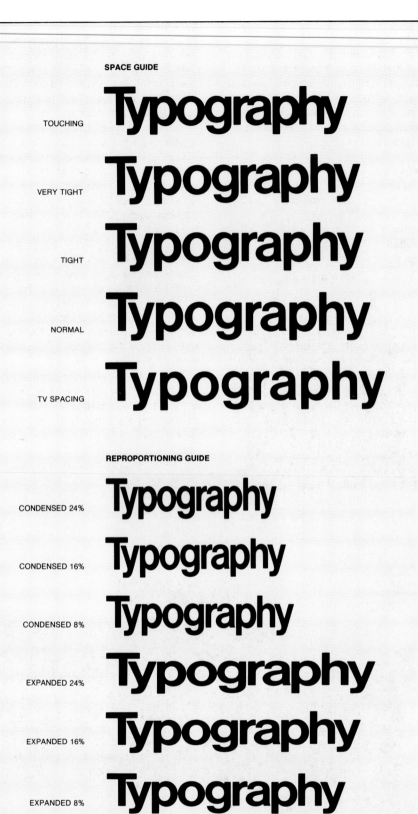

SPACE GUIDE

TOUCHING

VERY TIGHT

TIGHT

NORMAL

TV SPACING

REPROPORTIONING GUIDE

CONDENSED 24%

CONDENSED 16%

CONDENSED 8%

EXPANDED 24%

EXPANDED 16%

EXPANDED 8%

OBLIQUE

Digital Composition

Digital composition, sometimes referred to as third-generation systems, is dramatically different in both storage and output from the second-generation phototypesetting systems. With the latter, characters are stored as photographic images. With digital composition systems the characters are stored electronically as digital data.

Digital systems are high-speed, type-generating machines capable of setting type at the rate of thousands of characters per second. Furthermore, digital type can be electronically expanded, condensed, slanted, and manipulated, thus offering the designer unlimited design possibilities.

CRT SYSTEMS

The first successful digital typesetter was the Digiset 501T, developed by Rudolph Hell in 1965. It was a high speed system that combined sophisticated computer electronics with a CRT (cathode ray tube) for character generation.

In terms of speed CRTs are to phototypesetting what phototypesetting is to linecasting. For example, a typical linecasting machine can set type at approximately 5 cps (characters per second), a phototypesetter from 30 to 100 cps, and a CRT anywhere from 1,000 to 10,000 cps.

The quality of type is in direct ratio to the speed of the setting: the faster the characters are generated and the fewer scan lines produced, the lower the typographic quality. In many cases a reading proof will be set at 10,000 cps with 300 scan lines per inch. The final copy is set at the slower 3,000 cps with over 1,000 lines per inch.

The original CRTs were expensive, limiting their use to jobs having high-volume typesetting requirements, such as newspapers, timetables, inventories, phone directories, catalogs, and price lists.

There are two basic CRT systems, which are defined by how the type is stored: *formation* and *projection*.

Formation. In this system (Computer Logic Character Formation) all the characters are stored in the computer as small dots or closely spaced vertical lines, too small to be seen by the naked eye. When a character request comes, the computer sends the configuration of the character as an electronic signal to the cathode ray tube where the character is formed. A lens then focuses and projects this image onto photosensitive paper or film (see page 39).

Projection. This system (Character Projection) scans the characters to be set, which are stored on an image master, and translates this information into thousands of vertical lines (800 to 5,400 per inch). These images are then relayed to the cathode ray tube and projected onto photosensitive paper or film. This is the system used by the Linotron 505.

Teletypewriter.
The means of communication between the operator and the Linotron and vice-versa. Also capable of producing a printout status report on the state of the program.

Tape readers.

Character monitor display shows the characters as they are generated (set).

Control unit.
Includes a built-in computer, which is the brains of the system. It receives instructions by tape commands (paper or magnetic) and tells the reproducer unit what type to use, the size, and how to set it.

The reproducer unit sets type from image masters (shown above). Typesetting speed ranges from 170 to 300 lines per minute depending on the typographic quality desired.

The Mergenthaler Linotron 505 CRT system.

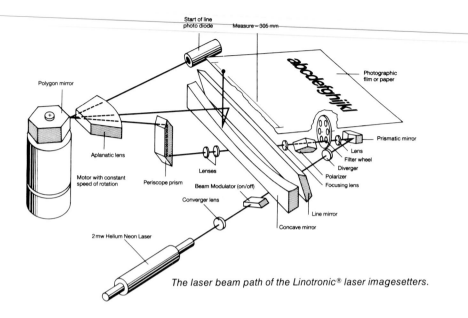

The laser beam path of the Linotronic® laser imagesetters.

Linotronic® 300 and 500 laser imagesetters.

LASER SYSTEMS

Laser imagers, or typesetters, using digital technology can reproduce any image that can be digitized. This includes not only type, but photographs, illustrations, and other graphic images. Furthermore, by combining these elements, laser imagers are capable of handling page makeup.

With laser imaging, all graphic images are stored as digital data. To generate the images, a raster image processor (RIP) must read the data and then instruct the laser beam to reproduce the images as a series of dots, or *pixels*. Depending on the circumstances, the output may be on a video screen, as with desktop publishing, or on paper, film, printing plates or a disk (for storage).

Laser technology also adds another important feature; not only can images be reproduced by the photographic process (paper and film), but also through the xerographic process (photocopies). Although these low-cost, readily available photocopies are not reproduction quality, they are more than adequate as proofs.

Perhaps the major challenge facing the manufacturers of laser imagers is the need for ever-increasing amounts of storage and improved processing speeds. A partial answer to storage may be supplied by compact disks and optical disks, while more sophisticated processing chips will certainly improve processing speeds.

G G
G G

Digital type can be electronically manipulated to offer the designer unlimited design possibilities.

DIGITAL TYPE

As technology changes, so too does typeface design. The designs that served metal type and phototype so well are not always suitable for digital composition.

In 1973, URW of Hamburg, West Germany, developed IKARUS, a means of digitizing typefaces suitable for the new generation of typesetters and desktop publishing systems.

With the IKARUS design system, characters are stored electronically as a series of points, or dots, that define curves, corners, and tangents. The points, along with special hints help the computer calculate the outline of characters and other typographic subtleties. This data is then used to generate the characters as either bit maps for low-resolution printers and video screens (*bitmap* and *run-length bitmap*), outlines for high resolution typesetters (*vector outline*), and most recently, as curvilinear (*bézier IKARUS* and *Purdy spiral*).

One of the problems with digitized type is maintaining the quality and character of a typeface when used with low to medium resolution videos and printers. At 300 dpi the type appears stepped, or jagged, and is often unrecognizable. This is particularly true for the smaller sizes.

To compensate for this, some type designers have attempted to design new typefaces that eliminate many of these negative effects. Two examples worth noting are Matthew Carter's Charter and Bigelow & Holmes's Lucida. While such efforts are commendable, the vast majority of type users still require the traditional faces in a recognizable form.

To improve the quality of the type-faces, manufacturers have introduced the concept of "hinted" typefaces. As the type is being reduced or enlarged, *hints* inform the scaling program which qualities should be maintained and which sacrificed to achieve good letterform design. This innovation reduces jagged edges and improves legibility, and it helps the designer make realistic letterspacing judgments.

The search for the ideal method of digitally reproducing a typeface requires a mathematical formula that offers speed, accuracy, and compact storage.

There is one serious concern about digitized type that must be weighed against its many attributes and this is the loss of individual characteristics that make a particular typeface unique. Subtle curves tend to be flattened, as is the case with Optima; serifs become equal rather than varying in weight, as with Garamond; and so on.

Should all typefaces become homogenized it would be a great loss to graphic designers and lovers of typeface design. It is hoped that with such advanced technologies as URW's NIMBUS, Bitstream's FONTWARE, and Adobe's hinting, that it will be possible to further enhance the appearance of the traditional designs.

BITMAP

RUN-LENGTH BITMAP

VECTOR OUTLINE

BEZIER IKARUS

PURDY SPIRAL

Typesetting Considerations

When it comes to type there is a saying among designers: *You deserve what you accept.* There is a great deal you can do to insure that the type you get from the typographer is worth accepting. Regardless of the typesetting method—desktop, photo, or digital—there are certain general considerations that should be addressed: the typesetting system you choose, the typographer you hire, and how you specify the type.

The "right" typesetting system for your particular job may vary: sometimes you require excellence in typography, other times speed or cost may be the important considerations.

Some systems are designed for high-speed composition of straight, uncomplicated copy such as newspapers; others can produce more complex work, such as charts, tabular material, catalog pages, and textbooks. Also, the degree of sophistication in computer programming varies greatly from one system to another.

Not only is it necessary to find the right system, but it is also desirable to find the right typographer. Keep in mind that just as a good book designer is not necessarily a good advertising designer, a good book typographer is not necessarily a good advertising typographer.

Also the difference in what typographers charge may be considerable; advertising typographers, for example, whose work is more demanding, are more expensive than publishers' typographers, who are able to schedule work far in advance and take weeks and months to produce a job.

The designer should also be aware that typesetting shops today are sometimes run by people who do not always have a strong typographic background. Their prices can be attractive, but the errors they make due to unfamiliarity with typography may more than eat up the savings.

It's an excellent idea, where possible, to visit the typographer to see the actual equipment and study its capabilities. Also, before setting a job, always get a type specimen—not just a single line, but a block of type that displays the quality of the type, color, format, leading, etc. Here are a few items you may wish to consider.

Typefaces Available. The number of typefaces offered by a manufacturer or typographer is an approximate number and will probably expand as new typefaces are added. A single typeface usually refers to *one style of type in all sizes.* For example, Helvetica roman is one typeface, Helvetica italic another.

From the designer's point of view, the number of typefaces is not as important as the quality of the typeface and typesetting. Although all systems have most of the popular typefaces, the designer should not expect to find any consistency of design, style, x-height, character per pica, etc., among manufacturers.

Type Size Range. This is the minimum and maximum point size a system is capable of producing. With phototypesetting, if the type-size range is extreme, such as 5 to 72 point, you can assume that this may involve a font change. Generally speaking, the smaller sizes are set on one font and the larger sizes on another to avoid distortion that may occur in both type and letterspacing when type is enlarged too much. Digital typesetters can generate sharp type at sizes up to approximately 1,000 points. Many systems can also set type in fractions of point sizes.

Maximum Line Length. The longest possible line a machine can set is generally limited by the width of the paper. Some systems are capable of setting type the width of tabloids and full-size newspapers; others are capable of setting type sideways to take advantage of the roll's length rather than the width. This is ideal for setting long signs in a single piece.

Leading Range. The leading, or line-spacing, range is generally unlimited and is usually measured in points and fractions of points. With some systems leading can also be specified as a percentage of the body size, in millimeters, or in the European Didot system.

Reverse Leading. This means that the system can set type anywhere on the page. For example, it can set columns of type. This is an excellent feature for setting tabular work or positioning heads, vertical rules, complex equations, etc. In such cases, it is possible to go directly to page makeup without having to cut and paste.

Units to the Em. Although the designer works in picas and points, typesetting machines work in units. The unit is a variable measurement, based on the division of the em (the square of the type size). In a 54-unit system each unit is $\frac{1}{54}$ em (or $\frac{1}{54}$ of the type size being set). Both the line length and the type being set are measurable in units as well as in picas and points. By adding up the unit value of the characters it is possible for the machine to determine when a line is ready to be justified. (See page 15 for a complete discussion of the unit system.)

Letterspacing. By adjusting the overall letterspacing (also called *tracking*) it is possible to improve legibility, control the amount of space copy will occupy, and change the color of the printed piece. Although most typesetting machines measure letterspacing in units, designers find it more convenient to specify letterspacing with the general terms: *normal, tight, very tight,* and *open* (or *loose*).

Normal letterspacing is the way the type comes off the machine, with no extra space added or deleted. With tight and very tight letterspacing, space is deleted; with loose letterspacing, space is added. The tighter the setting, the more characters can be set per line, and the blacker, or denser, the setting will appear.

When setting type tight or very tight, have a specimen set that shows enough copy to enable you to properly judge the effect. You may find that the letterspacing is improved between straight letters, such as *i*'s and *l*'s, but that round letters, such as *c*'s and *o*'s, tend to overlap. Good words to include in any sample setting are *hillbilly, schoolbook,* and *millimeter,* because they show the effect of the letterspacing on both straight and round letters.

Open letterspacing is seldom used with lowercase letters as they are designed to fit together without additional space. Open letterspacing is more appropriate when setting all caps, which often benefit from the addition of space.

Wordspacing. Like letterspacing, wordspacing is adjustable and can be specified by the designer. Wordspacing, specified as *normal, tight, very tight,* and *open,* is generally the same as letterspacing. Too much wordspacing has the effect of breaking up the line into individual words, while too little causes words to run together.

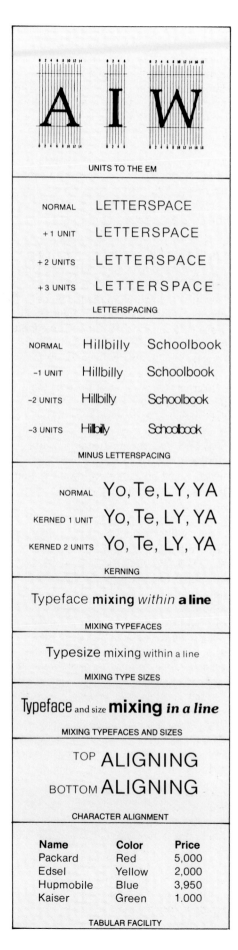

Kerning. This is the ability to selectively reduce the letterspacing between certain letters while the rest of the setting remains the same. It is shown in units and is usually used between certain letter combinations, such as *Ye, Yo, Te, LY,* and *YA,* that are generally improved by the deletion of one or two units of space. The ability to kern is particularly desirable when setting display type.

Mixing Typefaces. Just because a typesetting machine has the capacity to mix a variety of typefaces in the same line does not mean that it is practical or aesthetically desirable. With phototype-setting machines, not all typeface changes can be controlled from the keyboard. Font changes often require monitoring by the operator, who must make changes manually. This is not only time-consuming but costly. Mixing typefaces does not present a problem when the type is being set digitally.

Mixing Type Sizes. With the capacity to mix a variety of type sizes in the same line, as with mixing typefaces, aesthetics is always a consideration. On phototype-setting machines, mixing type sizes can be accomplished by keyboard commands, which automatically change fonts, or by making a manual change. Mixing type sizes is not a problem when type is set digitally.

Character Alignment. This is very important if you intend to mix typefaces, type sizes, or both. If the type is base-aligning, all the characters will align along the base of the characters. If it is top-aligning or center-aligning, the type may have to be cut and pasted in mechanicals to make it base-aligning.

Tabular Facility. Tabs give you the ability to set columns of text or figures at predetermined locations on a given pica measure. The number of tab positions available to the keyboard operator can also be important: some machines have only one, while others have as many as 300. Also important is what the system is capable of doing at each tab position; that is, can it set type flush left only, or can it also set type flush right and centered?

Pi Position Available. The designer may have occasion to set special characters that are not included in the standard font: foreign accents, characters for setting scientific formulas, mathematical equations, etc.

Some machines allow blank spaces on regular fonts where pi characters can be added by the operator. These characters are either supplied by the designer or taken from the system's library of pi characters.

With digital typesetting, most suppliers offer scanning devices for direct input of special characters and logotypes. Other systems have special pi fonts available that carry an assortment of popular pi characters, which can be added to the others in the machine by mixing.

Photographic Paper and Film. There are three basic types of photographic materials used on typesetting machines: *stabilization paper, photographic paper,* and *film.* Stabilization paper is the least expensive and the most difficult to keep under control. Furthermore, if it is not properly fixed after processing, it will fade. Photographic paper, while more expensive, affords a higher degree of control and a higher-quality image. Photographic film, which is the most expensive, produces the highest-quality results. Both paper and film are available in varying widths.

In all cases, the designer should be aware that failure to control exposure and development can cause perceptible variations in the weight (color) of the type, making it difficult to match corrections to the original setting.

When the output is film, care should be exercised to obtain emulsion-to-emulsion contact at every phase of the work. Shooting through the film base will cause the type to spread and "heavy up."

Usually, any weight differences are obvious to the naked eye. If you are uncertain, however, an optical compara-tor, or *eye loop,* can be used to measure the thickness of the individual character. This is a precision magnifying glass with a reticle (fine lines etched on the lens), which permits measurements in the thousandths of an inch.

Using the eye loop, type should be inspected for plugging (areas that fill in) and weaknesses (hairlines that fade or disappear). The loop is also handy for checking the accuracy and crispness of halftone dots and other reproduction qualities.

Note: There is also a "direct-to-plate" process, in which the type is exposed onto a plate material that goes directly to press. This is used generally for short runs, such as for stationery.

Plain Paper. Besides the three photographic papers, there is also plain paper, which is widely used with digital typesetters, ink-jet printers, and desktop-publishing systems. Plain paper is less expensive than photographic paper and requires no processing. And no processing means no chemical odors.

Justification. Hyphenation and justification is the method by which the computer makes end-of-line decisions. In a *hyphenless* setting, the words are not hyphenated, but extra space is added between the words and letters to justify the line. With a *discretionary*, all words three syllables and over are hyphenated by the operator and the computer hyphenates as necessary to justify the lines. With *logic*, the computer is pro-grammed with a specific set of rules of hyphenation. All words covered by these rules will be hyphenated accordingly. If the rules cannot be applied, the line will be justified by adding wordspace or letterspace. The *exception dictionary* on a computer searches for the word in question. If the word is there, it is hyphenated, if the word is not there, it is hyphenated according to preprogrammed rules.

Characters per Font. The number of characters in a single font is usually around 90 although some may have as many as 256, including foreign accents. If typesetting involves multilanguage copy, the number of characters and foreign accents can be important. With digital typesetting, some manufacturers are making it possible to access their entire typeface library through a modem or via storage on a CD/ROM disk.

Lines per Minute. The traditional industry standard for measuring the typesetting speed of a machine, based on newspaper lines: straight matter set in 8-point type on an 11-pica measure, or approximately 30 characters per line.

Letraset.

Formatt.

Transfer Type. Although not "composition" in the mechanical sense of the word, transfer type is yet another means of setting type. If cost is a factor and the amount of type to be set is small, you may find that no typesetting method, photo or otherwise, is inexpensive. At times like this you might consider transfer type. The type, both text and display, is carried on sheets approximately 10″ x 14″. In many cases, type is available not only in black, but also in white and a range of colors. This can be a great asset in preparing finished comps. In addition to alphabets, sheets with borders, rules, symbols, ornaments, drawings, screens, etc., are also available.

The two most common ways of transferring type are pressure-sensitive lettering and cut-out lettering. Both do the same job and both are easy to use.

Pressure-sensitive Lettering. (Letraset, Prestype, Chartpak, Cellotak, Tactype, etc.) Remove the protective backing tissue and position the sheet on the working surface. Press the letter gently with your finger to make sure it is lying flat. To transfer the letter, burnish it *gently* with a ballpoint pen or pencil, using sweeping strokes. These strokes do not affect the actual letter on the underside of the sheet. After the letter has been burnished, gently lift the sheet. The letter will remain on the working surface. Then place the next letter in position, using the system of lines or bars on the sheet to ensure correct alignment and letterspacing. After the entire word has been transferred, place the backing sheet over the word and burnish firmly.

Cut-out Lettering. (Artype, Formatt, Zip-a-Tone, etc.) Using a razor blade or X-acto knife, lightly cut around the desired letter, including any guidelines that may be necessary for proper positioning of the letter. As you cut, be careful not to cut through the protective backing sheet. Insert the tip of the razor blade under the letter and lift it away. Position the letter directly on the art and burnish it lightly, preferably with a wooden stylus. When you are satisfied that it is properly positioned, burnish firmly and trim away any unwanted guidelines.

Custom Transfers. There are times when commercial transfer type is not available in the desired size, style, and color; or, if available, the job may require too many words to be positioned one letter at a time. In such cases the designer must go to a specialty house where they are equipped to make dry transfers to specifications. Normally, the house will require a same-size, black-and-white version of the type (or line art) along with a color swatch or color specification. When considering custom transfers, keep in mind that small type sizes and detailed images may present problems. If uncertain ask the service house to show you samples of their work.

There are a number of technologies offering a range of features and prices. Some involve chemicals and hand work while others use only heat and pressure. Among the more popular systems are Color Key™ overlays, I.N.T.™ custom transfers, Dynamark™ self-adhesive signs and labels, Chromatec® transfers and Omnicrom® color transfers. Design-ers may wish to consider purchasing one of these systems; they are relatively inexpensive, do not require a darkroom, and will most likely pay for themselves in a reasonable amount of time.

Type Specimens

To enable the designer to see the enormous difference in various type-setting systems, the major manufacturers of machine, typewriter, photo, and digital systems have set type specimens of the same five popular typefaces: Garamond, Baskerville, Bodoni, Century Expanded, and Helvetica.

All specimens are set in 10-point type with 2 points leading. The manufacturers are listed alphabetically and the type-faces are identified both by their original names (as above) and by the manufac-turer's special names. The designer should note that not only does the type design differ from one system to another, but the number of characters per pica may vary as well. The systems represented are:

Agfa Compugraphic Corp./digital

Alphatype Inc./digital

Berthold Inc./digital

Harris Corp./photo

IBM Corp./typewriter

Itek Graphix/digital

Linotype Co./cast, photo, and digital

Monotype Corp./cast, photo, and digital

Photon Inc./photo

Varityper Corp./typewriter and digital

AGFA COMPUGRAPHIC (DIGITAL)

I am the voice of today, the herald of tomorrow. I am type! Of my earliest ancestry neither history nor relics remain. The wedge-shaped symbols impressed in plastic clay in the dim past by Babylonian builders foreshadowed me: from them, on through the hieroglyphs of the ancient Egyptians, down to the beautiful manuscript letters of the medieval scribes, I was in the making. JOHANN GUTENBERG was the first to cast me *in metal. From his chance thought straying through an idle reverie—a dream most golden—the profound art of printing*

GARAMOND ANTIQUA

I am the voice of today, the herald of tomorrow. I am type! Of my earliest ancestry neither history nor relics remain. The wedge-shaped symbols impressed in plastic clay in the dim past by Babylonian builders foreshadowed me: from them, on through the hieroglyphs of the ancient Egyptians, down to the beautiful manuscript letters of the medieval scribes, I was in the making. JOHANN GUTENBERG was the first to cast me in metal. *From his chance thought straying through an idle reverie—a dream most golden—the profound art of printing with movable types was born. Cold,*

BASKERVILLE

I am the voice of today, the herald of tomorrow. I am type! Of my earliest ancestry neither history nor relics remain. The wedge-shaped symbols impressed in plastic clay in the dim past by Babylonian builders foreshadowed me: from them, on through the hieroglyphs of the ancient Egyptians, down to the beautiful manuscript letters of the medieval scribes, I was in the making. JOHANN GUTENBERG was the first to cast me in metal. *From his chance thought straying through an idle reverie—a dream most golden—the profound art of printing with movable types was born.*

BODONI BOOK

I am the voice of today, the herald of tomorrow. I am type! Of my earliest ancestry neither history nor relics remain. The wedge-shaped symbols impressed in plastic clay in the dim past by Babylonian builders foreshadowed me: from them, on through the hieroglyphs of the ancient Egyptians, down to the beautiful manuscript letters of the medieval scribes, I was in the making. JOHANN GUTENBERG was the first to cast me *in metal. From his chance thought straying through an idle reverie—a dream most golden—the profound art of printing*

CENTURY OLDSTYLE

I am the voice of today, the herald of tomorrow. I am type! Of my earliest ancestry neither history nor relics remain. The wedge-shaped symbols impressed in plastic clay in the dim past by Babylonian builders foreshadowed me: from them, on through the hieroglyphs of the ancient Egyptians, down to the beautiful manuscript letters of the medieval scribes, I was in the making. JOHANN *Gutenberg was the first to cast me in metal. From his chance thought straying through an idle reverie—a*

TRIUMVIRATE

ALPHATYPE (DIGITAL)

I am the voice of today, the herald of tomorrow. I am type! Of my earliest ancestry neither history nor relics remain. The wedge-shaped symbols impressed in plastic clay in the dim past by Babylonian builders foreshadowed me: from them, on through the hieroglyphs of the ancient Egyptians, down to the beautiful manuscript letters of the medieval scribes, I was in the making. JOHANN GUTENBERG was the first to cast me in metal. From *his chance thought straying through an idle reverie—a dream most golden —the profound art of printing with movable types was born. Cold, rigid,*

NEW GARAMOND

I am the voice of today, the herald of tomorrow. I am type! Of my earliest ancestry neither history nor relics remain. The wedge-shaped symbols impressed in plastic clay in the dim past by Babylonian builders foreshadowed me: from them, on through the hieroglyphs of the ancient Egyptians, down to the beautiful manuscript letters of the medieval scribes, I was in the making. JOHANN *GUTENBERG was the first to cast me in metal. From his chance thought straying through an idle reverie — a dream most golden*

BASKERLINE (BASKERVILLE)

I am the voice of today, the herald of tomorrow. I am type! Of my earliest ancestry neither history nor relics remain. The wedge-shaped symbols impressed in plastic clay in the dim past by Babylonian builders foreshadowed me: from them, on through the hieroglyphs of the ancient Egyptians, down to the beautiful manuscript letters of the medieval scribes, I was in the making. JOHANN GUTENBERG was the first to cast me in metal. *From his chance thought straying through an idle reverie—a dream most golden—the profound art of printing with movable types was*

BODONI

I am the voice of today, the herald of tomorrow. I am type! Of my earliest ancestry neither history nor relics remain. The wedge-shaped symbols impressed in plastic clay in the dim past by Babylonian builders foreshadowed me: from them, on through the hieroglyphs of the ancient Egyptians, down to the beautiful manuscript letters of the medieval scribes, I was in *the making. JOHANN GUTENBERG was the first to cast me in metal. From his chance thought straying through*

CENTURY X

I am the voice of today, the herald of tomorrow. I am type! Of my earliest ancestry neither history nor relics remain. The wedge-shaped symbols impressed in plastic clay in the dim past by Babylonian builders foreshadowed me: from them, on through the hiero-glyphs of the ancient Egyptians, down to the beautiful manuscript letters of the medieval scribes, I was in *the making. JOHANN GUTENBERG was the first to cast me in metal. From his chance thought straying through*

CLARO (HELVETICA)

BERTHOLD (DIGITAL)

I am the voice of today, the herald of tomorrow. I am type! Of my earlist ancestry neither history nor relics remain. The wedge-shaped symbols impressed in plastic clay in the dim past by Babylonian builders foreshadowed me: from them, on through the hieroglyphs of the ancient Egyptians, down to the beautiful manuscript letters of the medieval scribes, I was in the making. JOHANN GUTENBERG was the first to cast me in metal. *From his chance thought straying through an idle reverie—a dream most golden—the pro-*

GARAMOND

I am the voice of today, the herald of tomorrow. I am type! Of my earlist ancestry neither history nor relics remain. The wedge-shaped symbols impressed in plastic clay in the dim past by Babylonian builders foreshadowed me: from them, on through the hieroglyphs of the ancient Egyptians, down to the beautiful manuscript letters of the medieval scribes, I was in the making. JOHANN GUTENBERG was the first to cast me in metal. *From his chance thought straying through an idle reverie—a dream most golden—the profound*

BASKERVILLE BOOK

I am the voice of today, the herald of tomorrow. I am type! Of my earlist ancestry neither history nor relics remain. The wedge-shaped symbols impressed in plastic clay in the dim past by Babylonian builders foresha-dowed me: from them, on through the hieroglyphs of the ancient Egyptians, down to the beautiful manuscript letters of the medieval scribes, I was in the making. JOHANN GUTENBERG was the first to cast me in metal. *From his chance thought straying through an idle reverie—a*

BODONI OLD FACE

I am the voice of today, the herald of tomorrow. I am type! Of my earlist ancestry neither history nor relics remain. The wedge-shaped symbols impressed in plastic clay in the dim past by Babylonian builders foreshadowed me: from them, on through the hieroglyphs of the ancient Egyptians, down to the beautiful manuscript letters of the medieval scribes, I was in the making. JOHANN GUTENBERG was the first to cast me in metal. *From his chance thought straying through an idle reverie—a dream most golden—the pro*

CENTURY EXPANDED

I am the voice of today, the herald of tomorrow. I am type! Of my earlist ancestry neither history nor relics remain. The wedge-shaped symbols impressed in plastic clay in the dim past by Babylonian builders foreshadowed me: from them, on through the hiero-glyphs of the ancient Egyptians, down to the beautiful manuscript letters of the medieval scribes, I was in the making. Johann Gutenberg was the first to cast me in metal. *From his chance thought straying through an idle*

HELVETICA

IBM (TYPEWRITER)

I am the voice of today, the herald of tomorrow. I am type! Of my earliest ancestry neither history nor relics remain. The wedge-shaped symbols impressed in plastic clay in the dim past by Babylonian builders foreshadowed me from them on through the hieroglyphs of the ancient Egyptians, down to the beautiful manuscript letters of the medieval scribes. I was in the making. Johann Gutenberg was the first to cast me in *precious stores of knowledge and wisdom long hidden in the grave of ignorance; I coin for you the enchanting tale, the*

PRESS ROMAN (TIMES ROMAN)

I am the voice of today, the herald of tomorrow. I am type! Of my earliest ancestry neither history nor relics remain. The wedge-shaped symbols impressed in plastic clay in the dim past by Babylonian builders foreshadowed me from them on through the hieroglyphs of the ancient Egyptians, down to the beautiful manuscript letters of the medieval scribes. I was in the making. Johann Gutenberg was the first to cast me in *precious stores of knowledge and wisdom long hidden in the grave of ignorance; I coin for you the enchanting tale, the*

BASKERVILLE

I am the voice of today, the herald of tomorrow. I am type! Of my earliest ancestry neither history nor relics remain. The wedge-shaped symbols impressed in plastic clay in the dim past by Babylonian builders foreshadowed me from them on through the hieroglyphs of the ancient Egyptians, down to the beautiful manuscript letters of the medieval scribes. I was in the making. Johann Gutenberg was the first to cast me in *precious stores of knowledge and wisdom long hidden in the grave of ignorance; I coin for you the enchanting tale, the*

BODONI

I am the voice of today, the herald of tomorrow. I am type! Of my earliest ancestry neither history nor relics remain. The wedge-shaped symbols impressed in plastic clay in the dim past by Babylonian builders foreshadowed me from them on through the hieroglyphs of the ancient Egyptians, down to the beautiful manuscript letters of the medieval scribes. I was *precious stores of knowledge and wisdom long hidden in the grave of ignorance; I coin for you the*

CENTURY EXPANDED

I am the voice of today, the herald of tomorrow. I am type! Of my earliest ancestry neither history nor relics remain. The wedge-shaped symbols impressed in plastic clay in the dim past by Babylonian builders foreshadowed me from them on through the hieroglyphs of the ancient Egyptians, down to the beautiful manuscript letters of the medieval scribes. I was in the making. Johann Gutenberg was the first to cast me in *precious stores of knowledge and wisdom long hidden in the grave of ignorance; I coin for you the enchanting tale, the*

UNIVERS

ITEK (DIGITAL)

I am the voice of today, the herald of tomorrow. I am type! Of my earliest ancestry neither history nor relics remain. The wedge-shaped symbols impressed in plastic clay in the dim past by Babylonian builders foreshadowed me: from them, on through the hiero-glyphs of the ancient Egyptians, down to the beautiful manuscript letters of the medieval scribes, I was in the *making. JOHANN GUTENBERG was the first to cast me in metal. From his chance thought straying through an*

GD (GARAMOND)

I am the voice of today, the herald of tomorrow. I am type! Of my earliest ancestry neither history nor relics remain. The wedge-shaped symbols impressed in plastic clay in the dim past by Babylonian builders foreshadowed me: from them, on through the hiero-glyphs of the ancient Egyptians, down to the beautiful manuscript letters of the medieval scribes, I was in the *making. JOHANN GUTENBERG was the first to cast me in metal. From his chance thought straying through an idle reverie—a*

BK (BASKERVILLE)

I am the voice of today, the herald of tomorrow. I am type! Of my earliest ancestry neither history nor relics remain. The wedge-shaped symbols impressed in plastic clay in the dim past by Babylonian builders foreshadowed me: from them, on through the hieroglyphs of the ancient Egyptians, down to the beautiful manuscript letters of the medieval scribes, I was in the making. JOHANN GUTENBERG *was the first to cast me in metal. From his chance thought straying through an idle reverie—a dream most*

BO (BODONI)

I am the voice of today, the herald of tomorrow. I am type! Of my earliest ancestry neither history nor relics remain. The wedge-shaped symbols impressed in plastic clay in the dim past by Babylonian builders foreshadowed me: from them, on through the hiero-glyphs of the ancient Egyptians, down to the beauti-ful manuscript letters of the medieval scribes, I was *in the making. JOHANN GUTENBERG was the first to cast me in metal. From his chance thought straying*

CE (CENTURY EXPANDED)

I am the voice of today, the herald of tomorrow. I am type! Of my earliest ancestry neither history nor relics remain. The wedge-shaped symbols impressed in plastic clay in the dim past by Babylonian builders foreshadowed me: from them, on through the hiero-glyphs of the ancient Egyptians, down to the beautiful manuscript letters of the medieval scribes, I was in the *making. JOHANN GUTENBERG was the first to cast me in metal. From his chance thought straying through an idle*

HV (HELVETICA)

HARRIS (PHOTO)

I am the voice of today, the herald of tomorrow. I am type! Of my earliest ancestry neither history nor relics remain. The wedge-shaped symbols impressed in plastic clay in the dim past by Babylonian builders foreshadowed me: from them, on through the hieroglyphs of the ancient Egyptians, down to the beautiful manuscript letters of the medieval scribes, I was in the making. JOHANN GUTENBERG was the first to cast me in metal. *From his chance thought straying through an idle reverie–a dream most golden–the profound art of printing with movable types was*

GARAMOND

I am the voice of today, the herald of tomorrow. I am type! Of my earliest ancestry neither history nor relics remain. The wedge-shaped symbols impressed in plastic clay in the dim past by Babylonian builders foreshadowed me: from them, on through the hieroglyphs of the ancient Egyptians, down to the beautiful manuscript letters of the medieval scribes, I was in the making. JO-HANN GUTENBERG *was the first to cast me in metal. From his chance thought straying through an idle reverie–a dream most*

BASKERVILLE

I am the voice of today, the herald of tomorrow. I am type! Of my earliest ancestry neither history nor relics remain. The wedge-shaped symbols impressed in plastic clay in the dim past by Babylonian builders foreshadowed me: from them, on through the hieroglyphs of the ancient Egyptians, down to the beautiful manuscript letters of the medieval scribes, I was in the making. JOHANN GUTENBERG was the *first to cast me in metal. From his chance thought straying through an idle reverie–a dream most golden–the pro-*

BODONI

I am the voice of today, the herald of tomorrow. I am type! Of my earliest ancestry neither history nor relics remain. The wedge-shaped symbols impressed in plastic clay in the dim past by Babylonian ·builders foreshadowed me: from them, on through the hiero-glyphs of the ancient Egyptians, down to the beauti-ful manuscript letters of the medieval scribes, I was *in the making.* JOHANN GUTENBERG *was the first to cast me in metal. From his chance thought straying*

CENTURY EXPANDED

I am the voice of today, the herald of tomorrow. I am type! Of my earliest ancestry neither history nor relics remain. The wedge-shaped symbols im-pressed in plastic clay in the dim past by Babylonian builders foreshadowed me: from them, on through the hieroglyphs of the ancient Egyptians, down to the beautiful manuscript letters of the medieval *scribes, I was in the making.* JOHANN GUTENBERG *was the first to cast me in metal. From his chance*

VEGA (HELVETICA)

LINOTYPE (CAST)

I am the voice of today, the herald of tomorrow. I am type! Of my earliest ancestry neither history nor relics remain. The wedge-shaped symbols impressed in plastic clay in the dim past by Babylonian builders foreshadowed me: from them, on through the hieroglyphs of the ancient Egyptians, down to the beautiful manuscript letters of the medieval scribes, I was in the making. JOHANN GUTENBERG was the first to cast me in metal. *From his chance thought straying through an idle rev-erie—a dream most golden—the profound art of printing*

GARAMOND #3

I am the voice of today, the herald of tomorrow. I am type! Of my earliest ancestry neither history nor relics remain. The wedge-shaped symbols impressed in plastic clay in the dim past by Babylonian builders foreshad-owed me: from them, on through the hieroglyphs of the ancient Egyptians, down to the beautiful manuscipt let-ters of the medieval scribes, I was in the making. JOHANN GUTENBERG *was the first to cast me in metal. From his chance thought straying through an idle reverie—a*

BASKERVILLE

I am the voice of today, the herald of tomorrow. I am type! Of my earliest ancestry neither history nor relics remain. The wedge-shaped symbols impressed in plas-tic clay in the dim past by Babylonian builders fore-shadowed me: from them, on through the hieroglyphs of the ancient Egyptians, down to the beautiful manu-script letters of the medieval scribes, I was in the mak-*ing.* JOHANN GUTENBERG *was the first to cast me in met-al. From his chance thought straying through an idle*

BODONI

I am the voice of today, the herald of tomorrow. I am type! Of my earliest ancestry neither history nor relics remain. The wedge-shaped symbols im-pressed in plastic clay in the dim past by Babylonian builders foreshadowed me: from them, on through the hieroglyphs of the ancient Egyptians, down to the beautiful manuscript letters of the medieval *scribes, I was in the making.* JOHANN GUTENBERG *was the first to cast me in metal. From his chance*

CENTURY EXPANDED

I am the voice of today, the herald of tomorrow. I am type! Of my earliest ancestry neither history nor rel-ics remain. The wedge-shaped symbols impressed in plastic clay in the dim past by Babylonian builders foreshadowed me: from them, on through the hiero-glyphs of the ancient Egyptians, down to the beauti-ful manuscript letters of the medieval scribes, I was *in the making. Johann Gutenberg was the first to cast me in metal. From his chance thought straying*

HELVETICA

LINOTYPE (PHOTO)

I am the voice of today, the herald of tomorrow. I am type! Of my earliest ancestry neither history nor relics remain. The wedge-shaped symbols impressed in plastic clay in the dim past by Babylonian builders foreshadowed me: from them, on through the hieroglyphs of the ancient Egyptians, down to the beautiful manuscript letters of the medieval scribes, I was in the making. Johann Gutenberg was the first to cast me in metal. *From his chance thought straying through an idle reverie–a dream most golden–the profound art of printing with movable types was born.*

GARAMOND #3

I am the voice of today, the herald of tomorrow. I am type! Of my earliest ancestry neither history nor relics remain. The wedge-shaped symbols impressed in plastic clay in the dim past by Babylonian builders foreshadowed me: from them, on through the hieroglyphs of the ancient Egyptians, down to the beautiful manuscript letters of the medieval scribes, I was in the *making. Johann Gutenberg was the first to cast me in metal. From his chance thought straying through an idle reverie–a*

BASKERVILLE

I am the voice of today, the herald of tomorrow. I am type! Of my earliest ancestry neither history nor relics remain. The wedge-shaped symbols impressed in plastic clay in the dim past by Babylonian builders foreshadowed me: from them, on through the hieroglyphs of the ancient Egyptians, down to the beautiful manuscript letters of the medieval scribes, I was in the making. Johann Gutenberg *was the first to cast me in metal. From his chance thought straying through an idle reverie—a dream most golden*

BODONI

I am the voice of today, the herald of tomorrow. I am type! Of my earliest ancestry neither history nor relics remain. The wedge-shaped symbols impressed in plastic clay in the dim past by Babylonian builders foreshadowed me: from them, on through the hieroglyphs of the ancient Egyptians, down to the beautiful manuscript letters of the medieval scribes, I was in the *making. Johann Gutenberg was the first to cast me in metal. From his chance thought straying through an*

CENTURY EXPANDED

I am the voice of today, the herald of tomorrow. I am type! Of my earliest ancestry neither history nor relics remain. The wedge-shaped symbols impressed in plastic clay in the dim past by Babylonian builders foreshadowed me: from them, on through the hieroglyphs of the ancient Egyptians, down to the beautiful manuscript letters of the medieval scribes, I was in the *making. Johann Gutenberg was the first to cast me in metal. From his chance thought straying through an*

HELVETICA

LINOTYPE (DIGITAL)

I am the voice of today, the herald of tomorrow. I am type! Of my earliest ancestry neither history nor relics remain. The wedge-shaped symbols impressed in plastic clay in the dim past by Babylonian builders foreshadowed me: from them, on through the hieroglyphs of the ancient Egyptians, down to the beautiful manuscript letters of the medieval scribes, I was in the making. Johann Gutenberg was the first to cast me in *metal. From his chance thought straying through an idle reverie—a dream most golden—the profound art of printing with movable types*

GARAMOND #3

I am the voice of today, the herald of tomorrow. I am type! Of my earliest ancestry neither history nor relics remain. The wedge-shaped symbols impressed in plastic clay in the dim past by Babylonian builders foreshadowed me: from them, on through the hieroglyphs of the ancient Egyptians, down to the beautiful manuscript letters of the medieval scribes, I was in the making. Johann Gutenberg was the first to cast me in *metal. From his chance thought straying through an idle reverie—a*

BASKERVILLE

I am the voice of today, the herald of tomorrow. I am type! Of my earliest ancestry neither history nor relics remain. The wedge-shaped symbols impressed in plastic clay in the dim past by Babylonian builders foreshadowed me: from them, on through the hieroglyphs of the ancient Egyptians, down to the beautiful manuscript letters of the medieval scribes, I was in the making. Johann Gutenberg was the first to cast me in metal. From his *chance thought straying through an idle reverie—a*

BODONI

I am the voice of today, the herald of tomorrow. I am type! Of my earliest ancestry neither history nor relics remain. The wedge-shaped symbols impressed in plastic clay in the dim past by Babylonian builders foreshadowed me: from them, on through the hieroglyphs of the ancient Egyptians, down to the beautiful manuscript letters of the medieval scribes, I was in the making. Johann Gutenberg was the first to cast me in *metal. From his chance thought straying through an*

CENTURY EXPANDED

I am the voice of today, the herald of tomorrow. I am type! Of my earliest ancestry neither history nor relics remain. The wedge-shaped symbols impressed in plastic clay in the dim past by Babylonian builders foreshadowed me: from them, on through the hieroglyphs of the ancient Egyptians, down to the beautiful manuscript letters of the medieval scribes, I was in the making. Johann Gutenberg was the first to cast me in *metal. From his chance thought straying through an*

HELVETICA

MONOTYPE (CAST)

I am the voice of today, the herald of tomorrow. I am type! Of my earliest ancestry neither history nor relics remain. The wedge-shaped symbols impressed in plastic clay in the dim past by Babylonian builders foreshadowed me: from them, on through the hieroglyphs of the ancient Egyptians, down to the beautiful manuscript letters of the medieval scribes, I was in the making. JOHANN GUTENBERG was the *first to cast me in metal. From his chance thought straying through an idle reverie – a dream most golden – the profound art of printing*

GARAMOND

I am the voice of today, the herald of tomorrow. I am type! Of my earliest ancestry neither history nor relics remain. The wedge-shaped symbols impressed in plastic clay in the dim past by Babylonian builders foreshadowed me: from them, on through the hieroglyphs of the ancient Egyptians, down to the beautiful manuscript letters of the medieval scribes, I was in the making. JOHANN GUTENBERG *was the first to cast me in metal. From his chance thought straying through an idle reverie – a dream most golden – the profound art*

BASKERVILLE

I am the voice of today, the herald of tomorrow. I am type! Of my earliest ancestry neither history nor relics remain. The wedge-shaped symbols impressed in plastic clay in the dim past by Babylonian builders foreshadowed me: from them, on through the hieroglyphs of the ancient Egyptians, down to the beautiful manuscript letters of the medieval scribes, I was in the making. JOHANN GUTENBERG was the *first to cast me in metal. From his chance thought straying through an idle reverie – a dream most golden – the profound*

BODONI

I am the voice of today, the herald of tomorrow. I am type! Of my earliest ancestry neither history nor relics remain. The wedge-shaped symbols impressed in plastic clay in the dim past by Babylonian builders foreshadowed me: from them, on through the hieroglyphs of the ancient Egyptians, down to the beautiful manuscript letters of the medieval scribes, I was *in the making. JOHANN GUTENBERG was the first to cast me in metal. From his chance thought straying*

CENTURY EXPANDED

I am the voice of today, the herald of tomorrow. I am type! Of my earliest ancestry neither history nor relics remain. The wedge-shaped symbols impressed in plastic clay in the dim past by Babylonian builders foreshadowed me: from them, on through the hieroglyphs of the ancient Egyptians, down to the beautiful manuscript letters of the medieval scribes, I was in the *making. Johann Gutenberg was the first to cast me in metal. From his chance thought straying through an idle*

HELVETICA

MONOTYPE (PHOTO)

I am the voice of today, the herald of tomorrow. I am type! Of my earliest ancestry neither history nor relics remain. The wedge-shaped symbols impressed in plastic clay in the dim past by Babylonian builders foreshadowed me: from them, on through the hieroglyphs of the ancient Egyptians, down to the beautiful manuscript letters of the medieval scribes, I was in the making. JOHANN GUTENBERG was the *first to cast me in metal. From his chance thought straying through an idle reverie – a dream most golden – the profound art of printing*

GARAMOND

I am the voice of today, the herald of tomorrow. I am type! Of my earliest ancestry neither history nor relics remain. The wedge-shaped symbols impressed in plastic clay in the dim past by Babylonian builders foreshadowed me: from them, on through the hieroglyphs of the ancient Egyptians, down to the beautiful manuscript letters of the medieval scribes, I was in the making. JOHANN GUTENBERG *was the first to cast me in metal. From his chance thought straying through an idle reverie – a dream most golden – the profound art*

BASKERVILLE

I am the voice of today, the herald of tomorrow. I am type! Of my earliest ancestry neither history nor relics remain. The wedge-shaped symbols impressed in plastic clay in the dim past by Babylonian builders foreshadowed me: from them, on through the hieroglyphs of the ancient Egyptians, down to the beautiful manuscript letters of the medieval scribes, I was in the making. JOHANN GUTENBERG was the *first to cast me in metal. From his chance thought straying through an idle reverie – a dream most golden – the profound*

BODONI

I am the voice of today, the herald of tomorrow. I am type! Of my earliest ancestry neither history nor relics remain. The wedge-shaped symbols impressed in plastic clay in the dim past by Babylonian builders foreshadowed me: from them, on through the hieroglyphs of the ancient Egyptians, down to the beautiful manuscript letters of the medieval scribes, I was *in the making. JOHANN GUTENBERG was the first to cast me in metal. From his chance thought straying*

CENTURY EXPANDED

I am the voice of today, the herald of tomorrow. I am type! Of my earliest ancestry neither history nor relics remain. The wedge-shaped symbols impressed in plastic clay in the dim past by Babylonian builders foreshadowed me: from them, on through the hieroglyphs of the ancient Egyptians, down to the beautiful manuscript letters of the medieval scribes, I was in *the making. Johann Gutenberg was the first to cast me in metal. From his chance thought straying through*

HELVETICA

MONOTYPE (DIGITAL)

I am the voice of today, the herald of tomorrow. I am type! Of my earliest ancestry neither history nor relics remain. The wedge-shaped symbols impressed in plastic clay in the dim past by Babylonian builders foreshadowed me: from them, on through the hieroglyphs of the ancient Egyptians, down to the beautiful manuscript letters of the medieval scribes, I was in the making. JOHANN GUTENBURG was the first to cast me in metal. *From his chance thought straying through an idle reverie – a dream most golden – the profound art of printing*

GARAMOND

I am the voice of today, the herald of tomorrow. I am type! Of my earliest ancestry neither history nor relics remain. The wedge-shaped symbols impressed in plastic clay in the dim past by Babylonian builders foreshadowed me: from them, on through the hieroglyphs of the ancient Egyptians, down to the beautiful manuscript letters of the medieval scribes, I was in the making. JOHANN GUTENBURG was the *first to cast me in metal. From his chance thought straying through an idle reverie – a dream most golden – the profound art of printing*

BASKERVILLE

I am the voice of today, the herald of tomorrow. I am type! Of my earliest ancestry neither history nor relics remain. The wedge-shaped symbols impressed in plastic clay in the dim past by Babylonian builders foreshadowed me: from them, on through the hieroglyphs of the ancient Egyptians, down to the beautiful manuscript letters of the medieval scribes, I was in the making. JOHANN GUTENBURG was the *first to cast me in metal. From his chance thought straying through an idle reverie – a dream most golden – the profound*

BODONI

I am the voice of today, the herald of tomorrow. I am type! Of my earliest ancestry neither history nor relics remain. The wedge-shaped symbols impressed in plastic clay in the dim past by Babylonian builders foreshadowed me: from them, on through the hieroglyphs of the ancient Egyptians, down to the beautiful manuscript letters of the medieval scribes, I was *in the making.* JOHANN GUTENBURG *was the first to cast me in metal. From his chance thought straying*

CENTURY EXPANDED

I am the voice of today, the herald of tomorrow. I am type! Of my earliest ancestry neither history nor relics remain. The wedge-shaped symbols impressed in plastic clay in the dim past by Babylonian builders foreshadowed me: from them, on through the hieroglyphs of the ancient Egyptians, down to the beautiful manuscript letters of the medieval scribes, I was in the *making. Johann Gutenburg was the first to cast me in metal. From his chance thought straying through an idle*

HELVETICA

PHOTON (PHOTO)

I am the voice of today, the herald of tommorrow. I am type! Of my earliest ancestry neither history nor relics remain. The wedge-shaped symbols impressed in plastic clay in the dim past by Babylonian builders foreshadowed me: from them, on through the hieroglyphs of the ancient Egyptians, down to the beautiful manuscript letters of the medieval scribes, I was in the making. Johann Gutenberg was the first to cast me in metal. From his *chance thought straying through an idle reverie—a dream most golden—the profound art of printing with movable types was*

GARAMOND

I am the voice of today, the herald of tomorrow. I am type! Of my earliest ancestry neither history nor relics remain. The wedge-shaped symbols impressed in plastic clay in the dim past by Babylonian builders foreshadowed me: from them, on through the hieroglyphs of the ancient Egyptians, down to the beautiful manuscript letters of the medieval scribes, I was in the making. Johann *Gutenberg was the first to cast me in metal. From his chance thought straying through an idle reverie - a dream most though*

BASKERVILLE

I am the voice of today, the herald of tommorrow. I am type! Of my earliest ancestry neither history nor relics remain. The wedge-shaped symbols impressed in plastic clay in the dim past by Babylonian builders foreshadowed me: from them, on through the hieroglyphs of the ancient Egyptians, down to the beautiful manuscript letters of the medieval scribes, I was in the making. Johann Gutenberg *was the first to cast me in metal. From his chance thought straying through an idle reverie - a dream straying thro*

BODONI

I am the voice of today, the herald of tomorrow. I am type! Of my earliest ancestry neither history nor relics remain. The wedge-shaped symbols impressed in plastic clay in the dim past by Babylonian builders foreshadowed me: from them, on through the hieroglyphs of the ancient Egyptians, down to the beautiful manuscript letters of the medieval scribes, *I was in the making. Johann Gutenberg was the first to cast me in metal. From his chance thought straying*

CENTURY SCHOOLBOOK 455

I am the voice of today, the herald of tomorrow. I am type! Of my earliest ancestry neither history nor relics remain. The wedge-shaped symbols impressed in plastic clay in the dim past by Babylonian builders foreshadowed me: from them, on through the hieroglyphs of the ancient Egyptians, down to the beautiful manuscript letters of the medieval scribes, I *was in the making. Johann Gutenberg was the first to cast me in metal. From his chance thought straying*

NEWTON MEDIUM 597

VARITYPER (TYPEWRITER)

I am the voice of today, the herald of tomorrow. I am type! Of my earliest ancestry neither history nor relics remain. The wedge-shaped symbols impressed in plastic clay in the dim past by Babylonian builders foreshadowed me: from them, on through the hieroglyphs of the ancient Egyptians, down to the beautiful manuscript letters of the medieval scribes, I was in the making. *Johann Guttenberg was the first to cast me in metal. From his chance thought straying through an idle rev-*

GARAMOND

I am the voice of today, the herald of tomorrow. I am type! Of my earliest ancestry neither history nor relics remain. The wedge-shaped symbols impressed in plastic clay in the dim past by Babylonian builders foreshadowed me: from them, on through the hieroglyphs of the ancient Egyptians, down to the beautiful manuscript letters of the medieval scribes, I was in the making. *Johann Guttenberg was the first to cast me in metal. From his chance thought straying through an idle rev-*

BASKERVILLE

I am the voice of today, the herald of tomorrow. I am type! Of my earliest ancestry neither history nor relics remain. The wedge-shaped symbols impressed in plastic clay in the dim past by Babylonian builders foreshadowed me: from them, on through the hieroglyphs of the ancient Egyptians, down to the beautiful manuscript letters of the medieval scribes, I was in the making. *Johann Guttenberg was the first to cast me in metal. From his chance thought straying through an idle rev-*

BODONI

I am the voice of today, the herald of tomorrow. I am type! Of my earliest ancestry neither history nor relics remain. The wedge-shaped symbols impressed in plastic clay in the dim past by Babylonian builders foreshadowed me: from them, on through the hieroglyphs of the ancient Egyptians, down to the beautiful manuscript letters of the medieval scribes, I was in the making. *Johann Guttenberg was the first to cast me in metal. From his chance thought straying through an idle rev-*

SCHOOLBOOK

I am the voice of today, the herald of tomorrow. I am type! Of my earliest ancestry neither history nor relics remain. The wedge-shaped symbols impressed in plastic clay in the dim past by Babylonian builders foreshadowed me: from them, on through the hieroglyphs of the ancient Egyptians, down to the beautiful manuscript letters of the medieval scribes, I was in the making. *Johann Guttenberg was the first to cast me in metal. From his*

MEGARON MEDIUM

VARITYPE (DIGITAL)

I am the voice of today, the herald of tomorrow. I am type! Of my earliest ancestry neither history nor relics remain. The wedge-shaped symbols impressed in plastic clay in the dim past by Babylonian builders foreshadowed me: from them, on through the hieroglyphs of the ancient Egyptians, down to the beautiful manuscript letters of the medieval scribes, I was in the making. *Johann Gutenberg was the first to cast me in metal. From his chance thought straying through an idle reverie—a dream most*

GARAMOND

I am the voice of today, the herald of tomorrow. I am type! Of my earliest ancestry neither history nor relics remain. The wedge-shaped symbols impressed in plastic clay in the dim past by Babylonian builders foreshadowed me: from them, on through the hieroglyphs of the ancient Egyptians, down to the beautiful manuscript letters of the medieval scribes, I was in *the making. Johann Gutenberg was the first to cast me in metal. From his chance thought straying*

BASKERVILLE

I am the voice of today, the herald of tomorrow. I am type! Of my earliest ancestry neither history nor relics remain. The wedge-shaped symbols impressed in plastic clay in the dim past by Babylonian builders foreshadowed me: from them, on through the hieroglyphs of the ancient Egyptians, down to the beautiful manuscript letters of the medieval scribes, I was *in the making. Johann Gutenberg was the first to cast me in metal. From his chance thought straying*

BODONI

I am the voice of today, the herald of tomorrow. I am type! Of my earliest ancestry neither history nor relics remain. The wedge-shaped symbols impressed in plastic clay in the dim past by Babylonian builders foreshadowed me: from them, on through the hieroglyphs of the ancient Egyptians, down to the beautiful manuscript letters of the *medieval scribes, I was in the making. Johann Gutenberg was the first to cast me in metal. From*

CENTURY EXPANDED

I am the voice of today, the herald of tomorrow. I am type! Of my earliest ancestry neither history nor relics remain. The wedge-shaped symbols impressed in plastic clay in the dim past by Babylonian builders foreshadowed me: from them, on through the hieroglyphs of the ancient Egyptians, down to the beautiful manuscript letters of the med*ieval scribes, I was in the making. Johann Gutenberg was the first to cast me in metal. From his*

ARISTOCRAT

Cross Reference Chart

COMMERCIAL TYPEFACES	AGFA COMPUGRAPHIC	ALPHATYPE	BERTHOLD	HARRIS	ITEK	LINOTYPE	MONOTYPE	PHOTON	VARITYPER
BASKERVILLE	BASKERVILLE	BASKERLINE	BASKERVILLE	BASKERVILLE	BK	BASKERVILLE	BASKERVILLE	BASKERVILLE	BASKERVILLE
BODONI	BODONI	BODONI	BODONI	BODONI	BO	BODONI	BODONI	BODONI	BODONI
CALEDONIA	CG CALIFORNIA	CALEDO	CALEDONIA	LAUREL	CD	CALEDONIA	CALEDONIA	HIGHLAND	HIGHLAND
CASLON	CASLON	CASLON 74	CASLON	CASLON	CL	CASLON	CASLON	CASLON	CASLON
CENTURY EXPANDED	CENTURY EXP.	CENTURY X	CENTURY EXP.	CENTURY EXP.	CE	CENTURY EXP.	CENTURY EXP.	CENTURY EXP.	CENTURY EXP.
CENTURY SCHOOLBOOK	CENTURY SCHOOLBOOK	CENTURY TEXT	CENTURY SCHOOLBOOK	CENTURY SCHOOLBOOK	CS	CENTURY SCHOOLBOOK	CENTURY SCHOOLBOOK	CENTURY SCHOOLBOOK	SCHOOLBOOK
CLARENDON	CLARENDON	CLARENDON	CLARENDON	CLARIQUE	CN	CLARENDON	CLARENDON	CLARENDON	CLARENDON
COPPERPLATE	COPPERPLATE	COPPERPLATE GOTHIC	COPPERPLATE GOTHIC	GOTHIC NO. 31	CO	COPPERPLATE	COPPERPLATE GOTHIC	COPPERPLATE GOTHIC	COPPERPLATE
FUTURA BOOK	FUTURA BOOK	ALPHATURA BOOK	FUTURA BOOK	FUTURA BOOK	FU45	SPARTAN BOOK	FUTURA BOOK	PHOTURA BOOK	FUTURA BOOK
FUTURA LIGHT	FUTURA LIGHT	ALPHATURA LIGHT	FUTURA LIGHT	FUTURA LIGHT	FU35	SPARTAN LIGHT	FUTURA LIGHT	TECHNO LIGHT	FUTURA LIGHT
FUTURA MEDIUM	FUTURA MEDIUM	ALPHATURA MEDIUM	FUTURA MEDIUM	FUTURA MEDIUM	FU55	SPARTAN MEDIUM	FUTURA MEDIUM	TECHNO MED.	FUTURA MEDIUM
FUTURA BOLD	FUTURA BOLD	ALPHATURA BOLD	FUTURA BOLD	FUTURA BOLD	FU75	SPARTAN BLACK	FUTURA BOLD	TECHNO BOLD	FUTURA BOLD
GALLIARD	GALLIARD	GALLIARD	GALLIARD		GL	GALLIARD	GALLIARD		GALLIARD
GARAMOND	GARAMOND	NEW GARAMOND	GARAMOND	GARAMOND	GD	GARAMOND	GARAMOND	GARAMOND	GARAMOND
HELVETICA	CG TRIUMVIRATE™	CLARO	HELVETICA	VEGA	HV	HELVETICA	HELVETICA	NEWTON	ARISTOCRAT
MELIOR	CG MELLIZA	URANUS	MELIOR	MEDALLION	ME	MELIOR	MELIOR	BALLARDVALE	HANOVER
NEWS GOTHIC	NEWS GOTHIC	NEWS GOTHIC	NEWS GOTHIC	NEWS GOTHIC	NG	TRADE GOTHIC	NEWS GOTHIC	NEWS GOTHIC	NEWS GOTHIC
OPTIMA	CG OMEGA	MUSICA	OPTIMA	ZENITH	OP	OPTIMA	OPTIMA	CHELMSFORD	CHELMSFORD
PALATINO	CG PALACIO	PATINA	PALATINO	ELEGANTE	PT	PALATINO	PALATINO	ANDOVER	ANDOVER
STYMIE	STYMIE	STYMIE	ROCKWELL	CAIRO	ST	MEMPHIS	ROCKWELL	STYMIE	STYMIE
TIMES ROMAN	TIMES NEW ROMAN®	NEW ENGLISH	TIMES ROMAN	TIMES ROMAN	TS	TIMES ROMAN	TIMES NEW ROMAN	TIMES NEW ROMAN	TIMES ROMAN
UNIVERS	UNIVERS	VERSATILE	UNIVERS	GALAXY	US	UNIVERS	UNIVERS	UNIVERS	UNIVERS

NEWSPAPER TYPEFACES

COMMERCIAL TYPEFACES	AGFA COMPUGRAPHIC	ALPHATYPE	BERTHOLD	HARRIS	ITEK	LINOTYPE	MONOTYPE	PHOTON	VARITYPER
AURORA	NEWS NO. 2		A.G.	REGAL		AURORA		GROTESQUE COND.	EMPIRA
CORONA	NEWS NO. 3		A.G.	ROYAL	CR	CORONA	CORONA	CROWN	CROWN
IMPERIAL	NEWS NO. 2		A.G.	IMPERIAL			IMPERIAL	BEDFORD	
REGAL				REGAL	RG			EMPIRA	EMPIRA
ROYAL				ROYAL			CLARION		
EXCELSIOR	NEWS NO. 14	LEAGUE TEXT		REGAL BERLIN	EX	EXCELSIOR	EXCELSIOR	EXCELLA	CAMELOT
IONIC		NEWS TEXT MEDIUM		IONIC NO. 5	IC	IONIC NO. 5	IONIC	DORIC	
REX	NEWS NO. 10		BODONI BOLD	REX				ZAH	
SPARTAN BOOK/AGATE	SANS NO. 2	ALPHATURA BOOK	FUTURA COND.	FUTURA	FU45	SPARTAN BOOK	20TH CENT. BOOK	TECHNO BOOK	
BODONI BOLD	BODONI BOLD		BODONI BOLD	BODONI BOLD	BO65	BODONI BOLD	BODONI BOLD	BODONI BOLD	BODONI BOLD
FUTURA CONDENSED	FUTURA COND.		FUTURA COND. BOOK	FUTURA COND. BOOK	FU57	SPARTAN BOOK COND.	FUTURA COND.	TECHNO MED. COND.	FUTURA CONDENSED

Note: Listed above are the family names of typefaces. To find a specific style or version of typeface, the designer should obtain a type specimen book from a typographer or manufacturer.

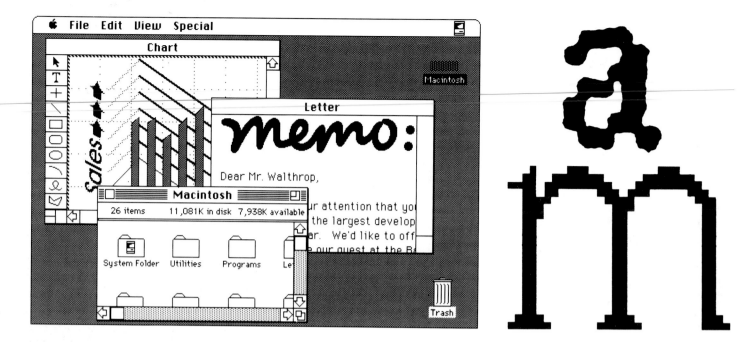

PageMaker

QuarkXPress

Aldus FreeHand

Adobe
Illustrator 88

Microsoft Word

PixelPaint

Digital
Darkroom

HyperCa

Adobe Fonts Bitstream Fonts LetraStudio Super 3D Swivel 3D

3M
3.5, DS, HD
double side
high density
2.0 MB
HD

300dpi

400dpi

2540dpi

dus Persuasion

OmniPage

Desktop Publishing

Desktop publishing, or electronic publishing, has added a dramatic new dimension to graphic design. This innovation has given the designer a freedom never before experienced: the ability to create and manipulate design elements with unforeseen speed and ease.

No longer is the designer totally dependent on the schedule and skills of typesetters, photostat operators, paste-up personnel, and others whose efforts were necessary in the creation of a design. Now, with a relatively inexpensive desktop-publishing system, the designer can perform all these tasks while seated at a computer terminal.

This section will serve as an introduction to desktop publishing. It will help the designer understand the basic principles involved in this rapidly expanding technology. Only by hands-on experience can the designer fully understand and appreciate the potential of desktop publishing.

With desktop publishing comes an entirely new vocabulary: bits, bytes, pixels, floppies, jaggies, raster, bitmaps, ROM, RAM, to name but a few.

The Basic System

In 1982 John Warnock and Charles Geschke left the Xerox Imaging Center in Palo Alto, California, and developed a standard language that computers could use for communicating visual information —Adobe PostScript. Using this technology, Apple Computers, Inc., introduced the PostScript LaserWriter, and desktop publishing was born.

Since that time the only constant in the industry has been change and growth: every month sees a new development or innovation, and the end is nowhere in sight. In spite of this, it is possible to describe a typical system while making allowances for future innovations.

Desktop-publishing systems can be broken down into two major components: *hardware* and *software*. Hardware, which refers to the equipment itself, includes a *keyboard*, *monitor*, *central processing unit* (CPU), and optional peripheral devices such as a *scanner* and *printer*.

Software refers to the operating system's programming and the various programs, called *applications*, which are stored on disks.

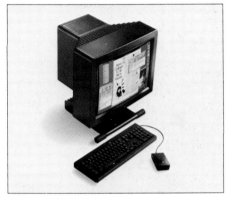

The NeXT™ computer.

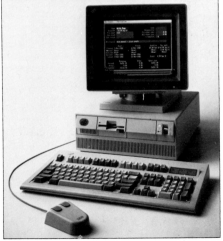

The IBM®.

Keyboard. The keyboard is used to input copy and as a means of "talking" to the system. In addition to the keyboard is an accessory, called a *mouse*, that both speeds up the design process and eliminates keystroke commands. By clicking the mouse buttons or moving the mouse across a flat surface, the operator is able to call up programs, commands, select typefaces, reduce or enlarge design elements, and position copy. (Not all systems use a mouse; in addition to, or in place of, the mouse are joysticks, tracking balls, wands, and pucks.)

Monitor. The monitor, or screen, is a video display terminal similar to a television screen that permits the operator to see the design as it develops. For the designer, this screen is the *desktop* or working environment where documents and files are organized, managed, and the design is viewed. (The fact that the system sits on a desktop is fortuitous.)

The image on the screen is created by an electronic beam that moves rapidly line by line across the inside of the picture tube, beginning at the upper left and ending at the lower right. As the beam scans, it illuminates the tiny dots that make up each line. The dots are called *picture elements*, or *pixels*. The more dots per line, the higher the resolution, but the slower the scanning process.

Most screens are low resolution, approximately 72 dpi (dots per inch); a typical 9-inch screen has 175,104 dots (512 across by 342 down). The advantage of low-resolution screens is that images can be called up and manipulated rapidly. The disadvantage is that with so few dots, or pixels, it is difficult to render small, curved images, such as type, without getting a step effect or "jaggies." (This is not the case with high-resolution screens.)

Monitors are available for viewing images in monochrome, gray scale, and full color. The monochrome monitor displays the image in a single color, usually black and white, and is the least expensive. The gray scale monitor generates 256 shades of gray, making it particularly useful when working with photographs. Full-color monitors are the most expensive, with the color quality determined by the number of bits. An 8-bit monitor can generate 256 colors, which is adequate for general color editing; 24- and 32-bit monitors are capable of displaying millions of colors,

enough to reproduce virtually every color in a full-color image.

The size of the screen varies, with the most popular sizes ranging from 9 to 24 inches. Screens can be either horizontal, ideal for spreads, or vertical, designed to accommodate a full page.

Central Processing Unit. The central processing unit, or CPU, is the heart and brains of the system, responsible for all the processing and accessing of data. It is made up of three major components: the *operating system*, *disk drive*, and *microprocessor*.

The operating system (which is low-level software) controls most of the computer's basic chores, such as moving data and managing memory. The system's software is continually updated by the manufacturer and assigned a new version number. Popular systems are the Macintosh Operating System, Microsoft Disk Operating System (MS/DOS), UNIX, DOS-Windows 3.0, and OS/2.

The disk drive records, retrieves, and stores information on either portable 3.5- or 5.25-inch floppy disks or on internal hard disks for greater storage capacity and faster access. For still greater storage, some systems can accommodate compact disks and optical disks (see page 62). Storage is measured in megabytes (MB).

The microprocessor is made up of integrated circuits, or chips, designed to carry out software instructions. The speed and power of the microprocessor is measured in bits and megahertz (MHz).

The entire system operates on two types of memory: *ROM* (read-only memory) and *RAM* (random-access memory). ROM is the permanent memory that "reads" the various programs and other data for the design process and the storage of information for future use. Information in ROM is permanent and does not vanish when the system is turned off.

RAM, on the other hand, stores information temporarily while the designer is working on a specific project. Switch off the computer and the information in RAM disappears. To save data, RAM has to be transferred and stored on a disk. *Simply stated, ROM is storage memory and RAM is working memory.*

All memory is measured in kilobytes (K), megabytes (M), and gigabytes (G). The greater the memory, the greater the design possibilities.

Scanner. The scanner is like an electronic photocopier that converts images into digital data. The image to be scanned is placed on a glass platen as with a photocopier. The laser reads the image and records it electronically as rows of dots. The more rows, the smaller the dots, and the finer the image. Scanned images can be reduced or enlarged to fit a desired space or manipulated to create special effects.

Some scanners accommodate only line copy while others are capable of scanning continuous-tone copy, black and white and color. With additional software some scanners can function as an OCR (optical character recognition) device capable of reading both type-written and typeset copy.

Printer. The printer generates hard-copy through the use of a RIP (raster image processor), which recreates the image by converting the digital data into row upon row of tiny dots. At the low end of the scale are the dot-matrix printers, which are the fastest but least refined, out-putting images at 40 to 100 dpi. Laser printers, while slower, produce relatively high-quality images at 300 to 1,000 dpi.

At the top end are the high-resolution printers employed by typographers and service bureaus capable of generating images at up to 2,540 dpi. There are also film-output printers available with resolutions up to 8,000 dpi. These are particularly popular with designers working on 35mm slide projects.

Printers are available for both black-and-white and color output.

Macintosh® Apple® scanner.

HP LaserJet Series III printer.

Macintosh® IIfx with keyboard, mouse, and monitor.

Programs. Software programs, called *applications*, are stored on floppy disks and perform specific tasks. There are literally thousands of programs created for every purpose from word processing, design, illustration, page makeup, slide presentation, animation, video generation to accounting.

It is with this language that the program digitally constructs the designer's layout on the output device: the monitor, printer, or other peripheral. It does this by organizing all the design data into a continuous flow of off/on commands, which in turn builds the design by laying down a pattern of dots.

Programs are written in one of a number of computer languages (*page description languages* or *PDL*). For a system to work properly, all components must understand the same language. For example, a program written in Adobe PostScript should output to a device that can interpret the Adobe PostScript language. (Some software companies have written programs that run on different computer systems and are able to share documents and files with one another.)

Programs are generally quite expensive and can be accidentally erased or damaged. To avert such a disaster the designer will "install" the data onto the internal hard disk for storage and retrieval and make a backup disk. If the system does not have a hard disk storage, a duplicate disk is made and stored.

Note: Programs are frequently updated and renumbered by the manufacturer. These updates are available from the software companies often at a fraction of the cost of the new program.

A few of the software programs, or applications, used by graphic designers.

ANALOG VS. DIGITAL

In order to understand desktop publishing—and the latest technologies in imaging, typesetting, printing, thermofaxing, and high-definition television—it is a good idea to begin with basic principles underlying these technologies.

It has been said that we are analog people living in a digital world. In an analog world things are as they seem: one is one, two is two, and eight is eight. A line drawing, a printed page, and a photograph are just as they appear. In a digital world these images are reduced electronically to dots and the information concerning the arrangements of these dots is stored in a computer.

From analog to digital: the quality of the reproduction is determined by the size of the type and the resolution (dots per inch). The higher the resolution, the finer the image.

Bits, Bytes, Binary, and Pixels.

Anything made up of two units or parts may be referred to as *binary*, thus digital computers, which turn the complexity of the real world into a code based on the numbers 0 and 1, are binary.

Binary digits are usually referred to as *bits*. These can be either 1 or 0 and are the smallest units of information a computer can hold. Bits, when grouped, are called *bytes*. All images, including type, can be reduced electronically to bits and bytes.

Bits can be in only one of two states, either off or on, very much like a light switch. By turning bits off and on a digital image, made up of thousands of tiny dots (called *picture elements*, or *pixels*), is created on the viewing screen.

Bits, being such small units of digital information, are not practical for expressing the power of a computer's memory or disk storage capacity. Instead the following terms are employed:

Byte. A group of bits treated as a single entity. A byte can represent any value between 0 and 255. Bytes composed of 8, 16, 24, and 32 bits are most common.

Kilobyte. 1,024 bytes, often abbreviated as *KB* or simply *K*. As a rough rule of thumb, 1KB is the equivalent of approximately 1,000 characters.

Megabyte. 1,024 kilobytes, often abbreviated as *MB* or simply *M*. Megabytes are also used to specify the capacity of a computer's memory. A thousand pages of double-spaced typewritten copy requires approximately 1 MB of storage.

Gigabyte. 1,024 Megabytes, often abbreviated as *GB* or simply *G*.

The advantages of digitizing the world around us are numerous. While analog images are fixed and allow for little manipulation beyond enlarging and reducing, digital information has no limits. Not only can digital images (type and illustrations) be reduced and enlarged, but they can be rotated, outlined drop shadowed, reversed, italicized, expanded, condensed, wrapped around curved objects, waved like a flag, colors changed and transmitted all over the world in a matter of seconds.

In short, digitizing offers the designer unlimited freedom to create, reproduce, and disseminate designs that would have been impossible a few years ago.

The Design Process

Desktop publishing has dramatically altered the design process and the designer's role. Today, designers are becoming a combination of artist and technician as they control the job from concept to finished piece, free from many tedious tasks and outside services.

Desktop publishing, however, has also placed many additional burdens on the designer. Some designers have found themselves more involved in editorial implementation and mundane production tasks that normally would have been handled by others. Since it is more efficient for designers to input simple text themselves, they may find it useful, or even necessary, to acquire basic typing skills.

The design process can be seen as four distinct functions: *input*, *design and layout*, *output*, and *storage*.

Note: Not all manufacturers use the same terminology; while terms may vary, the principles remain the same.

INPUT

All jobs begin with the input of copy and images to be stored in the computer memory. How this is accomplished depends on the particular job and the form in which it is received.

The ideal situation is for the client to have all the typewritten copy and illustrations stored on a floppy disk(s) that is compatible with the designer's system. The disk itself can be sent to the designer or the information on the disk can be transmitted to the designer over telephone lines via a *modem*. Either way, the copy can be entered directly into the designer's system and called up on the monitor for the design process to begin.

If the copy is in typewritten form (hard copy), it must first be keyboarded. Generally speaking, designers are not expected to do keyboarding, in which case the designer or client may have to hire a typist, or pay a service bureau, to transfer the typewritten copy onto a disk that is compatible with the designer's system. The problem with keyboarding typewritten copy, however, is the risk of introducing errors, incurring extra cost.

Another possible solution is to have the typewritten (or typeset) copy read by an OCR program or device capable of reading letterforms and converting them into digital information that can be stored on disks. With OCRs, all copy should be carefully proofread, as marks, smudges, or misshapen characters may be incorrectly read. Other input devices are digital cameras, slide digitizers, compact disks, and optical disks.

Images may also be created by the designer (via keyboard, mouse, drawing tablet), or input from original hard copy via the scanner. Either way, line art, such as type, logos, or ink illustrations, are the simplest to input and require the least amount of storage. Continuous-tone images, both black and white and full color, require a more sophisticated scanner and a great deal more storage, especially for full color.

In the event a client's disk is incompatible with your system, it is often possible to have a conversion disk made. This can be handled by many service bureaus.

Keyboard

Disk

Modem

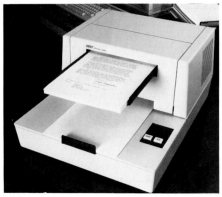
OCR

DESIGN AND LAYOUT

The entire operation is controlled via the keyboard, a hand-held device, (such as a mouse) or a combination of both. To begin a job the designer "opens" an appropriate program and then selects a "tool" from the "toolbox" which appears on the screen. This tool, displayed as an icon, graphically represents one of a variety of design, text, drawing, or illustrating techniques used to create art.

The design process continues by selecting options from "menus" which appear on a "menu bar" at the top of the screen. Typical menu titles are *file*, *edit*, *page*, *font*, etc. These menus provide the designer with various editorial and design options, for example, under page are layout specifications and under font are all the typographic considerations.

As designs are tested, images appear on the screen in areas referred to as *windows*. Design data and text information is held electronically in *files*, which in turn are stored in *folders*. To further aid the designer, a *dialog box* will at times display requests for additional information or notify the designer that something needs to be resolved.

The designer has a wide assortment of typefaces from which to choose: some of the standard faces come as part of the basic system, while others must be purchased. In most cases *screen fonts* control the image that appears on the screen and *printer fonts* control the image generated by the printer. There are, however, some situations where the same font will be used for both.

Most designers work with a number of programs. It is not unusual to create illustrations with program A, scale and retouch photographs with program B, and then "import" the illustrations and photographs into program C which controls the grid, type, and client's copy. The speed and ease by which design elements can be changed and manipulated make it a simple matter to view options that otherwise would never be tried. The computer allows the designer to save numerous revisions for use in other areas or future projects.

At the end of a session or the day's work, the designer will copy the files or documents onto a duplicate, or backup disk. This is a precaution as disks can *crash*, that is become unusable, in which case the designer could lose all or some of the files on the disk.

Menus offer the designer a variety of design and editorial options.

Designer's frequently work with low-resolution screen images for speed and high-resolution printer images for quality.

Agfa Compugraphic 9400 PS with laser printer and Macintosh® SE system.

Linotype Linotronic 300 and 500 imagesetters with processor.

Apple® LaserWriter®

HP PaintJet color graphics printers reproduce images by a thermal inkjet process at 180 dpi.

OUTPUT

One of the great advantages of desktop publishing systems is the printer's capacity to produce proofs at various stages of a job, thus permitting the designer the luxury of controlling every phase of the design from roughs through final form, be it a presentation comp, printed piece, or camera-ready art.

The least expensive of the printers is the dot matrix, which provides proofs of 40 to 100 dpi (dots per inch) on regular bond paper. This is satisfactory for only rough proofs, as type will be rather coarse and smaller sizes difficult to read. Curved lines or illustrations will be noticeably ragged.

For better reproductions the designer must go to laser printers, which are capable of generating images of between 300 and 1,000 dpi. While still less than perfect, the quality of the hard copy from laser printers is usually more than adequate for many newspapers, local advertisements, and company communications, such as newsletters.

For reproductions of the highest quality, the disk is generally sent to a professional typographer or service bureau where high-resolution printers, or imagesetters, generate type and images over 3,000 dpi on fine photographic paper or film. That adds up to nearly ten million dpi, which is more than adequate for even the smallest type sizes. Some jobs, such as all type and simple graphics, can be output at 1,100 dpi, while slides and view graphs require 4,000 and beyond.

There are also a number of color printers on the market that are ideal for making inexpensive color comps, bar charts, highlighting information, etc. Color printers are also handy when proofing jobs for the size and position of graphic elements. Unfortunately, the color is not accurate enough for color approval or color corrections. Color printers range in technology and price, with dot matrix printers being the least expensive, followed by ink jet printers. Thermal transfer printers are the most expensive but offer the highest resolution.

Generally speaking, the quality of a printer's output depends on the choice of typeface or image, sophistication of the software and hardware, and the output refinement determined by the dots per inch. When outputting there is a tradeoff between the number of dots per inch, the speed, and the quality: the fewer dots per inch, the faster the output, the poorer the quality. Conversely, the more dots per inch, the slower the output, and the greater the quality.

Once the job has been output and approved, the designer has a number of options. If all the graphic elements are in place then the output can serve as the mechanical and be sent directly to the printer. If incomplete, the designer will often combine new and old technologies: from laser printer, to waxer, to pasteup. In some cases, where compatible technologies exist, the disk itself can be sent to the printer or transmitted over telephone lines via modem.

Enlargement of a letter from a dot matrix printer.

GARBO

GARBO

GARBO

GARBO

The more dots per inch (dpi) the finer the image, but the slower the speed.

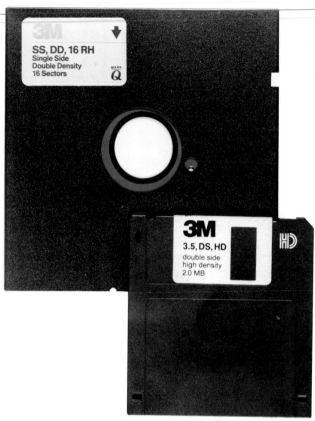

5¼" and 3½" floppy disks.

STORAGE

Storage is an ongoing procedure during the design process; from early proofs and typesetting to saving all, or part, of the job for future use. Storage can be either fixed or removable; with the fixed storage being held on the internal, hard disks and the removable storage on floppy disks, CD disks, or optical disks.

Storage is dictated by the size and complexity of the job. A small job can be stored on a single floppy disk (a 1MB disk will store approximately 1,000 manuscript pages), while a large complex job will require many. Another possibility is the use of the internal, fixed hard disk, which allows for greater storage than floppies.

For mass storage there are laser-driven CD-ROM (compact disk, read only memory), CD-WORM (compact disk, write once, read many), and rewritable optical disks. They are similar in size and form to the audio compact disks and require either a separate player or disk drive.

CD-ROM disks are designed for storage only. CD-WORM disks can be written into only once, at which point the information is permanent and not erasable. Optical disks are "read, write, and erasable."

In terms of storage these disks are in a class by themselves, capable of storing the equivalent of approximately 1,500 floppy disks worth of data. For example, a single disk can store an entire encyclopedia, dictionary, thesaurus, spelling checker, and countless other directories and reference books. Some are even designed to accommodate sound, animation, and music.

Regardless of the method of storage, the trend in the industry is to make all disks more compact, faster, and less expensive.

Compact disks store massive amounts of data.

Optical disks not only store massive amounts of data, but are read, write, and erasable.

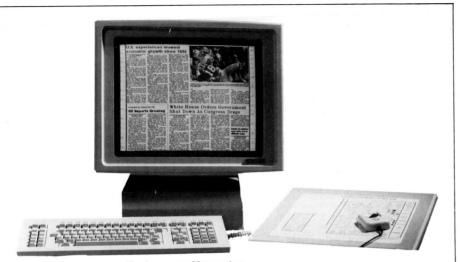

Harris composition system.

COMPOSITION SYSTEMS

Area composition systems, also called *page layout systems* or *makeup terminals*, are very much like desktop publishing systems only more complex. They incorporate sophisticated software, composition programs, high-resolution scanners, imagers, and powerful computers designed to handle a wide variety of tasks. Some systems interface with wire services and remote work-stations.

Composition systems are widely used for setting full-page retail ads, classified ads, and complex straight matter, such as directories and the yellow pages. Composition systems are very popular with the newspaper industry.

Here's how they work. The designer lays out the ad and specifies the copy in the usual manner, be it hard copy or floppy disk. An operator, working at a video terminal, inputs and styles the copy through the use of a keyboard, cursor, and mouse. When the input matches the designer's layout, the entire job is transmitted to the output device.

Speeds vary dramatically depending on the job and the output device. The more complex the job and the higher resolution desired, the more time it will take for the RIP (raster image processor), or imager, to build the page. Most systems are capable of making an entire newspaper page in approximately ten minutes.

As desktop publishing systems become more sophisticated, the distinction between them and composition systems will no doubt fade.

THE FUTURE OF DESKTOP PUBLISHING

With changes happening so rapidly in the field of electronics and digital processing, it is far easier to see where we are going rather than to pinpoint exactly where we are today.

In the near future all systems and software will be integrated, compatible, and user-friendly—not only between personal computers, but with main-frames, and other forms of electronic communication, such as facsimile machines, telephones, and television. Among the many features will be voice and handwriting recognition.

Software and hardware design will be greatly improved. Graphic images will appear on the screen as sharp as the originals and typefaces will retain all their unique characteristics. With perfect type, sharp halftones, and accurate color, fewer proofs will be required.

Designers will continue to take on added responsibility for entire jobs, ranging from editorial duties to production tasks, such as color separations and page makeup. All communication will be electronic (disks, modems, and fax machines), and when approved, the entire job will arrive at the printer press-ready.

Designers involved with audio-visual presentations will take advantage of the new technology. Slides and slide projectors will be replaced by disks, monitors, and video projectors. Graphic designers seeking jobs will present their portfolios, animated, with sound, and in three dimensions.

To accomplish this and other wonders, computers will have far greater storage, increased RAM memory, and be capable of making complex calculations at ever greater speeds. And all this at a price the designer can afford.

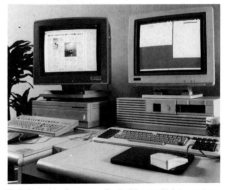

Hell Graphic Systems ScriptMaster™ integrates desktop publishing with production capabilities.

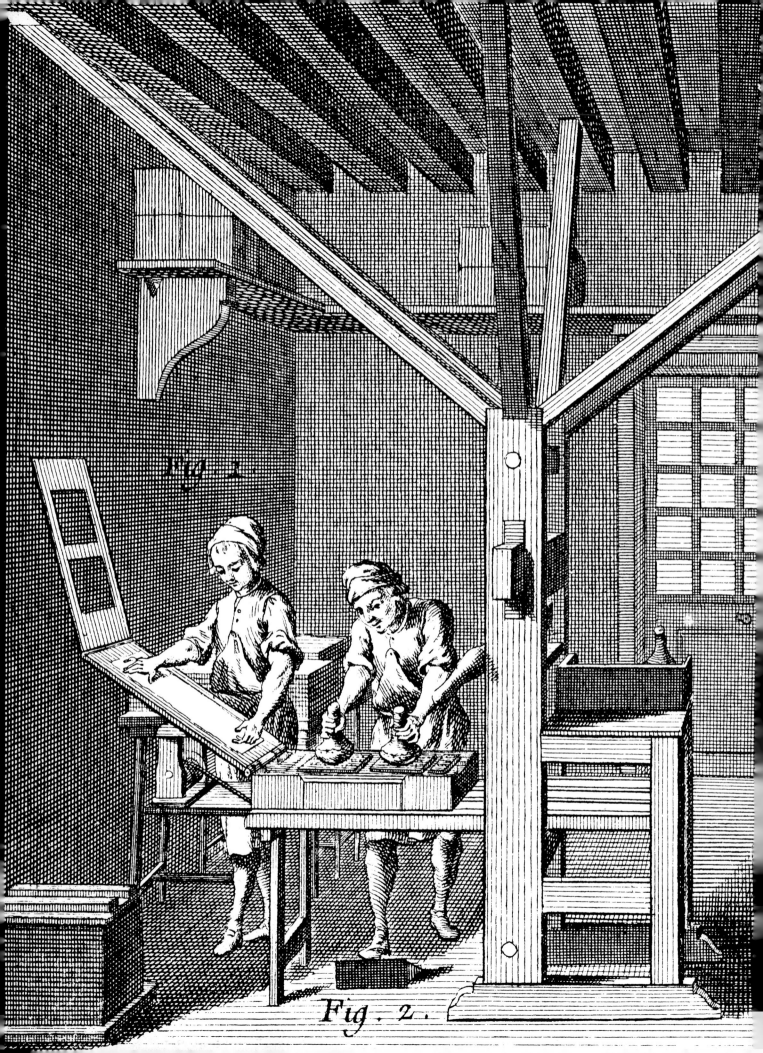

Fig. 2.

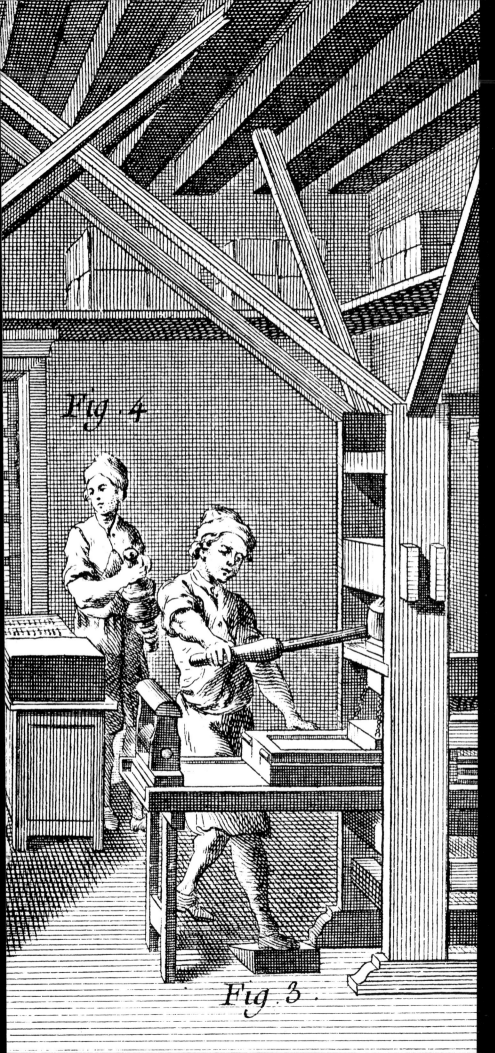

Fig. 4

Fig. 3.

Printing

The designer works out ideas on paper or by computer; the printer carries them out in metal. The process by which a design becomes a printed page may be of little concern to the average reader, but to the graphic designer it is crucial: it is the printing process that to a large extent dictates the designer's choice of type, illustrations, and paper, and even the preparation of mechanicals. In short, the more designers know about printing, the better they are able to control the quality and cost of a job.

In this section we shall deal only with black-and-white printing. Color printing will be dealt with separately in the following section.

An 18th century printing shop. On the left, the press is made ready and the type is inked ready for printing. On the right, type is being printed. In the background, the printed sheets are checked by the same man who is responsible for preparing the ink balls.

Copy

To the designer, copy usually means typewritten copy that is to be spec'd and set in type. To the printer or platemaker, copy means anything that is to be printed: type, photographs, illustrations, etc. All copy can be divided into two categories: line copy and continuous-tone copy.

Line Copy. Line copy is any image that is made up of solid black (or solid color), with no gradation of tone: lines, dots, rules, solid masses, etc. The type you are now reading is line copy, as are the illustrations below. Line copy is shot with a high-contrast film that sees everything in either black or white. The film is then developed, producing a *line negative* from which the printing plate is made.

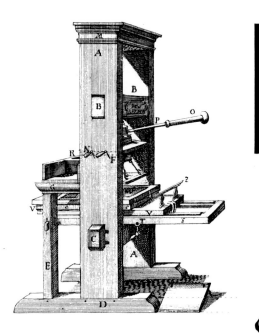

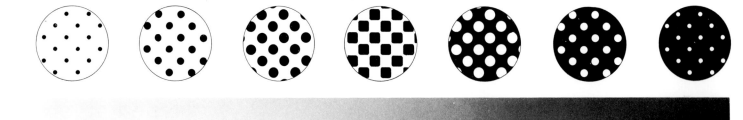

Although this illustration gives the illusion of continuous tone it is actually made up of solid black dots.

Continuous-tone Copy. Continuous-tone copy is any image that has a range of tones from white to black. Photographs, paintings, and charcoal or pencil drawings are all continuous-tone copy. If you look closely at an original photograph (not a reproduction in a book, magazine, or newspaper), you will notice that the tones vary and seem to melt into one another, resulting in a range of gray tones.

It is impossible to reproduce these tones exactly as you see them by any of the major printing processes. A printing press cannot print grays, it can only print solid tones; in this case, black.

Therefore, before continuous-tone copy can be printed, a line rendition of the image must be made. This can be done either by camera or scanner.

Unfortunately, continuous-tone copy cannot be reproduced by any of the major printing processes without first being converted to line.

Process Cameras and Scanners

The first step in making a printing plate is to convert the photograph from continuous-tone to line. This can be done either photographically or electronically. Photographically, the copy is shot through a screen by a *process camera*, also referred to as a *copy camera* or *graphic arts camera*. Electronically, the operation involves a *scanner* where the copy is either wrapped around a drum (see p. 106) or placed on a flat bed (see below). In either case the result is a *halftone negative*.

During the process it is possible to control the contrast in the highlight and shadow areas by varying the position of the middletone. The results you get will depend on the quality of the original copy, the clarity of your instructions, and the skill of the camera or scanner operator.

Amount of enlargement or reduction is controlled by moving both the lens and the copyboard.

Ground glass for focusing and centering image.

Camera back.

Door swings open and film is inserted and held in position by vacuum.

Scanners are rapidly replacing the process camera. Shown below is a Dainippon flat-bed scanner.

Control panel controls exposure times, vacuum, lights, filters, etc.

By varying the position
of the middletone (see arrow)
the equipment operator is able
to control contrast in
highlight and shadow areas.

Copyboard.
Copy to be shot is held flat
against copyboard by means of
a vacuum.

Lens with
aperture
settings.

Lamps to light copy
are set at 45° angles
to eliminate glare.

Camera bed.

Bellows.

A densitometer reads
the density of the image
in order to determine
the correct exposure.

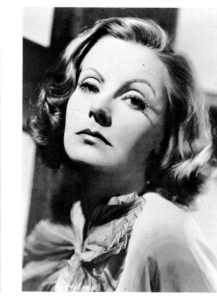

Normal highlight and shadow detail.

Highlight detail lost; shadow detail gained.

Highlight detail gained; shadow detail lost.

Halftone Screens

There are various kinds of screens: glass, contact, and electronic. The glass screen consists of a finely ruled grid pattern and is placed between the camera lens and film. The contact screen consists of a pattern of vignetted dots and is placed in direct contact with the unexposed film. Electronic screen effects are created by the scanner.

All produce the same results: they reduce continuous-tone copy to thousands of tiny dots (line copy) varying in size, shape, and number. When printed, these dots give the illusion of the original tones. The image is called a *halftone*.

Screens are measured by the number of lines per linear inch (or lines per centimeter). The most common are 55, 65, 85, 100, 120, 133, 150, 175, and 200. (Other screens are available up to 500, with still finer screens possible on the electronic scanner.)

The more lines per inch a screen has, the finer the dot pattern, and the less visually apparent is the dot pattern. For example, a 55-line screen has 3,025 dots per square inch, while a 150-line screen has 22,500. All things being equal, the 150-line halftone will look more like the original continuous-tone copy than the 55-line halftone, because the dots will be more numerous, finer, and closer together.

The screen used is determined by the surface of the paper, the type of printing plate, the quality of the printing press, and the skill of the operator. Newspapers, for example, use rather rough paper, stereotype printing plates, presses not designed for fine reproduction, and inks of watery consistency. Therefore, newspapers require a coarse, 85-line screen. If a finer screen were used, the paper would be unable to hold the detail and the spaces between the dots would fill in.

Magazines, on the other hand, use a smoother paper and are able to use finer screens, normally up to 150-line, and thus obtain finer, more detailed halftones. Obviously, it is important to match the screen to the paper and the printing conditions.

Enlarged glass screen.

Enlarged contact screen.

65-line screen.

85-line screen. (See detail.)

110-line screen.

120-line screen.

A magnifying glass is an invaluable tool for examining the quality of halftone dots.

100-line screen.

133-line screen.

AREA COMPOSED OF HIGHLIGHT DOTS

AREA COMPOSED OF SHADOW DOTS

AREA COMPOSED OF MIDDLETONE DOTS

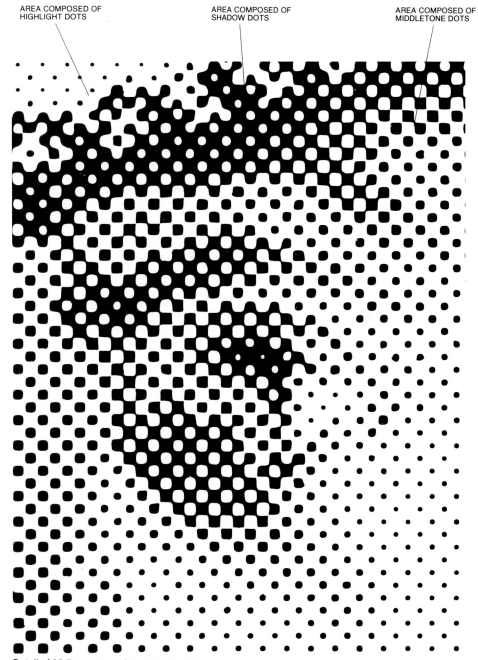

Detail of 85-line square-dot contact screen.

Halftones

Design would indeed be monotonous if all continuous-tone copy had to be reproduced in exactly the same manner. Fortunately, there are a number of things the designer can do with the conventional halftone. The particular approach is usually dictated by both aesthetic and practical considerations. Here are some of the more popular kinds of halftone reproduction.

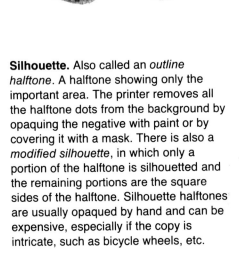

Square. A halftone that has been squared up. That is, all the corners are right angles. Although called a "square" halftone, it does not necessarily have to be square; it is in fact more often rectangular. Although there are also round and oval halftones, square halftones are the most widely used.

Silhouette. Also called an *outline halftone*. A halftone showing only the important area. The printer removes all the halftone dots from the background by opaquing the negative with paint or by covering it with a mask. There is also a *modified silhouette*, in which only a portion of the halftone is silhouetted and the remaining portions are the square sides of the halftone. Silhouette halftones are usually opaqued by hand and can be expensive, especially if the copy is intricate, such as bicycle wheels, etc.

Dropout. Also called a *highlight halftone*. A halftone in which certain areas have been highlighted by dropping out (eliminating) the screened dots. When printed, all that remains in the highlight areas is the white of the paper. The dots can be removed either photographically during film exposure or mechanically by opaquing them with paint on the halftone negative.

Vignette. A halftone in which the image fades almost imperceptibly into the white of the paper. Vignetting is done by an artist who creates the blend by air-brushing directly on the original art or overlay. This is a craft skill and can be expensive. In most cases printers would prefer designers to prepare their own art.

Combination Line and Halftone. As the name implies, part of the art is line and part is halftone. The line copy, in this case Babe Ruth's signature, is shot from separate copy as line and the con-tinuous-tone is shot as halftone, then the two are combined for reproduction. In this way the strength of the black in the line copy is held. (If line copy were to be shot as continuous-tone copy it would break up into dots, which when repro-duced would appear rough-edged and slightly gray rather than black.)

Line Conversions

In addition to the traditional halftone screens, there are a number of special line screens used to create a wide range of special effects, such as *circular*, *mezzotint*, *pebble*, *random*, *steel engraving*, *straight line (vertical and horizontal)*, and *wavy line*, to name a few. When used with imagination and good judgment, line conversions can create dramatic effects.

It is also possible for the designer to increase the degree of coarseness of any given screen by reducing the image before screening and then enlarging the screened image to the desired size. By reversing this process it is possible to reduce the coarseness of the screen. Too much reduction, however, can result in loss of detail.

Note: Line resolutions, unlike halftones, are usually handled by photostat shops or specialty houses and not by printers.

This series of line resolutions shows the wide range of effects made possible by varying the screens.

Square halftone.

Line resolution.

Horizontal wavyline.

Circleline.

Steel etch.

Steel engraving.

Toneline.

Mezzotint.

Vertical straightline.

Horizontal round dot.

Weave.

Linen.

Woodgrain walnut.

Fibril.

Crosshatch.

Page Makeup

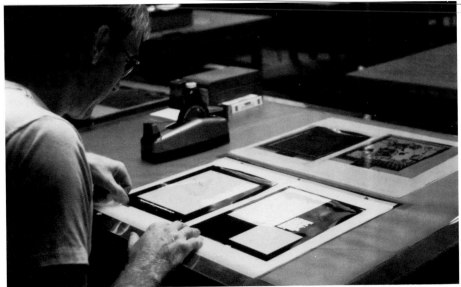

Page makeup in the traditional manner by stripping film negatives into flats.

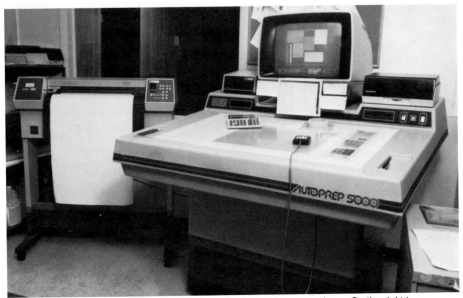

Today the trend is toward computer-aided or totally electronic page makeup. On the right is a Gerber Auto Prep 5000, capable of creating geometric shapes, film masks for cropping and positioning halftones, and ruling lay sheets for hand stripping. On the left is a proofing device which allows the operator to check the results on a small format prior to the final plotting.

After the line and continuous-tone copy has been photographed or scanned, page makeup begins. The film negatives are assembled or "stripped" into pages and signatures as dictated by the designer's layout and the imposition of the printed piece. This operation is called *stripping* and the assemblages are called *flats*. The operation can be manual, computer-aided (CAD), or totally electronic.

With the manual operation, the stripper affixes the film negative to a clear vinyl and then uses an opaque material (Rubylith® Amberlith® or Goldenrod®) to close the nonimage areas and block unwanted light during the photographic process.

The computer-aided process varies from printer to printer with some tasks being done electronically and others manually. For example, a typical division of labor may involve the computer handling the layout, positioning of crop marks, and the cutting of windows, while the stripping is done by hand.

With electronic page makeup all the elements are assembled electronically as digital data in the computer and then output on a single piece of film. Some systems are capable of outputting the data directly onto color proofing material or printing plates. The latter, however, can create an inconvenience and added expense if corrections have to be made.

There is no doubt that the printing industry is moving toward greater use of electronic page makeup. As all the data is digital, size changes, screen adjustments, and darkroom techniques are easier, and by reducing the human element, there is greater control and consistency in quality.

With electronic page makeup it is possible to store an entire book on a single spool of 70mm film by reducing each page fives times. For proof or platemaking the image is projected back up to normal size.

Blues. From the flat (or single piece of film), a paper proof, called a *blueprint*, is made by placing the flat in a vacuum frame and exposing it to a high-intensity arc lamp (see p. 87). The term *blueprint* is derived from the overall color of the proof, which ranges from light blue, representing white, to deep blue, representing black. If the job involves full-color images or mixed tints, color proofs will be supplied with, or instead of, blueprints (see page 110).

When examining a blueprint, among the many items of concern to both the designer and client are the following: position of elements, trim size, alignment, clean edges on halftones, proper color breaks, errors in copy, broken letters, and imperfections resulting from dust or scratches. All changes or corrections should be clearly indicated on the blueprint with a china marker as a guide for the printer, with new art submitted separately if necessary.

The printer will then make the necessary corrections. New copy will be shot and the negative stripped into the flat. If corrections are extensive a new blueprint should be prepared for designer/client approval. Corrections at this late stage are generally not too costly, as the printing plates have not been made, but changes can effect the schedule.

The final blueprint should be checked diligently, as this is the last review before the job goes to press. Clearly mark every correction or imperfection and then sign and date the proof. It should be noted that a signed blueprint is a legal contract permitting the printer to proceed with the job.

The corrected flat (or film) is now ready for platemaking.

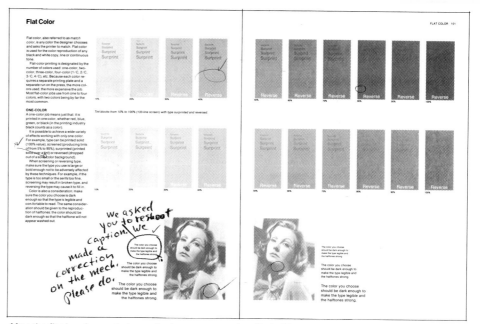

After the flat has been photographed, a paper proof, called a blueprint, is made. Pages 100 and 101 are shown above with errors and imperfections indicated by the designer.

Proof OK

Job No.

Proof No. Date

After you have read this proof carefully, please sign on the appropriate line. Indicate clearly on this proof if any corrections are to be made.

OK as is, no changes

OK with clean ups

OK with changes

An Additional proof required

Paper

Quantity

Ink

Description

Finishing

Art sent with proof ☐ Yes ☐ No

Art returned with proof ☐ Yes ☐ No

 1st 2nd 3rd Final

Date

Approval slips are often added to the job by the printer.

Platemaking

After the copy has been shot and the film developed, you get a film negative. It is from this film negative that the printing plate is made. (Although printing plates can also be made from film positives or digital data we shall base our discussions only on those made with film negatives.)

All printing plates have one thing in common: the area to be printed must stand apart from the nonprinting area. There are three basic ways to separate the printing area from the nonprinting area: (1) raise the printing area, (2) lower the printing area, or (3) leave both areas on the same level and treat the plate chemically so that the printing area accepts ink while the nonprinting area rejects it. These three ways form the bases of our three major printing processes: *letterpress*, *gravure*, and *offset lithography*.

There are two basic methods of plate-making. The traditional way, photo-graphically, by using a film negative, a light-sensitive metal or plastic plate, and chemicals. This is rapidly being replaced by direct laser imaging where a computer-driven laser engraves the image directly onto the plate.

Let's look at the platemaking process in conjunction with each of the printing processes.

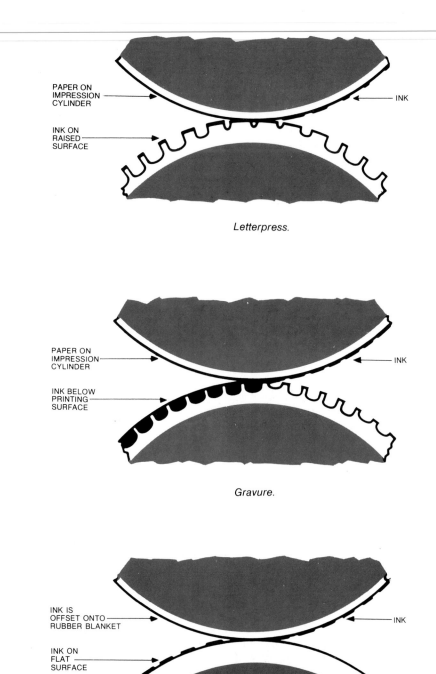

PAPER ON IMPRESSION CYLINDER

INK

INK ON RAISED SURFACE

Letterpress.

PAPER ON IMPRESSION CYLINDER

INK

INK BELOW PRINTING SURFACE

Gravure.

INK IS OFFSET ONTO RUBBER BLANKET

INK

INK ON FLAT SURFACE

Offset lithography.

Letterpress

Letterpress, also known as *relief printing*, is the oldest of the printing methods and probably the easiest to understand. When we print a woodblock or use a rubber stamp, we are printing by letterpress. The area to be printed is raised; when the surface is inked, the surrounding area, being lower, receives no ink and therefore does not print. The ink is transferred from the printing plate directly to the paper by means of pressure.

Because letterpress plates involve photography and engraving (actually *etching*), they are called *photoengraved printing plates* (more often referred to as *engravings*, *cuts*, or *zincs*), and the platemaker is called an engraver. Letterpress plates are usually made of zinc, magnesium, or copper. Zinc is primarily used for line copy and coarse screen work, while magnesium is used where detail and wearability are important. Copper, which is easier to etch and work, is used for high-quality line and halftone work.

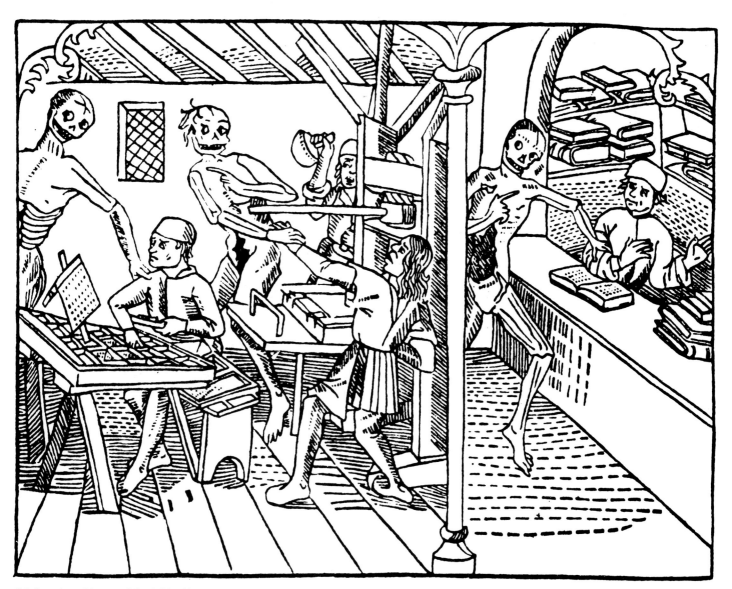

Printing shop "dance of death" by Mathais Huss, Lyons, 1499. This woodcut is one of the oldest illustrations depicting a printing shop. Note the letterpress in the center.

To make a letterpress plate, a photographic negative is brought into contact with a light-sensitive metal plate. The plate and negative are exposed to a light that passes through the clear part of the negative and strikes the plate. The exposed areas are light-hardened. The plate is then dipped into an acid bath. The hardened image area of the plate is impervious to the acid, while the remaining areas are etched to the desired depth. This leaves the image area raised and ready to be inked.

The plate is then "blocked"; that is, mounted on a piece of wood or metal to make it type-high (.918″). After the plate is blocked, it is inked and a proof is pulled. A copy of the proof is sent to the client and the plate is sent to the printer.

Not all letterpress printing requires a printing plate: type that is handset or cast can simply be inked and printed. If an illustration or halftone is to be combined with the type, then an engraving is made for that piece of art only. Most letterpress jobs are an assortment of type and engravings all "locked up" together in a frame called a *chase* and then placed in the press. An advantage of this system is that elements can be changed without the expense of having to make an entirely new plate.

There are times when the printer may wish to convert from one printing method to another. This is particularly common in cases where a job that was originally printed by letterpress is to be printed by offset lithography. In this case, the printing plates are converted to film from which a new plate is made. Three conversion systems are Brightype, Cronapress, and Scotchprint. (See Glossary.)

In recent years a great number of jobs, especially newspapers, have been converted from letterpress to offset. This is not because of a lack of quality in letterpress printing but because of the time involved in plate-engraving. To counteract the flow of business away from letterpress to offset, the letterpress industry has developed the photopolymer direct relief (PPDR) printing plate. This is a photosensitive plastic plate which when mounted on metal can be used as a regular letterpress plate. The photopolymer plate drastically reduces the time required to make a letterpress plate.

Original line copy to be shot.

Line negative.

Negative and plate exposed to light.

Plate is developed and etched in acid.

Plate is blocked to make it type-high.

Printed image.

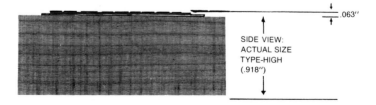
.063″

SIDE VIEW:
ACTUAL SIZE
TYPE-HIGH
(.918″)

CHARACTERISTICS OF LETTERPRESS

- Capable of high-speed, high-quality printing of jobs of a variety of sizes in black and white and in color.

- Consistent quality throughout run.

- Printing plates are generally more expensive than offset, but considerably less expensive than gravure.

- Capable of printing from handset or machine-set type as well as from original or duplicate printing plates.

- Duplicate plates are relatively expensive. The most commonly used duplicate plates are electrotypes, plastic plates, rubber plates, and stereotypes.

- Prints best on book papers. If halftones are to be printed, the paper must be calendered or coated. Also, accepts papers of any thickness, from the very thinnest to cardboard, depending on the type of press.

- When printing from original metal type or engravings, any part of the job can be changed without the expense of having to make entirely new plates. This does not apply when printing from one-piece duplicate plates or from curved plates (rotary).

- Among the uses of letterpress are short-run printing from type and engravings; jobs requiring numbering (tickets, forms, etc.); and imprinting, imprint changes, on-press die-cutting, slotting, perforating, embossing, debossing, etc. Also used for fine long-run publication work where the cost of the press plates can be economically amortized over a number of printings.

- Proofing is relatively inexpensive.

- Lays down an ink film thicker than offset but not as thick as gravure.

- Requires a lot of makeready time to compensate for the varying thicknesses of materials used: type, plates, engravings, etc.

Presses. There are three basic types of letterpress printing presses: platen, flat-bed cylinder, and rotary.

Platen. A press in which two flat surfaces come together to make an impression: one surface holds the printing plate; the other, called the platen, provides the pressure necessary to make the impression on the paper. There are two kinds of platen presses: the platen *flat-bed* (which was the press used by Gutenberg) and the platen *clamshell* (also called a *jobbing platen*). The clamshell is still in use today, mainly in commercial shops for short-run jobs of stationery, business cards, etc.

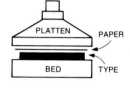

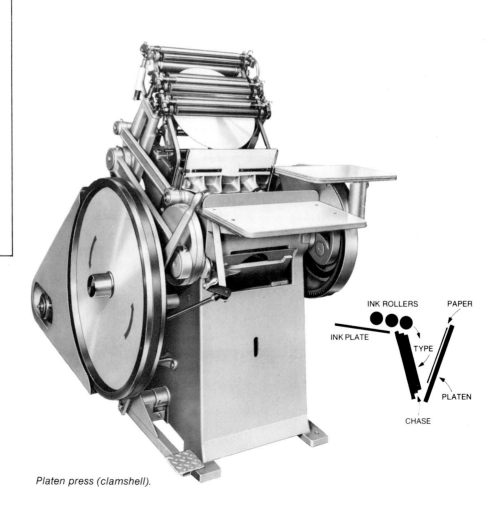

Platen press (clamshell).

Flat-bed Cylinder. As the name implies, this press consists of a flat-bed, which supports the printing plate or type form, and a cylinder which replaces the platen in providing the necessary pressure. These presses are usually larger and faster than platen presses. Excellent for booklets, catalogs, etc.

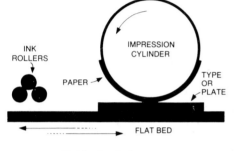

Flat-bed cylinder press.

First cylinder press manufactured by Friedrich Koenig, 1811.

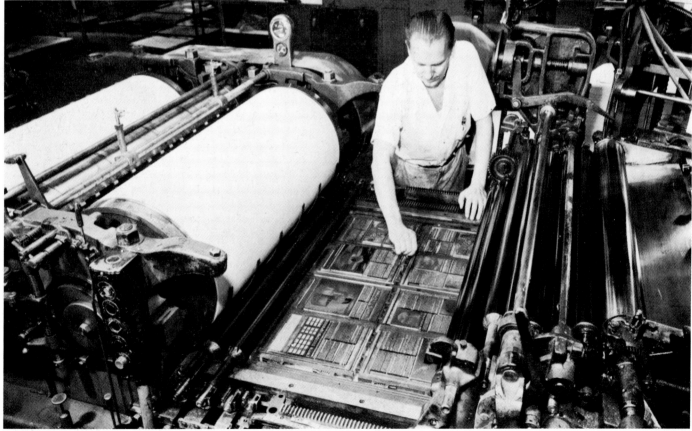

Type and engravings locked up in a type form ready to be printed.

Rotary. Unlike the platen and the flat-bed cylinder presses, in which the type or engravings to be printed are flat, the rotary press has a curved printing plate that either fits on a cylinder or wraps completely around it. This permits printing at high speeds and is ideally suited to long runs of high-quality work. A rotary press can print from individual sheets of paper (sheet-fed) or from a continuous roll (web-fed). Other rotary presses, called *perfecting presses*, can print both sides of the paper in a single pass at the same time.

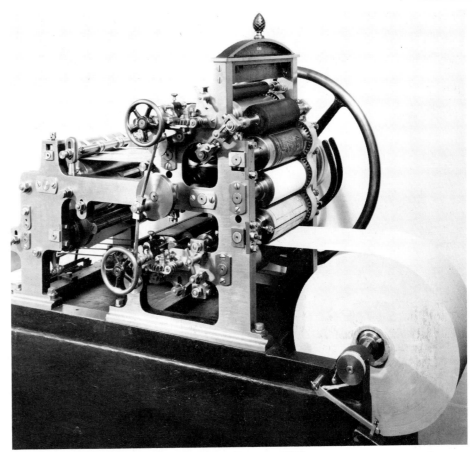

An early web-fed rotary press from Augsburg, Germany, 1883.

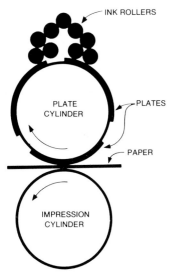

Rotary press.

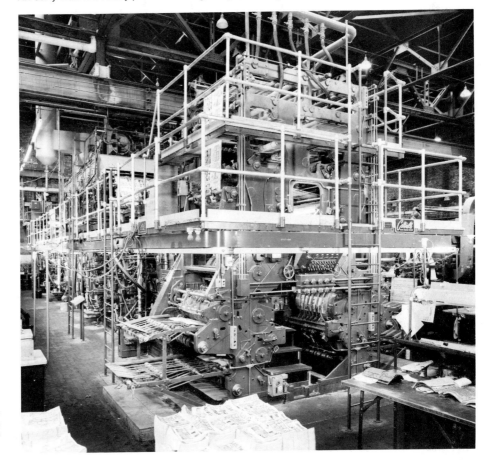

Huge web-fed rotary press capable of printing 40 pages on each side of the sheet in five colors.

Gravure

Gravure is the commercial form of *intaglio* printing. Intaglio is the second oldest printing process, dating back to 15th-century Germany. The original process is very simple: the image to be printed is cut or etched into the surface of the plate; the plate is then inked and wiped clean, leaving ink only in the recessed areas. When printed under pressure, the paper draws the ink out of the engraved areas, transferring the image onto the paper.

Gravure is printed from either curved plates, designed to wrap around a plate cylinder, or directly from etched cylinders. Like letterpress plates, gravure plates are photoengraved (or laser engraved); however, unlike letterpress plates, the area to be printed is lowered, not raised. To print, the entire surface of the plate is inked and then wiped clean with a flexible steel scraper called a "doctor blade," leaving ink only in the etched areas.

The unique aspect of gravure printing is that all copy, continuous-tone *and* line, must be screened. *This includes type.* The screening process is much more complicated than that used for either letterpress or offset lithography. However, the purpose is the same: to break the image up into thousands of microscopic dots which when etched in acid become tiny cells, varying in depth and diameter. The tonal gradations of the printed image are determined by the depth of the cells: the deep cells hold more ink and therefore print darker tones; the shallow cells hold less ink and print lighter tones.

Presses. Gravure printing is done on a rotary press and is primarily web-fed (rotogravure). Sheet-fed gravure is used most often for short runs and to reproduce works of art. The rotogravure press is designed to run at tremendous speeds and is ideally suited to long-run jobs such as mass-circulation catalogs, newspaper inserts, cigarette packages, postage stamps, etc.

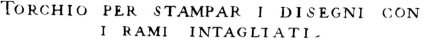
TORCHIO PER STAMPAR I DISEGNI CON I RAMI INTAGLIATI.

This 17th century engraving clearly shows the process of intaglio printing by hand.

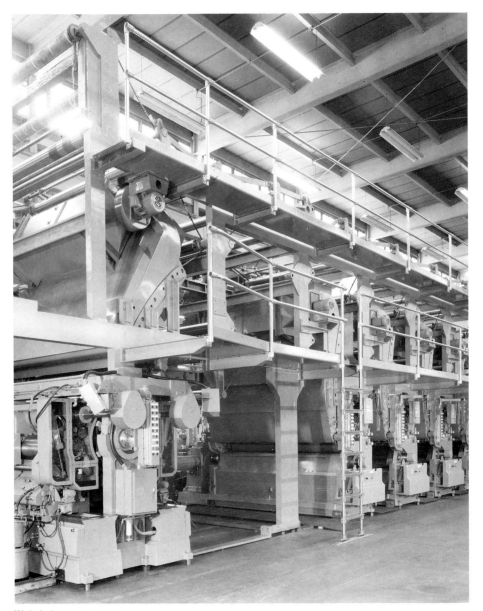

Web-fed gravure press.

Gravure printing cylinder.

CHARACTERISTICS OF GRAVURE

- High-quality, high-speed printing of black and white and of color.
- Consistent quality throughout run.
- Richest blacks and widest tonal range of all the printing processes.
- Most economical for long runs at high speed (web-fed). However, with careful preparation and attention to detail, short-run jobs can be printed at a cost competitive with that of quality letterpress or offset.
- Plates or cylinders are more expensive than either letterpress or offset plates, but they last longer.
- Duplicate plates or cylinders are expensive.
- Capable of printing on a wide range of surfaces. Although the highest quality is attained on smooth or coated stock, gravure can also produce high-quality work on inexpensive uncoated papers. An example of this is the Sunday supplements printed by rotogravure (web-fed gravure).
- Corrections are expensive because a new printing plate must be made.
- Proofing is much more expensive than for either letterpress or offset.
- Gravure printing is recognizable by the fact that the entire image area is screened, including the type. For this reason, gravure printing is better suited to reproducing continuous-tone images than to reproducing type (especially type with fine serifs or strokes and in sizes of less than 8 point).
- Able to most closely simulate the continuous-tone effect.

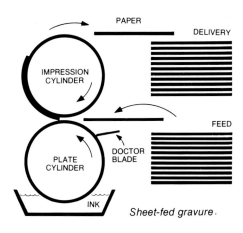

Sheet-fed gravure.

Offset Lithography

Of the three major printing processes, offset lithography is the most recent. It is a highly refined form of lithography invented in 1799 by a German named Aloys Senefelder. Lithography, which means "stone-writing," is based on the principle that water and grease do not mix. The image to be printed is drawn with a special grease crayon on a slab of highly polished limestone. The stone is then sponged with a solution of water, gum arabic, and acid. This solution is rejected by the greasy image area and absorbed by the nonimage area. When the stone is inked, the opposite happens: the ink, which is greasy, is accepted by the image area and rejected by the non-image area. To print the image, a sheet of paper is placed over the stone, pressure is applied, and the image is transferred to the paper. Properly prepared, a lithograph stone can produce hundreds of high-quality prints.

Jane Avril. Lithograph by Henri de Toulouse-Lautrec, 1899, 22" x 14". Collection, Museum of Modern Art, New York. Gift of Abby Aldrich Rockefeller.

Portrait of Aloys Senefelder. Lithograph.

Early Senefelder lithograph press.

The commercial form of lithography is called offset lithography, more commonly known simply as *offset*. (Offset refers to the method of transferring the image from the plate to a rubber blanket and then to the paper.) In offset lithography the flat stone is replaced by a thin, flexible metal printing plate designed to wrap around a printing cylinder.

The first step in making an offset plate is to create a flat by stripping both the line and halftone film negatives into their proper positions. This can be done manually or electronically (see page 76).

Before the actual offset plates are made, a photographic paper (or film) proof is made from the flat that shows the client the exact position of all the elements. These proofs are called *blues* (see page 77). After the proof has been approved and signed, the plate is made.

Traditionally, offset plates are made photographically. The plate, which may be aluminum, zinc, or a specially processed paper, is coated with a light-sensitive chemical. The flat is brought into contact with the plate and exposed to a high-intensity light. The clear part of the negative allows the light to reach the plate while the opaque, or dense, areas block the light.

The plate is then processed either by hand or put through an automatic processor where it is developed and made press-ready. That is, the plate is chemically treated so that the image area will reject the water solution and accept ink and the nonimage area will accept the water and reject the ink.

Plates can also be made electronically by direct laser imaging. In this case all the image data is in digital form and a computer-controlled laser engraves the image directly onto the plate.

As the platemaking process for offset is much simpler than for either gravure or letterpress, the printers will often make their own plates rather than depend on the services of an outside platemaker.

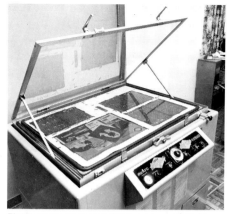
Flat in vacuum frame for exposure to light.

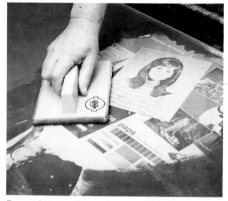
Removing coating not exposed to light.

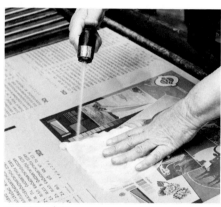
Washing plate.

Applying gum arabic solution to plate to inhibit oxydizing before printing.

CHARACTERISTICS OF OFFSET

- Capable of printing jobs of a variety of sizes in black and white and in color at a relatively low cost.
- Requires more attention than letterpress or gravure to maintain image consistency throughout run.
- Printing plates are relatively inexpensive and require only a short time to make as compared with letterpress and gravure plates.
- Duplicate plates are inexpensive.
- Printing plates can be either negative-working or positive-working; that is, made from either film negatives or film positives.
- Although the quality is highest on smooth or coated papers, offset can print effectively on rough-surface papers as well.
- Corrections require making a new plate, but plates are inexpensive.
- Proofing can be done either on the production press or special proofing presses. Proofing on the production press is expensive. Prepress proofs made from the flats are usually furnished in the form of blueprints, Cromalin® proofs or Matchprints® (if process color), or by overlay systems such as the 3M or Enco system of color proofs.
- Offers the designer great creative freedom: a great variety of substrates and finishes can be printed; vignette halftones are easy to produce; soft and subtle tones are easily reproduced.

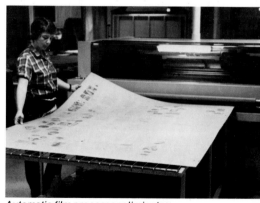
Automatic film processor eliminates the need for hand processing and affords better quality control.

Presses. There is a wide range of offset presses available, ranging in size from small office duplicators to huge web-fed perfecting presses capable of printing an entire book in a single run.

All offset presses are of the rotary type and have three cylinders: a *plate cylinder*, a *blanket cylinder*, and an *impression cylinder*. In operation, the printing plate, which is wrapped around the plate cylinder, first comes into contact with dampening rollers. These wet the entire plate with a solution of water, gum arabic, and acid. This solution is rejected by the image area and accepted by the non-image area.

Next the plate is inked and the process reversed. The ink is accepted by the image area and repelled in the non-image area. The inked image is then transferred onto a rubber blanket wrapped around the blanket cylinder, which in turn "offsets" the image onto the paper being pressed against the blanket by the impression cylinder.

The reason the image is transferred onto the rubber blanket rather than printed directly onto the paper is because the offset plate is very delicate and the abrasiveness of the paper would cause damage. In addition to extending the life of the plate, the rubber blanket, because it's compressible and conforms to the slightest degree of texture on the paper's surface, makes it possible to print on rough papers.

Multilith 1250. 11″ x 14″ (280 x 355 mm), 1/C.

Heidelberg TOM. 11″ x 15½″ (280 x 395 mm), 1/C.

Heidelberg MOVH. 19″ x 25½″ (480 x 650 mm), 4/C.

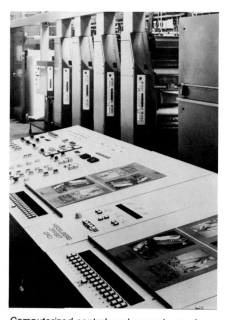

Computerized controls reduce make-ready time, minimize paper waste, stabilize print quality, and increase output.

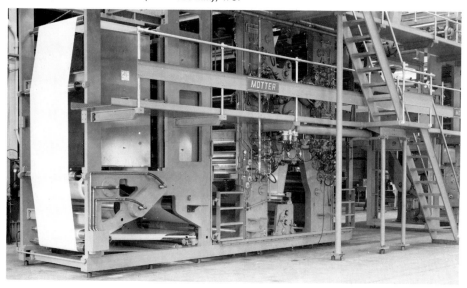

Motter 51″ (1300 mm) web-fed 4/C. Prints 2/C on full web or 4/C on half web.

Miehle-Roland 200. 20″ x 28″ (520 x 740 mm), 2/C.

Heidelberg GTOZ. 14″ x 20½″ (355 x 520 mm), 2/C.

Miehle-Roland 600. 28″ x 40″ (720 x 1020 mm), 6/C.

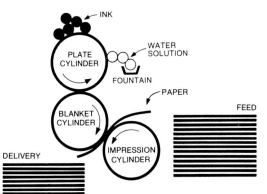

Sheet-fed offset press.

Other Printing Processes

Not all our printing demands are met by the three major printing processes. Today, our printing needs are highly diversified; printing is no longer restricted to ink on paper, but can be found on a wide range of materials such as glass, plastics, and metals, to name just a few. To satisfy this demand, printing methods have been diversified and specialized. Here are a few of the more popular printing processes with which the designer should be familiar.

Screen Printing. Screen printing, also known as *silkscreen printing*, is a stencil process. The stencils are either cut by hand or photographically prepared. They are bonded for support to a screen (silk, nylon, Dacron, or fine metal mesh) and stretched over a wooden frame to create a smooth flat surface. A squeegee is then used to force the ink through the open (image) area of the screen onto the surface to be printed.

Because the inking in screen printing is heavier than in other printing processes, it produces excellent results on a variety of smooth and rough surfaces: metal, glass, ceramic, wood, plastic, fabric, cardboard, and of course, paper. This makes screen printing ideal for a great many commercial projects, such as street signs, posters, and wallpapers.

A major advantage of screen printing is that because of the opaque quality of the ink, white or any light color can be printed on a dark surface in one appli-cation. And there are a great variety of inks available, including metallic inks and fluorescent colors. There is even a special ink that is used for screen printing electronic circuits.

Although the speed of screen printing does not compare favorably with that of the three major printing processes, it has attained an important place in the printing industry because of its versatility and unique advantages.

Flexography. Flexography is a form of relief printing in which a rubber or soft plastic printing plate, made from a mold of a letterpress plate, is used with fast-drying ink (usually aniline). The printing process is similar to that of rotary letterpress: the rubber plate is mounted on a printing cylinder and generally prints onto roll stock (web-fed).

Flexography is a versatile printing process, printing from one to six colors using webs up to 100″ wide. It can be used to print on paper, cellophane, foil, or plastic and is used for printing such diverse items as bubblegum and bread wrappers, wallpaper, paperback books, and shower curtains. Flexography is particularly popular with the packaging industry.

Because the printing plate used in flexography is flexible it can be easily mounted onto the plate cylinders with tape. Magnetic rubber is also used for plates. Changes can be inserted directly into the rubber plate by simply cutting out the old copy and replacing it with a patch. This operation is much easier than making a new plate. Printing cylinders are interchangeable, making it possible to change jobs quickly and easily.

Flexography does have its limitations, however. The ink has a tendency to spread, making it difficult to print a clean, sharp halftone. For this reason it is not unusual to use gravure cylinders on the press to print halftones and use flexog-raphy for the line work only. Also for this reason, small type sizes (6 point and smaller) should be avoided, and if the type is to be reversed, it should be bold enough so that it will not fill in.

UNFORTUNATELY,
IT IS IMPOSSIBLE TO SHOW
AN ILLUSTRATION OF
COLLOTYPE PRINTING
AS IT IS A SCREENLESS
PRINTING PROCESS.
THIS BOOK IS PRINTED BY
OFFSET LITHOGRAPHY
WHICH REQUIRES THAT ALL
CONTINUOUS-TONE COPY
BE SCREENED BEFORE
PRINTING.

Letterset. In letterset, also known as *indirect letterpress*, the image, carried on a one-piece, low-relief, wrap-around printing plate, is first offset onto a rubber blanket and then transferred from the blanket to the paper.

The purpose of letterset is to combine the quality of letterpress with the convenience of offset. Letterset printing is ideal for printing on metal or plastic (cans, labels, cartons) and offers consistency of printing quality and color.

Furthermore, it is possible for a printer with an offset press to modify it for letterset work. One of the advantages of this arrangement is that it allows the printer to lay down a heavier deposit of ink than would otherwise be possible with the offset press. Letterset printing is used mainly in the packaging industry.

Collotype. Also called *photogelatin*. The only process in which continuous-tone copy can be reproduced without the use of a screen. The basic concept is similar to that of offset lithography, in which water and ink do not mix. In collotype, moisture and ink do not mix. The printing plates are aluminum and are coated with a gelatin solution. The relative softness or hardness of the gelatin dictates the continuous-tone values: the soft areas accept more water and less ink; the hard areas accept less water and more ink. However, unlike offset lithography, in which the image is first offset, in collotype the image is transferred directly from plate to paper. Collotype is a short-run process, which is used extensively for one-sheet, two-sheet, and three-sheet posters; point-of-purchase displays; printed transparencies used in back-lighted displays and art reproductions. Runs are limited by plate life.

Thermography. Although thermography is a finishing process rather than a printing process, the designer should be familiar with it. Thermography is an inexpensive way to achieve an engraved look and feel and is frequently used to print business cards, invitations, decorative papers, and greeting cards. To produce this engraved look, the image is printed either offset or letterpress with a slow-drying ink and then dusted with powdered rosin. When heated, the powder and the ink fuse to give the type a raised, or engraved look. Thermography can be done in a number of colors, including gold, silver, and copper. The finish may be either dull or glossy.

Printing Terms and Techniques

When discussing printing with a printer you will find that the printer has a special language; the better you understand it, the easier communication will be. Let's examine some of the terms:

Backing-up. Printing the reverse side of an already printed sheet.

Form. In letterpress, type and other printing matter locked up in a chase ready for printing. In offset, refers to the printing plate. Can also refer to one side of a printed sheet.

Gang Printing. Also called *ganging up*. Printing a variety of different jobs on the same sheet of paper. After printing, the sheet is cut into the individual jobs.

Gripper Edge. The leading edge of a sheet of paper held by the grippers as it passes through the printing press. Paper allowance must be made at the gripper edge of from ¼" to ½", depending on the kind of printing press used.

Grippers. Metal fingers that hold the paper onto the impression cylinder of the press.

Imposition. The arrangement of pages in a form so they will be in the correct order when the sheet is printed, folded, and trimmed.

Makeready. The complete process involved in getting the presses ready to run after plates have been mounted: register, building up the form so all areas print evenly, ink and feeder control, etc.

One-up, Two-up, Etc. When printing small units it is often more practical and economical to repeat the image many times (two-up, three-up, etc.), using duplicate plates on a larger sheet of paper, than to print it singly (one-up) on a small sheet of paper. The advantage is that the cost of duplicate images is generally less than the cost of the additional press time that is required to print a single image on each pass through the press. This is especially true in offset lithography, for which duplicate plates are particularly inexpensive to make. Also, because the press plate is a given size on any press (that is, a smaller plate cannot be substituted just because your job is small), it is economical to make sure that the plate is covered with the greatest practical number of images.

Preparation. Also called *prep work*. All the work necessary in getting a job ready for printing: camera, stripping, platemaking, etc.

Sheetwise. A printing procedure in which one side of the sheet is printed with one form, the reverse side with another, and in both passes through the press, gripper and guide sides remain the same.

Split Fountain. A color printing technique in which two (or more) colors can be printed from a single plate by splitting the ink fountain on the press so that the left side prints one color and the right side another. Although the results can be spectacular, split fountain printing is difficult to control and the printed piece can be disappointing.

Work and Tumble. A printing procedure that allows the printer to "back up" a sheet without having to change printing plates. The plates for both sides of the sheet are contained in a single form; on the first pass through the press half the sheet receives the impression of Side A and the other half of the sheet receives the impression of Side B. The sheet is then tumbled; that is, turned over from front (gripper edge) to back, so that a new edge meets the gripper. With the same printing plate, Side A is backed up with Side B and Side B is backed up with Side A. Because changing the gripper edge means that adjustments must be made on press before printing the second side of the sheet, work and tumble is seldom used where close register is important. Also, because both ends of the sheet are used as gripper edges, extra paper must be allowed for margins.

Work and Turn. A printing procedure similar to work and tumble except that the second side of the sheet is printed by turning it over from left to right, so that the same gripper edge is used for both sides. Not having to change the gripper edge makes it much easier for the printer to hold proper register. For this reason, work and turn is more widely used than work and tumble.

Grippers and gripper edge.

Two-up.

Work and tumble.

Work and turn.

Printing Problems

Although some printing problems are not the designer's responsibility, the designer is of course affected by any imperfections in the printed piece resulting from a problem on press.

Printing problems are usually caused by the paper, the press, the printing plate, or the ink. If the problem is serious, the press may have to be stopped until a correction is made, and someone—the printer, the client, or the paper merchant—will have to pay for the delay.

The following are some of the more common printing problems.

Chalking. Also called *Powdering*. A condition that occurs when the printing ink is not properly bound to the paper and can be easily rubbed off as a powder. This condition is never noticed until the ink has had time to dry, and by that time it is too late to correct the factors that caused it. However, the job can be saved by using the same printing plate to print a transparent size over the entire job.

Crawling. This printer's term is so ambiguous that the same word can have opposite meanings within one plant. To some printers, crawling means the contraction of ink film on a surface that the ink has not wet completely; to others, it means the expansion of ink, such as might occur when a "soupy" ink overprints a wet ink film.

Crystallization. (Not to be confused with the same term, meaning the formation of crystals, used in chemistry.) A dried ink film repels a second ink that must be printed on top of it. For example, when a four-color job is printed on a two-color press, the first and second colors are printed on the first pass through the press; the third and fourth colors are printed in a subsequent pass, allowing enough time between passes to avoid smudging. It is during this time that crystallization can occur—the inks may dry too hard or some of the ink's components may rise to the surface and cause poor trapping (which see). Crystallization can be avoided by using an ink formulated to dry properly on the specific paper used and by paying attention to the time intervals between subsequent printings.

Doubling. As the name suggests, doubling is two impressions of each dot, which causes the printed image to appear heavier, or fuller, than it should. Doubling occurs in wet multicolor printing when the first color printed is picked up on the blanket of the second cylinder, which in turn, prints it back onto the next sheet. If it is in exact register this second imprint will not be seen, but if it is slightly off-register it will print as a light "ghost" dot next to the original dot, thus causing variations in tone and color values.

Drying, Poor. When ink requires an unreasonable amount of time to dry after printing. Poor drying can be caused by the kind and amount of dryers in the ink, dryer dissipation, too much moisture in the paper or a nonabsorbent paper, too much humidity in the printing plant, too much water being run, or too acid a fountain solution.

Emulsification. In offset printing, the dispersion of the fountain solution (acid, gum arabic, and water) in the ink. Emulsification affects the color strength of the ink and its ability to dry with a gloss, resulting in a washed-out, mottled appearance.

Flocculation. Also called *orange peeling*. Clumps of pigment particles are surrounded by clear vehicle, which causes the solid areas to resemble an orange peel. The condition can be caused by improper handling of the press, but it is generally regarded as an ink defect.

Ghosting. The printed image appears faint where not intended. This is caused by an abrupt change in ink take-off on the rollers. This may occur when a border is involved, for example: because the vertical sides strip off more ink than the horizontal, a solid printed behind will be starved for ink and print lighter in that area. Ghosting is one of the few printing problems that the designer should be able to foresee and control. One solution is to have the solid areas well distributed thereby giving the ink a chance to build up again on the rollers. Also, avoid running light tints of color: choose a lighter color and run more of it. Ghosting may also require imposition knowledge so talk to your printer.

Halation. Although not a press problem, halation may be mistaken for one. It appears in halftones (black and white or color) as a light, halo-like area around a very dark area. Halation is caused by improper automatic photographic developing, and new plates must be made to correct it.

Chalking.

Doubling.

Ghosting.

Ink hickies.

Moiré caused by rescreening a halftone.

Hickies, Ink and Paper. This is one printing problem with which most designers are familiar. Hickies may be caused by foreign matter in the ink or by loose paper fibers. Ink hickies are identifiable as small doughnuts (ink spots with white rings around them), while paper hickies appear as clean white specks.

Ink hickies occur when dirt or solids in the ink adhere to the blanket: ink is transferred from the particle to the paper, with the edge of the particle leaving a small uninked ring. Ink hickies continue to appear in the same place from sheet to sheet, and the only way to eliminate them is to do a complete wash-up and replace the ink in the fountain.

Paper hickies, on the other hand, are caused by clumps of paper fiber or dust adhering to the blanket (see *Picking*). As they absorb water they tend to repel the ink, becoming whiter as they repeat.

To eliminate hickies, find the source and remove them; otherwise frequent press wash-ups will be necessary. Another solution is to "blank" the stock, which means running uninked paper through the press and then washing the blanket. Drastic as this is, paper companies find blanking less expensive than supplying new paper.

Moiré. A moiré (pronounced *moh-ray*) is an undesirable pattern created by the optical meshing of screen dots when screens are superimposed on one another. This can happen whenever two or more screens are used. A common cause of moiré is when a printed halftone is rescreened for subsequent reproduction. For example, if you wished to reproduce the halftones on this page, and you shot the already screened halftone through a second screen, the result would be a combination of the two screens. This could cause a moiré. To avoid a moiré, the second screen must be set at a different angle from the first so that the angles of the two screens are about 30° apart.

There is another way to reproduce a previously printed halftone that will avoid creating a moiré. Because the halftone already has dots, it can be photographed as line art. This is a good solution if the dots are sharp and if the halftone does not have to be enlarged or reduced too much; overly enlarged dots become coarse, and if reduced too much the dots may be so close together that the halftone will fill in.

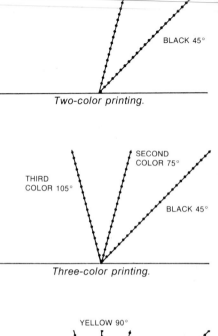

Two-color printing.

Three-color printing.

Four-color printing.

Screens angled at 45° are the least visible and are generally used for dark colors, such as black, while screens angled at 90° are the most visible and are reserved for the lightest colors, such as yellow.

Moiré produced by incorrect screen angles.

Mottle. An uneven or speckled appearance caused by the ink's inability to form a smooth, uniform film. Some forms of mottle are noticeable while the ink is wet; others become noticeable as the ink dries. Mottle can be caused by a number of factors: ink not properly adjusted to stock; stock not receptive to ink; uncoated stock with wild formation; coated stock with nonuniform ink absorbency; running too much ink on hard-surface, nonabsorbent stock; and too much dampening water. In some cases, mottle can be reduced or overcome by modifying the ink or keeping the dampening water to a minimum.

Off Color. When the job appears to be a different color from that specified. This can be the result of many things, the most obvious of which is a poor color match by the pressperson or ink manufacturer. This in turn could be caused by an inadequate color specimen, an incorrect paper sample, or insufficient information regarding the type of press, job, or form. Other factors that can affect color are the thickness of the ink film—the thicker the film, the darker the color will appear; whether or not the press rollers, fountain, and printing plates are properly cleaned; in offset, if too much water gets in the ink; and the color of the paper. Also, colors, especially tints and pastel shades, may darken or fade after printing.

Paper Curling. In offset, this can be caused by too much fountain water, which causes the sheets to curl up. (This is especially common in one-side printing on coated stock such as labels.) In other cases, when the printing ink is too tacky, the back edge of the printed sheet has a tendency to curl down if heavy ink coverage extends too close to the back edge of the sheet (tail-end hook). Extremes of humidity in the printing plant can also cause paper to curl, especially along the edges.

Picking. When the pull of the ink (the tack) is too strong for the paper, the surface of the paper is ruptured, or "picked." Picking may appear as small white specks in the solid printed areas of a paper's surface. It is caused by inks that are too tacky or papers that are too weak. Picking can often be corrected by adding a solvent or compounds to reduce the ink's tack, by slowing the press, or by changing to a paper with a higher pick strength. A lot of trouble can be avoided if paper is tested for pick strength before going to press.

Piling, Ink. Ink must transfer uniformly at each point in the printing system. If it does not, an accumulation of ink gradually builds up on the press rollers, making continued printing impossible. Among the causes of piling are inks that are not properly ground, and too much moisture on press which causes the paper coating to become tacky.

Piling, Paper. A problem in offset printing, where coated papers come in contact with moisture on the blanket. The coating is loosened and particles adhere to the blanket, causing halftones to become sandy and highlight dots to be lost. To avoid piling, the fountain solution may have to be modified or the paper changed.

Registration, Poor. In printing, the accurate positioning of one printing image over another is extremely important. When images are printed off-register, the resultant image is fuzzy. The two most common of the many reasons for poor registration are imprecise stripping and paper that is not stable (has a tendency to stretch). Also, the more colors used, the more prep passes, and the more chances there are for poor registration. Perhaps the most difficult job to control would be a job requiring tight registration, printed by a high-speed web press on cheap paper.

Scuffing. If an ink contains too much nondrying oil or varnish it rubs, or scuffs, easily even when dry. This is a particularly disastrous problem in packaging, where printed cartons or labels tend to rub against one another. Scuffing is also common in printing done on highly absorbent coatings such as Kromecote. Scuffing can be minimized by using a scuffproof ink, or by varnishing after printing, which is usually done on press.

Picking.

Scumming. In offset printing, the adherence of ink to the nonimage area. Scumming occurs only in lithography because the image and nonimage areas of the printing plate are on the same plane. When the nonimage area loses its ability to repel ink, the ink will be accepted and then transferred to the nonimage area of the print. This may be uniform over the sheet, but it is more likely to occur in the form of blotches at the ends and sides of the sheet.

Set-off. (Formerly called *offset*, a term now reserved for offset lithography printing.) Set-off occurs when the ink on a printed sheet fails to set in time and transfers to the underside of the sheet on top. This can be brought about by any combination of many factors that inhibit ink from setting.

Show-through. When the low opacity of a paper permits the printing to be seen from the other side of the sheet. Show-through can be avoided by printing on a more opaque sheet.

Slurring. The filling in of halftones and of reverse lettering, a common problem in offset printing, especially when printing on coated stock. Slurring is caused by too much ink or by slippage between the paper and either the printing plate or the blanket. Slur, or "drag," is most apt to happen when printing solids or halftones on a smooth-coated paper because the ink acts as a lubricant, aggravating the slippage. Usually, slurred type gains weight in only one direction.

Snowflaking. The failure of a printed ink to form a continuous film. Snowflaking is visible in the form of small holes, or voids, in the printed area. It is caused by water droplets in the ink which prevent the uniform transfer of a solid to the paper, or in gravure by too light a pressure setting between the cylinders, which prevents the paper from making contact with one or more gravure cells. Extremely rough stock will also cause snowflaking problems due to failure of the ink to make contact with the paper's surface.

Spreading. A thickening, or enlarging, of the printed image. This may be due to a number of things: a poorly made plate, running too much ink, excessive plate-blanket squeeze, etc.

Sticking. Also called *blocking*. Set-off (which see) carried to a point where the sheets actually stick together.

Strike-through. When the vehicle of the ink penetrates through the sheet so that it is visible from the opposite side. Strike-through is more apt to occur on an absorbent stock than on a nonabsorbent stock. A possible solution is to change the stock or print with an ink that has a higher hold-out formula.

Tinting. Found only in offset printing; occurs when pigment particles migrate to the fountain solution, producing a uniform discoloration of the background. Tinting differs from scumming in that it usually shows up over the entire plate rather than in streaks. When washed from the plate, the tinting instantly reappears.

Trapping, Poor. Trapping is the ability of an ink film to properly accept a subsequent ink film. To ensure good trapping in wet printing, the colors first printed must be tackier than subsequent colors; in this way, the first ink down helps pull the subsequent ink off the plate or blanket. If the ink manufacturer knows in what sequence the colors on a multicolor job is to be run, he can adjust the ink tack to minimize the likelihood of poor trapping.

Another form of trapping that is of concern to the designer is where two color areas meet. To avoid a white line between these two areas, a slight trapping, or overlapping, of the two colors is necessary.

Normal halftone dot enlarged.

Halftone dot affected by sluring.

Enlarged detail of halftone dots and solid area shows the effect of snowflaking.

Quality Control

Every designer wants the highest possible quality in a printed job. And most clients would add: at the lowest possible cost. It is the designer's responsibility to try to satisfy both demands. There are several areas in which the designer can influence both the quality and the cost of the job:

Design. Design is crucial to the quality of a job; it also has an enormous influence on the cost of a job. For example, the least expensive job to print is all line art, printed black. Adding a halftone means that original continuous-tone copy will have to be screened and stripped into position. This will add to your cost. And if you use a colored ink instead of black, expect to pay more. Not only do colored inks generally cost more, but since most printing plants are always running black ink, the press must be cleaned before printing another color. And after the job is printed, the press must be cleaned again before going back to black. By the same token, two-color jobs are more expensive than one-color jobs, and full-color printing is the most expensive.

Original Art. The quality of the printing plate is dictated by the quality of the original copy, so make sure all copy is of the highest possible quality. If the art is not perfect, have it retouched or crop the areas that will not reproduce well (make sure you consult with the client before cropping!). If the art cannot be improved, show the problem to the printer; a certain amount of correction is possible in the shooting, platemaking, and printing processes.

Paper. Find out enough about paper so that you will be able to make intelligent decisions. The best printing press and the best presswork are useless if the job is printed on the wrong paper. Paper must be suited not only to the printing process but also to the copy to be printed. For example, the selection of paper is far more critical for printing color and halftones than it is for printing type or line illustrations. The smoothness of the paper's surface directly affects the quality of the printed piece; a smooth paper permits each dot to print accurately; a rough paper tends to break up the dot patterns, creating a printed image that lacks strength and detail. In short, the more you know about paper, the better the chances that the job will be properly printed. (See *Paper*, page 121.)

Proofs. Check proofs carefully. If the job is printed by letterpress or gravure, you will receive an engraver's proof. In this case, the printing plate has already been made and what you see is exactly what will appear when the job is printed. If the plate is correct, it is sent by the engraver directly to the printer. Corrections or changes at this stage are expensive and may require handwork, or making a completely new plate. Whenever possible, an engraver's proof should be pulled on the same paper on which the job is to be printed.

If the job is to be printed by offset, you will receive a photographic proof. In this case, the printing plate has not been made, and what you see will not help you determine the quality of the printed job so much as reassure you that all the elements are correct and in their proper positions. Check the proofs carefully with the client to be certain there are no mistakes. Mark the corrections directly on the proof and return it to the platemaker or printer along with any new copy to be shot. Unless you ask for a corrected proof, the next time you see the job it will be printed.

Printer. In many cases, the printer can be more important than the printing process. A good printer can control the quality of a job by applying knowledge of the press, paper, and ink; a poor printer may destroy the job. The printer you choose may be someone you know by reputation or someone recommended to you. Ask the printer to discuss the job with you and perhaps show you similar jobs printed on the kind of paper you intend to use. It won't do you any good if you are shown a great letterpress job on smooth paper when you intend to print offset on rough paper!

At times the designer may have to work closely with the printer to determine imposition, sheet size, and press size. The size of the printing press is designated by the size of the sheet the press is designed to handle—for example, 22″ x 29″, 25″ x 38″, or 52″ x 76″. (In some cases there may be an inch or two difference between the official size and the sheet size because some presses are capable of taking a sheet size slightly larger than standard.) If the job is being printed by web, the press is measured by the width of the roll (web width) and the minimum and maximum cutoff of the roll.

Scheduling. Keep in mind scheduling requirements, allowing the proper amount of time for each of the trades to do its job. The typographer, the platemaker, and the printer must all be included in the schedule. And remember that it takes time to ship paper to the printer and the printed piece to the client. Also, do not overlook vacation schedules. These can involve closing entire plants for two weeks during the summer, and sometimes for the week between Christmas and New Year's Day.

It is impossible to anticipate everything that can go wrong with a job; there are just too many people involved. All you can do is plan well enough in advance so that if things do go wrong there will still be plenty of time to rectify them. Otherwise, you will find yourself making a compromise between what you want and what is available. In the end, lack of planning means more work for the designer, as well as a less than successful job.

Color Printing

Today, more and more printing is being done in color. Used properly, color can be very effective: it can attract attention, create sales appeal, clarify complex design, highlight specific points, or add a decorative touch. In short, color can be one of the designer's most important tools.

Color printing can be divided into two basic categories: *flat (or match) color* and *four-color process*. Let's examine each of these color printing methods more closely.

Enlarged detail of eye showing dot formation. The dots forming the highlight have been printed in a second color.

Flat Color

Flat color, also referred to as *match color*, is any color the designer chooses and asks the printer to match. Flat color is used for the color reproduction of any black-and-white copy, line or continuous tone.

Flat-color printing is designated by the number of colors used: one-color, two-color, three-color, four-color (1/C, 2/C, 3/C, 4/C), etc. Because each color requires a separate printing plate and a separate run on the press, the more colors used, the more expensive the job. Most flat-color jobs use from one to four colors, with two colors being by far the most common.

ONE-COLOR

A one-color job means just that: it is printed in one color, whether red, blue, green, or black (in the printing industry black counts as a color).

It is possible to achieve a wide variety of effects working with only one color. For example, type can be printed solid (100% value), screened (producing tints of from 5% to 95%), surprinted (printed solid or darker tint over a tint), or reversed (dropped out of a solid-color background).

When screening or reversing type, make sure the type you use is large or bold enough not to be adversely affected by these techniques. For example, if the type is too small or the serifs too fine, screening may result in broken type, and reversing the type may cause it to fill in.

Color is also a consideration: make sure the color you choose is dark enough so that the type is legible and comfortable to read. The same consideration should be given to the reproduction of halftones: the color should be dark enough so that the halftone will not appear washed out.

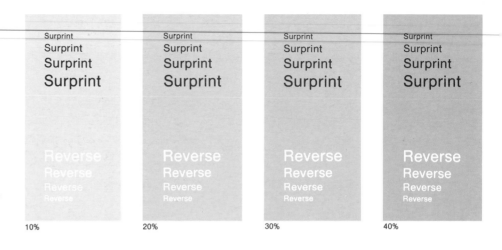

Tint blocks from 10% to 100% (133-line screen) with type surprinted and reversed.

The color you choose should be dark enough to make the type legible and the halftones strong.

The color you choose should be dark enough to make the type legible and the halftones strong.

The color you choose should be dark enough to make the type legible and the halftones strong.

Surprint Surprint Surprint Surprint Reverse Reverse Reverse Reverse	Surprint Surprint Surprint Surprint Reverse Reverse Reverse Reverse	Surprint Surprint Surprint Surprint Reverse Reverse Reverse Reverse	Surprint Surprint Surprint Surprint Reverse Reverse Reverse Reverse	Surprint Surprint Surprint Reverse Reverse Reverse Reverse	Reverse Reverse Reverse Reverse
50%	60%	70%	80%	90%	100%

Surprint Surprint Surprint Surprint Reverse Reverse Reverse Reverse	Surprint Surprint Surprint Surprint Reverse Reverse Reverse Reverse	Surprint Surprint Surprint Surprint Reverse Reverse Reverse Reverse	Surprint Surprint Surprint Surprint Reverse Reverse Reverse Reverse	Reverse Reverse Reverse Reverse	Reverse Reverse Reverse Reverse
50%	60%	70%	80%	90%	100%

The color you choose
should be dark enough to
make the type legible and
the halftones strong.

The color you choose
should be dark enough to
make the type legible and
the halftones strong.

The color you choose
should be dark enough to
make the type legible and
the halftones strong.

MULTICOLOR

Multicolor printing is printing in more than one color: two, three, four, etc.

The addition of a second color provides a variety of design possibilities: not only can the two colors be used separately, but they can also be combined as solids and screened tints to produce a wide range of colors.

Although it is possible to use any two colors, one of the most common combinations is black and a second color. This allows halftones and text type to be printed in black, while the second color can be used in a more decorative manner.

The addition of a third or fourth color extends the color possibilities. While technically everything that has been said

20%C/10%K	20%C/30%K	20%C/70%K
50%C/10%K	50%C/30%K	50%C/70%K
100%C/10%K	100%C/30%K	100%C/70%K

Screened tints: one color (C) plus black (K).

about one-color and two-color printing applies to three-color and four-color printing, there are a few factors to keep in mind when designing three-color and four-color jobs.

In many cases the designer may find that a three-color job costs as much as a four-color job. The reason for this is that most printers use either one-color, two-color, or four-color presses. To do a three-color job the printer has to either make multiple passes on his one-color or two-color press or use a four-color press for only three colors. Ideally, one pass through the press is preferable; it is less expensive and it offers the printer an opportunity to correct or balance the color while the job is running.

Although it is possible to print an

Full-range black and white halftone.

20% tint of second color.

Flat-tint halftone.

(Right). Duotones produced by shooting the black plate for contrast (upper left) and then surprinting it with a second color plate (orange) shot for overall detail. By varying the tonal value of the color plate it is possible to produce a wide range of effects.

unlimited number of colors, it is always a question of money: the more colors, the higher the cost.

Flat-tint Halftone. The flat-tint halftone provides an inexpensive way of introducing color into a halftone. The black-and-white halftone is overprinted on a flat background tint of the second color. The designer should keep in mind that the darker the tint, the darker the highlights will be, hence the flatter the halftone will appear.

Duotone. A duotone is a two-color halftone made from a regular black-and-white photograph (or color art treated as monochromatic art). To make a duotone, the photograph is shot twice, once for the black plate and once for the color plate

and usually at differing tonal ranges. For example, the black plate can be shot for contrast to hold the dark shadow tones, while the color plate can be shot for the middle tones. When printed, the halftone dots from these two plates will produce a more complete range of tones.

It is also possible to print a duotone using black for both the first and second color. This is sometimes called a *double-black duotone*. Double-black printing represents an effort to overcome the limitations of the printing process. Using a single negative, it is impossible for a printing ink to match the rich, solid blacks of a glossy photograph. To compensate, the printer adds a second negative for the shadow areas. When printed they combine to produce a rich, dense, black-

and-white image with excellent contrast.

Duotone printing is difficult to predict and depends a great deal on the quality of the original photograph and expertise of the printer. If you work with duotones, it is wise to ask the printer to show you samples of duotone printing, communicate your preferences, and supply the best halftones possible—ideally with a full range of tones from black to white.

Black halftone shot for contrast.

20% value blue halftone over black.

40% value blue halftone over black.

60% value blue halftone over black.

80% value blue halftone over black.

Full range blue halftone over black.

SPECIFYING FLAT COLOR

There are two ways to specify flat color: by asking the printer to mix a color that is part of a color-matching system or by asking him to match a color that is not part of a system (such as a piece of colored paper or a part of a painting). The first method is the most practical because it provides the printer with ink-mixing instructions for every color; the second method is more hit-or-miss, very much like mixing housepaints.

There are many color-matching systems in use today, the most widely used by designers being the PANTONE MATCHING SYSTEM.®*

This system is based on 11 Pantone Colors, which when mixed in varying amounts produce a total of 747 colors. These colors are numbered and arranged in a guide, or swatchbook, called the PANTONE Color Specifier 747XR. Besides the designer's edition, there is a printer's edition that includes ink-mixing formulas.

To specify a color, the designer looks through the swatchbook, chooses the color desired, and indicates its number on the mechanical. It is also a good idea to attach a sample of the color to avoid any possibility of error.

Swatchbooks are usually divided in two sections, one showing the colors printed

PANTONE® 284U PANTONE® 284U PANTONE® 284U
PANTONE® 285U PANTONE® 285U PANTONE® 285U
PANTONE® 286U PANTONE® 286U PANTONE® 286U

on a coated stock, the other showing them on an uncoated stock. It is important to see both, because the paper's finish will have a definite effect on how the color will look when printed: if the paper is coated, the colors will appear brilliant; if the paper is uncoated, the colors will appear soft or flat.

The color of the paper will also affect the appearance of any color that is printed on it. In standard swatchbooks the colors are printed on white stock, but there are swatchbooks available, mostly through paper companies, that show standard-color inks printed on a variety of colored papers.

Swatchbooks are also available that show colors printed on newsprint, as well as how the colors look when printed by every major printing process. If a job is to be printed by an unusual process or on an unusual surface (acetate, foil, metal, etc.), the designer should contact the printer for more information.

Although there are other color-matching systems, they offer the designer the widest range of worldwide services. In addition to inks, their colors are available in a number of related products—self-adhesive overlays, colored papers, and color markers—to help the designer control the color throughout a job.

*Pantone Inc.'s standard trademark for color reproduction and color reproduction materials.

Four-Color Process

Four-color process printing is the method used to reproduce full-color continuous-tone copy, such as transparencies, color prints, and paintings. Four-color process printing should not be confused with four-color printing, discussed earlier in this section. Whereas four-color printing can be done with any four flat colors, four-color process printing uses four specific colors, called *process colors*, which consist of the three primary colors—yellow, magenta (process red), cyan (process blue)—and black.

Note: Although most printers refer to the process colors simply as yellow, red, blue, and black, we shall use the correct terminology, yellow, magenta, cyan, and black, so as not to confuse the reader when discussing separations.

When printed, the four process colors appear as dots of solid color which combined in various sizes and patterns approximate the full range of colors found in the original image. It is interesting to note that the colors are created not by the overprinting of the inks, but by the optical mixing of the four original colors by the viewer's eye (similar to the principle of the pointillist technique developed by impressionist painter Georges Seurat).

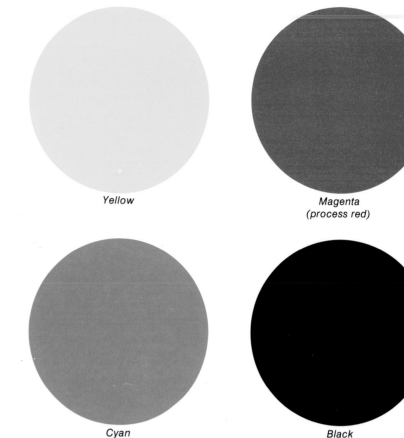

Yellow

Magenta
(process red)

Cyan
(process blue)

Black

Enlarged detail of flower
showing dot formation.

Bedroom Painting #7 by Tom Wesselman,
oil on canvas, 78" × 87". Philadelphia
Museum of Art. Adele Haas Turner &
Beatrice Pastorius Turner Fund.

COLOR SEPARATION

The first step in reproducing full-color continuous-tone copy is to make color separations. As the name suggests, color separation is the breaking down of the original copy into the four process colors: yellow, magenta, cyan, and black. There are two ways to do this, photographically and electronically.

Photographic Separation. Photographic separations can be made by process camera, enlarger, or by contact printing. To make color separations, the original copy is photographed four times through special filters. This results in four continuous-tone *separation negatives*, each carrying a record of the amount and distribution of one of the process colors found in the original copy.

Because process printing is halftone printing, the separations must be screened before printing plates can be made. To ensure that these dots will fall in correct relation to one another, each screen is set at a different angle. (See *Moiré*, page 94.)

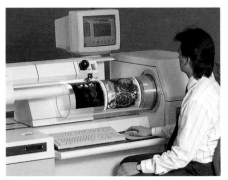

Laser beam scanners electronically break down full-color images into the four process colors.

Electronic prepress system designed for color separations, corrections, retouching, airbrushing, image modification, and page assembly.

Electronic Separations. Today, most color separations are handled by laser scanners, which electronically break down the image into the four process colors. The transparency or print (reflection copy) is wrapped around a drum, and as the drum spins a pinpoint of light is sent through the transparency, or bounced off the print. This light is read by the computer and converted into digital data. As the computer analyzes the information it exposes four sheets of film, one for each process color. The scanner is able to produce film that is scaled, screened or unscreened, positive or negative, right-reading or flopped, and to consider options of height-to-width distortions.

One of the major advantages of the electronic scanner is that it allows for methods of overall color correcting to be built right into the system, thus eliminating much of the hand work involved in conventional color correcting. Color and contrast can be modified by simply adjusting knobs on the control panel: colors can be made warmer, cooler, darker, lighter, etc. Designers should make it a point to give all color instructions to the printer before the separation process, as changes made after can be expensive.

The electronic drum scanner has one major restriction: it can only separate copy that is both flexible and small enough to be wrapped around the scanner drum, such as transparencies and unmounted prints or illustrations. Large or mounted copy must be separated on flat-bed scanners (see p. 68).

Electronic Color Imaging. One of the most dramatic innovations of the past decade has to be electronic color imaging (ECI), where colors and picture elements can not only be retouched, but totally changed. As all the data is stored digitally, both color and images can be manipulated endlessly by sophisticated computers: blue eyes can become brown eyes, and red cars, black cars. Picture elements can be retouched, repositioned, duplicated, stretched, compressed, combined with images from other sources, or entirely eliminated. Among the more popular color-imaging prepress systems (CIPS) are Crossfield Studio, Dainippon Screen, Hell Chromacom, and Scitex Response.

LIGHT REFLECTED OR TRANSMITTED FROM ORIGINAL COPY PASSES THROUGH A FILTER

BLUE FILTER

Screened separation negative: yellow printer.

Yellow proof.

(ABOVE) SEPARATIONS; (BELOW) PROGRESSIVE PROOF

Yellow proof.

GREEN FILTER

RED FILTER

MODIFIED FILTER

Screened separation negative: magenta printer.

Screened separation negative: cyan printer.

Screened separation negative: black printer.

Magenta proof.

Cyan proof.

Black proof.

Yellow plus magenta.

Yellow, magenta plus cyan.

Yellow, magenta, and cyan plus black.

Process printing is an attempt to reproduce all the colors of the spectrum with just three colors plus black. To understand why we use the specific colors we do in four-color process printing, it is important to understand the nature of light and color.

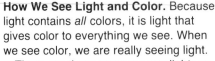

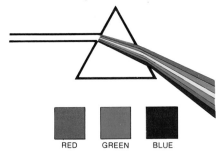

RED GREEN BLUE

Light and Color. Light contains all the colors of the spectrum. This can be demonstrated by directing a beam of light through a prism. Although the spectrum contains all possible colors, it can be broken down into three color regions—red, green, blue—each representing a third of the visible spectrum.

As it is possible to break light down into three colors, conversely these same three colors when projected on top of one another create white light. Whereas all three colors overlapping produce white, if one is removed, leaving only two overlapping colors, a totally different color is created: red and green, with the blue removed, produce *yellow*; red and blue, with the green removed, produce *magenta*; green and blue, with red removed, produce *cyan*.

Because the red, green, and blue combine to produce white light, they are called *additive* primaries. Because the yellow, magenta, and cyan are formed by taking away one of the three additive primaries, they are called *subtractive* primaries.

How We See Light and Color. Because light contains *all* colors, it is light that gives color to everything we see. When we see color, we are really seeing light.

There are three ways we see light: as direct, reflected, or transmitted. Direct light, as the name suggests, is from a light source, such as the sun, a candle, or a lightbulb. Reflected light is reflected off some opaque surface, such as that of a photograph, painting, or drawing. Transmitted light is passed through a transparent material, such as a photographic transparency, piece of colored glass, or filter.

As designers, we are mainly concerned with the last two kinds of light: reflected and transmitted. Let's look at a simple example of both:

First, let's examine what happens when light strikes a red apple. We have already established that light is made up of red, green, and blue. When this light strikes the apple, every color is absorbed by the apple except the color it is—red. The red is reflected off its surface, so the color that we see is the *reflected color red*.

Now let's take a piece of red glass. Once again, all the colors of light, except the color of the object, are absorbed. But in this case the red passes through the object rather than reflecting off its surface. You might say that the red glass has filtered out the green and blue, allowing only the red to pass through. As with the apple, the color we see is red, but it is a *transmitted color red*, not a reflected color.

Now let's apply this principle to separating color for process printing.

Separating Color. All colors are made up of varying amounts of the three additive primaries: red, green, and blue. Therefore it should follow that if we can separate a full-color image into these three colors, we should be able to recreate it by using the same three color in printing inks. Unfortunately, we canno The problem is that there is a limit to the number of colors that can be created using these three particular colors. For example, although red and green *light* produce yellow *light*, red and green *inks* produce a brown/black color. Therefore, not only would it be impossible to create yellow, but *any* color brighter than the original colors. The solution to the problem lies in the subtractive primaries yellow, magenta, and cyan. Using inks i these three colors it is possible to re- create all the colors of the spectrum.

To separate the full-color image into yellow, magenta, and cyan, it is necessary to photograph the copy three times, through filters which are the same color as the additive primaries: red, green, and blue. When the copy is photographed through the red filter, the green and blue is absorbed and the red passes through, producing a negative with a record of the red. By making a positive of this negative we will obtain a record of everything that is *not* red, or more specifically, a record of the green and blue. The green and blue, as we have seen earlier, combine to produce cyan; therefore, we have a record of the cyan. The same process is repeated for the magenta, using a green filter, and fo the yellow, using a blue filter. As each filter covers one-third of the spectrum, w now have a record of all the colors found in the original copy. When combined and printed with the correct colors—yellow, magenta, and cyan—we should be able to reproduce all the colors of the origina

In theory, this is correct. Unfortunately printing inks are not "pure"; they absorb colors that they would not absorb if they were pure. For this reason, the printed

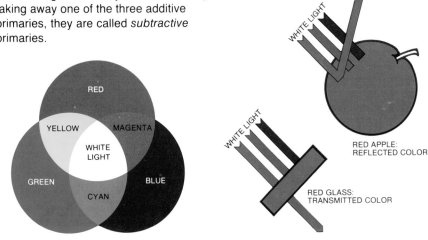

WHITE LIGHT

RED APPLE:
REFLECTED COLOR

WHITE LIGHT

RED GLASS:
TRANSMITTED COLOR

RED

YELLOW MAGENTA

WHITE LIGHT

GREEN BLUE

CYAN

Process printing is based on principles of light and color. Here is a brief explanation of these principles and how they affect four-color printing.

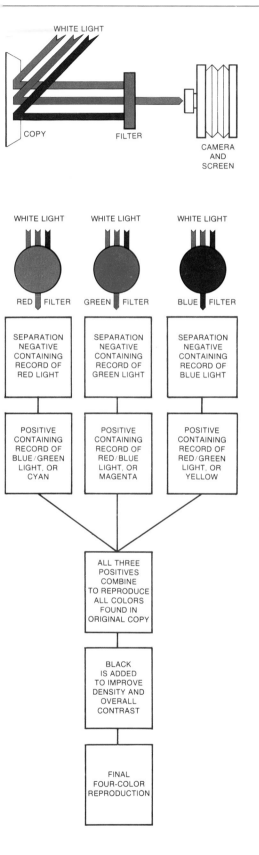

image will appear dirty or muddied unless color corrections are made on the separations to compensate for these ink deficiencies. Another problem is a lack of density in the shadow areas. To overcome this, a black separation is made by using a yellow filter or a combination of all three filters. The addition of black improves shadow density and overall contrast.

Reproducing the Image. The four separations are screened at different angles, and from these screened separations the printing plates are made. When printed, the image is reproduced as thousands of tiny dots laid down in thin layers of color. The particular color is determined by the size of the dots, the manner in which they overlap, and their relation to one another. Therefore the colors are produced not in the physical mixing of the inks, but in the optical mixing of individual colors by the viewer's eye.

Ink and Paper. The paper used has a major influence on the quality of the color printed on it. Because process inks are transparent, it is the light reflected from the paper's surface that supplies the light to the ink. For example, let's look at some cyan printed on a sheet of paper. The light passes through the transparent cyan ink as through a glass filter. The cyan absorbs the color it is not—red— and allows the color it is—blue and green—to pass through. These two colors reflect off the paper and back up through the ink. What we see is a blue and green color, or cyan. It is the quality and quantity of the reflected light that dictates the quality of the color. For this reason, the paper must be bright and neutral in color if it is to reflect maximum light. Also, because a rough surface will scatter the light and distort the color, the paper should be smooth so the ink will lie flat and filter properly.

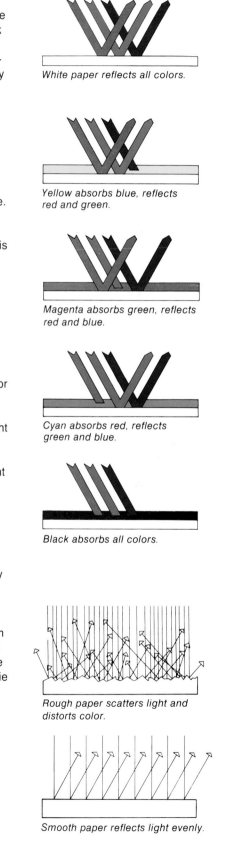

White paper reflects all colors.

Yellow absorbs blue, reflects red and green.

Magenta absorbs green, reflects red and blue.

Cyan absorbs red, reflects green and blue.

Black absorbs all colors.

Rough paper scatters light and distorts color.

Smooth paper reflects light evenly.

PROOFS

Before the job is printed the designer receives a color proof from the printer to be checked for color, size, registration, and overall quality. There are *prepress proofs* and *press proofs*.

Prepress Proofs. These are prepared before the printing plates are made, which means that the cost of corrections is relatively inexpensive when compared to the cost of corrections after the plates are made. There are three basic types of prepress proofs: *overlay proofs* and *transfer proofs*, which are conventional analog proofs made from the screened film separations, and *digital proofs*, which are generated electronically from digital data.

Overlay proofs consist of four sheets of acetate or mylar film, one for each process color, which when overlayed create the final proof. Overlay proofs are fine for confirming size and position, but can only be used for color correcting by a skilled craftsperson. Popular overlay proofs are 3M Color-Key,™ Hoechst Celanese Naps® and Paps,® DuPont Cromacheck,™ and Fuji Colorcheck.™

Transfer proofs are prepared by taking colored powders, or precoated color sheets, representing the process colors and causing them to adhere to a base material one color at a time. The

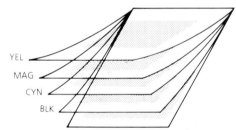

Overlay proofing combines four sheets of acetate or mylar to create a proof.

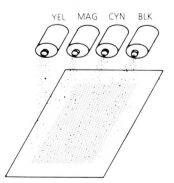

Transfer proofing uses four colored powders to create a proof.

resulting proof is a high-quality proof that can be used for color approval or color correcting. Among the better-known transfer proofs are DuPont Cromalin,® Hoechst Celanese Press Match,® Fuji Color-Art,™ and Agfa Agfaproof.®

A recent analog system worth noting is *electrostatic proofing* (DuPont EMP,™ Kodak Signature,® and Stork Colorproofer®). This technology promises high quality, screened proofs (or progressive proofs) that can be produced on the client's paper and are suitable for color correcting. DuPont EMP™ is also capable of producing multiple proofs at the rate of one per minute.

Digital proofing is the technology of the future. Depending on the system, digital proofs can be either continuous-tone (dithered dot) or traditional (halftone dot). Colors range from poor to very good. Digital proofs take only minutes to prepare, and some believe the technology is the predecessor to the era of filmless, plateless printing. Among the competing technologies are *thermal sublimation* (DuPont 4CAST™), *ink jet* (Iris®), *digital photographic continuous-tone* (Hell CPR403®), and *electric photographic* (Stork Digital Colorproofer®).

When considering prepress proofs, the designer should keep in mind that each process offers certain advantages and disadvantages, and that cost is often a factor. Some of the new technologies are so expensive that the proofs may never be a commercial success. Try to select the color proof that is right for the job and the budget; in some cases all you'll need is a color photocopy (see page 160).

Press Proofs. These are made directly from printing plates and with the same paper and inks as the final printing. Press proofs can be pulled on either a small four-color proofing press or a large production press. Along with the press proof the designer may receive a set of *progressive proofs*, or *progs*, consisting of a number of sheets, each showing a process color by itself and in combination with the others. The sequence of colors is determined by the printer on a job-to-job basis. (The progressive proof on pages 106 and 107 uses a yellow, magenta, cyan, black sequence.) Reading progressive proofs is difficult and should be left to an experienced person who, with the aid of a color bar, can best determine how the color should be corrected.

Color Bar. Most proofs carry a color bar consisting of the four process colors and usually including tints, overprints, slur bars, star targets, etc. Although of little concern to the designer, to the printer the color bar represents a simple and accurate means of quality control.

At a glance the printer can tell if the colors are accurate and if the proper amount of ink is being carried on each plate. If necessary, the color strength can be measured with a densitometer. Any variation in the color strength will affect the printed piece. The color bar also shows such printing problems as poor trapping and dot gain.

Perhaps most important for the printer is the fact that the color bar is independent of the copy being reproduced and therefore represents a consistent guide.

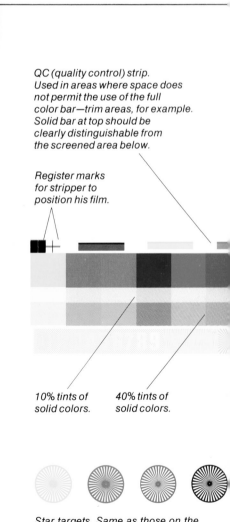

QC (quality control) strip. Used in areas where space does not permit the use of the full color bar—trim areas, for example. Solid bar at top should be clearly distinguishable from the screened area below.

Register marks for stripper to position his film.

10% tints of solid colors.

40% tints of solid colors.

Star targets. Same as those on the color bar except not squared off.

Correcting Proofs. Color corrections may be necessary, although adequate communication at the outset will minimize this need. Color proofs should be carefully checked, most importantly for such obvious things as correct size, sharpness, imperfections, spots, scratches, and for accuracy of color.

Unless you are very familiar with the four-color process it is often difficult to say specifically what is wrong with a color. For example, the fact that something appears too blue does not necessarily mean the printer used too much cyan; it could mean that one of the other colors is not printing properly, making the blue appear too strong. Fortunately, it is not the designer's job to tell the printer how to correct the color, but simply to indicate what is wrong.

An important factor in color correcting and color communication between designers, printers, and clients is the light under which the job is viewed. Most printers use a standard light source (5,000° Kelvin) for both the transparency viewer (light box) and the overall lighting. This means that everyone in the printing plant views the color under the same conditions.

Ideally, the designer, or whoever corrects the color, should view the printed image under the same lighting conditions. Many large agencies and studios have areas set aside that are specially lighted and painted a neutral color (Munsell gray) for viewing proofs. The reason for neutral gray is to reduce the effect reflected light might have on one's color judgment.

Although a number of people may wish to see the proofs, only one person should have the responsibility for correcting them. Each person sees color differently, and it could confuse the printer if each corrected the proofs.

Corrections, or specifically, instructions on what you are looking for, should be written clearly on the proof. This marked proof becomes the printer's working guide. Be sure to give the printer ample time to make corrections; remember, extensive corrections may involve dot etching (chemically or electronically altering the size of the dots) or even making new separations.

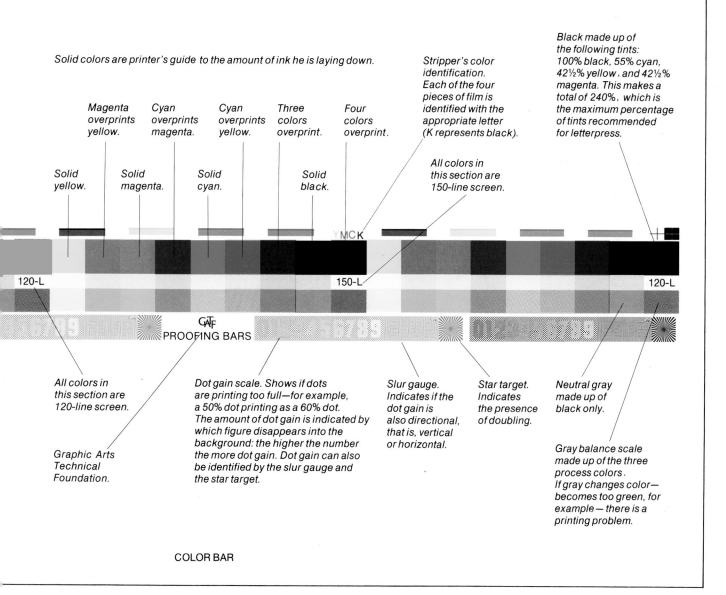

Solid colors are printer's guide to the amount of ink he is laying down.

Magenta overprints yellow.

Cyan overprints magenta.

Cyan overprints yellow.

Three colors overprint.

Four colors overprint.

Stripper's color identification. Each of the four pieces of film is identified with the appropriate letter (K represents black).

Black made up of the following tints: 100% black, 55% cyan, 42½% yellow, and 42½% magenta. This makes a total of 240%, which is the maximum percentage of tints recommended for letterpress.

Solid yellow.

Solid magenta.

Solid cyan.

Solid black.

All colors in this section are 150-line screen.

120-L 150-L 120-L

PROOFING BARS

All colors in this section are 120-line screen.

Graphic Arts Technical Foundation.

Dot gain scale. Shows if dots are printing too full—for example, a 50% dot printing as a 60% dot. The amount of dot gain is indicated by which figure disappears into the background: the higher the number the more dot gain. Dot gain can also be identified by the slur gauge and the star target.

Slur gauge. Indicates if the dot gain is also directional, that is, vertical or horizontal.

Star target. Indicates the presence of doubling.

Neutral gray made up of black only.

Gray balance scale made up of the three process colors. If gray changes color— becomes too green, for example — there is a printing problem.

COLOR BAR

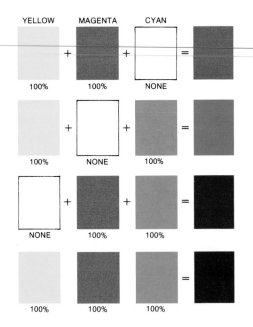

YELLOW	MAGENTA	CYAN	
100% +	100% +	NONE =	
100% +	NONE +	100% =	
NONE +	100% +	100% =	
100%	100%	100% =	

PROCESS COLOR AS FLAT COLOR

Although process color is used primarily for the reproduction of full-color continuous-tone images, it can also be used to reproduce black-and-white line copy in color. This is possible because many flat colors can be approximated by combining various tints of the four process colors. This technique is commonly used for jobs such as ads, posters, magazines, and book covers.

Note: When combining process-color tints, keep in mind that the more ink applied to the paper's surface, the muddier the colors become. The total percentage of tints should not exceed 240%. For example, 100% yellow, 100% magenta, and 40% cyan would be acceptable, whereas 100% yellow, 100% magenta, and 100% cyan would not be.

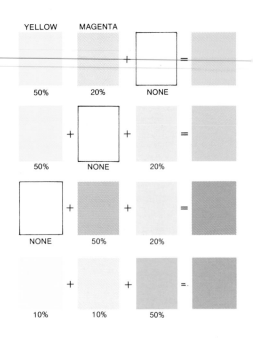

YELLOW	MAGENTA		
50% +	20% +	NONE =	
50% +	NONE +	20% =	
NONE +	50% +	20% =	
10% +	10% +	50% =	

Johannes Gutenberg Kupferstich 1584

TIPS AND SUGGESTIONS

Four-color printing is an art that calls on the skills of the photographer, the plate-maker, and the printer. The designer, too, can contribute a great deal to the success of a job.

One way to help achieve high-quality color printing is to start with the best original copy possible, whether reflective copy or transparent copy. Given a choice between reflective copy and transparent copy, most printers would rather work from transparencies. They are easy to handle, can be separated either photographically or electronically, and because they are small, they can be ganged-up to reduce costs.

When working with color transparencies it is advisable to use the larger sizes. Although it is possible to get good reproductions from some 35mm transparencies, the results are generally much sharper with 4" x 5" or 8" x 10" transparencies. This is because the emulsion in the 35mm transparency can appear grainy when enlarged too much or when the photo is out of focus.

To get a good transparency you must work with a good photographer; the best and least expensive time to control the color, the lighting, and overall quality is during the shooting. Ask the photographer to bracket the shots (shoot at different exposures), then with your printer choose the best one. If you have a choice between a light transparency and a darker one, choose the darker. Generally speaking, the darker, or fuller, transparency will produce better results than the lighter transparency, which could appear washed out. If you are not satisfied with any of the transparencies, consider retouching or reshooting the job. The cost of reshooting will probably be less than the cost of extensive color correcting.

Before releasing transparencies for separation, check them carefully for imperfections such as scratches. High-quality originals not only reduce or eliminate the need for corrections, but they also save time and money.

If you have a transparency with imperfections, have it retouched by a professional. Another way is to make a full-color print (a dye transfer, C-print, or Cibachrome), retouch that, and then use it for separations.

When comparing a transparency to the printed image, or proof, don't expect the printed image to match the brilliance of the transparency. Allowances must be made for the fact that the transparency is viewed by light passing through it, which gives the color a brilliance that could never be matched by ink on paper. On the other hand, when comparing a color print or painting against a proof, the proof should be a close match because both are reflective copy.

Keep in mind that some colors, especially violets and reds, are difficult, if not impossible, to match. At times you may find it wise to accept the color, if it is well balanced, even if it doesn't match the transparency exactly, rather than incur the time and expense of color correcting. This is especially true in cases where it is impossible to check the transparency against the original subject.

1. 75% Y, 10% M
2. 50% Y, 10% M, 50% C
3. 50% Y, 10% M, 100% C
4. 100% K

1. 50%M, 75% C
2. 100% Y, 75% M, 75% K
3. 25% M
4. 100% Y, 100% M
5. 100% Y, 25% M

1. 100% Y
2. 100% C
3. 100% K

1. 75% Y, 100% C, 75% K
2. 75% Y, 50% M, 5% K
3. 10% Y, 50% M
4. 100% Y, 50% M, 75% C

1. 100% Y, 100% M
2. 100% Y, 100% C

1. 50% M, 100% C
2. 75% Y, 50% M
3. 75% M, 100% C
4. 75% Y, 10% M, 50% C
5. 100% K

Calumet 4" x 5" view camera.

Tints used for illustrations on the opposite page.

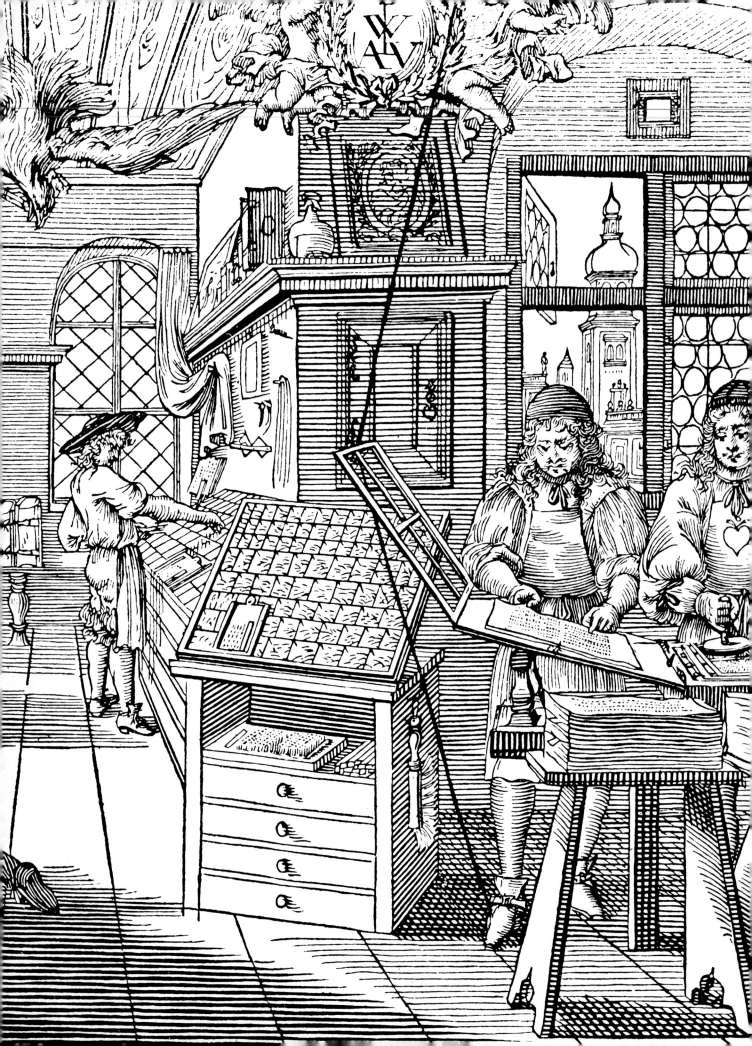

ABRAHAM VON WERDT

Inks

Inks must serve a wide range of printing needs: letterpress, gravure, offset lithography, flexography, and screen printing, to name just a few. Inks must also be capable of printing on a variety of surfaces, such as paper, cardboard, plastic, foil, glass, textile, and metal. Although the designer is not responsible for the preparation of printing inks, it does help to understand what they are made of, the different ink-drying processes, and how ink behaves when used with different printing processes and printing surfaces.

17th century print shows type being inked.

Basic Ingredients of Ink

Printing inks, in one form or another, have been around since long before Johann Gutenberg invented printing with movable type. Three hundred years before Christ, the Chinese were using inks to print with wooden blocks. One of the earliest ink formulas included lamp-black, glue, and water. This was later improved somewhat by the addition of linseed oil, but it was not until the late 19th century, with the introduction of synthetic oils and man-made resins, that the quality of printing inks was greatly improved.

A series of woodcuts showing the early Chinese ink-making process.

1. Manufacturing lampblack.

2. Straining the glue.

3. Pounding the ink.

The specific ingredients used in the manufacture of printing inks are dictated by many factors—the printing process, the ink-drying system, the surface to be printed, etc.—however they can be broken down into three categories: pigment, vehicle, and miscellaneous ingredients (mainly driers and compounds).

Pigment. The fine, solid particles that give printing ink its color. In addition to determining color, pigment contributes to the ink's opacity and permanence. It is also the pigment that determines whether the printed page will bleed if wet. Pigments can be organic or inorganic.

Vehicle. The liquid ingredient into which the pigment and other ingredients are mixed. The function of the vehicle is to act as a carrier for the pigment, and as a binder to affix the pigment to the printed surface. It is also partially responsible for the gloss and hardness of the dried ink film. To a great extent the vehicle determines the "body" of the ink; that is, the viscosity, consistency, and flow characteristics (fluidity) of an ink. Inks with rapid flow characteristics are called "long"; those with slow flow characteristics are called "short." The type of printing process and drying system determines the type of vehicle used. Some of the more popular vehicles are based on drying oils, rosin resins, petroleum oils, synthetic resins, and organic solvents (e.g., alcohol).

Miscellaneous Ingredients. One of the most important ingredients that all oxidizing inks must have is a drier. (The process of drying ink by oxidation will be discussed on page 117). This is usually made from oil, a metallic salt, or a mineral compound and is added to the ink to help it dry more rapidly.

Waxes and compounds are added to prevent set-off and sheet sticking, and to improve scuff resistance. Greases, lubricants, reducing oils, and solvents are used to reduce tackiness and aid penetration and rapid setting. Body gums and binding varnishes help inks print more sharply, improve drying, and prevent chalking. Antiskinning agents reduce excessive drying and skinning on press and in storage. Cornstarch adds body to the ink and prevents set-off.

Because every pigment-vehicle combination behaves differently, the addition of these ingredients is carefully controlled; what is effective in one case may be harmful in another.

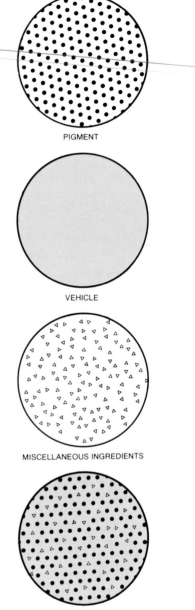

PIGMENT

VEHICLE

MISCELLANEOUS INGREDIENTS

INK

Ink-Drying Processes

Before inks dry they "set." Setting is the initial stage of the drying process in which the printed sheets, though not fully dry, can be handled without smudging. The ink is considered dry when the ink film is converted to a solid state and is absolutely dry to the touch.

Perhaps the best way to understand the ink-drying process is to think of the ink as a fresh coat of paint on a board. Part of the paint is absorbed into the wood, part of it gels (polymerization), and the rest dries by evaporation.

Drying is brought about by one, or more usually by a combination, of: absorption, evaporation, oxidation/polymerization, and precipitation.

Absorption. Also called *penetration*. The ink used is usually quite thin, and the vehicle, which is nondrying, is absorbed by the inner fibers of the paper, where it stays damp for some time. Meanwhile, the pigment remains on the surface. This is the ink-drying process used by most newspapers, which explains why one's fingers are always so dirty after reading a newspaper.

Evaporation. Also called *volatization*. Used in gravure and flexography: the ink is dried principally by the evaporation of the solvent from the ink, leaving behind a solid film of resin and pigment. The evaporation drying process is used with or without heat. Screen printing and die stamping inks, as well as heat-set ink (a specialty ink discussed on page 119), are also dried by evaporation.

Oxidation/Polymerization. A two-step ink-drying method used for most offset and letterpress inks. Oxygen is absorbed by the drying oil portion of the vehicle (oxidation), followed by a cross-linking of molecules (polymerization), causing the ink film to gel and then harden.

Precipitation. A drying method in which the printed piece is subjected to water in the form of steam, a fine mist, or merely the moisture in the atmosphere. The water moisture causes the binder to be thrown out of the solution (precipitated), binding the pigment firmly to the paper. Commonly used for steam-set and wax-set inks.

The correct ink drying system is determined by the printing process, press speed, web weight, and ink cover. While working to increase the overall efficiency, manufacturers are also developing improved exhaust systems to meet EPA standards.

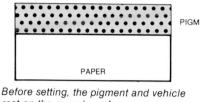

Before setting, the pigment and vehicle rest on the paper's surface.

After setting, the vehicle seeps into the paper, leaving the pigment on the surface.

A 31-foot natural-gas fired, hot-air web dryer designed for press speeds of 2,000 feet per minute. After leaving the press, the web passes through the dryer riding on a cushion of air.

Ink and the Printing Process

Each printing process requires an ink with different characteristics. The ink used is also determined by the kind and speed of the press, the surface to be printed, and the end use of the printed piece. Let's examine some of the inks used for the more common printing processes, and the specific properties of each.

Letterpress Inks. Designed to print from a raised surface. Letterpress inks must be tacky and viscous enough to hold to the surface of the plate until printed. In addition to this, each type of letterpress printing press requires an ink with a different combination of ingredients. The platen press uses an ink that does not flow freely and is very tacky; cylinder press inks flow more freely and are less tacky; rotary press inks are the least tacky. Another reason for using longer inks on the rotary press is its high speed; the higher the speed of the press the thinner the inks must be. Letterpress inks can be dried by absorption, evaporation, or oxidation/polymerization.

Gravure Inks. Designed to print from a depressed surface. Gravure inks must be very fluid to fill the thousands of tiny wells, and at the same time have enough body and adhesion to be pulled from the wells onto the paper. Gravure inks should be totally free of hard particles that might scratch the engraved cylinder or plate. The consistency of the ink must be maintained to permit the doctor blade to properly clean the plate and ensure a proper transfer of the printed image to the paper. Gravure inks are quick-drying and are usually dried by evaporation. (They can also be dried by absorption.) Because of the highly volatile solvents used in gravure inks, they must be handled with care.

Offset Lithography Inks. Designed to print from a flat surface. "Litho" inks are usually longer and more viscous and heavy bodied than letterpress inks. Offset inks must be resistant to the dampening action of the water used in offset printing. They must also be non-bleeding. Because the film of ink deposited on the surface of the paper is about half as thick as that of letterpress, the inks must be strong in color to compensate. To supply the proper ink for offset, the inkmaker must know if it is to be used on a one-color, two-color, or four-color press, and also the order in which the colors are to be printed. Offset inks are usually dried by evaporation, oxidation/polymerization, or penetration.

Screen Printing Inks. Designed to be forced through a mesh screen onto a wide range of surfaces such as paper, cardboard, metal, ceramic, and glass. Screen printing inks are short and buttery. To ensure good adhesion, the binder must be changed to suit the surface being printed. The thickness of the ink film is controlled by the mesh size. To avoid clogging the screen, it is important that the solvents used in the ink do not evaporate too rapidly.

Flexography Inks. Another form of letterpress printing which employs rubber plates and solvent or water-based inks designed to print on a wide range of surfaces, including paper, cellophane, plastic, and metal foil. Flexography ("flexo") is extremely popular in the packaging industry; the ink colors are bright, strong, opaque, and can be made resistant to light and abrasion. Flexography inks are very fluid and fast-drying and can therefore be printed at high speeds. Most flexography inks have an organic solvent base and are dried by evaporation; others have a water base and are dried by either absorption or evaporation.

Letterset Inks. Just as letterset is a combination of letterpress and offset lithography, letterset inks are a combination of letterpress and offset inks. Letterset inks are transferred from printing plate to blanket to paper on a special offset press that does not require the use of a fountain. Because no fountain solution is used, there is more latitude in the vehicle and pigment that can be used in the making of the ink. The thickness of the ink film is usually greater than that used in regular offset printing. Letterset inks are dried in the same way as letterpress and offset inks.

Inks, Varnishes, and Laminations

Specialty inks are the result of the ever-increasing demand for brighter colors, higher speeds, and new printing techniques. The following are some of the more commonly used specialty inks, varnishes, and laminations:

Cold Set. Unlike all other inks, cold-set inks are solid at room temperature, but melt at 150° to 200°. The printing plate and the press must first be heated to melt the ink. When printed on the relatively cold paper, the ink immediately reverts to its solid state. There is no smudging, no set-off and the printing is almost tack-free. Cold-set inks produce sharp printing results, however they require a complicated heating and cooling system.

Fluorescent. Available in a rather limited range of a few reds, yellows, blues, and greens. Fluorescent inks are bright and vibrant, but they require two passes to achieve full color. Day-Glo is one brand of fluorescent pigment whose formula is the most widely used today. Fluorescent inks are most widely used for screen printing signs.

Heat Set. A fast-drying ink that permits large, high-speed, high-quality runs. To use heat-set inks, the press must be equipped with a heating unit, cooling rolls, and an exhaust system. As the printed sheet passes over the heating unit the solvent is evaporated, leaving only an ink film, which dries almost immediately. Used for printing almost any job involving long runs.

High Gloss. Made possible by the development of a vehicle that permits only a minimal penetration of the paper's surface and ensures a maximum gloss. For the best results and highest possible gloss, the paper used should be coated or cast-coated stock with a surface resistant to the penetration of the vehicle. The drying of high-gloss inks should be done with the least amount of heat in order not to reduce the gloss. Available for both letterpress and offset.

Lamination. There are three types of laminations: *liquid*, *UV* (ultra-violet), and *film*. Laminations are totally different from varnishes and are used more as a means of protection and to achieve a higher gloss. For this reason laminations are popular with book jackets, annual reports, magazine covers, etc.

The liquid lamination process lays down a coating of clear, liquid plastic on the surface of the printed piece. UV is a silk-screen process, while film laminating bonds a sheet of clear plastic to the surface. Film lamination, while the most expensive, offers more strength, protection, and longevity than liquid or UV.

Magnetic. These inks are made with special pigments which can be magnetized after printing. The printed characters can then be recognized by electronic reading equipment. In order to be successful, the printing must be of high enough quality to meet the rigid requirements of the equipment. Magnetic inks are used a great deal for such jobs as bank checks and business forms.

Metallic. Metallic powders such as bronze, gold, aluminum, and copper are suspended in the vehicle, which also serves to bind the powders to the surface of the paper. When preparing gold inks (the pigment is actually bronze powder), the bronze powder and vehicle must be mixed just before printing because the bronze has a tendency to tarnish rapidly once the ink is mixed. Metallic inks are also available in a metallic paste, which makes far less of a mess.

Moisture Set. These inks are created in such a way that when the printed surface is subjected to water, usually in the form of steam or a fine spray, the binder is thrown out of the solution (precipitated), binding the pigment to the paper. Moisture-set inks are relatively odor free and are popular with the food-packaging industry for such things as bread wrappers, milk containers, and paper cups. Moisture-set inks dry principally by precipitation.

News. Generally used on web presses for printing newspapers, these inks have a fluid consistency that must be adjusted to the type of press, press speed, and stock. News inks are made of inexpensive raw materials (mineral oils and carbon blacks) and are generally dried by absorption. As newspaper is uncoated and has a rough surface, it permits the ink to penetrate readily.

Quick Setting. Primarily designed to prevent set-off. After the ink has been printed the vehicle rapidly penetrates the paper, leaving a film of ink that dries almost immediately on the surface. This permits printing at high speeds and also reduces the time required before printing the reverse side of the printing surface. Quick-setting inks, which have a high gloss, are most effective when printed on enamel or cast-coated stocks, and they may be used for both letterpress and offset.

Scuffproof or Rubproof. Hard-drying inks made particularly for labels, cartons, box wraps, or any printed pieces that can be marred by rubbing against one another or against the sides of a shipping container.

Varnish. There are two types of varnish: *dull*, or *matte*, and *gloss*. Used with imagination, varnishes can create spectacular results, whether to enhance individual images or entire backgrounds. They can be run as a flat panel or halftone. Some designers are even experimenting with tinted varnishes where a little pigment is added to the varnish. Varnishes are handled the same as inks and require their own plate on the press. While there are no hard-and-fast rules, varnishes do work better on coated stocks. Varnishes do tend to yellow with time and reduce the metallic look when printed over metallic colors. Varnishes are also a must when running matte inks, to reduce scuffing. A designer would be wise to discuss the use of varnish with the printer before proceeding with a job.

Waterbase Systems. Generally used to print corrugated containers and wallpaper, greeting cards, and novelties. Waterbase inks require special rollers on press and can be washed with water after printing. There is also a trend toward waterbase inks in newspaper printing.

Wax Set. A specially prepared vehicle permits this ink to set and dry immediately when immersed in a bath of molten wax. It was developed to fulfill the need for faster printing and handling of bread wrappers and other wax papers.

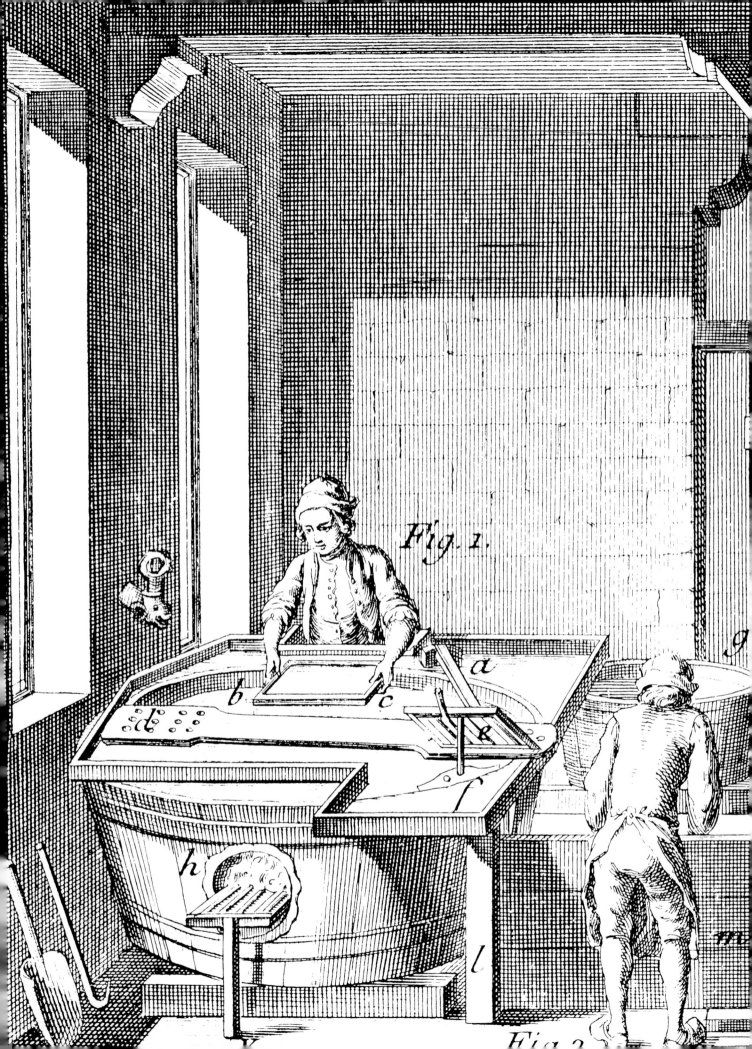

Fig. 1.

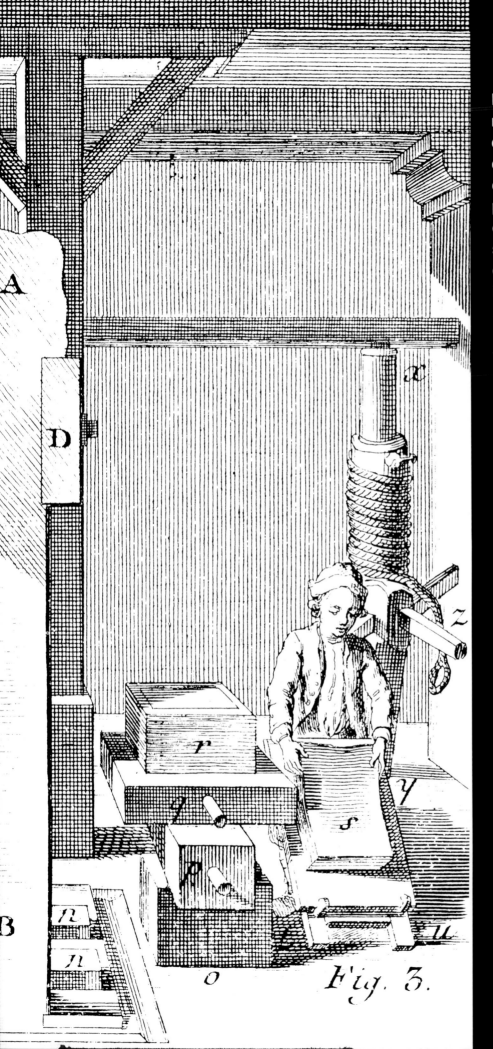

Paper

Paper is one of the designer's main considerations, and the designer will be expected to choose the "right" one from an enormous range of available papers. This choice will be easier if the designer understands the properties and characteristics of paper: what it is made from, how it is made, and the processes that make one paper different from another.

An 18th century French paper-mill. The vatman (Figure 1) forms the sheet of paper in the mold, from which it passes to the coucher (Figure 2), who places the sheet between felts to absorb excess water. The sheets are then squeezed in a large press, after which the layer (Figure 3) separates them from the felts.

History of Paper

The word "paper" is derived from the Greek word *papyrus*, meaning reed. The predecessor of true paper was developed by the Egyptians around 300 B.C. It was made by weaving reeds together, soaking them in water, and pounding them to the desired smoothness and thickness.

The invention of paper as we know it has been credited to Ts'ai Lun, in China, in the year A.D. 105. In Chinese papermaking, tree bark, rags, or other fibrous materials were beaten until they formed a pulpy substance. This was mixed with water in a large vat. Then a shallow, porous mold was dipped into the pulp; as the mold was lifted up, the water drained away through the sievelike bottom, leaving behind a mat of fibers. When removed from the mold and dried, this mat of fibers became a sheet of paper.

The papermaking craft passed from the Chinese to the Arabs in the 8th century, and from the Arabs to the Spanish in the 12th century. Other countries were slow to follow: papermaking arrived in Italy in the 13th century, in France in the early 14th century, and in Germany in the late 14th century. It was 1495 before papermaking was established in England, and 1690 before the first American paper mill went into operation.

Papermaking has come a long way since Ts'ai Lun. Although some papers are still handmade, most are made on enormous papermaking machines. These machines are several hundred feet long and produce a continuous sheet of paper called a "web."

In spite of its progress, the process of papermaking still consists of removing the water from a mixture of fibers and water to form a fibrous mat.

Illustrations from Kamisuki Chohoki's 18th century A Handy Guide to Papermaking *clearly show the basic principles involved in making paper.*

1. Cutting branches.

2. Boiling bark.

6. Drying inner bark.

7. Washing bark.

11. Diluting pulp.

12. Making a sheet of paper.

3. Peeling bark.

4. Peeling inner skin.

5. Soaking inner bark in lye.

8. Boiling bark in lye.

9. Washing bark again.

10. Beating bark to pulp.

13. Applying sheet to drying board.

14. Trimming sheets.

15. Packing finished paper.

Papermaking

Three ingredients are required to produce paper: water, power, and cellulose fibers. Cellulose fibers are found in trees, grass, cotton, bamboo, sugar cane, etc. At one time or another paper has been made from all of these. Today, the most common sources of cellulose fibers are wood, rag (including raw cotton fibers), and old paper.

The choice of fibers determines much of the paper's basic characteristics. For example, pulp from softwood trees has long fibers, which gives paper strength; pulp from hardwood trees has short fibers, which gives paper bulk and body. Rag pulp, on the other hand, contains fibers that are not only longer and stronger than wood fibers, but which are also freer of impurities, resulting in a stronger paper.

Most papers are made from a blend of various wood fibers and occasionally a mixture of rag and wood fibers. And with today's emphasis on conservation and ecology, there is an increasing demand for recycled paper. Once treated to remove impurities such as inks and dyes, old pulp paper can be made into excellent "new" paper.

Other sources notwithstanding, trees are by far the most common source of cellulose fibers. There are two basic processes by which trees are reduced to pulp. One is a mechanical process, the other a chemical process.

Hardwood:	leaf bearing	short fiber	even formation	less strength	greater bulk
Softwood:	needle bearing	long fiber	coarse formation	greater strength	less bulk

Hardwood (partial listing): birch, beech, maple, elm, ash and some oak.

Softwood (partial listing): white pine, hemlock, spruce, and fir.

MECHANICAL PROCESS

This is the simplest and most economical way to reduce trees to pulp. Pulp made by the mechanical process is called *mechanical* or *groundwood pulp*. The tree is cut into logs four feet long and the logs are tumbled against one another in huge drums to remove the bark. Any remaining scraps of bark are blasted away by high-pressure jets of water. The logs are then ground into tiny particles by a huge grindstone.

Because the grinding action reduces the fiber length, groundwood pulp does not produce a strong paper. Also, because the entire log is used, groundwood pulp contains undesirable elements such as resins, lignins, and gums, which cause the paper to yellow and become brittle with age. But because the entire log is converted into pulp, the mechanical process is a low-cost, high-yield method of producing paper. And although groundwood pulp lacks strength and permanence it does have good absorbency, bulk, and opacity. The largest users of groundwood pulp are newspapers, for whom the low quality and short life of the paper are not drawbacks.

Tree reduced to logs.

De-barked logs ready for the grinder.

Old grindstones.

Cross-section of a tree.

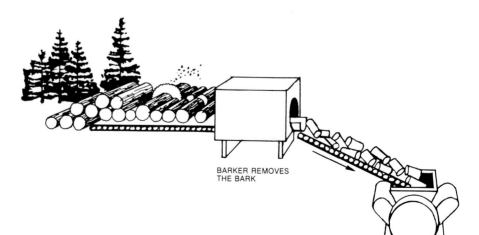

BARKER REMOVES
THE BARK

GRINDER

CHEMICAL PROCESS

As the name implies, the chemical process involves the use of chemicals and produces what is called *chemical pulp*. As in the mechanical process, the tree is cut into logs and stripped of its bark. This time, instead of being ground into tiny particles, the logs are reduced to small chips by powerful rotating knives. The chips are then fed into a huge silolike "digester" where they are pressure-cooked in chemicals (sulfite, sulfate, and soda). This chemical action reduces the chips to a mass of individual fibers by dissolving the lignin that holds the fibers together.

Chemical pulp produces a stronger, brighter, more permanent paper than groundwood pulp and is used in the majority of high-quality papers. Unfortu-nately, compared with the mechanical process the chemical process yields much less pulp from the same amount of wood. This in part explains the high cost of fine papers compared with that of newsprint.

Washing, Screening, and Bleaching. After the wood has been reduced to pulp, it is washed, screened, and bleached to remove any remaining impurities that may produce undesirable qualities in the paper. Impurities can cause paper to discolor, affect its permanence, and even affect its performance on the printing press. Without being washed, screened, and bleached, the pulp at this stage could not be made into a white enough printing paper for the majority of our needs.

Beating. The pulp, or blend of pulps, is now ready for the beating process, also called refining or stock preparation. Beating accomplishes two things: it roughens, or frays, the fibers to give them a greater surface attraction, and it extracts a gelatinous substance from the fibers that helps bond them together when the paper is made. It is also at this stage that the basic nature of the paper is determined: if the duration of the beating is short, the paper will be soft, bulky, and opaque (similar to blotting paper); if the beating duration is long, the paper will be hard, thin, smooth, and less opaque.

Stock Preparation. Although the pulp at this stage is highly refined, it is still not ready to be made into paper. To give the

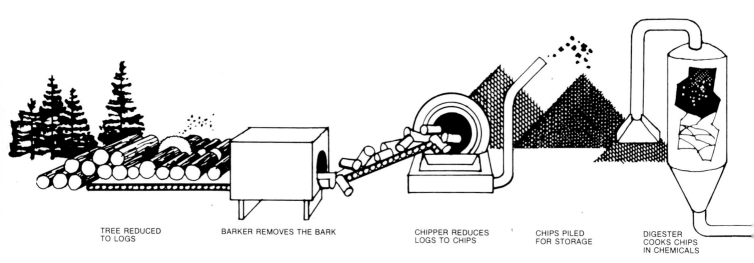

TREE REDUCED TO LOGS BARKER REMOVES THE BARK CHIPPER REDUCES LOGS TO CHIPS CHIPS PILED FOR STORAGE DIGESTER COOKS CHIPS IN CHEMICALS

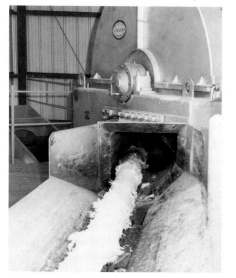

De-barked log.

Chips.

Digesters.

paper smoothness, opacity, and resistance to moisture, "additives" such as fillers, sizing, and coloring (dyes) are added. As we shall see, making paper is like making a cake, with each grade of paper having its own recipe. It is what goes into the batter that dictates the end product:

Fillers. Also called *loading agents*, these are fine mineral pigments that fill in the spaces between the fibers to create a smoother, more uniform surface. They also increase opacity and improve printing qualities. The most common filler is clay, which is naturally white. Other fillers are calcium carbonate and titanium dioxide.

Sizing. Also called *size*, this is an essential ingredient in most printing papers. The size holds the fibers together and makes the paper resistant to the penetration of water and ink, so that the ink will not run when we write or print on paper. The most common sizing is either rosin (acid) or alkaline agents, which is usually added during the beating process.

Another form of sizing, called *surface sizing*, is applied to the surface of the paper while it is still on the papermaking machine. Surface sizing is frequently starch, and its function is to bind down the fibers of the paper to produce a smoother printing surface.

Sizing is particularly important when printing by offset lithography because it prevents fibers from sticking to the blanket and interfering with the printing.

After the additives have been added, the pulp is mixed with huge quantities of water—approximately 1% pulp to 99% water—to form a milklike suspension called "furnish." The furnish is held in a large container called a "head box," which is situated at the head of the papermaking machine. From here the journey begins through the next four stages of the papermaking process: forming, pressing, drying, and calendering.

BLOW TANK REDUCES CHIPS TO FIBERS

WASHER REMOVES IMPURITIES

SCREEN REMOVES KNOTS, SPLINTERS, ETC.

BLEACHING TOWER WHITENS PULP

PULP IS BEAT, REFINED, AND ADDITIVES ADDED

TO HEAD BOX →

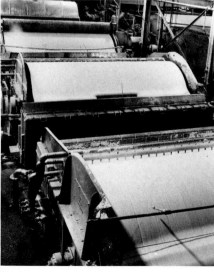

Washers.

Refiners.

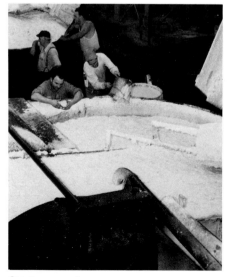

Stock preparation.

Forming. This is the process by which the furnish becomes a sheet of paper. Forming takes place on the section of the papermaking machine called the Fourdrinier (named after the Englishman who developed it in the early 1800s). The Fourdrinier, more commonly referred to as the "wire," is a huge, continuous belt of finely woven wire or plastic cloth supported by rollers or foils.

The furnish is released from the head box onto the wire. As the wire moves forward it vibrates from side to side. The vibration and the suction from beneath the wire drain off excess water and cause the fibers to interweave, forming a continuous web, or sheet, of paper. The amount of furnish released from the head box, together with the speed of the wire, dictate the weight of the paper: the more

furnish and the slower the wire, the heavier the paper will be.

As the sheet is being formed, the underside (the wire side) takes on the texture of the wire: if the wire is coarse, the texture will be coarse; if smooth, the texture will be smooth. To make the top of the sheet (or felt side) match the underside, a huge cylinder called a "dandy roll" is used. The dandy roll, which is the width of the wire, is covered with a woven mesh similar to the wire. As the sheet travels along the wire it passes under the dandy, which levels the fibers and imparts its texture to the paper. Papers formed with this type of dandy are known as *wove* papers.

Another type of dandy imparts a grid pattern of horizontal and vertical lines onto the paper. Papers made with this

type of dandy are known as *laid* papers and are an imitation of the first hand-made papers.

The dandy roll is also used to create watermarks. This is done by adding a raised wire watermark design to the dandy roll. When the pattern comes into contact with the paper it presses down the fibers, making the area it touches thinner and therefore more transparent. Watermarks and laid marks are actually planned imperfections in the paper-making process.

Pressing. After forming on the wire, the sheet is still 80% water. To reduce the water content, the sheet, supported by a felt belt, is fed through a series of three presses. Each press consists of two rollers, one directly above the other. As

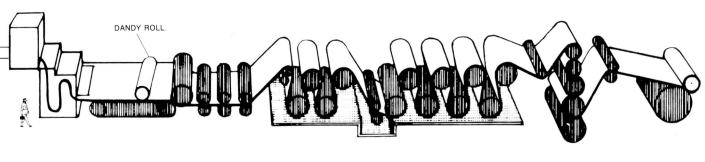

DANDY ROLL.

HEAD BOX STORES AND METERS PULP ONTO WIRE

FOURDRINIER, WHERE PAPER IS FORMED

PRESS SECTION REMOVES EXCESS WATER

ON-MACHINE COATING OR SIZING

DRYING SECTION DRIES THE SHEET

CALENDER STACK SMOOTHS PAPER'S SURFACE

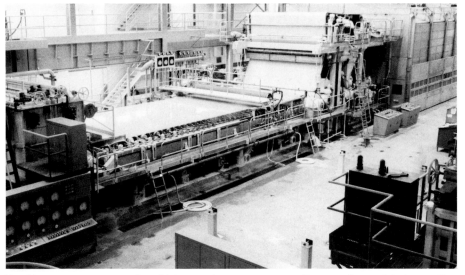

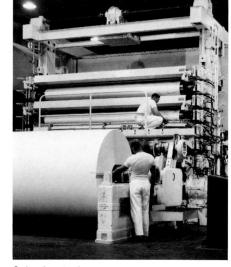

Head box. *Fourdrinier, or wire.* *Press section and drying section.* *Calender stack.*

the paper is pressed between the rollers, the water is squeezed out of it. It is also during the pressing stage that specially woven felt belts can be used to give the paper a "felt finish."

Drying. The sheet, which is still 70% water, is fed directly from the presses to the dryer. The dryer consists of a series of steam-heated cylinders approximately four feet in diameter. These are mounted in two rows, one above the other, but staggered so that no cylinder is directly above another. The paper is carried by an asbestos felt belt which is threaded in such a way as to permit both sides of the paper to come in contact with the heated cylinders. After leaving the dryer, the paper contains from 4% to 6% water. This amount of water in the paper is

necessary to ensure good printing and folding characteristics and to keep the paper in balance with the relative humidity of the atmosphere.

Calendering. From the dryer, the paper is passed, under pressure, through a vertical stack of highly polished cast-iron rolls, called *calenders*. The function of the calenders is to increase the smoothness and gloss of the surface of the paper, an operation not unlike ironing a freshly laundered shirt. The degree of smoothness is dictated by the number of calenders (or "nips") the paper is run through. The more calenders, the smoother the surface of the paper and the higher the gloss.

It is interesting to note that from the time the pulp is poured from the head

box until it becomes a finished sheet of paper, often less than two minutes have elapsed.

Slitting and Sheeting. After calendering, the web is wound into large rolls. These rolls are then slit as they are rewound. At this point, these smaller rolls can be shipped out for web printing or they can be transferred to the sheeting department of the mill to be cut into sheets for use on sheet-fed presses.

Special Finishes. Not all papers are finished on the papermaking machine; some require further finishing off-machine, such as additional coating, super-calendering, and embossing. These finishes are discussed later in this section.

PAPER IS WOUND
INTO LARGE ROLLS

SLITTER SLITS LARGE ROLLS
INTO SMALLER ROLLS

SHEET CUTTER CUTS
ROLLS INTO SHEETS

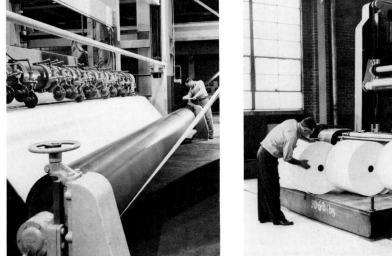

Slitter.

Slit rolls.

Inspection of sheets.

Characteristics of Paper

All papers have characteristics in common, which when understood should help the designer choose the right paper for the job. The six basic characteristics of paper are grain, weight, bulk, opacity, color, and finish.

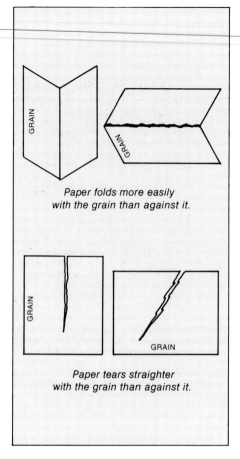

Paper folds more easily with the grain than against it.

Paper tears straighter with the grain than against it.

	BOOK 25 x 38	BOND 17 x 22	COVER 20 x 26	INDEX 25½ x 30½
EQUIVALENT WEIGHTS (basic weights in bold type)				
BOOK	**30**	12	16	25
	40	16	22	33
	45	18	25	37
	50	20	27	41
	60	24	33	49
	70	28	38	57
	80	31	44	65
	90	35	49	74
	100	39	55	82
	120	47	66	98
BOND	33	**13**	18	27
	41	**16**	22	33
	51	**20**	28	42
	61	**24**	33	50
	71	**28**	39	58
	81	**32**	45	67
	91	**36**	50	75
	102	**40**	56	83
COVER	91	36	**50**	75
	110	43	**60**	90
	119	47	**65**	97
	146	58	**80**	120
	164	65	**90**	135
	183	72	**100**	150
INDEX	110	43	60	**90**
	135	53	74	**110**
	170	67	93	**140**
	208	82	114	**170**

Grain. The grain of the paper is the direction in which the fibers line up when the sheet is made; it is in this direction that the paper folds and tears most easily. If the grain runs lengthwise the paper is called "grain-long"; if it runs across the width, the paper is called "grain-short." The direction of the grain is a most important consideration when ordering paper, because it affects foldability and printability. The grain on the page you are now reading runs parallel to the binding—that is, grain-long—which enables the pages to be turned easily.

There are a number of ways to determine the direction of the grain in a piece of paper. One is to simply tear a sheet of paper across and then down; it will tear most easily, and straighter, with the grain. Another test, which works well for uncoated papers, is to tear off a corner and lick it; after a few seconds it will curl in the direction of the grain.

Weight. Known as *basis weight*. This is the weight in pounds of 500 sheets of standard-size paper. The size of the sheets weighed is determined by the type of paper. For example, the standard size of bond paper is 17" x 22"; of newsprint, 24" x 36"; of book papers, 25" x 38"; of cover stock, 20" x 26". Typical weights of book papers are as follows: 30, 40, 45, 50, 60, 70, 80, 90, 100, and 120 lbs. The book you are now reading is printed on 80-lb. paper (500 sheets of 25" x 38" book paper weighs 80 lbs.).

If you were designing a job and wished to use another grade of paper than that used in this book, but one of equivalent weight, you would refer to the above table under 80-lb. book paper. You will see that a 31-lb. bond, a 44-lb. cover, and a 65-lb. index are all approximately the same weight.

BULK FOR 70-LB. UNCOATED		
Finish	**PPI**	**Caliper**
Antique	274	29.2
Eggshell	318	25.2
Machine Finish	412	19.2
English Finish	474	16.9

BULK FOR 80-LB. UNCOATED		
Finish	**PPI**	**Caliper**
Antique	240	33.3
Eggshell	278	28.2
Machine Finish	360	22.2
English Finish	416	19.2

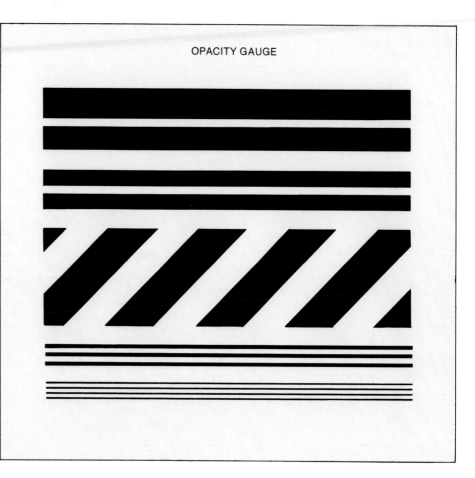

OPACITY GAUGE

Bulk. A term used to describe the thickness of paper. Generally speaking, the rougher the paper, the higher the bulk. There are two ways to measure bulk. The first is to measure the thickness of four sheets of paper (eight pages) with a micrometer. This measurement, called a *four-sheet caliper*, is given in thousandths-of-an-inch and is referred to as mils or points. A four-sheet caliper of the paper in this book measures 17.2 mils, or 17.2 points. However, the more common way to measure bulk, especially in book publishing, is to quote the "pages per inch" (PPI). The page you are now reading bulks at 390 PPI.

It is the bulk that determines the thickness of a book. There are two ways in which a designer can increase bulk: choose a heavier paper—replace a 60-lb. paper with a similar 80-lb. paper, for example—or choose a paper of the same weight with a rougher finish.

Opacity. The capability of a paper to take ink on one side without it showing through on the other. From the designer's point of view, this means that if the paper is not sufficiently opaque, the reader will be distracted by the printed material showing through from the other side, a condition called "show-through."

Opacity is affected by the paper's weight and bulk. The heavier and more bulky the paper, the more fibers there are to retard the passage of light and therefore the more opaque the paper is.

There are two kinds of opacity that can be measured: *visual*, which is the opacity of the unprinted sheet; and *printed*, which is the opacity of the printed sheet.

Visual opacity can be accurately measured by an opacimeter and is expressed in terms of percentage, 100% being totally opaque. No printing paper has 100% opacity, but some come closer than others. The visual opacity of this page is 97%.

Printed opacity presents a different problem. Because some papers absorb more ink than others (resulting in the ink being absorbed by the paper to the extent that it shows through on the other side in a condition known as "strike-through"), it is possible to have two papers with the same visual opacity but with different printed opacities.

Printed opacity is affected by the paper's ink holdout; that is, the paper's capacity to hold ink on the surface rather than absorbing it. The greater a paper's ink holdout, the higher its printed opacity.

Printed opacity cannot be measured in terms of percentages, only by the degree to which strike-through is present in a printed sheet. Printed opacity is generally referred to as being high, medium, or low. If you examine this page, you will see that in addition to its high percentage of visual opacity it also has a high degree of printed opacity.

The designer can also get a general idea of the opacity of paper by using an opacity gauge (shown above). The gauge is placed under the sheet of paper: the more difficult it is to see the gauge, the more opaque the paper. An opacity gauge is particularly handy when comparing unprinted papers.

LIMITS OF CONTRAST

PAPER=WHITE

INK=BLACK

You cannot have a highlight brighter than the paper nor a shadow deeper (darker) than the ink.

HOW FINISH AFFECTS THE BULK (PAGES PER INCH)

Finish	50 lb.	60 lb.	70 lb.	80 lb.
UNCOATED				
Antique	350–380	290–320	250–270	210–230
Eggshell	420–470	350–390	310–330	260–290
Machine Finish	520–580	440–480	380–410	330–360
English Finish	620–660	520–570	450–480	390–420
COATED				
Pigmented or Film-coated	590–610	430–450	400–420	370–390
Blade-coated	690–710	500–520	430–450	370–390
Conversion-coated (gloss)	*	*	560–580	470–490

*Not available: paper too light to support coating

Color. Printing papers are available in a wide range of colors and also in a wide range of whites. The "whiteness" of paper is controlled by the addition of bleaches, fluorescent dyes, pigments, and other additives. Whiteness ranges from cream-white to blue-white and encompasses every imaginable white in between. The color of the paper you choose will affect everything printed on it: an image printed on a cream-white sheet will look quite different from the same image printed on a blue-white sheet. Remember, the whiteness of the paper controls the whitest highlight of your reproduction; in other words, you cannot have a highlight brighter than the color of the paper.

Finish. Refers to the way in which the surface of the paper has been treated. For example, we have already seen how wove and laid finishes are applied by the dandy while the paper is forming on the papermaking machine and the felt finish, which is a rather toothy finish, is applied during the pressing stage. Uncoated papers are also finished on the paper-making machine during the calendering process. Coated papers are finished either on or off the papermaking machine. The more specialized finishes, such as pebble, ripple, and stucco, are done off the papermaking machine by special embossing rollers that emboss the finish on the paper.

The particular finish given to a sheet of paper affects its bulk: the more a paper is pressed and calendered the thinner it becomes, and therefore the less it bulks and the lower its opacity.

The finish is an important considera-tion for the designer. If the job to be printed involves small type, type with fine serifs, or fine halftone reproductions, a paper with a smooth finish is a good choice. If, on the other hand, the job to be printed is a book that is all text, and comfort of reading is the most important consideration, then a more textured stock may be the most appropriate. The same principle applies when choosing between a dull and a glossy finish: it is much more comfortable to read type on a dull finish than on a glossy finish; however color or halftones will appear more brilliant on a glossy stock than on most dull-coated stocks.

Printing Papers

Not all papers are used for printing; they are also used for wrapping paper, tissue paper, and paper bags, among other things. As designers, however, our main interest is in printing papers. These can be divided into four categories: newsprint, writing papers, cover papers, and book papers.

Rather than use the paper manufacturers' trade names, which are so numerous that they would confuse the reader, we shall use only generic names to describe the different papers in this chapter. Once the broad categories are understood, it is a simple matter for the designer to communicate needs to the paper manufacturer or merchant.

NEWSPRINT

Newsprint is one of the lowest grades of printing paper. It is made primarily from groundwood pulp with about 30% chemical wood pulp added for strength and color. Because the entire log is used to make the pulp, newsprint is a low-cost paper with good bulk and opacity. However, because of impurities in the paper, it has low brightness and a tendency to yellow and becomes brittle.

Newsprint is the least expensive of all the printing papers and is often used when permanence is not important. It lacks strength, has limited printing qualities, and tends to discolor. It is therefore generally used for newspapers, and mass market paperbacks.

WRITING PAPERS

Writing papers can be categorized as follows: bond, ledger, and various grades of business papers used for duplicating purposes. They are available in a wide assortment of colors and finishes.

Bond. This term was originally applied to papers of high strength and durability, such as those used for government bonds, stock certificates, and legal papers. Today, bond paper has a wide variety of uses, perhaps the most common of which is for writing paper. Among the essential qualities of good bond paper is an ability to take ink well and be easily erased.

Bond papers run from 100% rag content to no rag content at all. The usual rag fiber content is 25%, 50%, or 75%. The highest-quality bond papers are made of 100% rag fiber. Cotton fibers alone make an extremely strong, white paper, and when mixed with linen fibers they produce a paper of the highest quality. In fact, banknotes are printed on paper made from a mixture of cotton and linen fibers. Bond papers are available in a variety of colors.

Ledger. This paper frequently has a high rag content. It is a strong paper made to withstand a great deal of handling and folding, and is used for ledgers and records.

Business Papers. It is the rare business today that does not have some form of duplicating machine: photocopier, mimeograph, spirit duplicator, Multilith, etc. Most business papers are made to order for the equipment manufacturer; the designer has very little to do with this segment of the paper industry.

COVER PAPERS

Cover stock is stiff, heavyweight paper, and as the name suggests it is used primarily for magazines, paperback books, catalogs, etc. It is available in a wide range of colors, weights, and finishes. The standard size of cover papers for determining the basis weight is 20″ x 26″. The basis weights usually available in cover papers are 65, 80, and 100 lbs.

BOOK PAPERS

Book papers encompass the widest range of printing papers and are therefore of particular interest to the designer. Although called book papers, they are used not only for book work, but for practically everything we read, with the exception of newspapers. Book papers can be divided into two major categories: coated and uncoated. The standard size of book papers used to determine the basis weight is 25″ x 38″. The basis weights usually available in book papers are 40, 45, 50, 60, 70, and 80 lbs.

Uncoated Papers. Uncoated paper is the most basic, least sophisticated type of sheet. It is produced on the paper-making machine without any special coating operations. It is categorized according to its bulk and the relative smoothness of its surface:

Antique. Of all the uncoated papers, antique has the roughest surface and highest bulk. Its relatively toothy surface makes it an excellent paper for bulking up a book. Although not recommended for the reproduction of fine halftones, it is an excellent choice for books containing line illustrations and type. (Antique-finish paper is also referred to as "vellum," especially by people who do commercial jobs as opposed to book work.)

Eggshell. A smoother version of antique. Its texture, as the name implies, is like that of an eggshell. Because eggshell paper is pressed more than antique, it is smoother and less bulky.

Machine Finish (MF). A smoother version of eggshell. Having been calendered, it bulks less. Ideal for lengthy books—400 to 600 pages—consisting mainly of type. A variety of bulks is available in machine-finish papers, usually referred to as regular, medium, and plate finish.

English Finish (EF). A smoother, lower bulking version of machine-finish paper, originally manufactured for letterpress printing of halftones. Special fillers such as clay are added to the pulp that permit the calenders to give the paper a very smooth finish. (The filler originally used was English clay, which is why the paper is called English finish.) Today, due to the availability of moderately priced coated papers that are capable of even better halftone printing, there is no longer a great demand for English-finish paper.

Coated Papers. These papers have a special clay coating which when super-calendered gives the paper an extremely glossy finish. The purpose of this coating is to bury the fibers so that the printing ink does not come into contact with them at all. This means that the ink, rather than being absorbed into the paper, rests on the surface, giving coated papers excellent ink holdout. The higher the ink holdout, the more brilliant the printed image will appear.

Coating can be applied either while the paper is on machine (machine-coated) or off machine (off-machine-coated or conversion-coated). Generally speaking, papers coated off machine are of a higher quality and more expensive than papers coated on machine; the coatings applied are thicker and the operation is more time-consuming. This does not mean however that all off-machine-coated papers are better than all on-machine-coated papers. With so many variations of paper-coating techniques it is impossible to make such a broad statement; in the final analysis, each paper must be judged on its own merits.

The finish of a coated paper may be dull or glossy. The higher the gloss, the more brilliant the reproduction of half-tones or color. However, high-gloss papers are not recommended as background for type matter because the surface may interfere with the readability of the type. The following are some of the more popular coated papers:

Uncoated papers tend to absorb ink.

Coated papers hold ink on the surface, resulting in more accurate color.

Pigmented or Film-coated. These are the least expensive machine-coated papers and are basically the same. The pigment is applied to both sides of the paper after the first drying stage by the original on-machine method of using rollers to coat the paper. This wash coating is transferred from the roller to the paper's surface and quickly dried. The finish makes an excellent paper for jobs containing two-color images, halftones, or type; its low cost makes it ideal for textbooks.

Conversion-coated. A wash coating is applied on the papermaking machine. The rolls of paper are then transported to an off-machine coating unit in the coating department of the mill. Here the sheet receives a highly viscous coating of high-quality pigments applied slowly by rollers. The sheet is dried by hot air, then finishing operations such as gloss-calendering, embossing, or dull-finishing are performed. Conversion-coated papers are ideal for four-color work and prestige publications such as art books and annual reports.

Not all conversion-coated papers are of the same high grade. Because the off-machine coating can be done in a number of ways—roll, airbrush, air knife, or blade—the quality of the paper will vary.

Blade-coated. An on-machine operation that produces a range of high-quality papers at moderately high speeds. After a precoating of pigments, an excess of a more viscous coating is applied to the paper and smoothed by a flexible blade to control the amount of coating. Blade-coating produces what is called a *matte* surface, which in appearance is similar to a dull-coated sheet. Blade-coated papers are ideal for jobs containing four-color reproductions, text matter, and halftones.

Cast-coated. The highest possible gloss is obtained in cast-coated paper, which has a finish similar to that of a glossy photograph. Cast-coating is a special off-machine process in which the paper is given a special coating and then pressed against a large, highly polished chromium drum. Because of the difficulty of manufacture, cast-coated sheets, unlike other papers, are sold on a per-sheet basis and not by weight. Cast-coated papers are the most expensive to make, and so are used selectively; for example, as covers for annual reports.

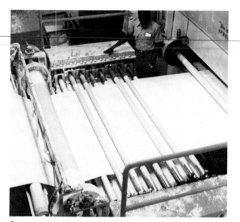
Conversion-coater (roll application).

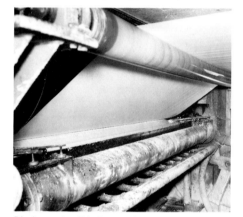
Blade-coater (blade not shown).

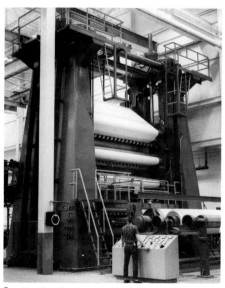
Supercalenders.

Choosing the Right Paper

Choosing the right paper is a combination of personal preference and common sense. The paper must satisfy the demands of the printing process as well as design and economic requirements.

Printing Process. Your first consideration when choosing paper is how the job is to be printed. As letterpress, gravure, and offset lithography are three distinct printing processes, they each require papers with different characteristics:

Letterpress. Letterpress prints by direct impression; that is, the raised metal printing plate comes into direct contact with the paper. In the early days of letterpress printing, jobs consisted mainly of type and an occasional line illustration. The papers, generally rough and bulky, had to be dampened before printing to allow the type to "snuggle down," ensuring a good impression. If the paper was too dry or if too much pressure was applied, the sharp edges of the type might emboss or cut the paper and ruin the opposite side for printing.

Today, letterpress printing is no longer limited to type and line illustrations; it also includes halftones. Furthermore, the paper is no longer dampened before printing, so letterpress paper must be smooth enough to ensure a uniform ink transfer yet strong enough to accept pressure without tearing.

Gravure. Like letterpress, gravure printing is also by direct impression. However, unlike letterpress, the printing plate is relatively smooth and the ink is carried in well-like cells rather than on a raised surface. For these reasons, grauvure papers should be smooth and have a certain amount of absorbency: smooth so that the surface will come into close contact with the printing plate; absorbent so they will draw the ink from the cells. Although the finest gravure printing is done on high-quality coated and uncoated papers, newsprint also makes a good surface for gravure.

Offset Lithography. Unlike letterpress or gravure, offset is not a direct-impression process; the inked image is first transferred from the printing plate to a rubber blanket and then to the paper. The rubber blanket is compressible, conforming to the surface variations of the paper. This permits offset to print on both smooth and relatively rough surfaces. Offset papers must be properly sized to resist the moisture that is always present in offset printing. Furthmore, as

offset inks are more tacky than either letterpress or gravure inks, the paper must have good surface strength to avoid "picking" (the removal of bits of the paper's surface during printing when the pulling force, or tack, of the ink is greater than the surface strength).

Printability. Apart from choosing a paper you like, you should also consider its printability. Printability is dictated by a paper's absorbency and surface. Good printability is especially crucial when printing color or halftones because the quality will depend entirely on how accurately each dot prints.

Absorbency. Uncoated papers tend to absorb ink, causing halftone dots to be feathery and lacking in definition. Coated papers, on the other hand, have better ink holdout, resulting in sharper halftone dots and a sharper image.

Surface. If the surface of the paper is smooth, the ink transfer will be uniform and accurate, resulting in a printed image with good detail, contrast, and color. If the surface is rough, the dots will not print accurately and the printed image will lack strength and detail.

The pH Factor. The pH registers the amount of acid or alkaline ions in the papermaking solution, with 7.0 being neutral; 0 to less than 7.0, acid; and 7.0 to 14, alkaline. It has been determined through extensive artificial aging tests that papers using chemicals with a pH value of less than 7.0, therefore on the acid side, will deteriorate faster than their companions on the alkaline side. The libraries, being concerned about the longevity of the books on the shelves as well as for archival reasons, have been in the forefront to encourage, if not insist, that the publishers manufacture their books on neutral or alkaline papers.

Recycled Paper. An option the designer must consider is the use of recycled paper. On the positive side, reworked fibers are generally shorter, flexible, less bulky, more opaque, and they lend these qualities to the finished paper.

Recycled paper, however, must be collected and separated before it can be used. Assuming the product has not been contaminated by industrial or consumer waste, it generally has to be de-inked. This is a chemical process not unlike the original cooking process that separates virgin fibers from the log. (Ironically, this process develops its own waste product that requires disposal.)

The bottom line is that recycling paper is not a low-cost process.

Recycling paper, though, does provide an outlet for some of the post-consumer waste, and it helps conserve a natural resource. Most major paper companies are now seriously involved in the manufacture of recycled papers: either 100% recycled paper or a combination of old and new paper.

Some of the products available today are duplicator paper, writing paper, high-speed copier paper, envelopes, forms, book papers, bond papers, ledger, cover, and text papers. As the price difference between recycled and virgin paper narrows, recycled papers will command an ever greater share of the market.

Economic Considerations. Quality in paper, as in everything else, is reflected in cost. Perhaps the best way to control cost is to choose the right paper for the job. If in doubt as to your choice of paper, contact the printer or paper merchant. Not only are they capable of discussing the specific problem, but they can show you printed samples that will give you a good indication of just what you can expect from any given paper.

Rough paper breaks up halftone dots.

Smooth paper permits dots to print accurately.

Typography

The basic terminology used in typesetting methods is derived from metal type. As with all terms, some of the terms have been modified to accommodate the newer typesetting methods, regardless of the type-setting method.

ABCD
EFGHIJK
LMNOPQRST
UVWXYZ
abcdefghijklmno
pqrstuvwxyz
1234567890
&.,:;'""?!()
* / # $ % ¢ *

Type. The individual letter, figure or punctuation mark is called a character.

Measuring Type. There are two basic units of measurement in typography.

12

FOLD

Dedicated to every graphic designer whose printed piece did not quite measure up to his expectations

5

TRIM

4

FOLD

13

GLOSSARY 197

200

197

204

BLANK

201

208

205

205

193

196

LETTERSPACE
LETTERSPACE
LETTERSPACE
L E T T E R S P A C E

Imposition

Imposition is the arrangement of pages on a printed sheet in such a way that they will be in correct order when the sheet is folded and trimmed. A full sheet will normally print in units of 4, 8, 16, and 32 pages. When folded, these units are called *signatures*.

FOLD

TRIM

FOLD

TRIM

9

8

1

16

Introduction

Acknowledgments

Illustration Credits

Handset

Actual imposition used in this book showing pages on one side of a printed sheet.

Basic Impositions

The best way to understand imposition is to actually take a sheet of paper, fold it, number the pages, and make up the signatures described in this chapter. You will notice that the odd-number pages are always on the right, the even-number pages always on the left. This is standard procedure in all publications.

Let's look at some basic impositions, for a 4-page, 8-page, and 16-page signature:

Four-Page Signature. The smallest signature possible. Take a sheet of paper and fold it once. Beginning with the outside page facing you, number the sections 1 through 4. Now open the sheet and lay it flat. This is exactly how the pages would have been imposed in order to print four consecutive pages: on one side of the sheet are pages 1 and 4, on the other side pages 2 and 3.

Eight-Page Signature. Take another sheet of paper and fold it twice. Number the pages consecutively 1 through 8. Open it up and lay it flat; this is the imposition for an 8-page signature. Notice that the pages are not in order, and that some are actually upside down on the sheet. Naturally, when folded and cut, the pages will all be rightside up and in their proper order. Also notice that an 8-page signature is folded at the head and in addition at the spine or binding edge. You can see how important trimming is in this case to permit the pages to be opened.

Sixteen-Page Signature. Now take a sheet and fold it three times. Number the pages consecutively 1 through 16. (Underline the figure 9 so as not to confuse it with the figure 6.) Open it up and lay it flat; this is the imposition for a 16-page signature. It is possible by following the same procedure to make 32-page and 64-page signatures. By changing the folds it is also possible to make 12-page, 24-page, and 48-page signatures.

If you examine this book you will see that it is made up of thirteen 16-page signatures, twelve of which are printed in

| 4 | 1 |

| 2 | 3 |

4-page signature.

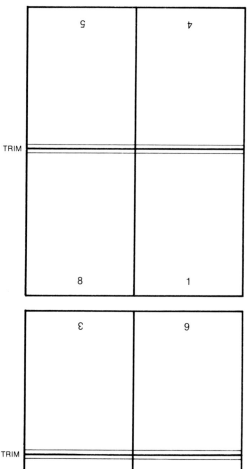

ς	�165
TRIM	
8	1

ε	9
TRIM	
2	7

8-page signature.

black and white and one in color. Imposition is not determined by the designer, but by the binder and the printer: the binder, because only he or she knows how the pages should be positioned to be handled most efficiently on the equipment; the printer, because he or she has to take the imposition supplied by the binder and make it work.

One factor both the printer and the binder consider when figuring the imposition is an extra paper allowance of ⅛″ to ¼″ on all outside margins. This will be trimmed, or cut off, when the sheets are squared up.

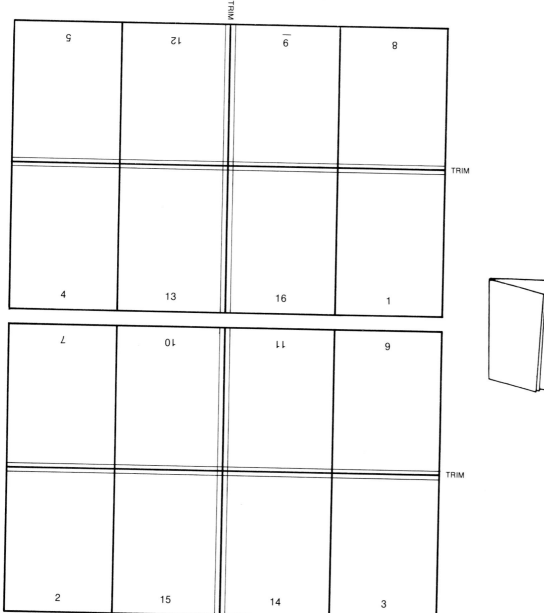

16-page signature.

Imposition and Color

By printing one color on the first side of a sheet and two colors on the second side, it is possible to give the impression that two colors were used throughout. For example, let's imagine an 8-page signature in which, for reasons of economy, a second color is to printed on only one side of the sheet. By referring to the illustration of the 8-page signature you will see that one side of the sheet prints pages 1, 4, 5, and 8; the other side prints pages 2, 3, 6, and 7. Therefore the designer can choose either of these page sequences for the second color. This will give the impression of two-color printing throughout the signature even though it is really only on one side of the sheet.

Another way to introduce even more color on the second side of the sheet is the split-fountain technique. Instead of running a single second color, the ink fountain is divided in half, with the right side printing one color and the left side another. If the two colors are allowed to meet, the inks blend to form a range of colors.

This side prints in one color.

This side prints in two colors.

COLOR A BLEND COLOR B

8-page signature with a second color printed on one side only.

Imposition and Gang-ups

Until now we have discussed imposition in situations where all the pages are the same size. But there is also a problem of imposition when a variety of different-size jobs are printed on a single sheet (ganged-up).

For example, a letterhead, a memo, and an invoice all to be printed on the same paper with the same color ink can be ganged up on a single sheet. In figuring the imposition, the printer must know the quantities involved. If they are all the same (1,000 of each, for example), the sheet must be divided so that one impression of each job is printed on every pass through the press. If the quantities vary, the sheet must be divided in such a way as to print some items once (one-up) and others more than once (two-up, three-up, etc.).

COMBINATION LAYOUT	
A	TWO-UP
B	FOUR-UP
C	THREE-UP
D	ONE-UP
E	ONE-UP

Poor impositions, requiring too many cuts.

Good imposition, allowing for standard cutting operations.

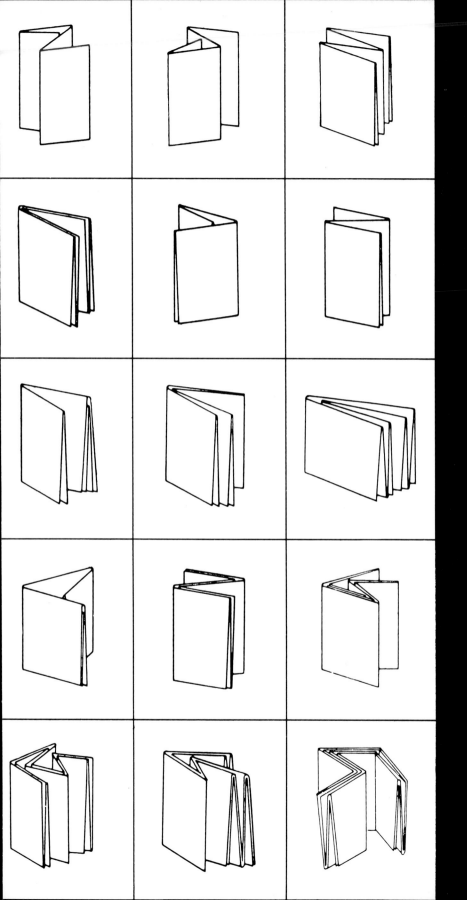

After the sheet has been printed it is folded. This is usually done automatically on a folding machine capable of making single or multiple folds. In addition to folding, some machines are also equipped to handle a number of other services such as pasting, perforating, scoring, slitting, and trimming.

Some sheets become folders, others become books. In this section we will discuss only folders; books will be discussed in the next section, *Binding*.

A variety of folders ranging from 8 pages through 80 pages

Folds and Folders

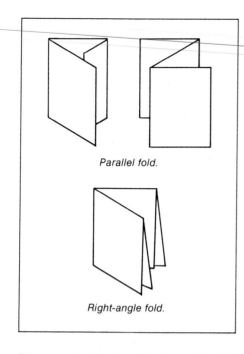

Parallel fold.

Right-angle fold.

There are two basic methods used to fold a sheet of paper: *parallel* and *right angle*. A parallel fold, as the name implies, is one that runs parallel to a previous fold. Parallel folds are made in business letters when they are folded twice in the same direction to fit their envelopes. A right-angle fold is one that is at a right angle to a previous fold. A familiar example of this is the "French fold" used in formal invitations. By using these two folds it is possible to produce a wide range of folders.

There are many names used to describe folders: bulletins, circulars, flyers, pamphlets, etc. These names tell us very little about how the folder was folded, or even about its general characteristics—in fact, in many cases the names are totally interchangeable. Rather than try to understand what is intended by these different names, let's compare folders in terms of the number of folds, the type of folds, and the number of pages created by these folds. Once again, it would be a good idea to take a sheet of paper and copy some of the folders discussed—you will find that each has a very distinct personality.

Four Page. The simplest folder possible: one fold, four pages. The sheet can be folded either on the short or the long side. Used for envelope enclosures, bill stuffers, price lists, etc.

Six Page. Two parallel folds, six pages. The folds can be either regular or accordion. Used for much the same purposes as the 4-page folder, except that it has an extra two pages.

Eight Page. By folding once and then folding again at a right angle to the first fold, we get what is commonly called a *French fold*. The advantage of this particular fold is that although the sheet can be printed economically on only one side of the sheet, the printing will still appear on both the inside and the outside of the folder. An 8-page folder can also be produced by making two parallel folds or three parallel accordion folds. These are particularly suitable if you wish to print on both sides of the sheet. They also have the advantage of being very easy to open.

Twelve Page. By combining the first fold with two right-angle folds, we make a 12-page folder. The folds can be either regular or accordion.

Sixteen Page. Again, with the first fold combined with two right-angle folds it is possible to make a 16-page folder. It is also possible to make a 16-page folder using three parallel folds. These folders are particularly suitable for transportation schedules.

Before designing a folder, check the printer or binder to learn which folder can best be accommodated by the press and folded most economically on the equipment. Keep in mind that the more folds, the more expensive the job will be. Also, remember that paper comes in standard-size sheets, so plan the job to keep waste to a minimum. Refer to the cutting chart on page 145 that shows the standard paper sheet sizes and the number of pages attainable from each.

Another factor to consider when designing folders is the paper. The grain of the paper you use is particularly important because it affects foldability; paper always folds and tears more easily in the direction of the grain (see page 130). The weight of the paper is also important. If the paper is too heavy, such as card or bristol stock, it will have to be scored before folding to ensure an even fold (see page 155).

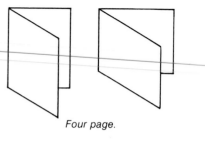

Four page.

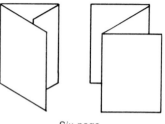

Six page.

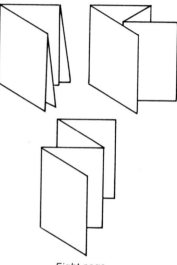

Eight page.

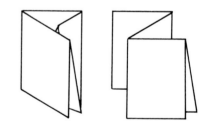

Twelve page.

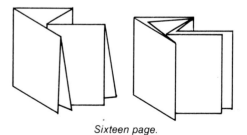

Sixteen page.

Cutting Chart

Paper is often made in standard sizes based on standard press sizes, therefore a paper of a given size will yield a given number of pages. Odd-size pages reduce the number of pages available from the sheet, create waste, and increase the cost of the job.

Here is a chart that shows the recommended trimmed page size and number of pages per sheet. The sizes shown have allowed for trim on top, bottom, and sides, but do not allow for bleeds. If the designer plans to have a halftone color bleeding off any side, an extra ⅛″ must be allowed.

Note: See also International Paper Sizes in Glossary.

Trimmed Page Size	Number of Pages	Number From Sheet	Standard Paper Size
3½ x 6¼	4	24	28 x 44
	8	12	28 x 44
	12	8	28 x 44
	16	6	28 x 44
	24	4	28 x 44
4 x 9	4	12	25 x 38
	8	12	38 x 50
	12	4	25 x 38
	16	6	38 x 50
	24	2	25 x 38
4½ x 6	4	16	25 x 38
	8	8	25 x 38
	16	4	25 x 38
	32	2	25 x 38
5¼ x 7⅝	4	16	32 x 44
	8	8	32 x 44
	16	4	32 x 44
	32	2	32 x 44
6 x 9	4	8	25 x 38
	8	4	25 x 38
	16	2	25 x 38
	32	2	38 x 50
Oblong 7 x 5½	4	8	23 x 29
	8	4	23 x 29
	16	2	23 x 29
8½ x 11	4	4	23 x 35
	8	2	23 x 35
	16	2	35 x 45
9 x 12	4	4	25 x 38
	8	2	25 x 38
	16	2	38 x 50

Envelopes

Not all folders require an envelope; some are planned as *self-mailing folders*. In this case, the front of the folder is designed to allow space for address and stamp, and is fastened with a seal.

Make sure the size you are planning is acceptable to the post office: there are minimum sizes. Also, if it is a turn-around mailing—that is, a business reply card (BRC) which is to be returned to the sender—there is a minimum caliper (.007 or 7 points) that the post office will accept.

When designing a mailing piece, the size of the piece will dictate the size of the envelope. Try to plan the job so that one of the standard envelopes can be used.

When estimating the size of the envelope, allow at least ¼″ clearance on all sides of the largest insert. If inserts are thick and bulky, extra allowance should be made. This is extremely important, because most envelopes are stuffed mechanically (by machine). If anything goes wrong, the envelopes will have to be stuffed manually, which is costly.

Envelopes are available in a wide range of styles, colors, and sizes; the most popular categories are *catalog*, *commercial/official*, *window*, *booklet*, and *announcement*.

Note: U.S. stationery sizes differ from those of most foreign countries. See *A4* in the Glossary.

Commerical/Official

Window

Number	Size
6	3⅜ x 6
6¼	3½ x 6
6¾	3⅝ x 6½
7	3¾ x 6¾
7¾	3⅞ x 7½
Data Card	3½ x 7⅝
8⅝	3⅝ x 8⅝
9	3⅞ x 8⅞
10	4⅛ x 9½
10½	4½ x 9½
11	4½ x 10⅜
12	4¾ x 11
14	5 x 11½

Catalog

Number	Size
1	6 x 9
1¾	6½ x 9½
2	6½ x 10
3	7 x 10
6	7½ x 10½
7	8 x 11
8	8¼ x 11¼
9½	8½ x 10½
9¾	8¾ x 11¼
10½	9 x 12
12½	9½ x 12½
13½	10 x 13
14¼	11¼ x 14¼
14½	11½ x 14½

Booklet

Number	Size
2½	4½ x 5⅞
3	4¾ x 6½
4¼	5 x 7½
4½	5½ x 7½
5	5½ x 8½
6	5¾ x 8⅞
6½	6 x 9
6¾	6½ x 9½
7	6¼ x 9⅝
7¼	7 x 10
7½	7½ x 10½
8	8 x 11⅛
9	8¾ x 11½
9½	9 x 12
10	9½ x 12⅝
13	10 x 13

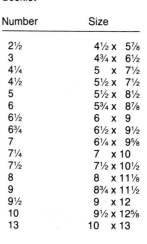

Announcement

Number	Size
A-2	4⅜ x 5⅝
A-6	4¾ x 6½
A-7	5¼ x 7¼
A-8	5½ x 8⅛
A-10	6¼ x 9⅝
Slim	3⅞ x 8⅞

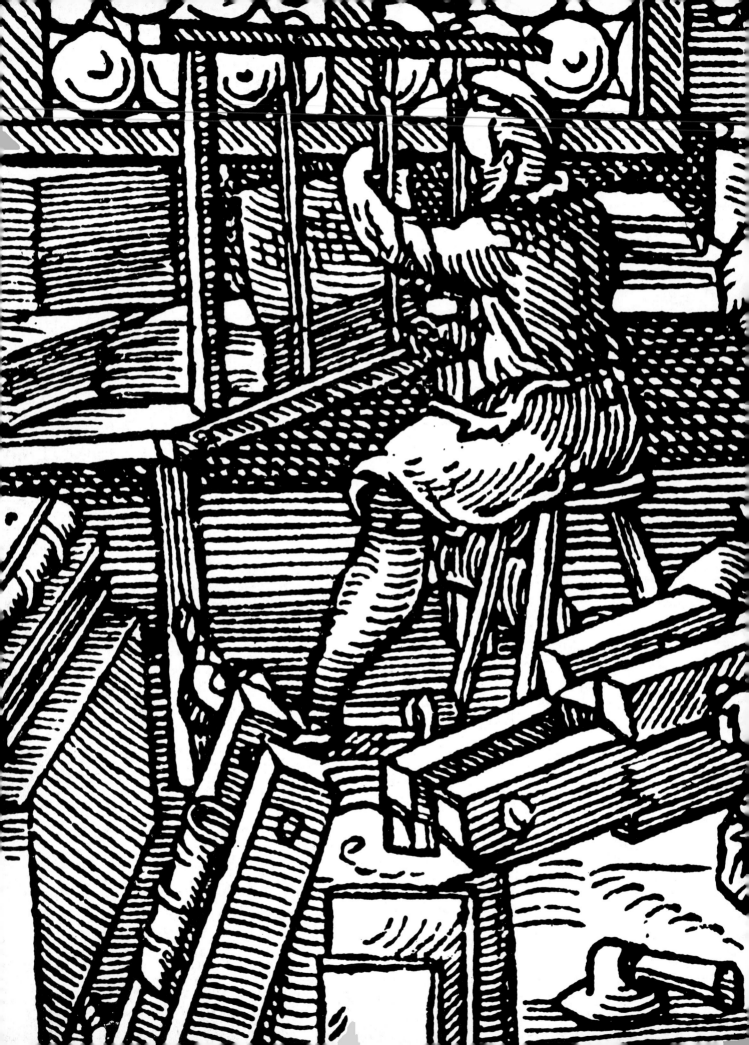

Binding

Binding is the fastening together of printed sheets, in the form of signatures, into books, booklets, magazines, etc. The choice of one particular binding over another is based on a variety of factors: practicality, permanence, and perhaps most important, cost. To this list the designer may wish to add aesthetics.

The bookbinder in his studio (Frankfurt, 1568). In the background, the signatures are gathered and sewn; in the foreground, the bound books are blocked.

Binding Methods

The first step in binding is to fold the printed sheets into signatures. Next, the signatures are gathered and collated; that is, put in the order in which they will appear in the bound book or magazine. These operations are usually done by machine unless the job is small enough to be done by hand. After the signatures are gathered they are bound.

There are four basic binding methods: wire stitching, mechanical, perfect, and edition. Let's examine each.

Saddle-wire stitching.

Side-wire stitching.

WIRE STITCHING

There are two methods of wire stitching: saddle-wire stitching and side-wire stitching. The particular method used is determined by the bulk of the paper and the number of pages to be bound. Thin books, such as pamphlets, catalogs, and bulletins, can be saddle-stitched; thicker books must be side-stitched.

Saddle-wire Stitching. This is the most common method of pamphlet or booklet binding; it is also the simplest and least expensive. The pamphlet is opened, hung on a "saddle," and wires are inserted through the backbone into the center spread. The booklet is then trimmed on three sides: top, bottom, and right. This can be done one side at a time with a guillotine-style paper cutter, or with a special three-knife trimmer that trims all three sides at once. A great advantage of saddle-wire stitching is that it allows the pages to open fully and the book to lie flat for easy reading.

Saddle-stitched books can be bound with a self-cover (a cover made from the same paper as the text pages and cut from the same signature) or a separate cover, which is usually heavier-weight paper.

Side-wire Stitching. Books or magazines that are too thick for saddle-wire stitching must be bound with side-wire stitching. In this case the wires are inserted ¼″ from the binding edge, passing through from the front page to the back page, where they are clinched. One disadvantage of this particular binding is that the wires prevent the pages from opening flat. Books bound in this manner usually have glued-on covers of heavy stock, which are added after the binding and before trimming.

Note: When designing a book that is to be side-stitched, make sure that the inside margin (the gutter) is wide enough to compensate for the extra space required by the wire.

Although side-wire stitching is still used, perfect-binding is more popular (see page 150), especially in magazines.

Muller Martinin Saddle-Stitcher.

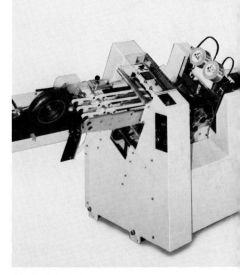

Harris flat-stitcher.

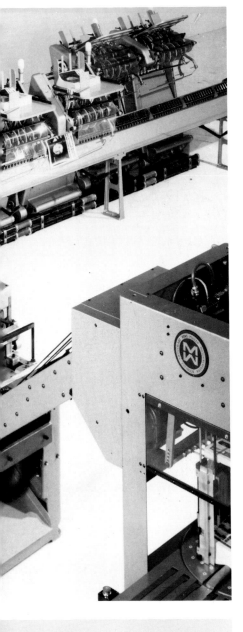

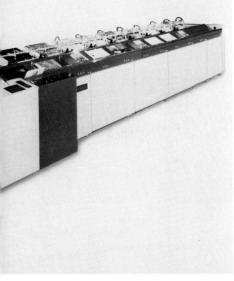

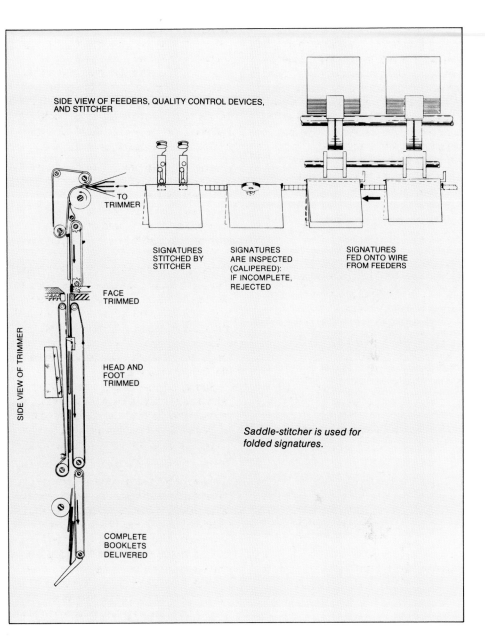

SIDE VIEW OF FEEDERS, QUALITY CONTROL DEVICES, AND STITCHER

TO TRIMMER

SIDE VIEW OF TRIMMER

FACE TRIMMED

HEAD AND FOOT TRIMMED

COMPLETE BOOKLETS DELIVERED

SIGNATURES STITCHED BY STITCHER

SIGNATURES ARE INSPECTED (CALIPERED): IF INCOMPLETE, REJECTED

SIGNATURES FED ONTO WIRE FROM FEEDERS

Saddle-stitcher is used for folded signatures.

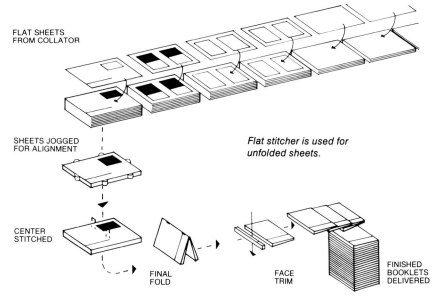

FLAT SHEETS FROM COLLATOR

SHEETS JOGGED FOR ALIGNMENT

Flat stitcher is used for unfolded sheets.

CENTER STITCHED

FINAL FOLD

FACE TRIM

FINISHED BOOKLETS DELIVERED

MECHANICAL BINDING

Mechanical binding is a method of binding in which the pages and cover are held together by mechanical means, usually by metal or plastic coils. A loose-leaf notebook, in which the rings open to allow for the addition or removal of pages, is also a form of mechanical binding.

After the signatures have been gathered and collated they are trimmed on all four sides. A series of slotted or round holes are then drilled in the binding edge by a drilling machine. The cover, which is usually cardboard, is drilled with identical holes. The cover and pages are then bound together by wire or plastic coils inserted into the holes. Metal and plastic binding wires are available in a variety of sizes, shapes, and colors.

Some of the more popular mechanical bindings are Cerlox, Mult-O, Spiral, Sure-lox, Tally-ho, and Wire-O. Among the advantages of mechanical binding is that the book lies absolutely flat when open, making it ideal for such uses as text-books and cookbooks.

Note: When designing for mechanical binding be sure to allow extra space at the gutter not only for trimming the signatures, but also for punching the holes. The exact amount of space will depend on the particular binding.

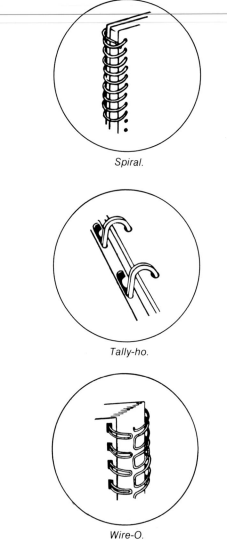

Spiral.

Tally-ho.

Wire-O.

PERFECT BINDING

Perfect binding represents the fastest growing segment of the binding industry. It is a method of binding in which the pages are held together and fixed to the cover by means of adhesive (or adhesive combined with notches in the signatures). After the signatures have been gathered, the backs are ground off, leaving a rough surface onto which the adhesive is applied. If added strength is required, a strip of gauze called "super" or "crash," which is a kind of cheesecloth, is glued over the spine.

Next, the cover is added: this can be either a soft cover or a hard cover. The soft cover, which is the least expensive, is made from a cover stock that is heavier than the text stock. The cover is glued to the spine and the book and cover are trimmed as a unit. The hard cover is more expensive and sturdier. It consists of a binding material such as cloth or paper pasted on binding boards. In hardcover binding, the book is trimmed first and the cover added later. This is similar to edition binding.

Perfect binding is relatively inexpensive and is widely used for paperbacks, manuals, and textbooks. Perhaps the most familiar example of perfect binding is the telephone book.

Note: When designing for adhesive-bound books, leave an extra ⅛" at the gutter to allow for the ⅛" that is cut off in the binding process. Notched-cut books do not require the extra ⅛".

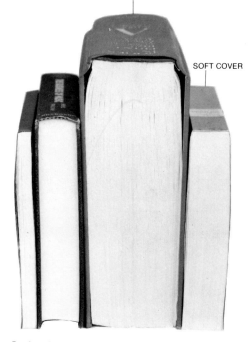

HARD COVER

SOFT COVER

Mechanical-bound book.

Perfect-bound books with soft and hard covers.

EDITION BINDING

Edition binding, more commonly known as hardcover or casebound, is the traditional way of binding a book. It is also the most permanent and most expensive. This book is an example of edition binding.

After the printed sheets are folded and gathered, they are sewn together in one of two ways: *Smyth-sewn*, in which the thread passes through the gutter of each signature; or *side-sewn*, in which the thread passes through the entire book ⅛″ from the gutter. Four-page endpapers are then pasted to the gutter edge of the first and last signatures. Because their function is to attach the book to its cover, these endpapers are usually a heavier stock than the text papers.

The book is then trimmed on three sides and glue is added to the spine to reinforce the stitching. Next, the spine is given either a round or flat contour, depending on the designer's choice (this book, for example, has a flat spine). A strip of "super" or "crash" is then glued the length of the spine for reinforcement.

While the signatures are being bound in one part of the plant, the covers, or cases, are being prepared in another. These covers are nothing more than two pieces of cardboard, called *binding boards*, covered with a binding cloth or paper. These are stamped or printed to show the name of the book, the author, and the publisher. This is usually done by "hot stamping" with a metallic foil. The book is then inserted into its case and the endpapers are pasted to the insides of both covers. This process is called *casing in*. The cased-in book is put in a special hydraulic press for drying. When dry, the book is inspected, wrapped in a dust jacket, and packed for shipping.

Flexible Binding. This is a variation of the hardcover book, except the cover is a flexible 8 to 25 point cover stock. The cover can be preprinted, laminated, or finished in a book-covering material. Some foreign publishers also add jackets. Flexible binding costs more than perfect and less than edition.

Endpapers pasted to first and last signatures along binding edge.

Signatures sewn together.

A strip of crash is placed over glued back. Headbands added.

Case is added.

One-piece case made from a single piece of binding material.

Three-piece case made from three pieces of binding material

Book-Covering Materials

It is usually the designer's job to specify the book-covering material. Today, books are bound in a wide variety of materials, ranging from traditional coverings such as paper and cloth to more exotic coverings such as silk, velvet, burlap, and even metal. To choose the right material, the designer must consider not only the aesthetic aspects, such as color and texture, but also how the material is finished. It is the finish that gives the material body, strength, durability, and printability.

Some covering materials are embossed to create special textures. This is particularly common with paper, which can be embossed to look like linen, buckram, leather, or to display decorative patterns.

Other covering materials lend themselves to being preprinted before binding. In this case, multiple cover images are printed on a large sheet of specially treated cloth or paper. The sheet is then cut and trimmed into individual covers.

Book-covering materials are available in rolls and sheets. The most popular roll sizes are 42″ and 44″, with other sizes available if the order is large enough to warrant special manufacture. The width of the binding material is dictated by the size of the book to be bound; the goal is to have as little waste as possible while still allowing enough material for board thickness, hinge, and turn-in on three sides. Generally speaking, the wider the roll, the more economical the use of materials and machine time, therefore the lower the cost per cover.

Book-covering materials can be broken down into two major categories: woven, which includes all cloths, and nonwoven, which includes paper and synthetics.

WOVEN

The basic cloth for almost all woven bindings is cotton. This base cloth, called *greige* (pronounced *gray*) goods, is woven in a variety of weights. To produce a high-quality white book cloth, the greige goods must first be bleached to remove impurities and make the cloth absorbent. The cloth is then finished by being impregnated, or filled, with starch, pyroxylin, or an aqueous-based acrylic to which color has been added.

Starch-filled cloth is a popular, low-cost binding material. The starch, similar to that used in doing the laundry, is forced into the cloth to give it body. Unfortunately, starch-filled cloth is easily stained by water and has a tendency to pick up moisture from the hands. The starch is also considered a delicacy by vermin such as cockroaches and mice.

For a stronger, more durable, vermin-and-moisture-resistant cloth, pyroxylin or acrylic is used. These substances are liquid plastics that can either be forced into the cloth (*impregnated*) or applied in coats (*coated*), the latter being the strongest and most expensive.

Besides the addition of starch, pyroxylin, or acrylic for strength and durability, the cloth can also be finished to give it a specific appearance. Here are three of the more popular finishes:

Linen. Starch, pyroxylin, or acrylic is applied to the surface of the bleached cloth, then scraped so that some of the white threads show through, giving the cloth a linen look. Linen-finish cloth is further recognizable by the fact that the reverse side of the cloth shows little color and remains practically white.

Vellum. For a vellum finish, the bleached cloth is first dyed to the approximate color of the starch, pyroxylin, or acrylic before it is applied. When scraped, the threads, being the same color as the finish, do not show as they do with the linen finish. This gives the cloth the appearance of having a solid-color finish. Vellum-finish cloths are also recognizable by the fact that the reverse side color is similar to the color of the surface.

Natural. Only starch is used to produce a true "natural finish." Once again the bleached cloth is dyed to the approximate color of the finish. This time, however, the starch is applied only to the reverse side of the cloth, and the cloth is not calendered, so that the surface will retain as much of its original textured, "natural" look and feel as possible.

Not only is it possible to produce linen, vellum, and natural finishes on cloth, but many of the cloths, especially those treated with pyroxylin, or acrylic, can be embossed to look like linen, buckram, leather, and other materials. Fortunately, manufacturers make up very complete sample books showing a wide variety of cloths in various grades, finishes, and colors. (It should be noted that while most companies manufacture similar products they use different trade names not only for each grade of cloth, but also for each finish. This can be very confusing when trying to make comparisons.)

Many book-covering cloths are manufactured to school and library specifications as laid down by NASTA (National Association of State Textbook Administrators) and LBI (Library Binding Institute). These organizations specify the weight and number of threads per inch, the tear and break strength, abrasion resistance, and so on, that the cloths must have. All cloths made to these specifications are then classified into the following grades: A, B, C, C1, D, E, and F. Cloths in F grade are the heaviest and most expensive.

The designer should note that the grade of a cloth does not imply a specific finish; any grade can be starch filled or pyroxylin or acrylic impregnated, any can have a linen or vellum finish, and some can have a natural finish.

Not all book cloths fall into one of these grades; there are cloths which for one reason or another do not satisfy the school or library specifications, but which do have desirable qualities of their own. These are usually referred to as "non-specification" book cloths.

The two best known manufacturers of book-covering cloths are Holliston Mills and Industrial Coatings Group.

Linen finish.

Vellum finish.

Natural finish.

NON-WOVEN

The non-woven category of book covering materials includes both paper and synthetic covers. It represents the fastest growing segment of the book-covering industry, and the major reason is cost: it is less expensive to bind a book with paper or a synthetic than with cloth. Furthermore, softcover books and paperbacks do not require dust jackets, as the jacket art is printed directly on the cover.

We have broken down the non-woven materials into three categories based on NASTA specifications: Type 1, paper; Type 2, reinforced paper; and Type 3, synthetic fiber. Let's examine each:

Type 1: Paper. This is the least expensive of all covering materials, but it is also the weakest. Type 1 paper is basically a heavy-duty kraft paper which has been bleached and/or dyed. However, like cloth, it can be finished to increase strength and durability by coating the sheet with acrylic, vinyl, or pyroxylin. Finishing not only strengthens the sheet, but improves ink holdout, and therefore printability. To add variety, papers can be overprinted with patterns or embossed to resemble linen, buckram, leather, or a wide range of decorative textures. Type 1 papers are most widely used for paperback and casebound books.

Binding papers are measured by thickness, measured in points (a point is 1/1000″), or basic weight, measured in pounds. The most commonly used paper for paperbacks is 8 and 10 point; for casebound (over boards) books, 65 pound.

Type 2: Reinforced Paper. In this case the base paper, or substrate, has been reinforced by adding polymers or resins to the pulp while the paper is being made. As with Type 1, the sheet can be further strengthened by coating it with acrylic, vinyl, or pyroxylin. It can also be embossed or overprinted. Type 2 reinforced paper is widely used for both soft-cover (self-supporting) and basebound (over boards) books. The most commonly used reinforced papers for softcover books are 14, 17, 20, 22, and 25 point; for casebound, 8, 9, and 10 point.

Type 3: Synthetic Fiber. These covering materials are neither cloth nor paper, but are made from synthetic fibers. At present there is only one substrate in this category: DuPont's Tyvek. This is one of the strongest and most durable of all covering materials. The synthetic fibers are spun into a sheet then bonded together by heat and pressure thereby producing what is known as a "spun bonded olefin." The result is a tough, hardwearing, stain-resistant sheet, which because of its spun fibers and lack of grain is extremely difficult to tear. And because of its whiteness and ink holdout it is very well suited to full-color printing providing the sheet is properly coated. Tyvek can be printed by either letterpress, gravure, offset lithography, screen printing, or flexography. However, special inks must be used for printing on Tyvek; those commonly used in printing contain solvents that can have an adverse effect. Also, Tyvek can easily melt if care is not taken when heat is applied during the book manufacturing process.

Tyvek is sold by DuPont in a raw, white state to various "converters" who make it available to their customers in a variety of styles, colors, overprint patterns, and embossing textures. Tyvek used for book coverings is almost always coated at least on one side. An exception to the above categories are supported and unsupported vinyls, whose use is generally limited to looseleaf bindings.

Other Binding Materials

In addition to deciding on the covering material, the designer will most likely have to make decisions concerning endpapers, stamping, binding boards (in some cases), and headbands.

Binding Boards. There are two basic binding boards: a pasted chipboard, called *pasteboard*, and a heavier, stiffer board called *binder board*. Pasteboard is made from layers of thin chipboard pasted together with an adhesive which is much stronger than even the chipboard. Binder board is a high-quality, single-ply, solid pulp board made to the full thickness in one operation. Binder board is about 50% denser than pasteboard. Most books are bound with pasteboard, which is more than adequate for books that receive normal handling. Textbooks, which receive a greater amount of handling, require the added strength of binder boards.

Binding boards are measured by points (a point is 1/1000″). The more popular sizes of pasteboards are 70, 85, and 95 points. There is an accepted tolerance of 5 points over or under any given size. For binder boards, the sizes are 70, 80, 88, and 98, with an acceptable tolerance of 2 points. There are heavier boards available, but these are seldom used.

For thinner, more flexible binding boards there is a felted product called *red flexible board* available in point sizes 24, 30, 35, and 50. This is a popular binding board for handbooks such as diaries, calendars, and yearbooks.

Endpapers. Endpapers, also called *endleafs*, *book linings*, and *flyleafs*, are found at the beginning and end of casebound books. Their main function is to hold the book in its case. (The casing-in process is described on page 151.) Endpapers are normally heavier than the text pages as they must hold the book together. Typical endpapers are 80 lb. and are made from special fibers chosen for their strength. A secondary function of endpapers is aesthetic; they can be very attractive. For this reason they are available in a wide range of colors and finishes. Endpapers can also be preprinted.

Foils and Pigments. After the boards have been covered and before the book is cased in, the cases are usually stamped with the title of the book and the name of the author and publisher. The most common method of accomplishing this is hot-stamping the case with metallic foil or pigment, available in silver, gold, copper, aluminum, and a wide range of both matte and glossy colors.

When selecting colors for stamping, the designer should be aware that the color will appear different, depending on the color of the binding material. Also, some foils stamp better than others, depending on the kind of binding material. For example, some foils are specially formulated for stamping on plastics. To avoid errors, the designer should have a sample case made up showing the specified binding material and stamping foil.

Headbands. These are tiny strips of cloth that protrude slightly from the head and foot of the inside of the spine. Their function is mainly aesthetic; when a book is casebound, the head and foot of the spine can have an unfinished look where the signatures are bound and pasted together. The headbands, which are very colorful, tend to dress up this area.

HEADBANDS

ENDPAPERS OVER
BINDING BOARDS

SPINE

COVER OR CASE

METALLIC FOIL
STAMPING

My Share of Wine
THE MEMOIRS OF ANTON SCHUTZ

Bindery Facilities

Although we tend to think of the binder in terms of simply binding books, there are many other services available. These are referred to as *finishing operations* and include blind stamping, die-cutting, drilling, edge-gilding, embossing, eye-letting, indexing, laminating, padding, perforating, punching, round-cornering, scoring, tabbing, tipping, and varnishing. Some of these, such as laminating, perforating, and varnishing, can also be done by the printer. It is a good policy when the job is being designed to consult the printer and binder to be sure they will be able to carry out your plans. They can make suggestions for improvements or modifications to fit existing equipment and materials. In the long run this will enable you to save time and obtain a better, less expensive job.

Let's examine some of the more common finishing operations.

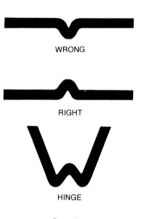

WRONG

RIGHT

HINGE

Scoring.

Die-cutting. The cutting of paper or cardboard with steel dies to remove a part or to leave a part attached so that it can be folded away from the rest of the sheet. Die-cutting is commonly used for mailing pieces, greeting cards, and point-of-purchase displays. The most common method of die-cutting is with steel rule dies made from thin steel blades bent into the desired form, not unlike a cookie cutter, and mounted onto ¾″ plywood. The die is mounted on a platen or letterpress, similar to the way in which a type form is mounted. The sheets are then die-cut individually or in groups, depending on the thickness of the paper.

Embossing. A finishing process that produces a raised image on the surface. Embossing is done directly on a letterpress or on a special embossing press. For heavy embossing, heat must be added. It is possible to emboss either a relief image or a bas-relief image. When no ink is used on the latter, it is called *blind embossing.* In addition to printer's inks, metallic foils can also be used in embossing.

Scoring and Perforating. Makes a crease in heavyweight paper, such as cover stock, to facilitate folding. When not scored, heavyweight papers have a tendency to fold unevenly and buckle, especially when they are folded across the grain. Scoring is usually done with a round-face scoring rule locked into a form on a platen or cylinder press. Scoring rules vary in thickness; the thicker the paper the thicker the rule must be to ensure a wide crease and a clean fold.

Stamping. Imprinting the case for case-bound books. First, a die is made of the copy to be stamped (from a mechanical supplied by the designer). If it is a short run, say 1,000, the dye can be made of magnesium or zinc; if longer, then the die is made of either copper or brass, both of which are harder, more durable metals. The metallic foil is then placed over the raised letters and transferred to the case by a combination of heat, pressure, and dwell-time (duration of heat and pressure application).

Blind stamping is done in the same way except that no foil is used; the die leaves only the impression of the letters in the binding material.

Die-cutting.

Embossing.

Stamping.

Blind stamping.

Mechanicals

The mechanical, also called a *paste-up* or *keyline*, is the master from which the printing plate is made. It contains all the design elements pasted in position on a piece of artboard and ready for the camera. It is important that the mechanical be accurate; if elements are not properly aligned, or if type is broken, these imperfections will be photographed and become part of the printing plate.

One day mechanicals will be a thing of the past, like metal type, replaced by sophisticated desktop-publishing systems. That time has not yet arrived and mechanicals remain an important function in the lives of many designers.

Some of the basic tools required to prepare a mechanical.

Scaling Art

Before the designer creates a layout or prepares a mechanical, original art generally has to be reduced or enlarged to fit the design. There are three practical methods by which the designer can scale art: the diagonal line, the proportional scale, and the electronic calculator.

Diagonal Line. Place a sheet of tracing paper over the artwork and draw a rectangle around it. Now draw a diagonal line from the lower left corner to the upper right corner (if the artwork is going to be enlarged, your line should extend well beyond the corner). Measure off the new width along the bottom line of the rectangle. From this point draw a vertical line upward until it intersects the diagonal. The point of intersection establishes the new height of the reproduction.

The diagonal-line method can also be used to find out the new width if the new height is known. Following the same procedure, you would measure the new height along one of the vertical sides of the rectangle and then draw a horizontal line until it intersected the diagonal.

Proportional Scale. The most common method of scaling art is to use a proportional scale. This low-cost instrument simplifies scaling and is easy to use; it's simply a matter of aligning two figures.

Using the example at the left, let's say you know the new width and wish to determine the new height. Align the actual width (2¼″) with the new width (4½″), then read the figure opposite the actual height. This will be your new height. The same principle applies when you know the new height and wish to determine the new width.

In addition to helping you establish new dimensions, proportional scales also show the percentage of the enlargement or reduction, in this case 200%. This comes in handy when ordering photostats or scaling art for the printer.

Electronic calculator.

4½″

6″

3″

2¼″

Scaling art using a diagonal line.

Electronic Calculator. Another method of scaling art is through the use of an electronic calculator, which permits size changes to be measured in fractions of a percent. This can make a dramatic difference in accuracy and is also helpful with the new generation of photostat machines, which are similarly calibrated.

To use the calculator method all fractions must be expressed in decimal equivalents: for example, 4½″ is 4.5″, 2¼″ is 2.25″; and 1¾″ is 1.75″. (See Metric System in Appendix.)

To determine the percentage of enlargement or reduction simply remember this formula: *Divide the desired size by the actual size.* Following the example at the left you would enter the following:

Desired width: 4.5″ ÷ Actual width: 2.25″ = 200% enlargement

At times you may wish to make all calculations in millimeters or even picas:

Desired width: 114mm ÷ Actual width; 57mm = 200% enlargement.
Desired width: 28 picas ÷ Actual width: 14 picas = 200% enlargement.

Remember, if the original is smaller than the desired size, the percentage will be more than 100%. If the original is larger than the desired size, the percentage will be less than 100%. If the original is the size you want, it should be marked 100% or S/S (same size).

Once you have obtained the percent of enlargement or reduction you can determine the new height. For example, if the original height was 3″ and the rate of increase was 200% the new height will be 6″ (or 152mm or 36 picas).

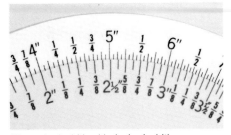

Align actual width with desired width.

The new art is 200% of the original art.

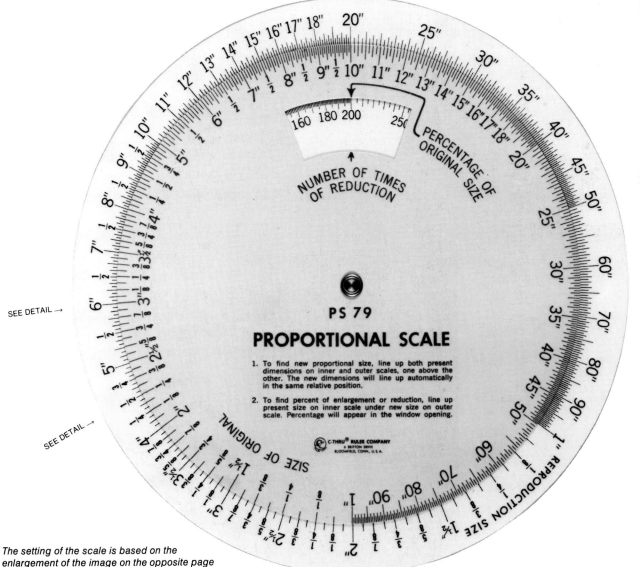

The setting of the scale is based on the enlargement of the image on the opposite page from 2¼″ x 3″ to 4½″ x 6″.

Photostats and Photocopies

Throughout the design process there is often the need for inexpensive prints that can be used to indicate the size and position of design elements on dummies or mechanicals: photostats and photocopies can serve this purpose.

Photostats can be either positive or negative. A positive stat is the same as the original copy; a negative stat is the opposite. For example, a positive stat of this page would have black type on a white background; a negative stat would have the values reversed, white type on a black background. To make a positive stat a negative stat must first be made. All stats, positives and negatives, are "right-reading"; that is, the type can be read normally from left to right.

Photostats can have either a glossy or a matte surface. Glossy stats tend to polarize all tones to either black or white. Because of their sharpness and their solid blacks, glossy stats are used for reducing or enlarging line copy, such as type or line illustrations. Glossy stats can be pasted directly on the mechanical and used. Matte stats, on the other hand, hold a wide range of tones and are used for shooting continuous-tone copy such as photographs, paintings, and illustrations. Matte stats are not of high enough quality to be used as shooting copy and are used mainly to show the size and position of halftones in mechanicals.

Original line copy.

Negative stat.

Positive stat.

In such cases, the photostat should be marked F.P.O. (for position only).

Also available from some stat houses are "direct positive" stats. As the name suggests, the process goes from positive to positive; no negative stat is made. The quality is high, and direct positive stats are slightly less expensive. However, you will not receive a negative, and negatives can be very useful, especially if you wish to reverse type.

When ordering stats it is important to state (1) the desired size, shown in inches or as a percentage of the original artwork; (2) the kind of paper, glossy or matte; and (3) whether the stat is to be positive or negative.

Photocopies. In recent years photocopiers have begun to offer designers an inexpensive alternative to photostats. Since the photocopying machines can reduce and enlarge most images they have largely replaced photostats for positioning art on comps and mechanicals. Not only are photocopies less expensive, but they are available on the premises.

There are also full-color copiers capable of producing inexpensive images from slides, photographs, and negatives. While the colors may not always be accurate, the images are more than adequate as position proofs.

Original halftone copy to be enlarged.

Negative stat made to same size as original.

Original line copy to be reduced *Negative stat shows reduction.* *Positive made from negative stat.*

Positive enlargement made from negative stat. *The same image flopped.*

Veloxes

A velox is a screened, *paper* photoprint that can be pasted directly in the mechanical and shot with other line copy, thus saving the expense of having the printer strip in the halftone.

Veloxes also allow the designer to see the job with the halftones in position, exactly as they will appear when printed. Also the designer can work directly on the velox with opaque white paint to create highlights or with black paint to add lines or solid black areas.

Veloxes, like regular halftones, are available in a wide range of screens—55, 65, 85, 100, 110, and 120—and can be printed as silhouettes, dropouts, etc. The finer the velox, the higher the risk of shadow areas filling in.

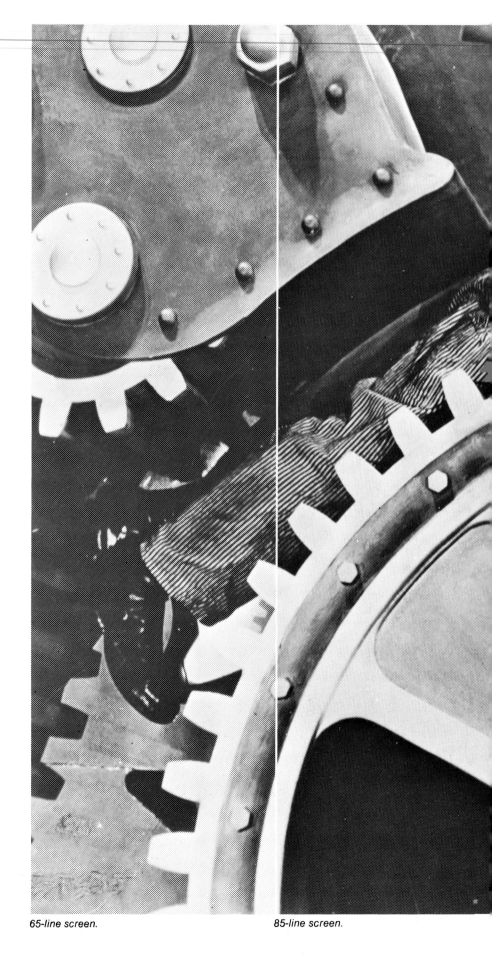

65-line screen. *85-line screen.*

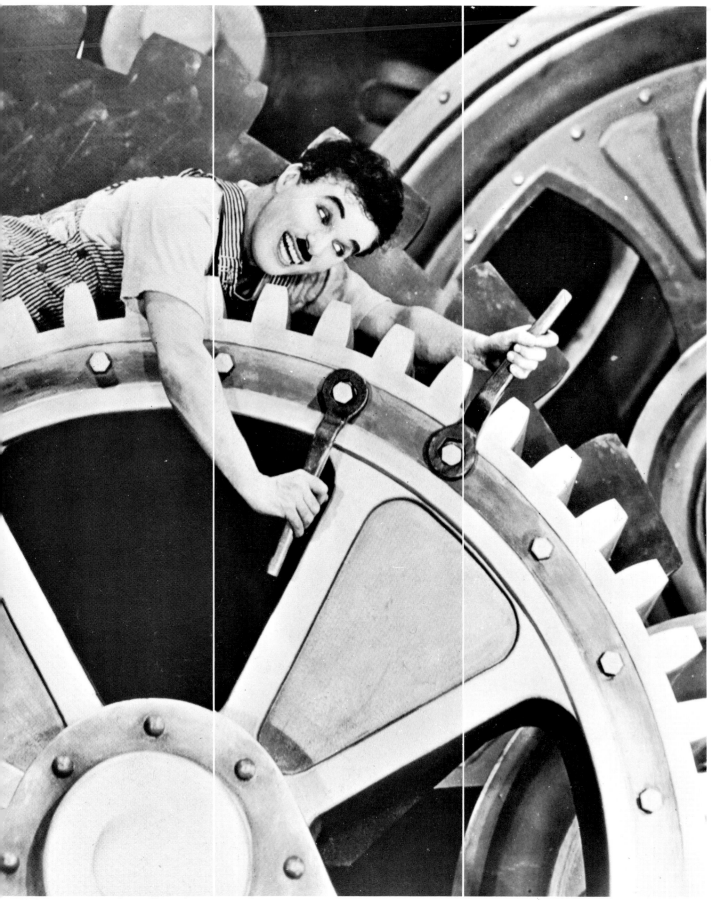

100-line screen. 110-line screen. 120-line screen.

Preparing Mechanicals

Perhaps the best way to understand mechanicals is to actually do one. In this way you can see the various steps involved and understand the reasons for them.

When preparing a mechanical, the first thing to do is organize your materials: T-square, triangles, illustration board (or artboard), repros, photostats, masking tape, rubber cement, scissors, tweezers, and single-edge razor blades. You will also need a pasting and cutting board. This can be a spare piece of illustration board large enough to allow you to cut and paste freely.

Let's follow the preparation of a simple mechanical that combines type (line copy) and a photograph (continuous-tone copy) and is printed in one color, black.

Check the repros carefully; if there are any imperfections such as broken letters, try to retouch them with your crowquill pen. If your efforts to patch things up fail, get corrected repros.

Cut out the individual elements to be pasted down. To do this, tape the repro securely to your cutting board, and using a metal T-square, a cutting triangle, and a sharp single-edge razor blade, cut at parallel and right angles to the lines of type. Sloppy cutting can cause optical illusions, making the type appear to be running up or downhill. Avoid cutting too close to the actual type, or you may accidentally slip and cut into the type.

ILLUSTRATION BOARD

Drawing Guidelines. Square up the illustration board and tape it securely to the drafting table with masking tape. Using your T-square, triangle, and light blue (nonreproducible) pencil, indicate the outside dimensions of the printing area, allowing a margin of a few inches all around. Whenever possible, mechanicals should be the same size as the printed piece.

Next, indicate the position of the type and art. These lines will serve as guidelines when pasting down type and ruling in the box that surrounds it. Light blue lines do not reproduce when the art is shot and may therefore be drawn in generously. They should be long enough so that they are not completely covered by the art you are pasting down.

The final printed piece.

CROPMARK

FOLDING LINE

HOLDING LINE

Cropmarks, Folding Lines, and Holding Lines.
There are certain lines that provide information to the printer and must appear in the negative: cropmarks, folding lines, and holding lines for halftones, color, or tint areas. Some of these occur outside the actual printing area and must be drawn with a red or black pen.

Cropmarks are drawn at all four corners and indicate the outside perimeter of the "live area" or printed piece. They also tell the printer where the job is to be trimmed in order to make the printed piece the correct size. Folding lines, which indicate where the printed piece is to be folded, are indicated by a broken line drawn outside the trim area. Holding lines indicate the exact area that is to be occupied by a halftone, color, tint, etc.

Drawing Rules.
Next, rule in the box surrounding the art with a ruling pen, Rapidograph, or good ballpoint pen. The reason for starting with the ruling-in of the box is that if you make a mistake you can simply start over with no great waste of time, whereas if the rest of the mechanical is finished and you make a mistake you either have to start over or patch it up the best you can. If you are uncertain about your ability to use a ruling pen, draw the rules separately on smooth paper or vellum, cut them out, and paste them down on your mechanical. The same method can be used to correct faulty lines that are already ruled.

Note: Desktop publishing systems make excellent boxes and rules which can be used in conjunction with traditional mechanicals.

Pasting Down Line Copy. Line copy, in this case consisting only of a glossy stat, is shooting copy and should be in perfect condition. Although we are beginning with line copy in this case, there is no specific order in which to paste down the various elements in your mechanical. Usually, the first element is the largest, or key, element to which the others will relate. Always try to start at the top and work down—in this way your triangle and T-square will be free to move down the mechanical without catching on elements that you have just pasted in position. Also, by working in this manner you will never cover your work with your tools; you will be able to see the elements and how they relate to one another at all times.

Using the tweezers, pick up the type and place it face down on the pasting board. Cover the entire area with one-coat rubber cement; be especially careful to cover the corners, as they have a habit of popping up and catching the T-square. (If you are not comfortable working with one-coat rubber cement, it is also possible to work with two-coat. In this case, both the art to be pasted down and the board are given a coat and allowed to dry. A slip sheet is placed over the board and the art is positioned over the slip sheet. Once the art is in the proper position the slip sheet is slowly removed. One advantage of this system is that it makes a very permanent bond.)

Once the art is covered with rubber cement, you have about 20 seconds to position it correctly on the mechanical. Because the rubber cement is wet, you can slide the art into position while checking it with your T-square and triangle to be certain it is properly aligned. Do not hold the art in the air while trying to find the exact position; this allows the cement to dry too quickly and does not give you enough time to check the alignment.

Also avoid picking the art up and putting it down again; this leaves a thin coat of cement on the art and on the board. Both coats will dry very quickly and when these two surfaces make contact they will bond immediately. If you have not properly positioned your art you will have to use rubber-cement thinner in order to lift it up. Then you will have to clean both surfaces and start over.

After the art is in position, place a clean sheet of tracing paper over it and press firmly to be sure all areas are securely pasted down. If an area has been missed, raise the edge gently, apply a little more cement, and press again.

Note: In many studios rubber cement has been replaced by waxing machines which lay a thin coat of melted wax on the copy to be positioned. The wax makes an effective bond, but it can be repositioned if necessary.

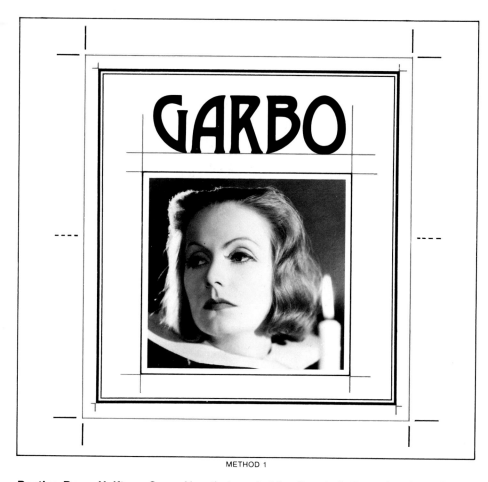

METHOD 1

METHOD 2

METHOD 3

Pasting Down Halftone Copy. Now that all the line copy is pasted down we must position the halftone, which in this case is a photograph. Unlike line copy, which is shooting copy and is therefore pasted into position on the mechanical, halftone art need only be indicated for size and position, as it is photographed separately and then stripped into the line negative. There are three ways to indicate the position of a halftone: (1) drawing a red holding line, (2) pasting down a scaled matte stat, or (3) using an acetate overlay.

In the first method, draw a red holding line, accurately indicating the size and position of the halftone. (When photographed, the film used is designed to shoot red as black; when developed, the red line will appear as white on the negative. It is into this area that the halftone will be stripped.) You may also wish to paste a matte stat inside the holding lines to indicate the piece of art to be used, and how much of it. Be careful not to cover the holding lines; leave about 1/16" between the edge of the stat and all holding lines.

Stats representing halftones are not shooting copy and so should be crossed out and keyed to the corresponding shooting copy. Write your instructions directly on each stat: "For position only; strip in halftone; see art *A*."

In the second method, trim a stat to the exact size of the halftone and paste it into position without using a holding line. This will work when the stat is dark enough so that a definite edge is visible on the negative, but not when the stat is so light that the printer cannot see the edge.

The third method involves the use of red acetate (Zip-a-Tone, Rubylith, etc.). Draw the holding line in light (nonreproducible) blue. Then cut a piece of red acetate slightly larger than the desired halftone area, being careful to cover all the holding lines. Because the acetate has an adhesive back, it will stick immediately. Trim the acetate to size along the holding lines, using a triangle, T-square, and razor blade. (Red rather than black acetate is used because the red is transparent enough that the designer can see his holding lines in order to cut accurately.) When the mechanical is photographed this red area will appear as a clear area in the negative. It is into this clear area, or "window," that the halftone will be stripped.

ART A
SQ. HT.
40%

Adding a Tissue Overlay. At this point the mechanical is essentially finished. Cut a sheet of tracing paper or vellum the size of the board and attach it to the upper edge with masking tape. This covering, called an *overlay*, protects the art and at the same time allows you to write your instructions to the printer; ink color, tint percentages, etc. Instructions should be written clearly and precisely; if there are any questions, consult the printer. For added protection, as well as a better appearance, a second sheet, or "flap," of heavy paper can be attached over the tracing paper.

Mounting Shooting Copy. It is always a good idea to mount shooting copy such as photographs or original art on a piece of artboard, with an overlay for protection. The key number, the type of shot required, and the percentage of reduction should be marked clearly on the board or tag attached to the board; for example, "Art *A*; square halftone; shoot at 40% of art." Cropmarks indicating how the photograph is to be cropped should be drawn on all four margins of the photograph or board. Where possible, use a grease crayon for marking photographs; it is not only less likely to destroy the surface, but its marks can be easily removed, returning the photograph to its orginal state.

Checking the Mechanical. Before releasing the mechanical, inspect it carefully to be certain that everything is in order. Make sure that it is clean, especially along the edges of the type; rubber cement has a bad habit of collecting dust which the camera will record.

To get an idea of how the printed piece will appear, look at the mechanical through a sheet of tracing paper or vellum. This will obscure the distracting cut marks, allowing you to see the elements of your design as a whole. Another fast, inexpensive, and effective way of checking the design is to make a photocopy of the mechanical, or, if time permits, a stat. Either way, this allows the designer or client an opportunity to make corrections while changes are still relatively inexpensive; it is easier for the designer to cut and paste with paper than it is for the printer to work with film.

When the printer receives the mechanical it is checked to make certain that everything needed is included and that the instructions are clear. Anything missing or incorrect means lost time, which can be serious if you are working against a tight deadline.

Handling Copy. It is important that copy, photographs, illustrations, or repros, be handled with the utmost care and respect. Apart from the obvious reason that all original artwork should be returned to the client in the same condition as it was received, there is also the consideration that the better the condition of the copy, the better the printed piece will appear. Although most of the following suggestions deal specifically with photographs, most can be applied to any type of artwork:

Writing on Photographs. Do not write on a photograph—front or back—or on an overlay that comes in contact with the photograph. The pressure of the pen or pencil will cause the writing impression to show on the surface of the photograph and be picked up in the printed piece. If photographs must be identified on the reverse side, use a grease crayon and press gently. A better solution is to use tags which can be taped to the back of the photograph and then removed after use.

Paperclips. Do not use paperclips on photographs as they too will leave an impression on the surface of the photograph that might appear in the printed piece. If you do use paperclips, insert a cardboard "padding" between the paperclip and the photograph (an index card folded over the photograph to protect it front and back will do).

Folding and Rolling. Never fold or roll a photograph. This will cause cracks in the emulsion which will appear in the printed piece. It can also destroy the photograph for future use. Damage caused in this way can be retouched if not too extensive. However, this can be an expensive operation.

Trimming. Never trim a photograph to its final size. This not only spoils the photograph for future use, but also limits the possibilities of correcting any error in cropping.

NEVER TRIM PHOTOGRAPH TO SIZE

NEVER USE PAPERCLIPS WITHOUT PADDING

NEVER DRAW CROPMARKS ON PHOTOGRAPH

NEVER WRITE ON PHOTOGRAPH

NEVER FOLD

How not to handle a photograph.

COLOR MECHANICALS

There are two basic methods for printing color: flat (or match) color and process color. (See *Color Printing*, page 99.) How the designer prepares the mechanical is dictated by which of these two printing methods is used.

Flat Color Mechanicals. In flat-color printing, the designer chooses one or more colors, and for each color the printer makes a printing plate. To prepare a mechanical for flat color, the designer makes the color separations him or herself; that is, the designer indicates which elements are to be printed in which colors.

If the different colors do not touch one another then all the type and art is mounted on the same mechanical board and the color breaks indicated on the tracing paper overlay. The printer will shoot the mechanical once for each color and then opaque elements not required on each negative. If the printed colors are to touch, the black (or major color) copy is pasted on the artboard while the copy for each additional color is pasted on acetate overlays, each one representing a color. (All copy pasted down is black and white; it is the printing ink that dictates the final color.) Each overlay is attached to the top of the board with drafting tape and then a final tracing paper overlay with printing instructions is attached.

When working with overlays, it is *very* important that all the elements be kept in alignment. For this reason, the acetate should have sufficient body to resist warping or shrinking. It is equally important that the printer maintain this registration if the job is to be printed properly. To ensure this, registration marks are used. These are fine crosses which can be drawn by hand or bought in rolls of self-adhesive transparent tape. Registration marks are placed in at least three positions on the board outside the print area and in precisely the same position on each overlay. The reason that such precision is essential is that the board and overlays are photographed separately and must register precisely when the printing plates are made in order to ensure proper color registration.

Some printers prefer register marks pasted only on the artboard. They then cut holes in the overlays and shoot all overlays using only these three register marks. This ensures perfect registration.

After the mechanical is finished, a color swatch at least 1″ square showing the desired color is added to each overlay along with printing instructions.

Yellow plate.

Cyan plate.

Black plate.

Mechanical for illustration on page 112.

Process Color Mechanicals. Process color printing, also referred to as full-color printing, is the method used to reproduce an image that has a full range of color, such as a transparency, painting, or color print. To prepare a mechanical for process color, all the designer has to do is paste a photostat or photocopy of the original art in position and indicate that it is to be printed in process color. The printer then takes the original copy and separates it into the four basic printing colors: yellow, magenta (process red), cyan (process blue), and black.

If there is line art, such as type, to be printed in color along with the full-color image, the designer must specify the color. This can be done in one of two ways by using a color chart or color swatch. The color chart, or color specifier, is usually supplied by the printer and illustrates the various colors available by combining tints of the process colors (see page 112). Although charts are available in most art stores, it is recommended that you use a chart especially prepared by your printer, as process colors and printing techniques do change from printer to printer.

The other possibility is to give the printer a color swatch, preferably a printed color rather than a silk screened oil, or water color. The printer will then determine how best to match the color.

Mechanical for page 105. All instructions would be written on an overlay.

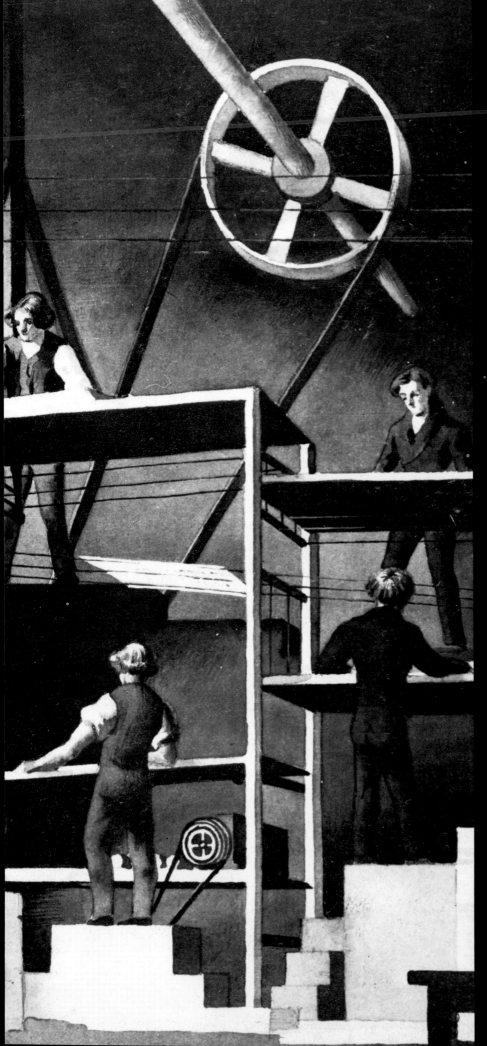

Appendix

This early printing press used by the London Times in 1827 was capable of printing 4,000 sheets per hour.

Glossary

A

AA. Author's alteration, or any alteration in text or illustrative matter which is not a PE (printer's error).

Abrasion resistance. Ability of ink or paper to withstand rubbing and scuffing.

Accordion fold. Series of parallel folds in paper in which each fold opens in the opposite direction from the previous fold—like an accordion.

Access. To gain entry to filed information.

Acetate. Transparent cellulose sheet placed over mechanical on which color separation or directions can be indicated.

Acetate proof. *See* Color overleaf proof.

Acetone. Volatile, fast-drying solvent.

Adhesive binding. *See* Perfect binding.

Adobe PostScript. A computer imaging system for page description.

A4. The international standard for business stationery: the equivalent to 8½ × 11 inches.

Against the grain. Folding paper at right angles to the grain.

Agate. Unit of measurement used in newspapers to calculate column space: 14 agate lines equal 1 inch. (Agate was originally the name of a 5½-point type.)

Airbrush. Small pressure gun, shaped like a fountain pen, that sprays paint by means of compressed air. Used to create effects of gradated tone and retouching photos.

Albumin plate. An albumin-coated offset press plate made from negatives. *See also* Deep-etch plate *and* Pre-sensitized plate.

Alcohols. Solvents used in flexographic and gravure inks.

Align. To line up, or place letters or words on the same horizontal or vertical line.

Alignment. Arrangement of type in straight lines so different sizes justify at the bottom (base-aligning) and ends of lines appear even on the page.

Alphanumeric. Refers to any system of letters and numbers (alphabet plus numerals). An example of an alphanumeric designation is "AB 220."

Alphasette. Phototypesetting system manufactured by Alphatype Corporation.

Amberlith. Also known as *camera amber*. Brand name for a red- or orange-coated acetate sheet used on a mechanical or on artwork as marking material to position halftones, areas of color, and tints. The coating is "strippable"; that is, it can be selectively cut and peeled away to create outlines and silhouettes.

Analogue computer. A type of computer that represents numerical quantities as electrical or physical variables, used in the industry to turn valves or machinery off and on. Such companies are not used in phototypesetting. *See* Digital computer.

Aniline dye. A synthetic organic dye, used in flexographic printing inks.

Aniline printing. Old term for flexography (*which see*).

Antique finish. Soft, bulky paper with a relatively rough surface, similar to the old handmade papers.

Application. A desktop publishing program that performs a specific task, such as word processing, graphics, etc.

Aquatone. Printing method combining fine screen gelatin plates and lithography.

Architecture. The general design features of a computer system of the circuit pattern of a chip.

Arc lamp. Lamp that produces light by a current arcing across two electrodes, usually of carbon. Used as a light source in photography or platemaking.

Art. All original copy, whether prepared by an artist, camera, or other mechanical means. Loosely speaking, any copy to be reproduced.

Artype. A brand name for self-adhering type printed on transparent sheets that can be cut out and placed on artwork. Available in a wide range of type styles and sizes.

Ascender. That part of the lowercase letter that rises above the body of the letter, as in *b, d, f, h, k, l,* and *t.*

Asymmetrical type. Lines of type set at random with no predictable pattern.

Author's alteration. *See* AA.

B

Backbone. Also called *spine.* In binding, that part of a book binding that connects the front and back covers.

Backing. A metal backing soldered to duplicate printing plates to make them 11 points (0.1524″) thick for use on patent blocks or printing bed bases.

Backing-up. In presswork, printing the reverse side of a sheet.

Back lining. Paper or fabric that adheres to the backbone, or spine, of a book.

Backup. A secondary resource duplicating a primary resource, such as a backup disk as a precaution in the event of a system failure.

Bad break. In composition, when the first line of a page is hyphenated. Also, incorrect end-of-line hyphenation.

Bag paper. Usually kraft paper (*which see*), used for making bags. Paper weight varies depending on bag size.

Bank. Cabinet or bench on which type is made up or stored in readiness for makeup.

Baronial envelope. Square type of envelope used for announcements, formal correspondence, and greeting cards.

Base. *See* Patent base.

Baseline. Horizontal line upon which all the characters in a given line stand.

Basis weight. Weight in pounds of 500 sheets (a ream) of paper cut to a given standard size (this is called the *basis size* and varies with paper grade).

Bastard progressives or progs. Also called *Hollywood progs.* A set of progressive proofs showing every possible color combination of the four process colors. The exact and specific effect of any two or three colors can be determined and intelligent comments formulated for correction by the platemaker. Sequence of a normal set of bastard progs is: yellow, red, yellow-red, blue, yellow-blue, red-blue, yellow-red-blue, black, yellow-black, red-black, blue-black, yellow-red-black, yellow-blue-black, red-blue-black, and yellow-red-blue-black.

Bastard size. A non-standard size of any material used in the graphic arts.

Baud. The unit of signalling speed; generally one bit per second.

Bearers. In composition, strips of type-high metal placed around the type form to protect the printing surface when the form is to be electrotyped. In photoengraving, the excess, or "dead" metal left on the printing plate to protect the live matter from excess pressure when molding for electroplating. On printing presses, metal rims beside the gears on which the printing cylinder rides. In reproduction proofing, strips of type-high metal placed outside the live matter of the form to even up the pressure and prevent the ink rollers from slurring the form.

Bed. In letterpress printing, the flat part of the press that holds the type form during printing: a job that is ready for the press is ready to be "put to bed."

Benday process. Application of dot or line patterns to line plates in order to create the effect of flat tones or shadings. Named after the man who developed the process, Ben Day. Now an obsolete process, superseded by laying photographic screen tints.

Bevel. Sloping edge around the outside of an engraving or electrotype that permits it to be locked with hooks onto a patent base (*which see*).

Bézier. A type of curve commonly used for specifying outlines of digital type. The exact shape of the curve is established by computer-determined control points. The bézier principle is also used with software drawing programs.

BF. Boldface (*which see*).

Bible paper. A thin, opaque, high-tensile-strength book paper used where low bulk is essential: for bibles, insurance rate books, encyclopedias, etc. Basis weights normally range from 14 to 30 pounds.

Binary. Anything made up of two units or parts may be referred to as binary. In computer systems, a base-2 numbering systems using digits 0 and 1.

Binary code. In computer systems, a code that makes use of two distinct characters, usually 0 and 1.

Binder. Person who does bindery work. Also, a device equipped with metal rings for holding looseleaf sheets.

Binder board. High-quality, single-ply, solid pulp binding board.

Bindery. An establishment that binds books, pamphlets, etc.

Binding. The fastening together of printed sheets in the form of signatures into books, booklets, magazines, etc. Also, the covers and backing of a book.

Binding board. Paper board, either binder board or pasteboard, used in bookbinding for the covers of casebound books.

Binary digit. In computer systems, the smallest unit of information representing one binary digit, 0 or 1. Also called a *bit.* The word is derived from the first two letters *binary* and the last letter of *digit.*

Bite. In photoengraving, the time required when etching with acid to produce a given depth: the depth of the etch increases with each "bite."

Bitmapped display. An image on the video screen in which each dot, or pixel, corresponds to, or is "mapped" to, a bit in the computer's random-access memory (RAM).

Black letter. Also known as *gothic.* A style of handwriting popular in the fifteenth century. Also, the name of a type style based on this handwriting.

Blanket. In offset lithography, the rubber-surfaced sheet around the cylinder which transfers the image from plate to paper.

Bleed. Area of plate or print that extends ("bleeds" off) beyond the edge to be trimmed. Applies mostly to photographs or areas of color. When a design involves a bleed image, the designer must allow from ⅛" to ¼" beyond the trim page size for trimming. Also the printer must use a slightly larger sheet to accommodate bleeds.

Blind embossing. A bas-relief impression made with a regular stamping die (*which see*), except that no ink or foil is used.

Blind keyboard. In photocomposition, a tape-producing keyboard which has no visual display and produces no hard copy.

Block. In computer systems, a group of words, characters, or digits held in one section of an input/output medium and handled as a unit.

Blocking. In letterpress, mounting an engraving on a block of wood or metal to make it type-high, permitting it to be locked up in a form to be printed. Also, the sticking together of printed sheets when piled too high before the ink has dried.

Blow-up. An enlargement of copy: photograph, artwork, or type.

Blueprints. Also called *blues.* Blue contact photoprints made on paper, usually used as a guide for negative assembly, preparing layouts, or as a preliminary proof for checking purposes.

Blurb. Summary of contents of a book presented as jacket copy. Also, a short commentary, such as a caption or the text in comic strip balloons.

Boards. *See* Binder board.

Board stock. *See* Paperboard.

Body. In composition, the metal block of a piece of type that carries the printing surface. It is the depth of the body that gives the type its point size. In printing, a term that refers to the viscosity, consistency, and flow of a vehicle or ink.

Body matter. Also called *body copy.* Regular reading matter, or text, as contrasted with display lines.

Body size. The depth of the body of a piece of type measured in points.

Body type. Also called *text type.* Type, from 6 point to 14 point, generally used for body matter.

Boldface. A heavier version of a regular typeface, indicated as *BF.*

Bond paper. A grade of writing and printing paper with a surface treated to take pen and ink well and have good erasure qualities. Cheaper grades of bond paper are made from all wood fiber; the better grades are made from rag fiber (25%, 50%, or 100% rag content). Used where strength, durability, and permanence are required.

Booklet. A small book, commonly bound in paper covers. Generally used for advertising or promotional purposes.

Book paper. A category or group of printing papers that have certain physical characteristics in common which make them suitable for the graphic arts. Used for books, magazines, and just about everything we read, with the exception of newspapers and pulp novels.

Books. Generally applies to printed, bound works. Books published as textbooks are called *school books;* those published for sale by bookstores are called *trade books.* Books printed and bound with paper covers are called *paperbacks.*

Borders. Decorative lines or designs available in type, used to surround a type form or page

BPS. Bits per second

Brackets. Pair of marks ([]) used to set off matter extraneous to the context.

Brayer. Hand roller used to apply ink to type or printing plates when rough proofs are desired.

Break for color. To separate, color by color, the parts of a job to be printed in different colors.

Brightype. Trade name for a machine for converting letterpress type or engravings into a photographic image that can be used for offset lithography or gravure printing. The metal type form is sprayed with a black lacquer which is then selectively removed by rubbing the printing surface, making the surface reflective and the background light-absorbent. The form is then photographed in shadowless lighting as if it were line copy, resulting in a photographic film negative. Manufactured by Ludlow Typograph Company. *See also* Cronapress *and* Scotchprint.

Bristol board. Also called *Bristol*. A good grade of thin cardboard or pasteboard with a smooth surface. Available in a variety of finishes and colors; ideal for drawing, writing, and printing. Used for cards, posters, displays, announcements, or for any job where stiffness is required.

Broadside. Large printed sheet folded for mailing.

Bourges. (Pronounced *burgess*.) Trade name for a thin, color-coated acetate overlay sheet keyed to standard printing inks. Used to produce color separations in art. Also comes in degrees of whites and grays for modifying photo backgrounds. The coating is removed either by a fluid or by scratching.

Brochure. Pamphlet bound in the form of a booklet, usually eight or more pages.

Broken package. A quantity of paper less than a standard wrapped amount (usually less than a ream). When ordered, broken packages carry a penalty charge.

Bronzing. Applying bronze or metallic powder over printed sizing ink while it is still wet to produce a metallic luster.

Brownprint. Also called a *brownline* or *Van Dyke*. A photoprint made from a negative and used as a proof to check the position of elements before the plate is made.

Buckram. Sized, heavy-weave cotton cloth used for binding books.

Buffer. In computer systems, a data-storage area situated between computer units. It may be a piece of hardware, an area of memory, a disc, or a tape.

Built-up letter. A letter in which the outline is drawn first and then filled in.

Bulk. The thickness of paper, measured by the caliper of pages per inch (PPI).

Bullet. Dot used as ornamental device.

Bulletin. Loosely used to describe several forms of printing, however it generally refers to one of a sequence of factual reports issued at irregular intervals. There is no particular form for a bulletin; it can be a single leaf, a folder, or a booklet.

Burin. In engraving, a pointed steel cutting tool.

Burnish. In photoengraving, to darken local areas of a printing plate by rubbing down the lines and dots, thus increasing their printing surfaces. Also, a general term for smoothing down self-adhering letters and shading sheets.

Burr. Rough edge or curl of metal left on a photoengraving as the result of burnishing, routing, or cutting.

Butted lines. Two or more linecast slugs placed side by side to produce a single line of type.

Byte. In computer systems, a group of adjacent bits (*which see*) operated on as a unit and usually shorter than a word. It can be one complete character.

C

C. & s.c. Capitals and small capitals. In composition, used to specify words that begin with a capital letter and have the remaining letters in small capitals, which are the same height as the body of the lower-case letters.

Calender. A set, or "stack," of cast-iron rollers with chilled, hardened surfaces, resting on one another in a vertical bank at the end of the papermaking machine. The paper passes through all or some of these rollers to increase the smoothness and gloss of its surface. *See also* Supercalender.

Calendered paper. Paper with a smooth finish produced by its being passed through the calender (*which see*) of the papermaking machine.

California job case. Tray in which handset type is stored and from which it is set. The individual cubicles are arranged for a minimum of motion and are sized to accommodate letters in quantities related to frequency of use.

Caliper. The thickness of a sheet measured under specific conditions. The paper is measured with a micrometer and is usually expressed in thousandths-of-an-inch (mils or points).

Calligraphy. Elegant handwriting, or the art of producing such handwriting.

Cameo. A die-stamping process in which the lettering or design slants up in relief.

Camera-ready art. Copy assembled and suitable for photographing by a process camera with a minimum number of steps.

Capitals. Also known as *caps* or *uppercase*. Capital letters of the alphabet.

Caps and small caps. Two sizes of capital letters on one typeface, the small caps being the same size as the body of the lowercase letters. Indicated as *c&sc*. Looks Like This.

Caption. Explanatory text accompanying illustrations.

Carbon black. A fine, intensely black pigment obtained by burning natural gas or oil with restricted air supply. Used in the manufacture of ink.

Carbon tissue. In rotogravure printing, a paper sheet coated with gelatin, plasticizers, and pigments used for photoprinting. It is exposed to strong lights through a gravure screen to produce a resist for etching gravure cylinders.

Cardboard. A general term used to describe a stiff, strong sheet of several layers of low-quality paper pasted together.

Cards. *See* Expansion cards.

Case. A type tray. Each character in a font of type has its own section in the tray, called a *type case*. Also, the covers of a casebound or hardcover book.

Casebound. *See* Edition binding.

Casing-in. The process of inserting the signatures of a book into its cover, or case.

Cast-coated paper. Paper that goes through the process of cast-coating (*which see*).

Cast-coating. A process in which the paper is pressed against a heated, polished drum while the coating is in a highly plastic condition. Cast-coating gives the paper an exceptionally high gloss and smoothness similar to that of a glossy photograph.

Casting. A typesetting process in which molten metal is forced into type molds (matrices). Type can be cast as single characters or as complete lines. Also, the casting of metal printing plates (stereotypes) from matrices (mats) for newspapers or books.

Casting box. Device used for casting flat stereotypes (*which see*).

Casting-off. Calculating the length of manuscript copy in order to determine the amount of space it will occupy when set in a given typeface and measure.

Cathode ray tube. In phototypesetting, electronic tube used to display letter images, in the form of dots (computer logic character formation) or lines (character projection), for exposure onto film, photopaper, microfilm, or offset plates.

Cell. In gravure printing, small etched depression (representing one halftone dot) in the surface of the gravure cylinder that carries the ink.

Centered type. Lines of type set centered on the line measure.

Center spread. *See* Spread.

CEPS. Color electronic prepress systems designed for the proofing of color images.

Chad. In phototypesetting, the paper waste resulting from holes being punched in paper tape or cards.

Chain lines. Also called *chain marks*. The widely spaced watermark lines (usually about 1″ apart), caused by chain marks, which run with the grain in laid papers. Chain lines are natural in handmade papers and can be imitated in machine-made papers.

Chalking. Also called *powdering*. In printing, a condition in which the pigment in the printing ink does not adhere properly to the printing surface and can be rubbed off as powder or chalk.

Chapter heads. Chapter title and/or number of the opening page of each chapter.

Character count. The number of characters in a line, paragraph, or piece of copy.

Character generation. In CRT phototypesetting, the projection or formation of typographic images on the face of a cathode ray tube, usually in association with a high-speed computerized composition.

Characters. Individual letters, figures, punctuation marks, etc. of the alphabet.

Characters-per-pica (CPP). System of copyfitting (*which see*) that utilizes the average number of characters per pica as a means of determining the length of the copy when set in type.

Chase. In letterpress printing, the rectangular steel frame into which type and engravings are locked up for printing.

Chipboard. Low-grade binding board made from wastepaper, usually used for backing padded forms.

Choke. The opposite of spread (*which see*).

Chroma. Also referred to as *hue*. Pure color, free from white or gray.

Chrome. *See* Color transparency.

Circulating matrix. In composition, the mold (matrix) from which Linotype and Intertype line-casting machines cast type. Called "circulating" because the matrices are automatically returned to the magazine for reuse.

Clasp envelope. Envelope in which the flap closes with a metal clasp. Flap may also have glue for sealing.

Clip art. Illustrations printed on paper that the designer cuts out and pastes into the design. With desktop publishing, clip art is electronic pictures that can be copied from one disk and "pasted" into another.

Coalesce. To fuse the structure of a substrate such as paper or film by means of pressure in order to change its light-transmitting characteristics.

Coated paper. Paper with a surface treated with clay or some other pigment and adhesive material to improve the finish in terms of printing quality. A coated finish can vary from dull to very glossy and provides an excellent printing surface that is especially suited to fine halftones. Examples are pigmented or film-coated, conversion-coated, blade-coated, cast-coated.

Cockle finish. The pucker characteristic of many bond papers, especially rag bonds, which adds a crispness to the paper.

Cold-set inks. Inks in a solid form which are melted and applied to a hot press. They solidify again upon contact with the paper.

Collate. To arrange sheets or signatures (*which see*) in proper sequence so the pages will be in the correct order before sewing and binding. In photocomposition, to compare and merge two or more identically ordered sets of items into one.

Collotype. Also known as *photogelatin*. A photomechanical method of printing, similar to lithography, that utilizes an unscreened gelatin-coated plate rather than a halftone screen to print continuous-tone copy. Collotype is the only feasible form of halftone reproduction that does not require a halftone screen. Produces true reproductions but is suitable for short runs only.

Color. In composition, the tone or density of type on a page.

Color bars. Carried on all four-color process proofs to show the printer the four colors that were used to print the image. Color bars show the amount of ink used, the trapping, and the relative densities across the press sheet. Used mainly as a guide for the platemaker and printer.

Color comp print. Paper print made from a transparency. Not up to the standards of a dye transfer (*which see*) and used primarily for layouts and presentations.

Color correction. Changing the color values in a set of separations to correct or compensate for errors in photographing, separation, etc. color is usually corrected by masking, retouching, or dot etching (*all of which see*). Also the act of indicating on a set of color proofs what color corrections are to be made by the printer.

Color filters. Transparent filters placed over the lens of the printer's camera that separate the colors in the original copy into the process colors for four-color process printing (*which see*). The original copy is photographed four times through color filters. A blue filter produces the yellow printer (the negative used to make the printing plate), a green filter produces the magenta (red) printer, a yellow filter produces the cyan (blue) printer, and a combination of all three is used to produce the black printer.

Color guide. Instructions on art or mechanical (usually flat color work) indicating the position and percentage of color required or an actual sample of the color.

Color-matching system. Method of specifying flat color by means of numbered color samples available in swatchbooks.

Color overleaf proof. Transparent acetate sheets that are photomechanically developed and used as proofs or for presentations. Available in a wide range of colors, including the four process colors. Suitable for simulating pre-press proofs (*which see*) of full-color art.

Color print. Photographic print in color, such as Anscochrome, Cibachrome, dye transfer, Kodacolor, and Kodak Type C.

Color process. Term used to describe multicolor printing from process-separated materials, as opposed to multicolor printing in nonprocess colors.

Color proof. Printed color image which enables the printer to see that is on the film and the client to make sure the color is accurate and in register. Ideally, the proof should be printed on the same press and paper that will be used for the finished job.

Color scanner. *See* Electronic scanner.

Color separation. The operation of separating artwork into the four process colors by means of filters in a process camera or by electronic scanners. The result is four continuous-tone films (negatives or positives) which when screened are used to make printing plates.

Color separation negative. A single black and white negative which carries a record of the proportion and distribution of one of the process colors as found in the original full-color image. A set of separation negatives consists of four black and white negatives (called *printers*), one each for the yellow, red, blue, and black.

Color terminology. In the printing industry, color is described in terms of *hue* (chroma), *strength* (saturation), and *gray* (value). Hue is the pure color, strength refers to the color's strength, or saturation, and gray refers to how "clean" the color is. These are not terms used by the artist; they have been suggested by the printing industry to help communication between designer, client, and printer.

Color transparency. Also called a *chrome*. A full-color photographic positive on transparent film: Agfa Color, Cibachrome, Ektachrome, Kodachrome, etc.

Column inch. A measure commonly used by smaller newspapers based on a space 1″ deep and a column wide.

Combination plate. Also called *combo*. Halftone and line work on one plate.

Command. A word or phrase describing an action for the computer to perform.

Comp. *See* Comprehensive.

Compatible. Application programs are designed to operate on specific computer systems, when used in this manner the program is said to be "compatible" with the computer.

Composing room. That part of a typesetting shop or a printing plant in which type is set, or composed.

Composing stick. In metal composition, a metal traylike device used to assemble type when it is being set by hand. It is adjustable so lines can be set to different measures.

Composition. Typesetting (*which see*).

Composition system. Also called *page layout system* or *makeup terminal*. An electronic composition tool designed for the complex manipulation of text and images by simple menu commands.

Compositor. A person who sets and arranges type, either by hand or machine.

Comprehensive. More commonly referred to as a *comp*. An accurate layout showing type and illustrations in position and suitable as a finished presentation.

Computer. A device for performing sequences of arithmetic and logical processes used in typesetting to store information and make the mathematical, grammatical, and typographic spacing and end-of-line decisions, *i.e.*, hyphenation and justification.

Computerized composition. Sometimes (erroneously) called *computer composition*. Composition produced with the aid of a computer, which when properly programmed, speeds up the mathematical decisions needed to drive a typesetting machine.

Condensed type. Narrow version of a regular typeface.

Consumable textbook. A self-contained book designed to be written in and completely consumed by the student and which does not depend on any other textbook or material. A consumable textbook would be used by one student for one term and then discarded, as opposed to a non-consumable textbook.

Consistency. *See* Body.

Contact print. Photographic print made by direct contact as opposed to enlargements or reductions made by projection where there is no direct contact. Prints are made from either a film negative or positive in direct contact with photographic paper, film, or printing plate. The size is a one-to-one relationship. Contact prints are usually made on a vacuum frame.

Contact printing frame. *See* Vacuum frame.

Contact screen. A halftone screen placed in direct contact with the film. Used for screening halftones. The "sandwich" through which light passes is made up of the following: continuous-tone positive, contact screen, and the new, unexposed film which will receive the light, resulting in a screened film negative ready for platemaking.

Continuous-tone copy. Any image that has a complete range of tones from black to white: photographs, paintings, etc.

Contrast. Wide range of tonal gradations between highlights and shadows.

Conversion systems. Systems by which metal type or plates are converted into film images. Used in converting from one printed method to another. *See* Brightype, Cronapress, *and* Scotchprint.

Cool colors. Blue green, and violet, as opposed to warm colors, red, yellow and orange.

Coprocessor. An auxiliary processor that relieves the demand on the main microprocessor by performing a few tasks.

Copy. In design and typesetting, typewritten copy. In printing, all artwork to be printed: type, photographs, etc., *See also* Continuous-tone copy *and* Line copy.

Copyfitting. Determining the area required for setting a given amount of typewritten copy in a specified typeface.

Counter. Space enclosed by the strokes of a letter, such as the bowl of the *b,d,p,* etc.

Counting keyboard. In phototypesetting, an input keyboard which adds up the unit widths of the characters and spaces. The keyboard operator must make all end-of-line decisions regarding hyphenation and justification. The counting keyboard produces a tape or disk used to drive a typesetting machine. *See also* Non-counting keyboard.

Covering power. Also called *opacity.* In printing, an ink's ability to cover the material beneath it to produce a uniform, opaque (*which see*) surface.

Cover paper. Term applied to a variety of heavy papers used for the outside covers of brochures, booklets, and catalogs.

CPI. Characters Per Inch. The measurement of the packing density of a magnetic tape, drum, disc or any linear device that information is recorded on.

CPS. Characters Per Second. A measurement referring to the output speeds of phototypesetting equipment.

CPU. Central processing unit.

Crash finish. A paper finish that simulates the look and feel of coarse linen.

Crawling. Term applied to the contraction of ink after printing on a surface that it has not completely wet.

Crocking. Also called *rub*-off. Smudging or transfer of dry particles of ink by rubbing after job has dried.

Cronapress. A trade name for Du Pont's system of converting metal type or letterpress printing plates into film. This film can then be used to make offset plates, gravure cylinders, or very faithful duplicate letterpress plates. The material to be converted is covered with a special pressure-sensitive film and pressure is applied with vibrating steel balls or pins which coalesce the film to make it clear, or transparent, at the points at which the raised letterpress dots or type touch it. The material is then dyed to make the non-coalesced areas light-blocking. The result is a film negative. *See also* Brightype *and* Scotchprint.

Crop. To eliminate portions of copy so that it better the fits the page design. Usually done by using cropmarks (*which see*) on the original copy to indicate to the printer where to trim the image.

Cropmarks. In design, the lines drawn on an overlay or in the margins of a photograph to indicate to the printer where the image should be trimmed.

CRT. *See* Cathode ray tube.

Crystallization. In printing, a condition in which a printed, dried ink film has insufficient tack to permit trapping, or the laydown of a second ink which is printed on top of it.

Cursives. Typefaces that resemble handwriting, but with the letters disconnected.

Curved plate. In letterpress and flexography, a press plate curved to fit the printing cylinder. In offset lithography, plates are thin metal sheets which are wrapped around the plate cylinder.

Cut. Also called (in Europe) *block.* A commonly used word for any typographic printing plate or engraving.

Cutoff. In web press, the distance, or interval, between cutting knives which chop the web into individual sheets.

Cutoff rule. A hairline that marks the point where a block of type moves from one column to another, or the end of a story in a column of type. Also, in newspapers, the horizontal dividing line between typographic elements.

Cut-out lettering. Self-adhering transfer type carried on acetate sheets that is cut out and placed on the working surface. Examples are Formatt and Letraset.

Cyan. Also referred to as *process blue.* One of the process colors (*which see*). Also, one of the filters in color separations.

Cylinder press. A letterpress printing press in which a cylinder is used to impress the paper upon the type.

D

Daisywheel. A font formed on the end of fingers that extend radially from a central hub.

Dandy roll. Also called a *dandy.* The wire cylinder on the papermaking machine that impresses laid and wove patterns and watermarks on the surface of the paper.

Data. Information input, output, stored, or manipulated by a computer system.

Database. A structured arrangement of data in a computer system.

Data bank. The mass storage of information which may be selectively retrieved from a computer.

Data processing. A generic term for all operations carried out on data according to precise rules of procedure. The manipulation of data by a computer.

Day-Glow. Trade name for inks and papers containing fluorescent pigments.

Dead metal. In printing, areas on an engraving not intended for printing; these must be routed, or cut away after molding. If the engraving is to be molded for electrotyping or stereotyping, dead metal is carried on the plate as internal bearers to protect the live matter from damage.

Dead white. A neutral white that has no perceptible tint.

Decimal equivalents. Here are some of the more common fractions that you might be called upon to change into their decimal equivalents:

Sixteenths		Eighths	
1/16	.0625	1/8	.125
3/16	.1875	3/8	.375
5/16	.3125	5/8	.625
7/16	.4375	7/8	.875
9/16	.5625	Quarters, Thirds	
11/16	.6875	and Halfs	
13/16	.8125	1/4	.250
15/16	.9375	1/3	.333
		1/2	.500
		2/3	.666
		3/4	.750

Deckle edge. Irregular, ragged edge on hand-made papers, or the outside edges of machine-made paper produced by the "pisser" on the papermaking machine (so called because a jet of water "pisses" on the edge of the unformed pulp as it travels on the wire just before it becomes paper). This action "cuts" the edge of the unformed pulp. Because the deckle edge has esthetic value, fancy papers and cover stocks are sold untrimmed.

Deep etch. In printing, the process by which a printing plate is produced by two separate etching operations. Used when type and line work must be etched separately from tone work so as to render printability.

Deep-etched plate. In offset, a plate (made from a positive film) on which printing areas have been recessed below the surface so that the plate may be used for long runs.

Deep-etching. In engraving, additional etching to the first bite given line plates or coarse-screen halftones.

Definition. The degree of sharpness in a negative or print.

Delete. A proofreader's mark meaning "take out." Looks like this: _ℓ_

Delivery end. In printing, that part of the press at which the finished, printed sheet is delivered.

Densitometer. An instrument having a light-sensitive photoelectric eye which measures density (_which see_) Used by the cameraman to get the correct exposure when shooting copy and by the printer to control the quality of the presswork. There are two types of densitometers: reflection and transmission.

Density. In photography, measurement of the opacity of a transparent or translucent object. On a film negative, the greater the density area, the more black it is. Density is measured from 0 to 4.0.

Density range. The range of density, expressed numerically, from shadow reading to highlight reading, on negative or positive film, or on a printed sheet. Density range is measured by a densitometer (_which see_).

Descenders. That part of a lowercase letter that falls below the body of the letter, as in g, j, p, q, and y.

Desktop publishing. A system with the capacity to produce publication-quality documents.

Diazo. In phototypesetting, a photographic diazo-process-developed proofing positive commonly used to produce positive photoproofs and better-quality photorepros from film positives by contact exposure.

Die cut. Paper or cardboard cut into shapes other than rectangle by means of die cutting (_which see_).

Die cutting. The cutting of paper or cardboard by pressure or by a blow with thin steel blades made up on a form (called a _die_) so that part of the sheet is excised, or slit, so that it can be folded away from the rest of the sheet for a "popup" effect. Used in mailing pieces, folding boxes, greeting cards, and in sales displays.

Digital computer. A computer that represents and processes information consisting of clearly-defined, or discrete, data by performing arithmetic and logical processes on these data. As opposed to the analogue computer (_which see_).

Dimension marks. L-shaped points or short marks indicated on mechanicals or camera copy outside the area of the image to be reproduced, between which the size of reduction or enlargement is marked. |←— —→|

Direct digital proofs. Proofs made directly from continuous-tone art and not from film negatives. The proofs are composed of dithered dots (_which see_) rather than traditional halftone dots.

Direct impression composition. _See_ Typewriter composition.

Direction of travel. In printing, the direction in which the printing stock or web moves through the press.

Directory. A means of locating data, such as files, in a computer system.

Direct process. In direct process color separation, the original copy is separated, screened, and sized in one step by a process camera or scanner. As opposed to the indirect process (_which see_).

Disk. An information storage medium. The most popular are the 3.5 inch flexible plastic disk, called a _floppy disk_, and the 3.5 inch _hard disk_ capable of storing very large amounts of information.

Display type. Type which is used to attract attention, usually 18 point or larger.

Distribution. In composition, the act of returning the type, leads, rules, slugs, furniture, and other printing materials to their storage places after use.

Dithered dots. A technique for alternating the values of adjacent dots (or pixels) to create the effect of intermediate values or colors. Dithering can give the effect of shades of gray on a black-and-white display or additional colors on a color display.

Ditto. Trade name for a type of office duplicator, manufactured by Ditto, Inc. Also, the name for typographic mark used as an abbreviation for "repeat what is above." Looks like this: ".

Doctor blade. In gravure, a thin-edged, flexible metal blade fitted on rotogravure pressures that scrapes off excess ink from the surface of the engraved printing cylinder prior to printing. This procedure cleans the surface, leaving only the cells (_which see_) filled with ink.

DOS. Disk operating system. A set of computer programs designed primarily to handle the transfer of data between a computer system and disk storage.

Dot etching. Local color correction on film containing screened color separations. Dot etching changes the size of the halftone dots, thereby changing the tone.

Dot Pitch. The distance between the dots on the screen.

Dots, halftone. Minute, symmetrical individual subdivisions of the printing surface formed by a halftone screen (_which see_).

Double-black duotone. A duotone (_which see_) in which both plates are printed in black.

Double burning. To expose the images of two or more films onto a new film or a printing plate, thereby creating a single image.

Double-dot halftone. Two halftone negatives combined into one printing plate, producing a printed reproduction with a greater tonal range than a conventional halftone. One negative reproduces the highlights and shadows, the other reproduces the middletones. Used primarily in offset lithography.

Double-thick cover. Two thicknesses of regular-weight cover pasted to together.

Double-tone halftone. Imitation of a duotone (_which see_) in which the color plate is purposely printed out of register to produce a duotone effect.

Downloadable font. A font that can be downloaded into a printer or computerized typesetter.

Downtime. The time interval during which a device (typesetting equipment, printing press, etc) is malfunctioning or not operating; or the time spent waiting for materials, instructions O.K's, etc., during which work is held up.

DRAM. Dynamic random access memory.

Drawdown. Ink film deposited on paper by a smooth-edged blade to enable an evaluation of the color and density of the ink.

Drawing paper. A general term for a wide assortment of papers used for pen or pencil drawing. Fiber composition ranges from rag stock to groundwood.

Driers. In printing, film-forming substances (oils, resins, etc.) or metallic additives added to inks to hasten their drying time.

Drilling. Perforating, by drilling, sheets to be bound in looseleaf folders or spiral-type bindings. Done by a special machine that has a row of drills, which can penetrate a greater thickness of sheets than can punches.

Dropout halftone. Also called a _highlight halftone_. In printing, a halftone in which the highlight areas have no screen dots; all that appears in the highlight areas is the white of the paper.

Dropout type. _See_ Reverse type.

Dryer. In printing, a mechanical device used to accelerated the drying time of printing inks.

Drying time. In printing, the time required for an ink to form a rub- or tack-free surface. Also, the time needed for drying before the opposite side of a sheet can be printed or finished.

Dry-mounting. A method of adhering photographs to mounting boards by using a special wax-backed tissue that bonds under heat and pressure.

Dry offset. _See_ Letterset.

Dry-transfer typed. _See_ Pressure-sensitive lettering.

Dummy. The preliminary layout of a printed piece, showing how the various elements will be arranged. It may be either rough or elaborate, according to the client's needs.

Dump. To printout the contents of a system's memory when a crash has occurred.

Duotone. A two-color halftone made from a regular black and white photograph. One plate is made for the black, picking up the highlight and shadow areas; a second plate is made for the second color, picking up the middletones. When printed, these two plates produce a monochromatic reproduction with a full range of tones.

Duplex. In linecaster machines, a matrix that carries two molds. Also the character that occupies the secondary position in a duplex matrix.

Duplex paper. Paper or board with a different color or finish on each side.

Duplicate plates. Plates made from the same negative film, or in the case of letterpress, from a Cronapress (*which see*) negative made from the original plates. Also, molded duplicates of original plates produced by electrotyping, stereotyping, or other molding processes. Duplicate plates make it possible to print multiple images in the same sheet, as well as to use more than one press at a time (for example, in cases when one ad must appear in more than one publication at the same time). The most commonly used letterpress duplicate plates are stereotypes, electrotypes, plastic plates, and rubber plates.

Duplicate transparency. A duplicate of an existing photograph, in transparency form. Done when more than one piece of the same art is required, when the transparency must be retouched, when the transparency is to be ganged up with others on a flat for same-focus enlargement or reduction, or when the original is too valuable to release.

Duplicator. Small office-type printing machine that reproduces copy in small quantities: Mimeograph, Multigraph, Multilith.

Dycril. Trade name for Du Pont's PPDR plates (*which see*).

Dyes. A soluble coloring matter, as opposed to pigments, which are insoluble.

Dye transfer. A full-color print made on specially coated paper from reflective art or transparency copy. The process involves color separating the art into three colors, making gelatin matrices that selectively absorb dye, and transferring the dye (one color per matrix) to the gelatin-coated paper. Used by artists for doing retouching or as short-run quantity displays.

Dylux. Trade name for a fast, self-fixing, light-sensitive proofing paper, manufactured by Du Pont. Proofs can be made from either positive or negative film and are processed in as little as 30 seconds. The paper is sensitive on both sides, permitting the creation of accurate dummies.

E

ECI. Electronic color imaging.

Edge-gilding. In binding, the addition of gold leaf to the page edges of a book. Common practice with bibles or finely printed limited-edition books.

Editing. Checking copy for fact, spelling, grammar, punctuation, and consistency of style before releasing it to the typesetter.

Editing terminal. Also called an *editing and correcting terminal*. In phototypesetting, a tape-operated visual display unit (VDT), using a cathode ray tube on which is displayed the results of keyboarding (captured on tape) for editing purposes via its attached input keyboard prior to processing the copy in a typesetting machine.

Edition binding. Generally refers to all commercial bindings, such as wire-stitched, perfect, mechanical, and casebound, as opposed to custom or handmade bindings. More specifically, it refers to just the latter, casebound, also referred to as *hardcover*. Edition binding is the most permanent of all binding methods: the signatures are gathered, sewn together, and cased-in (*which see*). This book is edition bound.

Eggshell antique. A soft, bulky paper with a finish that resembles the shell of an egg.

Egyptian. Type style recognizable by its heavy, square serif.

Electronic mail. Messages held or transmitted by a computer system.

Electronic scanner. Photoelectric equipment for scanning full-color copy by reading the relative densities of the copy to make color separations. The scanner is capable of producing negative or positive film either screened or unscreened. In printing, refers to an electric "eye" on a press that scans the printed sheet as it passes through the press for the purpose of register control, quality control, ink density, and register for cutoff, etc.

Electronically integrated publishing (EIP). A comparatively new concept that assumes the ability to have freely transportable bits and bytes from the creative process through to the final printed product.

Electrotype. Also called an *electro*. A duplicate of the engraving or type form, produced by electroplating. A vinyl mold is made of the original, sprayed with silver and then electroplated, with a coating of copper to form a shell-like cast. Extra hardness is obtained by overplating the copper with nickel or chromium after the shell is removed from the mold. After removal the shell is backed up (filled) with lead alloy to bring it to the proper height and give it the strength to withstand the pressure of the printing press. Where a lighter-weight plate is desirable for purposes of shipping or handling, the backing may be plastic, aluminum, or nylon instead of lead. Electrotypes may be flat, or curved to fit rotary cylinders. Electros are 11 points (0.1524″) and shell electros 0.063″ high.

Elite. The smallest size of typewriter type: 12 characters per inch as compared with 10 per inch on the pica typewriter.

Ellipses. Three dots (. . .) that indicate an omission, often used when shortening copy.

Elliptical dot. A halftone dot with a shape like that of a football, rather than the conventional square-dot shape. An advantage of elliptical dots is that they produce a smoother gradation of tones across the 50% tint areas of the halftone.

Em. Commonly used shortened term for em-quad (*which see*). Also, a measurement of linear space, or output, used by typographers.

Embossing. Producing a raised image on a printed surface. Embossing is done on a heavy-duty press, using special female dies and creating a male counter by making ready with a special compound. *See also* Blind embossing.

Em-quad. Called a *mutton* to differentiate it from an en-quad, called a *nut*, which is one half the width of an em. In handset type, a metal space that is the square of the type body size; that is, a 10-point em-quad is 10 points wide. The em gets its name from the fact that in early fonts the letter *M* was usually cast on a square body.

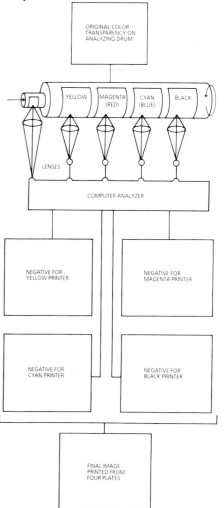

Electronic scanner.

Em-space. A space the width of an em-quad (*which see*).

Emulsion. In photographic processes, the photosensitive coating that reacts to light on a substrate.

Emulsion side. The dull, or matte, emulsion-coated side—as opposed to the glossy side—of photographic material.

En. Commonly used shortened term for en quad (*which see*).

Enamel-finish paper. A smooth-coated paper, excellent for printing fine halftones.

End-of-line decisions. Generally concerned with hyphenation and justification (H/J). Decisions can be either by the keyboard operator or by the computer.

End papers. The sheets at the front and back of a casebound book that attach the pages of the book to the cover, or case. They are usually of a heavier stock than the book paper.

Engrave. To cut, etch, or incise a surface. In printer's language, to make engravings for any printing process.

Engraver. An individual or firm engaged in making printing plates and dies.

Engraving. A relief printing plate used in letterpress. Usually made of zinc, copper, or magnesium. Also refers to the handwork done in the engraving process. Also, the itaglio plate used for the production of engraved cards and stationery.

Enlarger font. Negative film font used by Alphasette to produce type sizes larger than 16 or 18 point.

En-quad. Also called a *nut*. The same depth as an em but one half the width: the en space of 10-point type is 5 points wide.

Envelope-stuffer. Also called *Envelope enclosure*. Any small printed promotional piece that can be inserted into envelopes with statements or business letters.

Etch. The acid used by engravers to etch metal plates. In lithography, the fountain solution used to wet the offset plate.

Etching. In photoengraving, the eating away of the non-printing areas of the printing plate by acid to produce a relief printing surface. In stone lithography, the chemical treatment of the non-printing areas of the printing stone or plate so that they will not accept ink. In gravure, the etching of the image into the copper printing cylinder by acid. Also refers to the fine art intaglio process, or the line engraving of zinc, steel, or copper plates.

Exception dictionary. In computer-assisted typography, that portion of the computer's memory in which exceptional words are stored. Exceptional words are those words which do not hyphenate in accordance with the logical rules of hyphenation. For example, *ink-ling* would be an exceptional word since computer hyphenation logic would break it *inkl-ing*.

Execute. To carry out an instruction or program.

Expansion cards. Circuit boards which can be inserted into expansion slots to enhance a computer's performance or implement specialized functions. Also referred to as *Video cards* and *Display cards*.

Exposure. In photography, the time and intensity of illumination acting upon the light-sensitive coating (emulsion) of film or plate.

Extended. Also called *expanded*. A wide version of a regular typeface.

Extender. In printing, transparent white pigment used to cut, or extend, printing inks to reduce intensity and opacity.

F

Face. The part of metal type that prints. Also, the style or cut of the type: typeface.

Facsimile. More commonly referred to as *fax*. The transmission of graphic matter (letters, documents, charts, spreadsheets, pictures, etc.) by wire or radio. Some fax machines are capable of transmitting full-color images, while others have been integrated with personal computers in order to transmit data.

Fade-out. *See* Ghosting.

Fake process. A very intricate and tedious method of reproducing artwork by having the artist or designer separate, or translate, the color areas by means of overlays, one overlay for each color. Or using a color chart, he can designate the screen values of each color on overlays to be used by the printer as a guide to laying down screens in these areas to make the negatives.

Family of type. All the type sizes and type styles of a particular type face (roman, italic, bold, condensed, expanded, etc.).

Fast-drying ink. A printing ink that dries soon after printing.

Feathering. A ragged, or feathered, edge on printed type or engravings. Caused by poor ink distribution, incorrect impression, too much ink, or because a printing ink was used that would not release cleanly (split) from the plate during printing. Usually caused by long-pigment inks.

Feeder. That section of the printing press that mechanically separates the sheets and feeds them into position for printing.

Feet. That part of a piece of metal type upon which it stands.

Felt side. In paper manufacturing, the top side of the sheet, as opposed to the underside, or wire side. In some papers, the felt finish is made by impressing still-wet paper with variously structured felts.

File. Any collection of information stored on a disk; for example a document, resource or application.

Filler. Coating material used to fill the interstices in paper or cloth to add bulk, opacity, and create a smoother surface. Fillers may be starch, clay, talc, titanium dioxide, diatomaceous earth, etc.

Filling-in. Also called *filling-up*. In printing, a condition in which ink fills the area between the halftone dots or plugs up the counters of the type.

Film advance. The distance in points by which the film in the photounit of a phototypesetting machine is advanced between lines. A film advance of 11 points for a 10-point font means that the text is set with 1-point leading.

Film makeup. *See* Film mechanical.

Film mechanical. Also called a *photomechanical*. A mechanical made with text, halftones, and display elements all in the form of film positives stripped into position on a sheet of base film. A film mechanical is the equivalent of a complete type form; from the film mechanical photorepros or contact film are made for the platemaker.

Film processor. Machine which automatically processes sensitized and exposed film and/or paper: develops, fixes, washes, and dries.

Filter. A device (gelatin or glass) placed between the subject being photographed and the film in order to reduce or eliminate certain colors while allowing other colors to be recorded on film.

Filter factor. A number that indicates the increase in exposure necessary when a filter is used.

Fine papers. A general terms for the grades of paper used for writing and book printing: bond, ledger, cover and book.

Finish. The surface properties of paper.

Finishing. *See* Plate finishing.

First color down. In color printing, the first color printed on the sheet as it passes through the press.

First proofs. Proofs submitted for checking by proofreaders, copy editors, etc.

First revise. Also called *corrected proof*. The proof pulled after errors have been corrected in first proof. Additional corrections may call for revises.

Fixed fonts. Bitmapped master fonts capable of setting a range of type sizes.

Fixing. The process by which a photographic image is made permanent.

Flash-in. The double-exposure of negative film.

Flat. An assemblage of various film negatives or positives attached, in register, to a piece of film, goldenrod, or suitable masking material ready to be exposed to a plate. Also, when referring to printed matter, flat refers to a lack of contrast and definition of detail, as opposed to sharp, or contrasty.

Flat-bed press. A letterpress containing a flat metal bed on which locked up forms of type and plates in a chase are positioned for printing. To print, the paper is forced against the printing surface by an impression cylinder.

Flat color. Generally refers to solid colors or tints other than process colors.

Flat-tint halftones. Also called a *fake duotone*. Printing a black halftone over a flat tint of second color.

Flexography. Formerly known as *aniline printing*. A relief printing process using wrap-around rubber or soft plastic plates and volatile, fast drying ink. Widely used in the packaging industry.

Flooding. In printing, an excess of ink on the printing plate.

Flop. To turn over an image (for example, a halftone) so that it faces the opposite way.

Floppy disc. See Disk.

Fluorescent inks. Inks with fluorescent qualities that result in extreme brilliance. A well-known examples is Day-Glo.

Fluorographic. A patented process (Kemart) in which dropout, or highlight, halftones can be produced photographically due to the fluorescence of the paper on which the art is rendered, or by treating existing art or photographs with a fluorescent solution.

Flush cover. A cover trimmed to the same size as the text page, as opposed to an overhang cover, which is slightly larger than the page trim size. An example of a flush cover is that used for paperbacks.

Flyer. Advertising handbill or circular.

Foil. Sized metallic or pigment leaf used in stamping lettering or designs on a surface. Used primarily for stamping book covers.

Folder. A printed piece with one or more folds, each section of which presents a complete page.

Folder. (desktop publishing). An electronic holder of documents.

Folio. Page number. Also refers to a sheet of paper when folded once.

Font. Complete assembly of all the characters (upper and lowercase letters, numerals, punctuation marks, points, reference marks, etc.) of one size of one typeface: for example, 10-point Garamond roman. Font sizes (characters in a font) vary from 96 to 225, depending on the makeup of the font. Special characters (those not in a font) are called *pi* characters.

Foot. The bottom of a book or a page, as opposed to the top, or head.

Footnote. Note appearing at the bottom of a page referring to an item on same page. Indicated by superior numbers or by symbols such as asterisks, daggers, etc.

Foreword. Introduction to a book, usually written by someone other than the author.

Form. In letterpress, type and other matter set for printing, locked up in a chase, (*which see*) from which either a printed impression is pulled or a plate is made. In offset, refers to the flat (*which see*). Also refers to a printed piece or document containing blank spaces for the insertion of details or information and designed for use in office machines.

Format. General term for style, size, and allover appearance of a publication.

Formatt. A brand name for a self-adhering type, printed on acetate sheets to be cut out and applied to the mechanical.

Formatting. In phototypesetting, translating the designer's type specifications into format, or command, codes for the phototypesetting equipment. Formatting is gradually replacing markup.

Fotosetter. Trade name for a first-generation, circulating-matrix phototypesetting machine manufactured by Harris-Intertype.

Fototronic CRT. Trade name for a third-generation phototypesetting system incorporating high-speed cathode-ray tube technology, manufactured by Harris Corp.

Foundry type. Metal type characters used in hand composition, cast in special hard metal by type founders.

Foundry lockup. A form properly squared and tightly locked up for making molds for electrotypes, stereotypes, etc. Bearers surround the live matter. A proof of the locked-up form is called a *foundry proof.*

Fountain. On a printing press, the ink reservoir that holds the ink for immediate use while the press is printing, and from which the ink is metered to the form by the rollers. In offset lithography, it is also a reservoir for holding the etch for use in the dampening system. The fountain solution is metered onto the press plate by means of an engraved roller and a series of special covered rollers.

Fountain roller. On a printing press, the roller that revolves in the ink or dampening fountain and meters out the proper amount of ink to the distributing rollers.

Fountain solution. Also referred to as *etch*. In offset lithography, a mixture of alcohol or water, acid, buffer, and gum arabic that prevents the non-printing areas of the plate from accepting ink. Control of the *p*H (acidity and alkalinity) of the fountain solution in the dampening unit is crucial.

Four-color process. Method of reproducing full-color copy (original artwork, transparencies, etc.) by separating the color image into its three primary colors—magenta, yellow and cyan—plus black. This results in four printing plates, one for each color, which when printed produce the effects of all the colors of the original art.

Fourdrinier. Papermaking machine normally employed in the manufacture of paper.

Free sheet. Paper free from ground wood.

French fold. A double fold: the sheet is printed on one side only, then folded twice, once vertically and once horizontally, resulting in an economical, attractive four-page folder. Used for formal invitations, etc.

Frisket. In letterpress, selectively cut and excised protective paper used on the proofing press to cover any part of a printing plate so that it does not print. Friskets are used in process-color proofing to mask out the dead metal on the plates so that proofs can be pulled for customer submission. Also refers to any covering agent, such as Maskoid or masking tape, used to mask out areas when airbrushing art.

Frontispiece. An illustration on the page facing the title page of a book.

Fugitive inks. Inks that are not lightfast or permanent: they fade or change color when exposed to light, heat, or moisture. As opposed to permanent inks.

Full color. Process color (*which see*).

Furnish. The ingredients (pulp and additives) that go into the making of paper.

Furniture. In letterpress, the rectangular pieces of wood, metal, or plastic, below the height of the type, used to fill in areas of blank space around the type and engravings when locking up the form for printing.

G

Gallery. Cameras and darkroom of an engraving plant.

Galley. In metal composition, a shallow three-sided metal tray that holds the type forms prior to printing. Also refers to the galley proof (*which see*).

Galley proof. Also called *rough proof*. An impression of type, usually not spaced out or fully assembled, that allows the typographer or client to see if the job has been properly set.

Gang printing. Also called *ganging up*. In printing, running off any number of different jobs on the same sheet. After printing, the sheet is cut into the individual jobs and the printing cost is pro-rated.

Garbage. Unwanted information in memory.

Gate fold. A page that folds into the gutter, and when unfolded it is about twice the size of a normal page. Commonly used in magazines and catalogs in cases where the regular page is not large enough to contain all the information, or simply to create a special effect.

GATF. Graphic Arts Technical Association.

Gathering. Assembling individual sheets or folded signatures in proper sequence for binding.

Ghosting. A condition in which the printed image appears faint where not intended, caused by an abrupt change in ink take-off on the rollers. Ghosting often occurs when printing flat borders, L-shaped solids, and circles; it can generally be avoided in design by making sure the solid areas are well separated to permit a more even distribution of ink by the form rollers.

Gigabyte. 1,024 megabytes, abbreviated as *GB*.

Gigo. Garbage in, garbage out. Programming slang for bad input produces bad output.

Glossy. A photoprint made on glossy paper. As opposed to matte.

G/M². Grams per square meter; the metric method of classifying paper by weight.

Goldenrod. In offset printing, a sheet of opaque orange paper into which the negative films are stripped to make up a flat from which a printing plate is made.

Grain. Predominant direction of the fibers in a sheet of paper. When folding, the direction of the grain is important: a sheet folded with the grain folds easily; a sheet folded across the grain does not. In photography, the minute variations of density in a developed photographic emulsion caused by the irregular distribution of the silver crystals.

Gravure. Printing method based on intaglio printing, in which the image area is etched below the surface of the printing plate. The gravure plate or cylinder is immersed in ink then wiped clean with a doctor blade, leaving ink only in the etched areas. The areas cut below the surface of the printing plate carry the image, which is transferred directly, by means of pressure, to the paper. There are two basic gravure presses: rotogravure, which prints from cylinders onto a web of paper; and sheet-fed, which prints from flat plates curved around the cylinder of the press onto individual sheets.

Gray scale. A series of values of usually 16 or 21 steps from white through logarithmic (not arithmetic) gradations of gray to black. Used in processing film or photographically processed materials such as paper and plates.

Greige goods. (Pronounced *gray* goods.) The basic cloth, usually cotton, used for woven bookbinding materials.

Grid. In photocomposition, the rectangular carrier of a negative type font used in some systems. Also refers to the cross-ruled transparent grids over which all parts of a page or book layout will be assembled, or made up, in phototypography.

Gripper edge. The leading edge of a sheet of paper clamped by the grippers as it passes through the printing press. Allowance must be made on the stock to be printed for a gripper bite of from ⅜″ to ½″, depending on the kind of printing press used.

Grippers. In printing, the mechanical "fingers" on the gripper bar that hold the paper onto the impression cylinder of the press during impression.

Guide. A mechanical device on a printing press that causes all sheets to be printed with a uniform margin and in register.

Guide edge. Edge of the sheet that is fed to the guide.

Guideline. A line drawn on artwork to indicate the limits of the area to be printed.

Gutter. Blank space where two pages meet at the binding or blank space between the columns of type.

Gutter margin. Inner margin of a page.

Gutenberg, Johann. Inventor of moveable type and letterpress printing (*c.* 1455) as we know it today. Although preceded by the Chinese and the Koreans (*c.* 705 A.D.), it is Gutenberg who is remembered as the father of mass production and the progenitor of the machine age.

Hacker. A computer enthusiast usually up to no good.

Hairline. A fine line or rule, the finest line that can be reproduced in printing.

Halation. A blurring of the photographic image, particularly in highlight areas, caused by light reflected from the back surface of the substrate.

Half title page. The first page of a book after the endpapers. Carries the title of the book only and precedes the title page.

Halftone. The photomechanical reproduction of continuous-tone copy (such as photographs) in which the gradations of tone are obtained by the relative size and density of tiny dots produced by photographing the original copy through a fine cross-line screen. For the kinds of halftones possible, *see* Dropout, Duotone, Double-dot, Highlight, Silhouette, Square, Surprint *and* Vignette halftones.

Halftone negative. Also called *screened negative*. The negative film produced by shooting continuous-tone copy through a halftone screen (*which see*).

Halftone positive. Also called a *screened positive*. A photographic positive containing screened continuous-tone copy in the form of dots representing the tonal values to be reproduced.

Halftone screen. A fine-line engraved glass or photographic film screen used to convert continuous-tone copy to line copy (dots) for halftone printing.

Halo effect. In printing, the piling up of ink at the edges of the printed letters and halftone dots, especially in letterpress printing. The centers of the dots, although printing, appear lighter than the edges.

Handbill. Generally applies to a single leaf, printed on one side, for distribution by hand from door to door.

Hanging indentation. In composition, a style in which the first line of copy is set full measure and all the lines that follow are indented.

Hard copy. Typewritten copy.

Hardcover. *See* Edition binding.

Hard Disk. *See* Disk.

Hardware. The mechanical and electronic parts that make up a computer. See also *Software*.

Hardware. In phototypesetting and the word-processing field, a term referring to the actual computer equipment, as opposed to the procedures and programming, which are known as software.

Head. The top, as opposed to the bottom, or foot, of a book or a page.

Heading. Bold or display type used to emphasize copy.

Headline. The most important line of type in a piece of printing, enticing the reader to read further or summarizing at a glance the content of the copy which follows.

Head margin. The white space above the first line on a page.

Heat-set inks. Letterpress and web offset printing inks which dry under heat.

Heavy bodied inks. Printing inks having a high viscosity and stiff consistency.

Hickey. A defect, or spot, appearing in the printed piece. Hickies are caused by dust, lint, or bits of ink skin on the printing plate, the type form, or the blanket (in offset) and show up as specks surrounded by a halo effect (*which see*).

High key. Refers to a photograph in which the majority of tonal values are higher, or lighter, than a middle gray.

Highlight. In a photograph, the highlight area is the lightest area. Represented by the smallest dot formation in a halftone.

Highlight halftone. *See* Dropout halftone.

Holding lines. Lines drawn by the designer on the mechanical to indicate the exact area that is to be occupied by a halftone, color, tint, etc.

Hot type. Slang expression for type produced by casting hot metal: Linotype, Intertype, Monotype and Ludlow (*which see*), and sometimes handset foundry type.

Hue. That characteristic of color that we call "color": red, green, blue, etc., as opposed to shade, tint (*which see*).

I

Icon. A symbol shown on the computer screen to represent an object, concept, or message; for example, a disk, folder, document, trash, etc.

Idiot tape. A common term for an unformatted, *i.e.*, unhyphenated, unjustified tape (*which see*). Cannot be used to set type until command (format) codes are added and processed by a computer that makes all the end-of-line decisions.

Illustration. General term for any form of drawing, diagram, halftone, or color image that serves to enhance a printed piece.

Image master. Also called a *type matrix*. In phototypesetting, the type fonts, *i.e.*, a disc, film strip, etc.

Impose. In typesetting and make-up, the plan of arranging the printing-image carrier in accordance with a plan. To make up.

Imposing stone. *See* Stone.

Imposition. In printing, the arrangement of pages in a press form so they will appear in correct order when the printed sheet is folded and trimmed. Also, the plan for such an arrangement.

Impregnated. In book manufacture, the coating of the cover cloth. Cloths can be pyroxylin-impregnated, vinyl-impregnated, or starch-impregnated.

Impression. In printing, the actual process of taking a printed copy from type or plates. Also, the pressure of the printing surface upon the paper. *See* Kiss impression.

Impression cylinder. Cylinder that holds the paper against the printing surface so that contact is made and an impression produced.

Imprint. The printing of a person's or a firm's name and address on a previously printed piece by running it through another printing press.

Incunabula. Early printing, specifically that done in the 15th century.

Index. Alphabetical list of items (as topics or names) treated in a printed work that gives each item the page number where it can be found. Also a character used to direct attention. ☞

Indicia. Information printed by special permit on cards or envelopes that takes the place of a stamp.

Indirect letterpress. See Letterset.

Indirect process. In four-color process printing, the original copy is first separated into four continuous-tone (unscreened) negatives which are sized and screened later. As opposed to the direct process in which the copy is scaled, separated, and screened in one step.

Initial. The first letter of a body of copy, set in display type for decoration or emphasis. Often used to begin a chapter of a book.

Ink fountain. Also called the *fountain*. That part of the printing press that supplies ink to the inking rollers.

Ink holdout. A characteristic of paper that keeps the ink on the surface and prevents it from being absorbed into the paper's fibers. Too much absorption causes the printed image to lack sharpness and luster. Coated papers have better ink holdout than non-coated papers and are therefore capable of producing finer halftones.

Ink-Jet Printing. A printing technology in which a computer-controlled mechanism sprays dots of ink onto the paper to make up the image. This is a very high speed process popular for direct mail with personalized messages.

Input. In computer composition, the data to be processed.

Input device. In desktop publishing the keyboard and mouse are the primary devices responsible for sending information to the microprocessor.

Insert. A separately prepared and specially printed piece which is inserted into another printed piece or a publication.

Intaglio. In fine art, a printing process in which the image or design is cut or etched into the surface of the plate. In printing, the intaglio process is referred to as gravure (*which see*), and steel or copper engraving.

Interleave. See Slip sheet.

Interlinespacing. Also called *linespacing*. In photocomposition, term for leading (*which see*)

International page sizes. In Europe page sizes are designated by a letter-number and millimeters. The chart lists some common international sizes and their American equivalents.

International	European (mm)	American (in.)
A0	841 × 1189	33⅛ × 46¹³⁄₁₆
A1	594 × 841	23⅜ × 33⅛
A2	420 × 594	16⁹⁄₁₆ × 23⅜
A3	297 × 420	11¹¹⁄₁₆ × 16⁹⁄₁₆
A4	210 × 297	8¼ × 1 1¹¹⁄₁₆
A5	148 × 210	5¹³⁄₁₆ × 8¼
A6	105 × 148	4⅛ × 5¹³⁄₁₆
A7	74 × 105	2¹⁵⁄₁₆ × 4⅛
A8	52 × 74	2¹⁄₁₆ × 2¹⁵⁄₁₆
A9	37 × 52	1⁷⁄₁₆ × 2¹⁄₁₆
A10	26 × 37	1 × 1⁷⁄₁₆

Internegative. In photography, the negative taken by a camera from which a color print or transparency will be made. Also, the negative resulting from copying color art or transparencies for blow-up or reduction from which a final-size print or duplicate transparency will be made.

Intertype. Trade name for a linecasting machine similar to Linotype. Manufactured by Harris-Intertype Corp., now Harris Corp.

Italic. Letterform that slants to the right: *looks like this*.

J

Jacket. Also called a *dust cover*. The paper dust jacket of a casebound book.

Jaggies. A term for the jagged edges of the type or images formed on raster scan display, especially video screens.

Job press. A platen press (*which see*) used to print small jobs such as business cards, envelopes, tickets, etc. These presses are often referred to as *jobbers*.

Job shop. A commercial printing plant, as opposed to a publication shop.

Jog. To straighten or align by vibration the edges of a pile of papers so they are even.

Joint. That part of a book binding that forms the hinge at the spine.

Justified type. Lines of type that align both left and right of the full measure.

Justify. The act of justifying lines of type to a specified measure, flush right and left, by putting the proper amount of interword space between words in the line to make it even, or "true."

K

Kerned letters. Type characters in which a part of the letter extends, or projects, beyond the body or shank, thus overlapping an adjacent character.

Kerning. Adjusting the space between letters so that part of one extends over the body of the next. Kerned letters are common in italic, script, and swash fonts. In metal type, kerning is accomplished by actually cutting the body of the type for a closer fit. In phototypesetting, it is accomplished by backspacing, and composition set this way is often termed "set tight" or set with minus letterspacing.

Key. To code copy by means of symbols such as numbers or letters. Also refers to a device for tightening quoins (*which see*) or a device to tighten the hooks used with a patent base (*which see*).

Keyboard. In linecasting, phototypesetting, and typewriter or strike-on composition, that part of the typesetting machine at which the operator sits and types the copy to be set.

Keyboardist. Keyboard operator.

Keyed advertising. Advertisements that are coded to identify results. Used when the same ad is run in more than one publication.

Keyline. Mechanical (*which see*). Most paste-up art has key lines, which are the outlines of areas or of objects the designer has drawn, showing where a panel, color tint, or halftone is to be positioned.

Key negative. The negative (or positive) film that contains the basic format of the job and onto which all other negatives of tints or other colors will be registered.

Key plate. The term "key negative" or "key plate" usually refers to a negative or plate that carries most or all the indications as a guide for the stripper.

Kicker. Also called a *teaser*. A short line above the main line of a head, printed in smaller, or accent, type.

Kid finish. A finish that resembles soft, undressed kid. Used on high-grade or Bristol paper.

Kill. To delete unwanted copy. Also, to "kill type" means to distribute or dump metal type from a form that has already been printed, or to destroy existing negatives or press plates.

Kilobyte (KB). 1,024 bytes.

Kiss impression. The ideal meeting of plate and paper: the ink is properly split from the plate and distributed evenly and the paper is properly impressed but not indented.

Kleenstick. A brand name for a pressure-sensitive adhesive-backed paper. When repros are pulled on Kleenstick, they can be put down on the mechanical directly, without rubber cement.

Kraft. The name comes from the German word for "strong." A sturdy paper made from sulphate pulp, commonly used for wrapping.

Kromecote. A brand name for a cast-coated paper with a very glossy finish.

L

Lacquer. A clear, cellulose-derivative synthetic coating applied to the surface of a printed piece for protection and/or appearance. Before lacquering, the printer must use inks compatible with the lacquering process.

Laid paper. Paper having a laid pattern: a series of parallel lines simulating the look of the old handmade papers.

Laminating. Applying a thin plastic film (acetate or polyester) to a printed sheet for protection and/or appearance. A laminated surface has a hard, high gloss and is impervious to stains. Lamination may be applied in liquid form or in sheets. Liquid acetate is less expensive as it is done on a blade coater. Sheet acetate is applied by a laminating machine and is more expensive, but it is also thicker, has a higher gloss, and offers more protection. However, unlike liquid acetate, sheet acetate may peel if adhesion is not carefully controlled.

Lampblack. A carbon black pigment used to produced a dull, intensely black ink. Lampblack is prepared by the incomplete combustion of vegetable oils, petroleum, or asphalt materials.

LAN. Local area network.

Lap. In color printing, the area where one color overprints, or overlaps, another adjacent color. The amount of lap is specified in points; the thinnest lap is a hairline.

Last color down. In color printing, the last color to be printed.

Laydown sequence. In color printing, the sequence in which the colors are printed.

Layout. The hand-drawn preliminary plan or blueprint of the basic elements of a design shown in their proper positions prior to making a comprehensive (*which see*); or showing the sizes and kind of type, illustrations, spacing, and general style as a guide to the printer.

L.C. Lowercase, or small letters of a font.

LCD. Liquid-crystal display.

Leader. A row of dots, periods, or dashes used to lead the eye across the page. Leaders are specified as 2, 3, or 4 to the em; in fine typography they may be specified to align vertically.

Lead-in. The first words in a block of copy set in a contrasting typeface.

Leading. (Pronounced *ledding*.) In metal type composition, the insertion of leads (*which see*) between lines of type. In phototypesetting, the placement of space between lines of type: also called *linespacing* or *film* advance.

Leads. (Pronounced *leds*.) In metal type composition, the thin strips of metal (in thicknesses of 1 to 2 points) used to create space between the lines of type. Leads are less than type-high and so do not print.

LED display. Light-emitting diode display.

Ledger paper. A tough, smooth, non-receptive paper generally used for keeping business records, such as ledgers.

Legibility. The quality in type that affects the speed of perception: the faster, easier, and more accurate the perception, the more legible the type.

Length. In printing inks, that property which enables the ink to be stretched out into a long, thin thread without breaking. Long inks have good flow. Short inks cut off cleaner, permitting the printing of very delicate type and illustrations.

Letraset. Brand name for a rub-off, or dry-transfer, type.

Letterfit. In composition, the quality of the space between the individual characters. Letterfit should be uniform and allow for good legibility. In body type, the typesetter has no control over letterfit because it is an integral characteristic of the font structure. In display types, the designer is responsible for obtaining proper letterfit by cutting and fitting the letters (set on paper or film) until the optimum esthetic arrangement is achieved.

Letterpress. The printing method originally used to print using woodblocks or type. It is based on relief printing, which means that the image area is raised. The surface is inked by means of a roller and the image is transferred directly to the paper by pressure. *See* Flat-bed cylinder *and* Rotary.

Letterset. Also known as *dry offset* and *indirect letterpress*. A printing process in which a low-relief plate is used on a modified offset press. As in conventional offset printing, the ink is transferred from the plate to the paper by being offset from a blanket, but unlike offset printing, no dampening system is required.

Letterspace. The space between letters.

Letterspacing. In composition, adding space between the individual letters in order to fill out a line of type to a given measure or to improve appearance. In metal type, letterspacing is achieved by inserting thin paper or metal spaces, which are less than type-high and so do not print, between the letters. In phototypesetting, letterspacing is achieved mechanically by keyboarding extra space between letters or increasing the set width of the face. In phototypesetting, minus letterspacing (or kerning) is also possible.

Ligature. In metal or linecast type, two or three characters joined on one body, or matrix, such as *ff, ffi, ffl, Ta, Wa, Ya*, etc. Not to be confused with characters used in logotypes cast on a single body.

Lightface. A lighter version of a regular typeface.

Lightfastness. The resistance of a printed piece or colored material to color change when exposed to high-intensity ultraviolet (UV) light (sunlight or artificial light).

Linecaster. A typesetting machine (Linotype, Intertype) that casts entire lines of type in metal, as opposed to those that cast individual characters (Monotype).

Line conversion. Refers to the conversion of continuous-tone copy to line copy through use of conventional halftone screens or patterned special-effects screens.

Line copy. Any copy that is solid black, with no gradation of tones: line work, type, rules, etc.

Line cut. *See* Line engraving.

Line drawing. Any artwork created by solid black lines: usually pen and ink. A drawing free from wash or diluted tones.

Linen. A kind of finish given to book-covering materials or to paper.

Line engraving. A printing plate which prints only black lines and masses.

Line gauge. Also called a *type gauge* or a *pica rule*. Used for copyfitting (*which see*) and measuring typographic materials.

Line mechanical. An accurate paste-up of all line copy, ready to be shot (photographed).

Line negative. A high-contrast negative of line copy. Areas to be recorded are clear; all other areas are light-blocking.

Line overlay. Line work put on overlay to pre-separate line from halftone. Used in preparation of art for reproduction.

Line printer. In typesetting, a high-speed tape-activated machine that produces a hard copy printout for editing and correcting purposes. Specifically, a device capable of printing the line of characters across a page, *i.e.*, 100 or more characters simultaneously as continuous paper advances line by line in one direction past type bars, a type cylinder or a type chain capable of printing all characters in all directions.

Line printer proof. Proof printed by a line printer and used for reading purposes, or checking the outcome of typesetting, before actual setting.

Linespacing. In phototypesetting, the term for leading (*which see*).

Line work. Artwork consisting of solid blacks and whites, with no tonal values.

Lining figures. Numerals the same size as caps in a typeface: 1, 2, 3, 4, 5, 6, 7, 8, 9, 10. As opposed to Old Style figures: 1, 2, 3, 4, 5, 6, 7, 8, 9, 10. Lining figures align on the baseline.

Linofilm. Trade name for a line of phototypesetting machines and a system manufactured by Mergenthaler Linotype.

Linotron. Trade name for high-speed cathode ray tube phototypesetting machines and systems manufactured by Mergenthaler Linotype.

Linotype. Trade name for a widely used line-casting machine that sets an entire line of type as a single slug. Manufactured by Mergenthaler Linotype.

Lithography. In fine art, a planographic printing process in which the image area is separated from the non-image area by means of chemical repulsion. The commercial form of lithography is offset lithography (*which see*).

Lockup. In letterpress printing, a type form properly positioned and made secure in a chase for printing or stereotyping.

Logotype. Commonly referred to as a *logo*. Two or more type characters which are joined on one body as a trademark or a company signature. Not to be confused with a ligature, which consists to two or more normally connected characters.

Long ink. Length or stringiness in a printing ink denotes printing, transfer, and water-resistant qualities.

Lowercase. Small letters, or minuscules, as opposed to caps.

Ludlow. Trade name for a typecasting machine for which the matrices are assembled by hand and the type is cast in line slugs. Used principally for setting large display type and newspaper headlines. Manufactured by Ludlow Typograph Co.

M

Machine composition. Generic and general term for the composition of metal type matter using mechanical means, as opposed to hand-composition. The use of machines incorporating keyboards and hot metal typecasting equipment, *i.e.*, Linotype, Monotype.

Machine finish. An uncoated paper with a smooth but not glossy finish.

Magazine. The slotted metal container used to store matrices in linecasting machines.

Magazine specifications. Specifications for the making of printing plates to conform to publishers' special requirements.

Magenta. Also referred to as *process red*. One of the process colors (*which see*). Also, one of the filters used in making color separations.

Magnetic inks. Inks made with iron pigments that can be magnetized after printing to enable the printer matter to be picked up by electronic sensing (reading), or MICR (magnetic ink character reading), equipment. Widely used by banks for printing and machine processing checks.

Magnetic tape. In typewriter composition and photocomposition, a tape or ribbon impregnated with magnetic material on which information may be placed in the form of magnetically polarized spots. Used to store data which can later be further processed and set into type.

Mainframe. A large computer originally manufactured in a modular fashion.

Makeready. The process of arranging the form on the press preparatory to printing so that the impression will be sharp and even. In letterpress, makeready is done by evening-up the impression under the tympan packing to make certain all the printing elements are type-high and that the paper and form come together close enough to transfer the ink, but not so close that the surface will be bruised or the paper punctured. The object of makeready is to ensure a "kiss impression."

Makeup. Assembling the typographic elements (type and engravings) and adding space to form a page or a group of pages of a newspaper, magazine, or book. Makeup is the management of white space; that is, the mechanical and esthetic arrangement of the elements of a piece into a legible format for final reproduction.

Manila paper. A smooth, sturdy, buff-colored paper made from manilla hemp. Used for folders, envelopes, etc.

Manuscript. Copy to be set in type. Usually abbreviated to MS. (sing.) and MSS. (pl.). Can also refer to handwritten, as opposed to typewritten, material.

Margins. The areas that are left around type and/or illustrative matter on a page: the top, bottom, and sides.

Markup. In typesetting, to mark the type specifications on layout and copy for the typesetter. Generally consists of the typeface, size, line length, leading, etc.

Mask. Generally refers to any material used to block off, or mask, portions of an illustration or area in order to protect it. In photochemical work, light-blocking material is used to block off an area to prevent it from being exposed to light. In offset lithography, opaque material is used to protect non-printing areas of the printing plate during exposure. Also, an overlay to create outline shapes for halftones by photography.

Masking. In process-color reproduction, a photomechanical method using equipment and special filters to control or modulate color contrast and detail over the total area of each separation negative used for printed color reproduction. Masking is used primarily to reduce the contrast of transmitted light so that maximum reproductive value for reflected light can be attained. It is also used to heighten contrast when this quality is lacking in the transparency. Photographic masks may be either positive or negative, depending on the desired correction.

Masking paper. *See* Goldenrod.

Masking tape. A translucent, light-blocking red or solid black pressure-sensitive tape used to mask out unwanted areas of copy on negative or positive film. Also, a pressure-sensitive brown or white opaque tape used extensively in preparing artwork and making mechanicals.

Master proof. Also called a *printer's proof* or *reader's proof*. A galley proof (*which see*) containing queries and corrections which should be checked by the client and returned to the typographer.

Masthead. Any design or logotype used to identify a newspaper or publication.

Mat. In cast-type composition; the common (slang) term for a Linotype, Ludlow, or Monotype matrix (*which see*). In stereotyping, the papier-mâché or plastic mold of type and engraving forms from which stereotypes are cast. In rubber-plate work (flexography), the mold from which the rubber printing plates are cast. Also refers to a decorative matboard "frame" used to support a picture, as well as for purely esthetic effect, when framing.

Match color. *See* Flat color.

Matrix. (More commonly called a *mat*.) In foundry-cast type, the mold from which the type is cast. In linecasting, the specially designed mold for casting a character; lines of matrices are assembled for casting a slug. In phototypesetting, the glass plate that contains the film font negative: also referred to as a *type master*.

Matte finish. A paper with an uncalandered, lightly finished surface. Also, in photography, a textured, finely grained finish on a photograph or photostat. As opposed to glossy.

Mean line. Also called the *x-line*. The line that marks the tops of lowercase letters without ascenders.

Measure. The length of a line of type, normally expressed in picas and points.

Mechanical. Camera-ready past-up assembly of all type and design elements pasted on artboard or illustration board in exact position and containing instructions, either in the margins or on an overlay, for the platemaker.

Mechanical binding. A binding in which the pages are held together by mechanical means, usually by metal or plastic coils.

Mechanical separations. Copy prepared by the designer with overlays showing each color to be printed: one overlay for each color, all overlays in exact register with the base mechanical.

Megabyte (MB). 1,024 kilobytes.

Memory. The place in the computer's central processing unit where information is stored. *See also RAM* and *ROM*.

Menu. A video display of programs and tasks.

Merge. In photocomposition, a technique for combining items from two or more sequenced tapes into one, usually in a specified sequence, using a computer to incorporate new or corrected copy into existing copy and produce a clean tape for typesetting.

Metallic inks. Inks containing metallic bronze or aluminum powders in a varnish base which produce the appearance of gold, silver, copper, or bronze.

Metals. In letterpress, the kinds of metals used in platemaking are as follows: copper, for fine detail line work and quality halftone reproduction; magnesium, for long-run jobs such as packaging; zinc, for line work and coarse-screen halftones. In lithography, aluminum, zinc, or bi-metal and tri-metal combinations of these metals with copper or photosensitive polymers.

Metric system. A decimal system of measures and weights with the meter and the gram as the bases. Here are some of the more common measures and their equivalents. (*See* Metric system, page 198).

Mezzotint. In fine art, a form of etching in which the entire surface is "burred." Also, a line conversion of a photograph which imitates the mezzotint effect.

Microchip. Integrated circuit designed to process, store, and transmit massive amounts of data.

Micron. One millionth of a meter.

Microfilm. Photographic reproduction of data in a size too small to be read without magnification. Usually done on standard-size 70mm, 35mm, or 16mm film. Microfilm is currently being produced by computer-assisted CRT phototypesetting devices.

Microprocessor. An integrated circuit on the computer's main circuit board responsible for carrying out software instructions involving both logic and memory.

Middle tones. The tonal range between highlights and shadows in a photograph or reproduction. Usually represents tones between 30% and 75% value of the copy.

Mimeograph. Brand name for duplicating machine based on a direct-stencil process: ink is forced through a stencil of the original copy and onto a highly absorbent paper. Manufactured by A. B. Dick Co.

Minuscules. Smaller letters, or lowercase.

Modem. (*M*odulator *de*modulator) An electronic device that converts digital data from the computer terminal to signals that can be sent over regular telephone lines to another computer, LAN conference, electronic mail, etc. The power is measured in BPS (bits per second); the higher the BPS, the faster the information is transmitted and the lower the phone bill.

Modem. A device that permits computer data to be transmitted over common phone lines.

Modern. Term used to describe the type style developed in the late 18th century.

Moiré pattern. (Pronounced *moh-ray*). Undesirable patterns that occur when reproductions are made from halftone proofs. Caused by optical conflict between the ruling of the halftone screen and the dots or lines contained in the original; a similar pattern can occur in multicolor halftone reproductions due either to incorrect screen angles or misregister of the color impressions during printing. In four-color process work, the yellow printer (*which see*) is usually screened at a different screen (133-line) from the other three colors (120-line) to avoid a moiré.

Mold. *See* Matrix.

Monochromatic. Made up of tints and shades of only one color.

Monophoto. Trade name for a phototypesetting machine based on the same mechanical principles as Monotype (*which see*). Manufactured by The Monotype Corporation Ltd., England.

Monotone. Any type of artwork reproduced in one color only.

Monotype. Trade name for a typecasting machine that casts individual characters in lines. Manufactured by The Monotype Corporation Ltd., England.

Montage. Single image made up of several images.

Morgue. Collection or file of reference material.

Mortising. Cutting of a rectangular cavity, or hole, in an engraving block to allow type or other engravings to be inserted.

Mottle. In printing, spotty, mottled, or uneven areas, especially noticeable in printed solids, caused by tacky, transparent inks whose film split badly during impression.

Mounting. Backing engravings with blocks of wood to make them type-high. Also refers to the pasting of photographic prints onto stiff mounting board.

Mouse. A hand-held device used to supplement the keyboard when working with computers. When moved across a flat surface its motion is simulated on the screen by a cursor.

Mullen tester. A machine used to determine the bursting strength of paper.

Multicolor printing. Printing in more than one color.

Multitasking. The execution of a number of jobs in a computer system.

Multilith. Trade name for a small offset duplicator press used for small jobs such as cards, letterheads, envelopes, forms, etc.

Munsell system. A system of numerical gradation used to designate and specify colors.

Mutton quad. Also called a *mutt*. Nickname for an em-quad (*which see*).

M weight. The weight of 1,000 sheets of any given paper size. Not to be confused with basis weight (*which see*), which is the weight of 500 sheets of a specific paper size. For example, the basis weight of 500 sheets of 25″ × 38″ paper would be 50 lbs., but the M weight of the same sheet would be 100 lbs., generally written as *100M*.

N

Natural. An off-white color of paper, like ivory. Also, a kind of finish given book-covering materials.

Negative. A reverse photographic image on film or paper: white becomes black and black becomes white; intermediate tone values are reversed. Also, a short form of the term "film negative" used in photography or in photomechanical processes to make printing plates.

Negative assembly. Assembling or combining negatives on a flat (*which see*) in exact position according to a layout so that a plate can be exposed, etched, and printed as a complete unit.

Network. A collection of interconnected computers.

News inks. Printing inks used on newsprint. News inks dry by absorption.

Newsprint. A grade of paper containing about 85% groundwood and 15% unbleached sulfite. The weight is from 30 to 45 lbs. and the surface is coarse and absorbent. Used for printing newspapers and low-cost flyers or broadsides.

Nick. In hand composition, the grooves in the body of the type pieces that help the compositor assemble the letters. In film, a notch or notches in the edge of the film used to identify the type of film when handling in the darkroom.

Nickeltype. An electrotype (*which see*) plated with nickel or chromium instead of copper. In letterpress printing, the plates used to print red (magenta) inks are always chromium or nickel plated to prevent chemical reactions between plate and ink.

Noise. Any undesirable signal occurring in an electronic or communications system.

Non-consumable textbook. A textbook intended to be used and re-used over a number of terms (this book, for example). As opposed to a consumable textbook.

Non-counting keyboard. In phototypesetting, a keyboard at which the operator types the copy to be set, producing a continuous tape which is then fed into a computer to determine line length and hyphenation and justification.

Non-scratch inks. Inks that when dry are highly resistant to mars and abrasions.

Non-woven. In binding, any material that is not woven: paper, reinforced paper, and synthetic fibers.

Novelty printing. Non-publication printing, such as on balloons, calendars, pencils, matchbook covers, badges, etc.

Numbering. Printing consecutive numbers on invoices, tickets, etc. with a numbering machine. Usually done by letterpress, although some offset presses have numbering attachments.

Nut. Nickname for an en-quad (*which see*).

O

Oblique. Roman characters that slant to the right.

Oblong. In book binding, refers to a book that is bound on the short end rather than on the long end.

Offline. Refers to equipment not directly controlled by a central processing unit or to operations conducted out-of-process. As opposed to online.

Offset. Commonly used term for offset lithography (*which see*). Also used interchangeably with set-off (*which see*).

Offset lithography. Also called *photolithography* and, most commonly, *offset*. The commercial form of lithographic printing. Offset lithography is a planographic printing method; it is the only major printing method in which the image area and the non-image area of the printing plate are on the same plane. They are separated by chemical means, on the principle that grease (ink) and water (the etch in the fountain solution) do not mix. The ink is transferred from the plate onto a rubber blanket and then to the paper.

Offset paper. Paper specially made for offset printing. It may be coated or uncoated. It must be sized and strong enough to resist the pull of the tacky inks used and the washing away of the coating by the dampening system.

Old Style. A style of type developed in the early 17th century.

Old Style figures. Numbers that vary in size, some having ascenders and others descenders: 1 2 3 4 5 6 7 8 9 10 As opposed to lining figures: 1, 2, 3, 4, 5, 6, 7, 8, 9, 10.

One-up, two-up, etc. In printing, making one impression of a job at a time. By using duplicate plates, or by step-and-repeating the job on one plate, jobs may be printed two-up, three-up and so on.

Onionskin. A term applied to lightweight, semi-transparent bond-type paper used for making carbon duplicates when typing. Also used for airmail stationery to cut down on weight and save postage.

On-line. Connected to the system and readily usable.

Opacity. That quality in a sheet of paper that prevents the type or image printed on one side from showing through to the other: the more opaque the sheet, the less show-through it will have. Also, the covering power of an ink.

Opaque. Non-transparent; not allowing light to pass through. Also, to paint out unwanted areas on a film negative so they will not reproduce during platemaking.

Opaquing. The process of eliminating any portion of a film negative by painting over the unwanted areas with an opaque solution. Also, painting resist on areas of metal engravings not to be etched.

Optical center. A point 10% above the mathematical center of a page or layout.

Optical Character Recognition. The process of electronically reading typewritten, printed, or handwritten documents used in photocomposition. Copy to be set is typed on a special typewriter, then read by an OCR scanner which produces a tape for typesetting. This avoids the necessity for keyboarding by the keyboard operator, permitting typesetting by a typist.

Optical disk. A mass storage device using a laser to record and read digital data.

Ornamented. A typeface that is embellished for decorative effect.

Orthochromatic. Photographic emulsion sensitive to blue, green, and yellow, but not red light.

Outline. A typeface with only the outline defined.

Outline halftone. *See* Silhouette halftone.

Output. In typesetting, type that has been set.

Output device. Any device that receives information from the microprocessor, most commonly the monitor.

Overhang cover. A cover larger than the trim size of the pages it encloses, as opposed to a flush cover, which is the same size.

Overlay. Transparent paper or film flap placed over artwork for the purpose of (1) protecting it from dirt and damage, (2) indicating instructions to the platemaker or printer, or (3) showing the breakdown of color in mechanical color separations.

Overprinting. Also called *surprinting*. Printing one color over another, or surprinting type over a halftone reproduction.

Overrun. Printing a quantity in excess of what is ordered. Also, printing a quantity in excess of what is actually required. Buyers of printing should be aware of the extra charges that non-regulated overruns may add to the bill.

Ozalid. Photocopying machine used to produce paper proofs of strike-on or phototypeset typography.

P

Packing. In printing, the layers of paper between the impression cylinder and the tympan upon which the paper rests during printing in letterpress, or between the plate and the cylinder in offset lithography. Manipulating the packing to ensure a perfect printing impression is called *makeready*.

Page description language. The common computer language that ties together the various systems and output devices, such as monitors, keyboards, scanners, printers, and imagesetters.

Page proofs. Proof pulled of page before the print run for checking purposes.

Pagination. To number pages in consecutive order.

Pamphlet. Generally used interchangeably with the *booklet*. Also used to designate a minor booklet of a few pages.

Pamphlet binding. The binding of small pamphlets or booklets, usually by saddle-wire stitching or side-wire stitching (*which see*).

Panchromatic. Photographic emulsion sensitive to all colors. The range of color sensitivity approximates that of the eye.

Pantone Matching System.® Brand name for a widely used color-matching system (*which see*).

Paper. The name given all kinds of matted or felted sheets of fiber (usually vegetable, but sometimes mineral, animal, or synthetic) formed on a fine screen from a water suspension. Also, specifically, one of the two broad subdivisions of paper, the other being paperboard.

Paper basis weight. *See* Basis weight.

Paperboard. One of the two broad subdivisions of the general category of fibrous sheets known as paper, the other being the specific term paper. Generally, paperboard is heavier, thicker, and more rigid than paper. All sheets 12 points (0.012″) or more in thickness are classified as paperboard.

Paper grades. Categories of paper based on such characteristics as size, weight, and grain. The grade is often defined in terms of use. For example, bond, offset, tag, book, newsprint, etc.

Paper surface efficiency (PSE). A method of determining the printability of a sheet of paper. It is dictated by how much ink the paper absorbs and the smoothness of the surface. Evenness of the caliper of paper will also influence printability.

Paper tape. A strip of paper of specified dimensions on which data may be recorded, usually in the form of punched holes. Each character recorded on the tape is represented by a unique pattern of holes, called the *frame* or *row*. Frames usually consist of 5, 6, 7, or 8 tracks or channels, although some tape-controlled typesetting equipment requires 15- or 31-channel tape.

Paragraph openers. Typographic elements use to direct the eye to the beginning of a paragraph (¶ □). Often used when the paragraph is not indented.

Parallel processing. Harnessing several processors together to operate on a task.

Parameter. A variable that is given a constant value for a specific process. Commonly used in the printing industry to refer to the limits of any given system.

Parchment. A sheet of writing material made from goat or sheep skin. An imitation parchment is made from paper impregnated with vegetable oils.

Pass. A machine run: a complete cycle of one program or set of programs, input to output.

Pasteboard. Laminated chipboard used as binding board.

Paste-up. A mechanical (*which see*).

Patching. Method of making corrections in repros or film in which the corrected "patch" is set separately and pasted into position on the repros or shot and stripped into film.

Patent base. In letterpress, a diagonally slotted or honeycombed metal base on which unmounted 0.1524″ plates or electrotypes are secured with locking hooks to bring them to type-high.

PC. Personal computer.

PE. Printer's error, or mistake made by the typesetter, as opposed to AA (*which see*).

Pebble finish. A finish made up of fine designs embossed on the paper. A pebble finish adds texture to the surface. A sheet can be pebbled prior to printing or it can be pebbled by a pebbler after printing.

Pentop computer. Notepad-sized machine into which the user enters data with a stylus rather than a keyboard. When combined with a fax machine, users can send documents or diagrams back and forth with editing and notations.

Perfect binding. A relatively inexpensive method of binding in which the pages are held together and fixed to the cover by means of flexible adhesive. Widely used for paperbacks, manuals, textbooks, and telephone books.

Perfecting press. A printing press that prints both sides of a sheet or a web in a single pass through the press.

Perforating. The punching of a line of minute holes in a sheet so that a part may be easily torn away in the manner of postage stamps. In letterpress, perforating is done on press by steel perforating rules (*which see*). In offset and gravure, it is usually done off press as a binding operation, using a perforator or a perforating die.

Perforating rules. In letterpress printing, hardened steel rules, 1 or 2 points in width and slightly higher than type-high, which are made up in the form in the outline of the area to be perforated.

Perforator. In composition, a keyboard unit that produces punched paper tape. Each character and function is given a unique code which is punched across the tape. In bindery work, a machine that punches a series of closely spaced holes in paper.

Peripheral. An input or output device used in conjunction, and usually connected by cable, with a computer; for example, a printer, modem, or disk drive.

Permanent inks. Inks which do not fade or change color when exposed to sun or artificial light. As opposed to fugitive inks, which do.

Photocomposing. To photomechanically arrange continuous-tone line, or halftone copy for reproduction. *Not a synonym for photocomposition*. Also, the technique of exposing plates using a photocomposing machine (also called a step-and-repeat machine).

Photocomposition. *See* Phototypesetting.

Photocopy. A duplicate photograph, made from the original. Also, the correct generic term for Photostat, which is a trade name.

Photoengraving. Also called an *engraving block* (in Europe) or a *cut*. A relief printing plate produced by photochemistry, used in letterpress printing. Photoengravings can be produced as individual units or as multiple-page forms. Unmounted they're .063″.

Photogelatin. *See* Collotype.

Photographic paper. The chemically sensitized paper used for photographic printing.

Photogravure. The process of printing from an intaglio plate or cylinder in which the image to be printed is screened and etched below the surface of the plate.

Photolithography. Lithography using photomechanically prepared plates, as opposed to hand-drawn stones or plates. *See also* Offset lithography.

Photomechanical. The complete assembly of type, line art, and halftone art in the form of film positives onto a transparent film base from which autopositive diazo proofs can be pulled for checking and from which a one-piece control film negative can be made for the production of printing plates.

Photomechanical transfer materials (PMT). Photomechanical papers manufactured by Eastman Kodak: *Kodak PMT Negative Paper*, for making enlarged or reduced copies in a process camera; *Kodak PMT Reflex Paper*, for making reflex copies or contact proofs of line and halftone negatives in a contact frame; *Kodak PMT Receiver Paper*, a chemically sensitive paper for making positive prints in a diffusion transfer processor (can also be used to make photorepros).

Photon. Trade name for a line of typesetting machines, available in a variety of models. Manufactured by Photon, Inc.

Photopolmyer plates. Printing plates made of light-sensitive, polymerizable plastic mounted on steel and aluminum. Photopolymer printing plates are used in letterpress as well as letterset and offset printing. Manufactured by Du Pont and by Eastman Kodak Co.

Photostat. Trade name for a photoprint, more commonly referred to as a *stat*. Stats are most commonly used in mechanicals to indicate size, cropping, and position of continuous-tone copy. The original copy is photographed by a special camera and produces a paper negative. From this a positive stat is made. Stats can be either matte or glossy in finish. The use of stats pasted in mechanicals as actual shooting copy is a common but quality-negating practice. Only absolutely sharp stats should be used. Matte-finish stats are preferred since aberration due to the gloss when photographing the mechanical is minimized.

Phototext. Text matter set by means of photocomposition.

Phototype. Photographically composed type: type set on a phototypesetting machine.

Phototypesetting. Also known as *photocomposition* and erroneously as *cold type*. The preparation of manuscript for printing by projection of images of type characters onto photosensitive film or paper which is then made up in mechanicals or photomechanicals, from which printing plates can be produced. Phototypesetting machines always produce positive images of type, either on photosensitive paper or film.

Phototypography. The process of producing matter from graphic reproduction via the use of all photomechanical means: phototypesetting machines, cameras, photoenlargers, photocomposing machines, and photosensitive substrates.

Photo Typositor. Semiautomated photo-display unit manufactured by the Visual Graphics Corporation.

Pi. Metal type that has become indiscriminately mixed, such as when a type form spills, so that it is unusable until it is put back in order.

Pica. A typographic unit of measurement: 12 points = 1 pica ($\frac{1}{6}$″ or 0.166″), and 6 picas = 1″ (0.996″). Also used to designate typewriter type 10 characters per inch (as opposed to the elite typewriter type, which has 12 characters per inch).

Pi characters. Special characters not usually included in a type font, such as special ligatures, accented letters, and mathematical signs. Called *sorts* by Monotype.

Picking. A removal of part of the paper surface during printing. A condition that develops if the pulling force (the tack) of the ink is greater than the strength of the surface of or coating on the paper.

Piece fractions. In composition, combining two matrices to make a fraction when a matrix for the desired fraction is not available. Looks like this: $\frac{1}{3}$, in which case the $^1/$ is one piece and the $_3$ is the other piece.

Pigment. Insoluble particles that give color to printing inks (as well as paints), as opposed to dyes, which are soluble.

Piling. The build-up of ink on rollers, plate, or blanket during printing.

Pilling. Flaking, scaling, or peeling of particles from the surface of a substrate, or the stripping off of small threads from the dampening rollers of an offset press.

Pinholes. Small imperfections in the form of light-passing holes in the emulsion of a photographic negative. These must be opaqued before platemaking.

Pinholing. Failure of a printing ink to cover the surface completely, leaving small holes in the printed area.

Pixel. Short for "picture element. One of the thousands of tiny dots that make up the screen image.

Planer. In metal type composition, the flat block of wood used to tap or push down the type in the form into a perfectly flat printing surface during lockup. This is done by striking the planer with a mallet.

Planographic printing. A printing process in which the image area and the non-image area of the printing plate are on the same surface (as opposed to relief printing, in which the image area is raised, and intaglio, in which the image area is incised). The principal example of planographic printing is lithography, the commercial form of which is offset lithography.

Plastic plate. Duplicate letterpress printing plate. A mold is made of the original plate and plastic is forced into the mold by hydraulic press, resulting in a lightweight duplicate plate which is ideal where ease of handling and low shipping costs are considerations. Also, a generic term used to describe any plate made of plastic, *i.e.*, a photopolymer plate.

Plate. *See* Printing plate.

Plate finish. A finish that gives paper a smooth, hard surface.

Plate finishing. In letterpress, to mechanically change the formation of dots on photoengravings in order to increase or decrease tonal values. *See also* Dot etching.

Platen press. A letterpress operating on the clamshell principle where both the printing form and the paper lie flat. The image is transferred directly from the plate to the paper by means of pressure. The word *platen* refers to the flat surface on which the paper is positioned and rests when it comes in contact with the printing surface. Platen presses are often referred to as *jobbers*. They are slow and best suited for short-run jobs or for die-cutting.

Plotter. An output device that translates computer data into a graphic form on paper.

Ply. One of several layers of paper pasted together to make Bristol board or similar stock: thus, 1-ply, 2-ply, 3-ply, etc.

PMS. *See* Pantone Matching System.

Point. Smallest typographical unit of measurement: 12 points = 1 pica, and 1 point = approximately $\frac{1}{72}$ of an inch (0.01383″). Type is measured in terms of points, the standard sizes being 6, 8, 10, 12, 14, 18, 24, 30, 36, 42, and 48, 60, 72 point in body size.

Point systems. There are major type measuring systems in use today: the *English/American System* or *pica system*, used primarily by the English-speaking world, and the *European Didot System*, used by the rest of the world. They are very similar.

Until the eighteenth century there was no standardized method of measuring type, there were only vague categories of type sizes and with names such as canon, primer, pica, etc. During the mid-eighteenth century, Pierre Fournier, a French type designer and printer, developed a mathematical system for denoting type sizes. This was later refined by François Ambroise Didot, whose name is used for the system.

During the late-nineteenth century the United States and England developed their own system, which was based upon Didot's. The system, referred to as the English/American System, was adopted by the United States in 1886 and England in 1898.

Both systems are based on points. The Didot point, however, is slightly larger than the English/American point. for example, a 9-point European Helvetica measures close to 10 points on the English/American System. Apart from this, the only difference that may be of interest to the designer is that in the English/

American System twelve points make a pica, while in the Didot System twelve points make a "cicero."

Here is a comparison between the two systems of the more common type sizes:

DIDOT	PICA
4	4.3
5	5.4
6	6.4
7	7.5
8	8.6
9	9.7
10	10.7
11	11.8
12	12.9
14	15.0

Porosity. That quality in paper that allows the passage of air, gas, or liquid through the pores, or interstices.

Port. A socket on the back panel of the computer for plugging in a cable leading to another computer or peripheral device.

Positive. A photographic reproduction on paper, film, or glass that corresponds exactly to the original: the whites are white (*i.e.*, clear), the blacks are black (*i.e.*, opaque), as opposed to a negative, in which the tonal values are reversed.

Poster. A single sheet printed on only one side. Generally posted in a public place to be read in passing.

Pot. In cast type composition, the receptacle on the casting machine in which the metal is melted and stored.

Powdering. *See* Chalking.

Powderless etching. An etching method in which photoengravings are produced in a single "bite" through the addition of oil additives to the acid solution which coat the edges of the area being etched and prevent undercutting (*which see*).

PPDR. Photopolymer direct relief printing plate. A plastic plate used in letterpress.

Preface. A formal statement by the author that precedes the text of the book (as opposed to the introduction, which is actually a part of the text, and the foreword, which is most often written by someone other than the author).

Preparation. Also called *prep work*. In printing, all the work necessary in getting a job ready for platemaking: preparing art, mechanicals, camera, stripping, proofing.

Pre-press proof. Proof made directly from film before making printing plate.

Preprinted. A general term that applies to material that is printed and delivered in rolls or sheets to be added to, inserted, or used in the production of books, magazines, newspapers, etc. In other words, the preprinted material is printed before, and separately from, the overall job.

Presensitized plate. An offset plate or any other printing plate on which the light-sensitive coating has been pre-applied by the manufacturer.

Press proof. A proof pulled on the actual production press (as opposed to a proofing press) to show exactly how the form will look when printed. Press proofs are expensive and are normally requested only as a final check at the time of printing. Press proofs are usually checked right at the printing plant while the press waits.

Press run. The length of the run or the number of sheets to be printed.

Pressure-sensitive lettering. Type carried on sheets that is transferred to the working surface by burnishing. Examples are Artype and Prestype.

Prestype. A brand name for a rub-off, or dry-transfer, type.

Primary colors. The three basic colors from which all other colors can be mixed: red, yellow, and blue. In four-color process printing, the three primary colors—magenta (process red), yellow, and cyan (process blue)—with black added, are used to reproduce the full range of colors.

Print. A paper photograph made from a negative: a black and white photograph.

Printability. The generalized or specific properties required of all materials and components in the printing process to produce an acceptable printed piece. The more compatible the components, the greater the possibility of quality.

Printer. An individual or firm engaged in the business of printing. Also refers to a device that produces typewriter-like copy by electrical impulses, such as a Teletype machine or a line printer. In process printing, a printer is a separation negative; the red filter separation produces the cyan (process blue) printer; the green filter produces the magenta (process red) printer; and the blue produces the yellow printer.

Printer font. In desktop publishing, a font a printer can use.

Printer's devil. A now-obsolete term for an apprentice or helper in a printing shop.

Printer's error. *See* PE.

Printing depth. The minimum amount of etched relief required in a photoengraving or duplicate plates.

Printing ink. Fluid or viscous material that is transferred from the printing plate to the paper or other surface, resulting in an impression. Printing inks may by any color, even metallic or fluorescent.

Printing plate. A surface, usually made of metal, that has been treated to carry an image. The plate is inked and the ink is transferred to the paper of other surface by a printing press. Printing plates are also made of rubber, synthetic rubber, and plastics. Plates are classified as originals or duplicates depending on their origin. To print from an original is to invite possible disaster if it is damaged.

Printing press. A machine that transfers lettering or images by contact with various types of inked surfaces onto paper or other material, fed into it in various ways.

Printmaking. A fine art term that applies to the reproducing of original works by printing methods.

Printout. In phototypesetting, printed output in typewriter-like characters, done by a line printer.

Process camera. Also called a *copy camera* or a *graphic arts camera*. A camera specially designed for process work such as halftone-making, color separation, copying, etc. Process cameras are usually large and sturdily built.

Process color. Also called *full color*. Refers to the four-color process reproduction of the full range of colors by the use of four separate printing plates, one for each of the primary colors—magenta (process red), yellow, and cyan (process blue)—and one for black. In process color reproduction, the colors are mixed optically by the eye of the viewer rather than mechanically, as in a painting. Process color also refers to specially separated and screened plates for printing in two or three colors.

Process inks. The magenta, yellow, and cyan inks used to produce process colors.

Process lettering. (Also called *photolettering* or *photo process lettering*.) A photodisplay method in which alphabets converted to film are assembled piece by piece from a file box by hand. Fonts are usually available in one size of each style and assembled words are enlarged or reduced to fit the layout. Assembly is done by skilled lettering artists who retouch, modify, or improve upon the finished result before releasing it.

Process plates. Halftone color plates for a four-color process job: each plate, made to a separate screen angle to avoid a moiré pattern (*which see*), contains one of the process colors, magenta (process red), yellow, and cyan (process blue), plus black, which when printed in register produce the full range of colors.

Program. A collection of instructions and operational routines, necessary to activate a typesetting machine, that is stored in the computer. The more sophisticated the programming, the more versatile and the higher the quality of composition and system will provide. *See also* Application.

Progressive proofs. Proofs pulled of flat or process color plates showing each color alone and in combination with the others. Progressive proofs are used by the engraver in color correcting to determine the amount and density of the colors and their effect on other colors when making ready and running his press. Normal progressive proofs are pulled in this sequence: yellow, red, yellow-red, blue, yellow-red-blue, black, yellow-red-blue-black. *See also* Bastard (or Hollywood) progressives.

Projection. A negative or positive made by exposure in a camera, as opposed to contact exposure.

Proofreader. A person who reads the type that has been set against the original copy to make sure it is correct and who also may read for style, consistency, and fact.

Proofreader's marks. Shorthand symbols employed by copyeditors and proofreaders to signify alterations and corrections in the copy. These symbols are standard throughout the printing industry and are illustrated in most dictionaries, and on page 19 of this book.

Proofs. A trial print or sheet of printed material that is checked against the original manuscript and upon which corrections are made. See *also* Bastard progressives, Galley proof, Line printer proof, Master proof, Reader's proof, Reproduction proof *and* Rough proof.

Protection shells. Electrotyper's molds made by publications or electrotyper when original plates are to be released to another publication or as insurance against possible loss or damage of the originals during shipping or printing.

Prove. To pull a proof. Also refers to the testing of the accuracy of a computer program. *i.e.*, to verify the program.

Pull. In printing, to make a print by transferring ink to paper.

Pulp. Fiber material produced by chemical or mechanical means or a combination of the two from fibrous cellulose raw material and from which, after suitable treatment, paper is made.

Punched card. In photocomposition, a lightweight card punched with a pattern of holes in specific positions to represent data.

Punched kraft jackets. Simple protective jackets, or dust covers, made of kraft paper that are supplied by the binder for shipping books. These jackets usually have a hole punched in the spine so that the title of the book can be read.

Punched tape. In typesetting, a tape into which a pattern of holes is punched by a keyboard-actuated punch. The tape activates the typesetting machine when it is fed through a tape reader.

Punching. *See* Slot punching.

Punch register. A way of getting fast and efficient register using a register punch, which is not unlike a three-hole binder punch. Copy, film, masks, internegatives, and plates can all be punched identically and precision-registered by placing the punched holes over carefully positioned register pins, or studs.

Pyroxylin. Liquid plastic used to reinforce book-covering materials. Also used to coat index tabs.

Q

Quad. A piece of type metal less than type-high used to fill out lines where large spaces are required. An em-quad is the square of the particular type size: a 10-point em-quad is 10 points × 10 points. An en-quad is half the width of an em-quad. Quads are also made in 1½-em, 2-em, and 3-em sizes.

Quadding. Setting quads, or spaces larger than the normal word spaces, in a line of type. Traditionally, this meant inserting quads (*which see*) to justify lines of type. In linecasting or photocomposition it is also used to denote how to position the type by spacing it with quads: *quad left* is flush left, *quad right* is flush right, and *quad center* is centered. On command, the machine inserts space, in the form of quads or in increments of space representing quads, to perform the function desired.

Quoins. (Pronounced *coins*.) Expansible blocklike or wedge-shaped devices operated by the use of a *quoin key* and used to lock up a type form in the chase prior to putting it on press.

R

Rag papers. Papers containing a minimum of 25% rag or cotton fiber. These papers are generally made up in the following grades: 25%, 50%, 75%, and 100%.

Raised printing. *See* Thermography.

Ram. An acronym for "random-access memory." Memory chips that store information only when the computer is on, when switched off the information is lost forever. RAM can contain both application programs and the designer's own information. To save information in RAM it must be transferred to a disk.

Raster image processing (RIP). The conversion of type and images to an arrangement of dots which can be stored in a computer and called up on the screen and manipulated as necessary.

Rasterization. The process of converting image data into output data.

Read. To interpret data from storage.

Reader. A specialized device that can convert data represented in one form into another form. Readers used in typesetting include OCR readers, magnetic tape or card readers, punched tape or card readers, and in specialized applications, mark-sensing readers.

Reader's proof. Also called a *printer's proof*. A galley proof (*which see*), usually the specific proof read by the printer's proofreader, which will contain queries and corrections to be checked by the client.

Reading head. A device capable of sensing information punched or recorded on tape and converting it to another form of storage, or into signals that will operate a computer or a typesetting machine.

Ream. A unit of measure for paper of any size: 500 sheets of paper.

Recto. The right-hand page of an open book, magazine, etc. Page 1 is always on a recto, and rectos always bear the odd-numbered folios. Opposite of verso.

Re-etch. To etch again. In platemaking, to deepen the plate to bring out detail or to otherwise modify the image.

Reflection copy. Also called *reflective copy*. Any copy that is viewed by light reflected from its surface: photographs, paintings, drawings, prints, etc. As opposed to transparent copy.

Register. In printing, the accurate positioning of one film (positive or negative) or printing plate over another so that both are in the correct relationship, one to the other, and the effect of a "single image" results. When plates are printed off-register, or out of register, the printed image will become fuzzy, and if in process colors change color; in extreme cases a shadow effect is caused.

Register marks. Devices, usually a cross in a circle, applied to original copy and film reproductions thereof. Used for positioning negatives in perfect register, or, when carried on press plates, for the register of two or more colors in printing. Register marks should not be confused with corner, bleed, or trim marks.

Register pins. Stubby pins usually attached to a small metal base. Pins correspond to the size of register punch holes. *See* Punch register.

Relief. A printing method that uses a raised image area. The commercial form of relief printing is letterpress.

Reproduction proof. Also called a *repro*. A proof made from type that has been carefully locked up and made ready. Repro proofs are pulled on a special coated paper and pasted into mechanicals.

Resin. Organic substance used as a binder in making printing inks and paper.

Resist. Any substance used to inhibit the action of the acid when etching a plate.

Resolution. The fixed number of pixels or dots available on an output device (display screen, printer, imagesetter, etc.)

Retarders. Solvents added to printing inks to slow setting time.

Retouching. The correcting of imperfections in or the altering of a photograph or dye transfer print before it is reproduced. Retouching can be done by airbrushing or by using pencil, pen, brush, or dyes. Fluorescent white or colors should be avoided since they cause "hot spots" on the resulting film used for reproduction process which then must be corrected by the platemaker.

Return card. A card enclosed in a mailing to serve as a return postcard for the convenience of readers that may wish to respond to an offer.

Reversal film. Special contact film in which the black-white values are preserved in direct relationship to the original; that is, a positive produces a positive, and a negative another negative.

Reverse copy. Copy which is wrong-reading when printed.

Reverse plate. A printing plate in which the tonal values are exactly the opposite from the original art: the blacks are white, the whites are black. Plate is made from a film positive instead of a film negative.

Reverse type. In printing, refers to type that drops out of the background and assumes the color of the paper.

Revise. A change in instruction that will alter copy in any stage of composition.

Rice paper. A nonfibrous sheet (and so not a true paper) from the pith of a tree, with ivorylike texture, cut in thin layers.

Right-angle fold. In binding, refers to folds that are at 90° angles to each other.

Right-reading image. Any image that reads correctly from left to right, as opposed to wrong-reading image.

Ring binder. Most common form of loose-leaf binder in which sheets are fastened by two or more rings that pass through pre-punched holes along the binding edge.

Ripple finish. A paper finish with a wavy look produced by an embossing process.

Roll-out. Ink put down by a hand roller on glass or paper for testing purposes to determine color or other characteristics.

ROM. An acronym for "read-only memory." Memory chips that store information the computer used to operate, including starting itself. ROM is permanent and doesn't vanish when the system is turned off.

Roman. Letterform that is upright, like the type you are now reading. Also, more specifically, an upright letterform with serifs derived from Roman stone-cut letterforms.

Rotary printing. Any form of printing where the plate to receive ink is in cylinder form, rather than flat. Gravure, offset, flexography, and collotype are all rotary. Letterpress can be flatbed, or rotary, in which case the plates are curved. Most letter-press publication presses and newspaper presses are rotary. Rotary presses can be sheet-fed, which means single pre-trimmed sheets are fed into the press, or web-fed, which means the paper is fed into the press as a web from rolls.

Rotogravure. Web-fed gravure printing done on a rotary press. Used for the Sunday supplements of newspapers, magazines, or packaging and excellent for economical medium-run and long-run jobs.

Rough. A sketch or thumbnail, usually done on tracing paper, giving a general idea of the size and position of the various elements of the design.

Rough proof. Any proof pulled from type on a proofing press or from a plate without make-ready showing what the material proofed looks like. Rough proofs are usually pulled for identification purposes only, before filing away type galleys or engravings for storage. Also, an in-house proof pulled to check the work.

Routing. In engraving, the mechanical cutting away of unwanted metal in the printing plate. Also used to deepen the non-image areas of the plate. A router is a high-speed, hand-guided tool, very much like a drill.

Royal. A font-rendering technology developed by Apple Computers and Microsoft as an alternative to Adobe's PostScript formats, the standard font-imaging technology.

Rubber plate. A duplicate relief printing plate cast in rubber from a mold of the original plate. Rubber plates are used primarily in flexography and box and carton printing and sometimes in medium- or low-quality paperback book printing.

Rub-off type. *See* Pressure-sensitive lettering.

Rule. A black line, used for a variety of typographic effects, including borders and boxes. Rules are actual type-high typographic elements and come in a range of thicknesses called *weights* that are measured in points. Many rules are cast as duplex rules: two or more parallel lines of the same or of different thicknesses cast on the same body. Fine rules for letterpress work are often made of strip brass or steel. In addition to lines, rules may also be dotted, dashed, or contain fancy border designs.

Run in. To set type with no paragraph breaks or to insert new copy without making a new paragraph.

Running head. A book title or chapter head at the top of every page in a book.

S

Saddle-wire stitching. A common, inexpensive way of binding pamphlets and booklets if they are not too thick (usually less than ⅛"). The pages are bound together by wire staples inserted through the backbone, or folding line, and into the center spread where they are clinched. The folded sheets or pages are placed over a saddle to ensure proper positioning.

Safelight. A colored lamp used in darkroom work which gives enough light to see by yet does not affect the photographic material.

Sans serif. Without serifs (*which see*).

Sawtooth edge. Edge of a halftone that crosses the screen line at an angle causing symmetry of dots to break into the appearance of the teeth of a saw.

Scalable Fonts. Outline master fonts capable of setting a range of sizes, usually ½ to 99 points in ½-point increments.

Scaling. The process of calculating the percentage of enlargement or reduction of the size of original artwork to be enlarged or reduced for reproduction. This can be done by using the geometry of proportions or by the use of a desk or pocket calculator, logarithmic scale, or disc calculator.

Scanner. *See* Electronic scanner.

Scoring. Creasing paper mechanically so it will fold more easily. Usually necessary where paper is even moderately stiff or when the fold goes across the grain.

Scotchprint. Trade name for plastic, matte-finish translucent proofing material for making contact positives or negatives, intermediate for photomechanical platemaking. Used on conventional repro proof presses to convert letterpress plates to film. Manufactured by 3M.

Scratchboard. A clay-coated cardboard covered with black ink. By scratching and scraping into the black ink, it is possible to produce wood-engraving effects as well as black and white reverse effects.

Screen. In printing, the finely cross-ruled glass plate placed before the lens of a camera (or a contact screen placed in contact with the film) to break up continuous-tone copy into dots for reproduction as halftone or line copy. Screens are designated by number of ruled lines they contain—from 50 lines per inch to 500 lines per inch. The greater the number of lines per inch, the sharper and finer the printed halftone will be. The selection of the screen is dictated by the paper, press, and to a certain extent the nature of the copy. For example, the coarser screens (50 to 85) are used for newspapers, while the finer screens (100-line and up) are used on coated papers. Screens are also created electronically.

Screen angle. The angle at which two or more screens are turned in relation to one another to avoid the creation of an undesirable moiré pattern (*which see*) in the halftone dots. In four-color process printing, for example, the screens for the four plates might be angled as follows: 45°, 75°, 105°, and 120°.

Screened positive. The reverse, or opposite, of a screened negative. Term used to differentiate it from a continuous-tone positive.

Screen finder. A lined plastic template which when placed over a halftone can determine the screen ruling of a halftone.

Screen font. A font designed to be displayed on the monitor's screen. These are commonly paired with the more detailed printer fonts (*which see*).

Screen process printing. A printing method in which the image is transferred to the surface to be printed by means of ink squeezed by a squeegee through a stenciled fabric or metal wire screen stretched over a frame. Screen process printing is either a manual or mechanical operation, though it enjoys the benefits of photographic stencils, and automatic presses and driers. It allows the heavy application of paint on almost any material and is excellent for short-run line work, especially posters. Posters and point-of-purchase displays requiring a thick layer of paint and/or fluorescent inks are usually silkscreened.

Screen ruling. The number of lines per inch on a contact or glass halftone screen.

Scribed lines. Lines scratched (scribed) into the emulsion of negative film as opposed to lines ruled on original copy.

Scribing. Scratching clear lines in the emulsion of a blackened film so they will print as black rules.

Script. A typeface based on handwritten letterforms. Scripts come in formal and informal styles and in a variety of weights.

Scroll bar. A device that helps the operator navigate through a document on the screen.

SCSI (pronounced "scuzzy".) An acronym for "Small Computer System Interface," and the industry standard interface for high-speed access to peripheral devices.

Scum. In offset printing, a greasy film that can sensitize or clog non-image areas of the plate to accept ink and print.

Scumming. Also called *greasing*. A defect in offset printing caused by the unwanted sensitizing of a non-image area of the plate so that it accepts ink and prints.

Secondary color. The color that results from the mixing of two primary colors: orange (yellow and red), purple (red and blue), and green (blue and yellow).

Sector. A part of a track on the surface of a disk used to organize information stored on a disk. *See* Track.

Selectric. Trade name for a typewriter composition system manufactured by IBM.

Self-cover. A cover of the same stock (paper) as used in the rest of the book. Used for booklets or pamphlets when the cover stock does not have to be particularly strong or to save the cost of the extra materials and operations required to produce and bind a cover.

Self-mailer. A printed piece designed to be mailed without an envelope.

Separation. *See* Color separation.

Separation negative. *See* Color separation negative.

Series of type. Refers to all the sizes of one particular and unique typeface.

Serifs. The opening and closing cross-strokes in the letterforms of some typefaces. Sans serif typefaces, as the name implies, do not have serifs but open and close with no curves and flourishes.

Serigraphy. In fine art, the production of original color prints by pressing pigments through a silk screen with a stencil design. *See also* Screen process printing.

Set-off. Formerly called *offset*. The undesirable transfer of ink from one printed sheet to another.

Setting of ink. The initial phase of ink-drying. Printed sheets can be handled without smudging even though the ink is not yet fully dry when the ink has set.

Setup time. The time required to ready a job to run: to load the program, load and ready input/output devices, etc.

Set width. Also called *set*. In metal type, the width of the body upon which the type character is cast. In phototypesetting, the width of the individual character, including a normal amount of space on either side. This space, measurable in units, can be increased or decreased to adjust the letterspacing. Letterspacing can also be adjusted by using a larger or smaller than normal set size mode on the photounit. This function can also be performed in metal typography by the Monotype machine.

Sewed soft cover. A binding process in which saddle-sewn signatures are fastened to each other and to a soft cover.

Shade. A modification of a color produced by adding small amounts of black or a complementary color. In ink manufacture, commonly used as a synonym for *hue*.

Shadow. An area that is relatively dark, as compared with light, or highlight, areas in original copy or reproductions. Control of these values in halftone preparation is accomplished by a supplemental "flashing" of the film by a filtered light. This reinforces the dot exposure in the dark areas of the photo only.

Sheet-fed. A method of applying paper to a press in printing in which the paper is fed into the press as sheets rather than a web.

Sheetwise. A method of printing in which each sheet of paper is printed, first on one side and then on the other, one at a time, using the same gripper and side guide.

Shooting copy. The act of photographing copy for reproduction. Also, the copy, ready to be shot.

Short ink. Ink that cuts off cleanly because of its short fibers but with less ability to resist the dampening solution on an offset press. Short inks are preferred in screen process printing because they enable small type and halftones to be clearly and crisply printed. Opposite of long ink.

Shoulder. Space on the body of a metal type which provides for ascenders or descenders. Also provides the minimum space required to separate successive lines.

Show-through. The phenomenon in which printed matter on one side of a sheet shows through on the other side.

Side-wire stitching. Also called *side stitching.* A method of binding books, catalogs, and magazines in which wires in the form of staples are inserted near the binding edge, passing from the first page through the entire thickness and out the back where they are clinched.

Signature. A group of pages printed on a sheet of paper, which when folded and trimmed will appear in their proper sequence.

Silhouette halftone. More accurately called an *outline halftone.* A halftone reproduction in which the main image area is outlined by removing the dots that surround it.

Silkscreen printing. *See* screen process printing.

Sizing. In bookbinding, the process of applying a suitable bond between the binding material and the foil that is used for stamping. In paper manufacture, the material (also called *size*) added to produce a smooth, moisture-resistant surface.

Slip sheeting. Inserting blank sheets of paper between printed ones coming off the press to prevent set-off; that is, ink "offsetting" onto the back of the previously printed sheet.

Slitting. Cutting printed sheets or webs into two or more sections by means of a slitter. Slitting is done by cutting wheels on the press or the folding machine.

Slot punching. Punching, as opposed to drilling, holes into paper. Used in mechanical binding where holes that are not round (rectangular slots) are required. Slots permit insertion of looseleaf pages into binders that hold sheets by means of tapes rather than rings.

Slug. A line of type set by a linecasting machine. Also, the name of a thick, less than type-high spacing material in widths of 6, 12, and 24 points. These are usually cast on an Elrod machine in long strips which the printer saws to the required lengths.

Slur. A printing fault caused by drag or slippage at the point of impression of paper, printing plate, image carrier, blanket, or a combination thereof. To detect slurring, many printers print the GATF slur guide on the tail of the press sheets.

Small caps. Abbreviated *s.c.* A complete alphabet of capitals that are the same size as the x-height of the normal typeface.

Smearing. In printing, a condition in which, due to careless handling or distribution, ink spreads or smears over areas of the paper where it is not wanted.

Soft cover. Any non-board cover, usually a paper cover on a perfect-bound book.

Software. Computer programs, or instructions for the computer to carry out. *See* Hardware.

Solid. In composition, refers to type set with no leading between the lines. In printing, refers to areas that are completely covered with ink or areas that print 100% of a given color.

Solvent. A liquid that dissolves or suspends the pigment in the ink. Used as a reducer to "wet up" gravure inks or to clean the ink fountains.

Sorts. Individual letters in a font of type for use in replenishing used-up type in a case. Also used by Monotype to describe special characters not in the regular fonts.

Spacebands. Moveable wedges used by linecasting machines for wordspacing and to justify lines of type. After the line has been set as a row of matrices, the spacebands are forced up to tighten (*i.e.,* justify) the line prior to casting it.

Spaces. In handset type, fine pieces of metal type, less than type-high, inserted between words or letters for proper spacing.

Spacing. The separation of letters and words in type or the separation of lines of type by the insertion of space.

Spec. To specify type or other materials in the graphic arts.

Spine. Backbone (*which see*).

Spiral binding. A binding in which a continuous wire or plastic spiral is threaded through prepunched holes along the binding sides of the paper.

Split fountain. A color printing technique in which two or more distinct colors can be printed at the same time by dividing or splitting the ink fountain on the press, so that the left side prints one color and the right side another. A special rainbow effect can be achieved by splitting the fountain with narrow dividers. As the press runs, the oscillation of the rollers gradually blends the different colors. Where the two colors meet a third color is produced.

Spotting. The elimination of white dots on a photograph or negative by painting them out (*opaquing*) with a fine brush and water-soluble, light-blocking opaque.

Spray. In printing, material applied by spraying to prevent set-off (*which see*) of freshly printed sheets with a liquid which crystallizes, or a fine power, to keep the next sheet from coming into contact with the ink on the preceding one. These are called *no-offset sprays.*

Spread. A pair of facing pages. Also, in photography and platemaking, the enlargement of an image to ensure lap (*which see*), accomplished by producing a film by holding it out of emulsion-to-emulsion contact by the use of a layer of clear film which permits the light to spread as it passes through the layers.

Spreading. In printing, the enlarging or thickening of printed areas caused by the bleeding or lateral creep of the ink.

Square halftone. Also called a *square-finish halftone.* A rectangular—not necessarily square—halftone, *i.e.,* one with all four sides straight and perpendicular to one another. So called because the edges of the plate are machine-cut on a finishing machine.

Square serif. A typeface in which the serifs are the same weight or heavier than the main strokes.

S.S. Abbreviation for "same size."

Stabilization paper. Stabilization-processable (dry-processed) photopaper used in phototypesetting for output in the form of good-quality photorepros. Not the same as conventional photosensitive papers (Kodaline, Resisto), which are chemically wet-processed in a tray or in a film or paper processor. Stabilization-processed materials are sensitive to ultraviolet light and have a lifespan of only about six weeks; if kept for a longer period of time they must be washed and fixed. The nature of these papers is such that they process in a way that causes problems in matching image densities from batch to batch; this is especially troublesome when correcting previously set matter.

Staging. A method of correction photoengravings by covering (painting over and stopping out) certain areas and re-etching others.

Stamping. A printing method in which type or designs, in the form of a relief die, are impressed with heat and pressure through metal foil onto the surface to be printed. Blind stamping uses no ink or foil, so that the die alone makes the image.

Stamping dies. Heavy, deeply routed steel or brass plates or female dies used in bindery work or box printing. Some are made of hard rubber for box printing work.

Standard colors. A half-dozen basic colors chosen by the AAAA for use by the printer primarily for publication work such as magazines and newspapers.

Steel engraving. An intaglio printing plate that is made by manually cutting away the non-printing areas on a metal plate (usually copper or steel), leaving only thin lines, which will print in relief. Intricate designs may be machine-engraved using a pantograph or an engine lathe. Steel engraved plates are used to print engraved banknotes, stock certificates, fine stationery, and business cards. Printing is done by inking the plate, wiping clean the surface, and then, under great pressure, transferring the ink onto the paper by pressing the paper into the fine grooves that hold the ink.

Steel-plate printing. Also called *steel-die printing.* Intaglio printing using metal plates which are inked, the surface wiped clean, and impressed under great pressure onto the substrate.

Step and repeat. A method of making multiple images from a master negative of the same subject in accurate register. Step-and-repeat operations are done photomechanically and electronically (using a photocomposing or a *step-and-repeat machine*).

Stereotype. The oldest and least expensive way to make a duplicate letterpress plate. A papier-mâché or plastic mold is made of the original type or engraving. The mold (called a *mat*) is then filled with a molten metal to form a new plate that can be mounted on wood to make it type-high, shaved to electro-height, or cast in a curve to fit the cylinders of a rotary newspaper press. Stereotypes are very prevalent in newspaper printing where copy consists mainly of line art and coarse-screened halftones and printing is done at high speeds.

Stet. A proofreader's mark that indicates copy marked for correction should stand as it was before the correction was made. Copy to be stetted is always underlined with a row of dots usually accompanied by the word *stet*.

Stick. Composing stick (*which see*).

Stock. Also called *substrate*. Any material used to receive a printed image: paper, board, foil, etc. In papermaking, pulp which has been beaten and refined, and which after dilution is ready to be made into paper.

Stone. Also called an *imposing stone*. The surface, originally of stone but now of machined metal, on which letterpress forms are assembled, locked up, and planed down prior to putting them on press.

Stoneman. In letterpress printing, the worker at the printing plant who imposes the form; that is, assembles the typographic elements and locks them up in a chase on the stone.

Stone out. To remove minor unwanted areas or scratches from an offset printing plate by using an abrasive stone.

Storage. In computer-aided phototypesetting, pertaining to a device (a memory tape, disc, or drum) into which data can be entered, in which it can be held, and from which it can be retrieved at a later time.

Straight matter. In composition, body type (as opposed to display type) set in rectangular columns with little or no typographic variations.

Strike-on composition. *See* Typewriter composition.

Strike-through. In printing, the penetration of ink into the paper so that it shows through on the other side, or the embossed impression of the type in letterpress printing which can be seen on the opposite side of the sheet.

Stripper. Also referred to as a *make-up man*. Worker in a printing plant who assembles and strips negative or positive film onto a flat for making plates.

Stripping. Assembling photographic negatives or positives and securing them in correct position to the paper (goldenrod), film, or glass base which is to be used in making the press plates.

Stripping guide. Position layout or translucent layout tissue or rough paste-up which serves as a guide for stripping a film mechanical, etc.

Strip test. A test using chemically treated paper to determine the *pH* of an offset fountain solution.

Substance. Also referred to as *basis weight*. The basis used to measure the weight of paper: the weight in pounds of a ream (500 sheets) of paper cut to standard size, or 1,000 sheets cut to the M-weight size.

Substrate. The base material to be printed: paper, board, metal, etc., or the carrier or the emulsion or coating, such as film.

Sulphate wood pulp. Paper pulp made from wood chips cooked under pressure in a solution of caustic soda and sodium sulphide.

Sulphite wood pulp. Paper pulp made from wood chips cooked under pressure in a solution of bisulphite of lime.

Supercalender. An off-machine calendering process given coated papers to make the surface smooth and glossy. Also, the name given to a very smooth uncoated paper that was finished on the super-calendering machine. This paper, more commonly referred to as "super," is no longer made, having been replaced by less expensive coated papers.

Surprinting. The combining of images from two different negatives by superimposing them to produce one negative or one image on a press plate by double-burning (*which see*).

Swash. A cap letter with an ornamental flourish.

Swatchbook. A sample book put out by manufacturers of color-matching systems (such as Pantone Matching System) showing all the colors available. In the designer's edition, the colors are numbered for identification; in the printer's edition, ink-mixing instructions are also included. Also, books containing samples of papers.

T

Tabbing. Bindery operation in which tabs are cut into or adhered to the edge of a piece of paper.

Tack. The resistance offered by ink films during splitting. Tack is a measure of an ink's internal cohesion.

Tape. Punched paper ribbon (between 6- and 31-level) or magnetic (7- or 9-level) tape, produced by a keyboard unit and used as input to activate the photounit of a typesetting system or a computer for subsequent processing of the data thereon for phototypesetting machine input.

Tape editing. In phototypesetting, the transferring of information, via a visual display terminal or a line printer, from one tape to another to produce a corrected tape.

Tape merging. In typesetting, a method of editing and correcting tapes in systems in which every line of type is numbered.

Tap-out. A spot of ink applied to paper and tapped out by finger to reduce the ink to approximate thickness when printing and thus ascertain its true color.

Tear test. Method of determining the direction of the grain in a sheet of paper; paper tears easily with the grain. Also, a test made with calibrated instruments to establish tear strength of paper.

Tertiary colors. The colors produced by mixing any two of the secondary colors: orange-green, green-violet, violet-orange.

Text. The body copy in a book or on a page, as opposed to the headings.

Text paper. A general term that is applied to antique, laid, or wove papers. Used for booklets, programs, announcements, and advertising printing.

Text type. Main body type, usually smaller in size than 14 point.

Thermography. A finishing process that simulates the effect of steel-die engraving, producing raised letters. While the ink is still wet on the sheet, it is dusted with a resinous powder which adheres to the ink. The sheet is then passed through a heating unit that causes the particles of powder to fuse with the ink, imparting a raised effect to the letters.

Thinners. Clear liquids (solvents, diluents, oils, and vehicles) added to inks to reduce viscosity, or tack.

Thirty. The symbol "-30-" used by newspapers to end a story.

Three-color process. Almost the same as four-color process printing (*which see*), except that the black plate is eliminated.

Thumbnails. Small, rough sketches.

Time sharing. Running several jobs on the computer at the same time.

Tint. A color obtained by adding white to the solid color. In printing, a photomechanical reduction of a solid color by screening.

Tint block. A solid or a screened plate used to print a background color over which type or halftone art will be surprinted in a darker color or in black.

Tinting. In lithography, the discoloration of the background caused by the bleeding or washing of pigment in the fountain solution.

Tip-in. The process of pasting a leaf onto a printed page before or after binding. This is common in artbooks where a full-color reproduction is desired in a black and white signature (such as for a frontispiece).

Tissue paper. Also referred to as *tissue*. A general term that applies to all gauzy, lightweight papers that weigh less than 18 lbs. Used for a variety of purposes, but mainly for use with carbon paper for making copies in office correspondence.

Title page. The page of a book—usually page 3—that carries the title, the author's name, and the name of the publisher.

Titling. An alphabet of foundry type in which the capital letters fill the full face of the type. This permits the setting of caps with a minimum of leading. Titling caps have no matching lowercase alphabet.

Tone. The variation in a color or the range of grays between black and white.

Tone-line. The conversion of continuous-tone copy into a line copy by photography.

Toner. A full-strength, highly concentrated organic pigment containing no extender that is used to modify the hue or color strength of an ink.

Tooth. Refers to that quality of a paper's surface that feels and looks rough textured. Toothy paper is especially good for drawing in pencil or charcoal and for painting in watercolors, and is good for some printing needs: line or type printed by letterpress or by a lithographic process. It cannot be used by gravure because full contact between plate and paper is not possible, resulting in a snowflake effect.

Tracking. A term used by typographers in place of overall letterspacing.

Track. When preparing a disk to receive information it is divided into circular tracks, which are then divided into sectors.

Trademark. A unique device that identifies a product.

Transducer. A photoelectric cell device for converting input energy of one form into output energy of another. Used in OCRs.

Transfer key. Trade name of 3M for acetate proof (which see).

Transfer type. Type carried on sheets that can be transferred to the working surface by cutting out self-adhesive letterforms (cut-out lettering), or by burnishing (pressure-sensitive lettering). Examples are Artype, Formatt, Letraset, Prestype.

Transistor. Along with resistors, capacitors, and diodes, the transistor is a basic building block of an integrated circuit, or chip.

Transitional. A type style that combines features of both Old Style and Modern Baskerville, for example.

Transparency. A positive colored photograph on transparent film, such as Anscochrome, Kodachrome, or Ektachrome films, usable as copy for color separation and viewed by transmitted light.

Transparency viewer. Also called a *light box.* A box containing special light bulbs (5000 Kelvins) filtered through a diffuser. Used for viewing transparency copy under the best possible light conditions. Used especially when color correcting four-color process printing against the transparency.

Transparent copy. Copy viewed by transmitted light (*i.e.*, transparencies).

Transparent inks. Inks that permit the color of a previous imprint, or the color of the paper, to show through. A transparent color surprinted on another color will produce a third color.

Transpose. Commonly used term in both editorial and design to designate that one element (letter, word, picture, etc.) and another should change places. The instruction is abbreviated *tr.*

Transposition. A common typographic error in which letters or words are not correctly placed: "hte" instead of "the" or "Once a Upon Time" instead of "Once Upon A Time."

Trapping. The ability of an ink film to properly accept a succeeding ink film, making it possible to superimpose one color over another both in wet and in dry printing.

Trash. An icon that is used to discard information.

Trim. To cut off and square the edges of a printed piece or of stock before printing.

Trim size. The final size of a printed piece, after it has been trimmed. When imposing the form for printing, allowance must always be made for the final trim size.

TTS. An abbreviation for Teletypesetter, a trade name for a device that produces a perforated tape which can in turn operate the keyboard of a linecasting machine equipped to receive such input.

Tusche. The liquid emulsion ink that is painted or drawn on the lithographic stone in direct lithography to form the image. Tusche can be used to effect corrections on offset plates if the run is short.

Two-tone paper. *See* Duplex.

Tympan. In letterpress printing, the sturdy oiled paper that covers the packing on the impression cylinder or platen of a press.

Type. The letters of the alphabet and all the other characters used singly or collectively, to create words, sentences, blocks of text, etc.

Typecasting. Setting type by casting it in molten metal either in individual characters or as complete lines of type.

Type family. A range of typeface designs that are all variations of one basic style of alphabet. The usual components of a type family are roman, italic, and bold. These can also vary in width (condensed or extended) and in weight (light to extra bold). Some families have dozens of versions.

Type gauge. Commonly called a *line gauge.* A metal rule with a hook at one end calibrated in points and picas on one edge and inches on the other. Used to measure in typography. Also, slotted copyfitting gauges made in various lengths and graduated increments of ens or ems of each type size. These are used to gauge the number of lines set in a given type size; they are also useful for copyfitting.

Type-high. The height of a standard piece of metal type: .918″ (U.S.). A plate is said to be "type high" when mounted on wood or metal to the proper height to be used on a letterpress printing press.

Type metal. The metal used for cast type: alloy of lead, tin, and antimony, and sometimes a trace of copper.

Type series. One basic typeface design in its full size range, from 6 point up to 72 point, or sometimes even 120 point.

Typesetter. Term for a person(s) who sets type. Also, any device that sets type.

Typesetting. The assembling of typographic material suitable for printing or incorporating into a printing plate. Refers to type set by hand, machine (cast), typewriter (strike-on), photo-typesetting, and digital.

Typewriter composition. Also called *strike-on* or *direct impression* composition. Composition for reproduction produced by a typewriter.

Typographer. Person(s) who set type.

Typographic errors. Commonly called *typos.* Errors made in copy while typing, either at a conventional typewriter, or by the compositor at the keyboarding stage of typesetting. Typos made by the compositor are PE's (*which see*) and are usually corrected free of charge.

Typography. The art and process of working with and printing from type. Today's technology, by mechanizing much of the art, is rapidly making typography a science.

Tyvek. Trade name for a synthetic book-covering material made by DuPont.

U

U. & L.C. Also written *u/lc.* Commonly used abbreviation for upper and lowercase. Used to specify text that is to be set in caps (usually initial caps) and lowercase letters as written.

Uncoated paper. The basic paper, produced on the papermaking machine with no coating operations.

Unit. A variable measurement based on the division of the em into equal increments.

Unitization. Designing the characters in a font according to esthetically pleasing width groups. These width groups are measurable in units and are the basis for the counting mechanism typesetting equipment. Width units can be based on the em (square of a point size) or the set size of the font.

Unit system. A counting method first developed by Monotype and now used on most typesetting systems to measure in units the width of the individual characters and spaces being set in order to total the accumulated units and determine when the line is ready to be justified.

Unit value. The fixed unit width of individual characters.

UNIX. Operating system developed by the Bell Laboratories in 1971.

Unjustified tape. Also called an *idiot tape.* In photocomposition, an unhyphenated, unjustified tape (either magnetic or paper). The tape is keyboarded with no end-of-line signals (no hyphenation or justification), allowing the keyboard operator to type at maximum speed. The tape is then fed through a computer, which adds to the total units accumulated and resolves the hyphenation and justification according to a pre-programmed set of rules and produces a justified tape. The justified tape is used to operate the typesetting machine.

Unjustified type. Lines of type set at different lengths which align on one side (left or right) and are ragged on the other.

Update. In typesetting, to incorporate into the master tape or disk the changes required to reflect recent corrections or changes.

Uppercase. The capital letters of a type font: A, B, C, etc.

Upright. A book or catalog that is bound along its longest dimension. As opposed to oblong, in which the book or catalog is bound along its shortest dimension.

User friendly. Any part of a computer system that is easy for the novice to use.

V

Vacuum frame. Also called a *contact printing frame.* In photoengraving and offset lithography, a glass-topped printing frame used for exposing plates or making contact negatives and positives. Close contact between the film and the plate is maintained by the action of the vacuum pumps which expel the air trapped between the two layers of substrate.

Value. The degree of lightness or darkness of a color or of a tone of gray, based on a scale of graduated tonal values running from pure white through all the gradations of gray to black.

Van Dyke. Also known as a *brownline* or a *brownprint.* A photocopy having its image in a dark brown color, used as a proof.

VariTyper. Trade name for a special typewriter capable of setting type directly onto paper. It composes type in a number of different styles and can produce justified type semiautomatically.

Varnish. A thin, protective coating applied to the printed piece like ink on the printing press. Also refers to part or all of the vehicle in the ink.

Varnishing. Finishing process done on-press with ink rollers and blank plate or off-press with spray guns or blade coaters. Varnish may be added to protect the printed piece or for esthetic reasons. Press varnish can be selectively applied to spots (called *spot varnishing*) when a press plate is made to cover only the areas to be varnished. Care must be exercised to print with inks that are compatible with the varnish.

VDU. Visual display unit.

Vehicle. The liquid ingredient in ink. It serves as the carrier for the pigment, binds the pigment to the substrate, and gives the ink the quality of workability and drying.

Vellum. A term used to designate a certain paper finish: a strong, toothy, cream-colored, and relatively absorbent paper. Also, a kind of finish given woven book-covering materials.

Velox. A term, derived from the trade name Velox Print, for a high-quality screened photographic print used in the preparation of mechanicals. As it is line art, it can be shot right along with the line copy, thus saving stripping costs.

Velox Print. Trade name for glossy photoprint papers manufactured by Eastman Kodak.

Verso. The left-hand side of a spread, as opposed to the recto, which is the right hand side of a spread. The verso always carries an even-numbered folio. Also refers to the reverse side of a printed sheet.

Video cards. *See* Expansion cards.

Vignette halftone. A halftone produced to print so that the edges fade imperceptibly into the white of the paper.

Viscosity. That quality of printing inks that encompasses the properties of flow.

Visual. A layout or comp (*which see*).

Visual display. A visual representation of computer output.

Visual display terminal. A device containing a cathode ray tube on which copy can be displayed, edited, and corrected.

W

Warm colors. Red, yellow, and orange, as opposed to the cool colors, blue, green, and violet.

Wash drawing. Drawing done with black ink or paint diluted to various degrees to produce a range of grays. Also, halftone art characterized by light, even tones washed on illustration board by means of a brush. Darker tones are obtained by successive layers of washes.

Wash up. The process of cleaning the press: the rollers, the plate, and the fountain. Every time color is changed, a wash-up is necessary.

Watermark. The slightly translucent design produced in paper during manufacture by a raised pattern made of wire soldered onto the dandy roll. The watermark is usually a distinctive symbol or logo, identifying the band of paper or the manufacturer.

Water-soluble inks. Also called *watercolor inks.* Inks in which the pigments are soluble in water. Used in screen process printing, printing from rubber plates, and in gravure.

Waxed paper. Paper that has been waxed. There are two waxing methods: wet waxing, in which the paper is dipped into a wax bath and immediately chilled; dry waxing, in which the paper is passed through rollers immediately after it comes out of the wax bath, so that the wax is driven into the paper and the paper feels dry.

Web. A continuous roll of paper (used in web or rotary presses) in the process of manufacture in a machine, such as a printing press. After being printed, the web is cut into short lengths at the delivery end of the press, or run on other equipment such as packaging machinery.

Web-fed. A term applied to presses that print from continuous rolls (webs) of paper.

Web printing. Also called *roll-fed printing.* Printing method in which paper is fed into the press from continuous rolls (webs), as opposed to flat sheets as in sheet-fed printing. Webs are used in rotary letterpress (for publication printing), rotogravure (for newspaper and magazine presses), and for packaging presses and, increasingly, for offset presses for all work.

Weight. In composition, the variation of a letterform: light, regular, bold. In paper measurement, the weight of 500 sheets (a ream) of paper of standard size.

Wet printing. The printing of one process color over another before the first has dried.

WF. *See* wrong font.

Widow. The end of a paragraph or of a column of reading matter that is undesirably short: a single, short word; or the end of a hyphenated word, such as "ing." Widows are usually corrected editorially either by adding words to fill out the line or by deleting a word in the preceding line so that the widow moves up, becoming part of it.

Width. Variations of letterforms: condensed, extended.

Window. A clear, usually rectangular or square panel in a litho negative. Halftone negatives are positioned (i.e., stripped) in this window, with tape.

Window (desktop publishing). An area on the screen in which tool boxes, menus, icons, etc. are displayed. It is possible to layer multiple windows on the screen, although only the top one is active at any time.

Wire side. Also referred to as the *wrong side.* That side of the paper that has rested on the wire during manufacture. As opposed to the felt, or right, side.

Wire stitching. *See* Saddle-wire stitching *and* Side-wire stitching.

With the grain. A term used to describe the directional character of paper, often applied to the folding of a sheet of paper parallel to the grain. Paper folds more easily and tears straighter with the grin than against the grain.

Woodcut. Also called a *wood engraving.* A print made from a relief image cut into a block of wood. The block is inked with a roller and the image is transferred directly to paper by pressing the inked surface against it. Woodcuts are the grain side of the wood block while wood engravings are the end grain.

Woodtype. Type made from wood. Usually used for the larger display sizes over 1″. Wood type is made in sizes measured in lines, a line being 1 pica in depth. A 10-line face is thus 120-point type.

Wordspace. The space between words.

Wordspacing. In composition, adding space between words to fill out line of type to a given measure.

Word wrap. The automatic continuation of text from one line to the next without having to press the return key.

Work and tumble. Printing the second side of a sheet by turning it over from gripper edge to back so that a new edge meets the gripper and using the same guide edge. This printing technique also allows the printer to print both sides of the sheet without having to change the printing plate.

Work and turn. Similar to work and tumble except that the sheet is turned over from left to right so that the same gripper edge is used for both sides.

Work Station. Generally considered to be more powerful than a PC (personal computer), but less than a mainframe.

Work-up. In letterpress printing, the unwanted deposit of ink caused by quads, spaces, or other material normally below type-high that work up by pressure so that they come in contact with the paper and print. Work-up is usually caused by poor lockup (*which see*).

Woven. In binding, any material that is woven: cloth.

Wove paper. An uncoated paper that has a uniform surface with no discernable marks.

Wrap-around plate. Flexible relief printing plates made of thin zinc, magnesium, copper, or synthetic materials that are clamped around the plate cylinder of a rotary letterpress.

Wrinkles. In printing, creases in the paper that occur during printing, usually due to uneven absorption of moisture from the atmosphere. In inks, an uneven surface that forms during drying.

Write. Recording data on some form of storage.

Writing paper. A kind of paper with a smooth, sized surface to prevent ink from being absorbed into the fibers.

Wrong font. An error in typesetting in which the letters of different fonts become mixed. Indicated by proofreader by "wf."

Wrong-reading. An image that reads the reverse of the original. A mirror image.

WYSIWYG. An expression, pronounced "wizzy-wig," that means *What you see is what you get*. In other words, what you see on the screen is what you will get as output.

X

Xerography. An inkless printing process that uses static electricity. Xerox, a trade name for this process, is a good example of this.

X-height. The height of the body of lowercase letters, exclusive of ascenders and descenders.

X-line. *See* mean line.

Z

Zinc engravings. Referred to as *zincs*. Line of halftone etchings made on zinc for letterpress printing.

Zip-a-Tone. Trade name for a series of screen patterns imprinted on plastic sheets that can be used to achieve tone of various kinds on art work. Zip-a-Tone comes in dots, lines, stipples, etc.

Metric System

The metric system is a decimal system (based on increments of ten). It is the world's most widely used system of measurement, and it is only a matter of time before it will be fully adopted by the United States. At present, the metric system is already used by many of our major industries and by government agencies, including the Armed Forces. Its adoption is bound to affect phototypesetting and printing, and for this reason we have included the basics of the metric system in this book.

Also, included in this section is a brief discussion of degrees Celsius, also to be adopted shortly by the United States.

BASE UNITS

There are a number of different base units of measurement in the metric system, but we shall concern ourselves with only the three major units: the *meter* (m), for measuring length; the *gram* (g), for measuring weight; and the *liter* (l), for measuring volume.

The value of each of these base units is fixed: a meter is a little longer than a yard, a gram is about one-third of an ounce; a liter is a little more than a quart. But these units are not always convenient; they may be too large or too small, depending on what is being measured. To accommodate the fullest possible range of measurements, a prefix is added to the base units to make them smaller or larger. (See below).

Any prefix may be added to any base unit, although in practice there are some combinations that are seldom, or never, used. Of the above prefixes, the most commonly used are milli, centi, and *kilo*. Some of the combinations with which you may be familiar are the millimeter (mm), centimeter (cm), kilometer (km), milligram (mg), and kilogram (kg).

	PREFIX AND SYMBOL	DECIMAL EQUIVALENT
One thousand times smaller	milli (m)	.001
One hundred times smaller	centi (c)	.01
Ten times smaller	deci (d)	.1
Base unit		**1.00**
Ten times larger	deka (da)	10.00
One hundred times larger	hecto (h)	100.00
One thousand times larger	kilo (k)	1000.00

METER

The meter is the metric unit of length and the symbol is "m." The meter is a little longer than a yard (39.37 inches) and for this reason it is often referred to as "the metric yard." It is used to measure anything we now measure in yards or feet: height, rooms, distance, fabric, etc.

The *millimeter* (mm) is one one-thousandths of a meter. It is used for measuring film, tools, machinery, arms and ammunition, etc. It is also used in the graphic arts field to measure the thickness of paper and seems almost certain to replace the point in measuring type and linespacing.

The *centimeter* (cm) is one one-hundredths of a meter. It is used to measure objects we would normally measure in feet or inches: body dimensions, garment measurements, etc. When measuring larger objects, meters and centimeters can be combined; for example, 1 meter 6 centimeters could be either 105 centimeters or 1.06 meters (106 cm or 1.06 m).

The *kilometer* (km) is one thousand meters, or between one-half and two-thirds of a mile. Kilometers are used wherever we use miles: distance, speed limits, etc.

centimeter	.3937 inch
meter	39.3 inches
kilometer	39370. inches or .6214 mile

GRAM

The gram is the metric unit of weight and the symbol is "g." One gram is about one-third of an ounce (.0353 ounce) and is used to weigh anything we now weigh in ounces; for example, butter, cheese, coffee, chocolates, etc.

The *milligram* (mg) is one one-thousandths of a gram. It is used for measuring items in very small quantities, such as drugs, chemicals, etc.

The *kilogram* (kg) is one thousand grams (a little over two pounds) and iss used to weigh anything we now weigh in pounds; for example, a bag of potatoes may weigh 2 kilograms. Your body weight will also be measured in kilograms: 6 kilograms (132 pounds); 7 kilograms (154 pounds), etc.

milligram (mg)	.0000353 ounce
gram	.0353 ounce
kilogram	35.30 ounces, or 2.2 pounds

LITER

The liter is the metric unit of volume and the symbol is "l." One liter is slightly more than a quart (1.06 quarts). The liter is used to measure anything we now measure in quarts or gallons, from a bottle of beer to a tankful of gas.

The milliliter (ml) is one one-thousandths of a liter and is used to measure items packaged in small quantities, such as soda, toothpaste, shampoo, etc. It is also used for measuring the ingredients in recipes.

liter (l)	1.0567 quarts
milliliter (ml)	.00155 ounces

DEGREES CELSIUS

Degrees Celsius (formerly called degrees centigrade) will eventually be fully adopted by the United States. When this happens all temperatures will be expressed in degrees Celsius rather than the degrees Fahrenheit we are presently using. This will not only affect how we read the atmospheric temperature, but also how we read body temperature, cooking temperature, and the temperature at which photographic paper and film are developed.

There are two key figures to remember in degrees Celsius: *0 degrees*, the temperature at which water freezes, and *100 degrees*, the temperature at which water boils. Add to these two figures the ideal room temperature of 20 degrees (68°F), a warm summer day of 30 degrees (86°F) and a cool evening of 10 degrees (50°F). Once you become familiar with these few figures it will not be long before you can fill in the gaps.

TYPESETTING SYMBOLS

When setting type, the metric symbols, rather than the full name, should be used (2 km, not 2 kilometers). A space should be left between the number and the symbol, except for degrees Celsius, where no space is left (10°C). A period is never used after a symbol unless it is at the end of a sentence. Symbols are always shown as singular (1 km, 10 km, and 100 km).

Symbols are written in lowercase, with these exceptions: the C for degrees Celsius is capitalized because it is derived from the name of the originator of the system, Anders Celsius. Also, some nations have chosen to capitalize the symbol for liter to avoid confusion between the lower case l and the numeral 1. The U.K. and Europe use an italic lowercase *l* for the same purpose.

METRIC CONVERSION FACTORS

When you know	Multiply by	To find
inches	2.54	centimeters
feet	30.48	centimeters
yards	0.91	meters
miles	1.61	kilometers
ounces	28.35	grams
pounds	0.45	kilograms
pints	0.47	liters
quarts	0.95	liters
gallons	3.78	liters
degrees Fahrenheit	Subtract 32 and then multiply by 5/9	degrees Celsius
degrees Celsius	Multiply by 9/5 and then add 32	degrees Fahrenheit

Selected Bibliography

General

Advertising Agency and Studio Skills.
Tom Cardamone. New York: Watson-Guptill.

American Wood Type. Rob Roy Kelly.
New York: Van Nostrand Reinhold.

Anatomy of Printing. John Lewis.
London: Faber and Faber.

The Art of Advertising: George Lois on Mass Communication. George Lois.
New York: Harry N. Abrams, Inc.

Asymmetric Typography. Jan Tschichold.
New York: Reinhold.

Basic Typography: A Design Manual.
James Craig. New York: Watson-Guptill.

The Bauhaus. Hans Wingler. Cambridge:
The MIT Press.

Bookmaking. Marshall Lee.
New York: R.R. Bowker.

By Design: A Graphics Sourcebook of Materials, Equipment, & Services.
New York: Quick Fox.

Calligraphic Lettering. Ralph Douglass.
New York: Watson-Guptill.

A Chronology of Printing. Colin Clair.
New York: Frederick A. Praeger.

A Designer's Art. Paul Rand.
New Haven: Yale University Press.

Designing with Type. James Craig.
New York: Watson-Guptill.

500 Years of Printing. S.H. Steinberg.
London: Penguin.

Forget all the Rules You Ever Learned About Graphic Design. Bob Gill.
New York: Watson-Guptill.

Fundamentals of Modern Photo-Composition. John W. Seybold.
Media, PA: Seybold Pub., Inc.

Graphic Design Manual. Armin Hofmann.
New York: Van Nostrand Reinhold.

Graphic Designer's Production Handbook.
Norman Sanders. New York: Hastings House.

The Grid. Allen Hurlburt. New York:
Van Nostrand Reinhold.

In Print. Alex Brown.
New York: Watson-Guptill.

The Invention of Printing in China, and its Spread Westwards.
Thomas Carter.
New York: Ronald Press.

Layout. Allen Hurlburt.
New York: Watson-Guptill.

Living by Design. Pentagram.
New York: Watson-Guptill.

Magazine Design. Ruari McLean.
New York: Oxford University Press.

Milton Glaser. New York: J.M. Folon.

Ottmar Mergenthaler and the Printing Revolution.
Willi Mengel. Brooklyn: Linotype Co.

Papermaking: Art and Craft.
Washington, D.C.: Library of Congress.

Papermaking: The History and Technique of an Ancient Craft.
Dard Hunter. New York: Knopf.

Pasteups & Mechaniclas. J. Demoney and S. Meyer. New York: Watson-Guptill.

Photographing for Publication.
Norman Sanders, New York:
R.R. Bowker.

Pioneers in Printing. Séan Jennett.
London: Routledge & Kegan Paul.

Pioneers of Modern Typography.
Herbert Spencer. London:
Lund Humphreys.

Pocket Pal. International Paper Company. New York.

Printing Types: Their History, Forms, and Use. 2 Vols. Cambridge, Mass.:
The Belknap Press of Harvard University.

Production for the Graphic Designer.
James Craig. New York: Watson-Guptill.

Publication Design. Allen Hurlburt.
New York: Van Nostrand Reinhold.

The Story of Papermaking.
Edwin Sutermeister.
Boston: S.D. Warren, Co.

Symbol Source Book. Henry Dryfuss.
New York: McGraw-Hill.

Thirty Centuries of Graphic Design.
James Craig and Bruce Barton.
New York: Watson-Guptill.

Thoughts on Design. Paul Rand.
New York. Van Nostrand Reinhold.

Type Sign Symbol. Adrien Frutiger.
Zurich: ABC Edition.

Type and Typography. Ben Rosen.
New York: Van Nostrand Reinhold.

Working with Graphic Designers.
James Craig and WIlliam Bevington.
New York: Watson-Guptill.

Annuals

American Illustration Showcase.
American Showcase. New York.

American Photography Showcase.
American Showcase. New York.

Art Directors' Annual.
The Art Directors Club of New York,
New York.

*The Art Directors' Club of Toronto Show
Annual.* Wilcord Publications, Ltd.
Toronto, Ontario.

Art Directors' Index to Photographers.
Roto Vision S.A. Mies, Switzerland.

Creative Source Canada.
Wilcord Publications, Ltd.
Toronto, Ontario.

Graphic Design USA.
The Annual of the American Institute
of Graphic Arts. New York.

Graphis Annual. Zurich, Switzerland.

Graphis Packaging. Zurich, Switzerland.

Graphis Photo. Zurich, Switzerland.

Graphis Poster. Zurich, Switzerland.

Illustrators' Annual.
The Society of Illustrators. New York.

One Show. Roto Vision S.A.
in association with The One Club for
Art and Copy. New York.

Penrose Annual. International Revue
of the Graphic Arts. New York:
Hastings House.

The Society of Illustrators.
Madison Square Press. New York.

The Society of Publication Designers.
Madison Square Press. New York.

Typography.
The Annual of the Type Directors Club.
New York.

The Workbook Portfolio. Scott & Daughters
Publishing. Los Angeles.

Periodicals

Communications Art
410 Sherman Avenue
Palo Alto, CA 94303

Desktop Communications
International Desktop Communications,
Ltd.
48 East 43 Street
New York, NY 10017

Graphis
CH 8008
Zurich, Switzerland

How
F&W Publications, Inc.
1507 Dana Avenue
Cincinnati, OH 45207

Macworld
Macworld Communications
501 Second Avenue
San Francisco, CA 94107

Personal Computing
VNU Business Publications, Inc.
Ten Holland Drive
Hasbrouck Heights, NJ 07604

Print
355 Lexington Avenue
New York, NY 10017

Publish!
PCW Communications, Inc.
501 Second Avenue
San Francisco, CA 94107

Step-By-Step Graphics
Dynamic Graphics, Inc.
6000 N. Forest Park Drive
Peoria, IL 61614-3592

U & lc
216 East 45 Street
New York, NY 10017

Illustration Credits

Editors: Margit Malmstrom and Carl Rosen

Designer: James Craig

Production Manager: Stan Redfern

Typesetting: Trufont Typographers, Inc.

Text type: 9-point Helvetica